More Than Illustrated Music

New Approaches to Sound, Music, and Media

Series Editors: Carol Vernallis, Holly Rogers, and Lisa Perrott

Forthcoming Titles:

Musical New Media by Nicola Dibben
David Bowie and the Art of Music Video by Lisa Perrott
Popular Music, Race, and Media since 9/11 by Nabeel Zuberi

Published Titles:

Transmedia Directors by Carol Vernallis, Holly Rogers, and Lisa Perrott
Dangerous Mediations by Áine Mangaoang
Resonant Matter by Lutz Koepnick
Cybermedia: Science, Sound, and Vision edited by Carol Vernallis, Holly Rogers, Jonathan Leal, Selmin Kara
The Rhythm Image: Music Videos in Time by Steven Shaviro
YouTube and Music: Cyberculture and Everyday Life edited by Holly Rogers, Joana Freitas, and João Francisco Porfírio
More Than Illustrated Music: Aesthetics of Hybrid Media Between Pop, Art and Video edited by Kathrin Dreckmann and Elfi Vomberg

More Than Illustrated Music

Aesthetics of Hybrid Media Between Pop, Art and Video

Edited by Kathrin Dreckmann and Elfi Vomberg

BLOOMSBURY ACADEMIC
NEW YORK • LONDON • OXFORD • NEW DELHI • SYDNEY

BLOOMSBURY ACADEMIC
Bloomsbury Publishing Inc
1385 Broadway, New York, NY 10018, USA
50 Bedford Square, London, WC1B 3DP, UK
29 Earlsfort Terrace, Dublin 2, Ireland

BLOOMSBURY, BLOOMSBURY ACADEMIC and the Diana logo are trademarks of Bloomsbury Publishing Plc

First published in the United States of America 2023
This paperback edition published 2024

Copyright © Kathrin Dreckmann and Elfi Vomberg, 2023

Each chapter copyright © by the contributor, 2023

All rights reserved. No part of this publication may be reproduced or transmitted in any form or by any means, electronic or mechanical, including photocopying, recording, or any information storage or retrieval system, without prior permission in writing from the publishers.

Bloomsbury Publishing Inc does not have any control over, or responsibility for, any third-party websites referred to or in this book. All internet addresses given in this book were correct at the time of going to press. The author and publisher regret any inconvenience caused if addresses have changed or sites have ceased to exist, but can accept no responsibility for any such changes.

Library of Congress Cataloguing-in-Publication Data

Names: Dreckmann, Kathrin, editor. | Vomberg, Elfi, 1986- editor.
Title: More than illustrated music: aesthetics of hybrid media between pop, art and video / edited by Kathrin Dreckmann and Elfi Vomberg.
Description: New York : Bloomsbury Academic, 2023. | Series: New approaches to sound, music, and media | Includes bibliographical references and index. | Summary: "Examines the processes of hybridization between music video, film, and video art by presenting current theoretical discourses and exploring crucial questions of art practice"– Provided by publisher.
Identifiers: LCCN 2022031347 (print) | LCCN 2022031348 (ebook) | ISBN 9781501381232 (hardback) | ISBN 9781501381270 (paperback) | ISBN 9781501381249 (epub) | ISBN 9781501381256 (pdf) | ISBN 9781501381263 (ebook other)
Subjects: LCSH: Music videos. | Art and music.
Classification: LCC PN1992.8.M87 M67 2023 (print) | LCC PN1992.8.M87 (ebook) | DDC 780.26/7–dc23/eng/20220829
LC record available at https://lccn.loc.gov/2022031347
LC ebook record available at https://lccn.loc.gov/2022031348

ISBN: HB: 978-1-5013-8123-2
PB: 978-1-5013-8127-0
ePDF: 978-1-5013-8125-6
eBook: 978-1-5013-8124-9

Series: New Approaches to Sound, Music, and Media

Typeset by Deanta Global Publishing Services, Chennai, India

To find out more about our authors and books visit www.bloomsbury.com and sign up for our newsletters.

Contents

List of Figures — vii

Introduction *Kathrin Dreckmann and Elfi Vomberg* — 1

I Media Archaeology: The Beginning of Hybrid Media

1 Music Video and Its Convergence Potential: From the Hybrid to the Permeable *Henry Keazor* — 11
2 Sound and Vision: Early Artists' Video and Music *Chris Meigh-Andrews* — 29
3 The Process of Creating Was More Important than the Object *Ulrike Rosenbach* — 42

II Media Archives on Hybrids

4 It Belongs in a Museum? Music Videos in Danish Museum Exhibitions *Mathias Bonde Korsgaard* — 47
5 No Returns for Dislike: How Music Videos and Video Art Entered the Living Room in the 1980s *Linnea Semmerling* — 59
6 An Aura with Pencil, Brushes, and Pixels *Wulf Herzogenrath* — 73

III Hybrid Imagines: Media Aesthetics between Pop and Identity

7 You Need to Calm Down—Stardom and Cancel Culture: The Music Video as an Audiovisual Protest Poster *Elfi Vomberg* — 79
8 Facing the Lens of the Camera: Bodies, Self-portraiture, Portraiture, and Identity in Women Artists' Video *Laura Leuzzi* — 93
9 Spirit of Creation—between Documenting, Expressing, and Archiving *Interview with AnAkA* — 106

IV Aesthetics of Popular Media Hybrids

10 Trans* Bowie . . . Trans* Prince *Jack Halberstam* — 115
11 Black Queen and King: Iconographies of Self-empowerment, Canon, and Pop in the Current Music Video *Kathrin Dreckmann* — 125
12 Audiovisual Art Is about Hybridization *Barbara London* — 145

V Future Aesthetics on Hybrid Media

13 Music Video Distortion and Posthuman Technogenesis *Kristen Lillvis* 153
14 Untimely Futures and the Art of Revolutionary Life *Jami Weinstein* 165
15 Feeling Closer to the Track—The Representation of Blackness in Music Video *Modu Sesay* 179

VI Media Art Hybrids

16 Hold Up: Mapping the Boundaries between Music Video and Video Art *Kirsty Fairclough* 187
17 But Still . . . Is It Art?: Contemporary Music Video, Art (Discourse), and Authority—Revisited *Maren Butte* 198
18 Time-Based Media Art in Music Video—One Does Something the Other Cannot *Julia Stoschek* 213

Biographies 217
Index 222

Figures

1.1a	The album cover for *Give Me the Night* by George Benson, 1980	16
1.1b	*Give Me the Night* by George Benson, 1980	17
1.2	Léa Seydoux as Simone. *The French Dispatch* by Wes Anderson, 2021	19
1.3	*La Source* by Jean-Auguste-Dominique Ingres, 1856	19
1.4	*Run and Run* by Lyrical School, 2016	23
1.5	*Phenom* by Thao & The Get Down Stay Down, 2020	25
2.1	Beryl Korot setting up *Dachau 1975* at Brownwood College, Florida	31
2.2	*Three Tales*: Act 3 by Beryl Korot and Steve Reich, Rodney Brooks and Robot Kismet	33
2.3	John Sanborn and Phillip Glass, 2016	35
2.4	John Sanborn and Robert Ashley, Belgium	35
7.1	A sticky mixture: candy floss + pink prosecco = kitsch offensive. *You Need to Calm Down* by Taylor Swift, 2019	82
7.2	Two worlds collide: queer community and protest group. *You Need to Calm Down* by Taylor Swift, 2019	83
7.3	A Twitter user brings the word "hate" into play	84
7.4	A row of accusations against Taylor Swift	84
7.5	"Hate" is a term that is utilized again and again in concurrence with #TaylorSwiftIsOverParty	85
8.1	*Punto de fuga* by Pilar Albarracín, 2012	99
8.2	*Viva España* by Pilar Albarracín, 2004	100
8.3	*Dust Grains* by Elisabetta Di Sopra, 2014	101
8.4	*Il Limite* by Elisabetta Di Sopra, 2019	104
11.1	The Carters in front of the *Mona Lisa*. *Apeshit* by The Carters, 2018	128
11.2	A reaction to the Music Video on Twitter	129
11.3	Black Icarus in front of the Louvre. *Apeshit* by The Carters, 2018	130
11.4	The Carters in the Salle des États. *Apeshit* by The Carters, 2018	132
11.5	Part of the Painting *Portrait d'une femme noire*. *Apeshit* by The Carters, 2018	133
11.6	The Carters in front of the *Nike* with dancers. *Apeshit* by The Carters, 2018	134
11.7	Beyoncé and Dancers in front of *Coronation of Emperor Napoleon I and coronation of Empress Josephine in Notre-Dame Cathedral of Paris*. *Apeshit* by The Carters, 2018	135
11.8	Beyoncé in front of the *Nike of Samothrace*. *Apeshit* by The Carters, 2018	138
11.9	Jay-Z and Beyoncé posing in the Grand Gallery. *Apeshit* by The Carters, 2018	138

11.10 *The Intervention of Sabine Women. Apeshit* by The Carters, 2018	139
11.11 Swan Motif in front of the *Portrait of Madame Récarnier. Apeshit* by The Carters, 2018	140
11.12 Black Man on a horse in contrast to *The Charging Chasseur. Apeshit* by The Carters, 2018	141
17.1 *Lost Day* by Other Lives, 2019	207
17.2 *Lost Day* by Other Lives, 2019	208
17.3 *Lost Day* by Other Lives, 2019	208
17.4 *Lost Day* by Other Lives, 2019	209
17.5 *Cry Theme* by Klein, 2017	210

Introduction

Kathrin Dreckmann and Elfi Vomberg

The genre of the video clip was established more than forty years ago. Its specific audiovisual aesthetics are mainly served by two genres: video art and the music video. However, it is important to note basic historical as well as structural differences between these two genres: The media-archaeological roots of video art date back more than 100 years and are embedded in a long tradition of cinematic and visual arts. The genre of the music video is a complex form of pop cultural aesthetic that emerged in the 1970s and is closely related to everyday culture, art, as well as to media culture. It pervasively references pop cultural artifacts such as cartoons, video games, commercials, pieces of visual and video art, as well as elements from its own history. This complex structure of aesthetic discourse, which can be characterized by terms such as merging, blending, and blurring of audiovisual genres, has yet to be identified as a form of media hybridity that can be traced back to the practice of media art and its media-archaeological beginnings.

One of the first anthologies highlighting forms of hybridization that places the music video between video aesthetics and media art was published in 1987 by Veruschka Bódy and Peter Weibel: *Clip, Klapp, Bum. Von der visuellen Musik zum Musikvideo* managed to gather work by researchers who are still affiliated with exploring the music video today and have dedicated their career to writing about the aesthetics, history, and theory of the music video in close proximity to audiovisual and avant-garde art (Bódy and Weibel 1987). The contributions of Peter Weibel and Dieter Daniels are particularly noteworthy in that respect: early on they understood the intermedial permeability of the music video—its susceptibility to influences from heterogeneous sources—as an attribute specific to this new medium. Furthermore, they liberated it from a discourse that linked it exclusively to culture-industrial methods of production, distribution, and reception (Bódy and Weibel 1987; Daniels 1987). This was quite unusual in 1987, as a reading of their contemporaries reveals: collections and monographs from the same time generally chose a much more critical standpoint and only understood the music video as a particular product of the culture industry (Fiske 1986; Goodwin 1992; Kaplan 1987; Sanjek 1988; Schmidt, Neumann-Braun and Autenrieth 2009). In its many forms, the music video is a hybrid and highly permeable medium which proves to be much more than just "illustrated music," namely a specific art form situated between different genres and formats—a fact that was acknowledged only much later in the context of scholarly research. Carol Vernallis makes this an especially prominent point in her works and describes this change of paradigm as

follows: "We used to define music video as a product of the record company in which images are put to a recorded pop song in order to sell the song. None of this definition holds anymore" (Vernallis 2013: 208).

As a matter of fact, the music video nowadays can still be described as a permeable and nonreliable medium with its own sub-genres and structural implications as well as its own artistic aspirations. This makes it all the more difficult to work out a simple and general definition of the music video as an artistic genre. From the perspective of media archaeology, the question of how to combine music and image is something that has been around for a long time and even dates back to the seventeenth century, if one considers the impish, but nonetheless, visionary ideas of the German Jesuit monk Athanasius Kircher that were prominent at that time. The first technological concepts of the music video were created in three stages. Around 1904 there were the performative works by Thomas Alva Edison, which combined image and sound. But the works of Walter Ruttmann and Viking Eggeling on synesthesia were also experiments that translated sound into images and can be considered as precursors. Finally, the specific clip aesthetics of Oskar Fischinger's early video works in the 1940s, which are also considered precursors for advertising clips, could as well be seen as a media-archaeological starting point in the early history of the music video. Thus, the music video has always been a part of artistic avant-garde movements and has been interconnected with them constitutively (Bódy and Weibel 1987; Groos and Müller 1998; Zielinski 2010). This allows for the possibility to search for a point of departure in film history (Rogers 2017) as well as in the history of clip aesthetics—from Soundies to TV commercials. It is exactly these multilayered references that allow us to understand music videos or clips as artistic or hybrid genres from a very early point onward. These observations coincide with groundbreaking work on the history and theory of music videos. For example, the work of Holly Rogers particularly refers to the media history of this genre when she locates the hybrid and transmedial structures of the music video between film, video, and art music (Rogers 2013), notably in her work *The Music and Sound of Experimental Film* (2017).

References to other genres, as well as their mutual penetrations, are therefore part of a genealogical process, regardless of whether they emanate from film or from the processing of clip aesthetics. Either way, they evolve into something new. Mathias Bonde Korsgaard elaborates on this idea when he talks about the "logic of remediation on many different levels" and "hybridized and intense stylistic expression" which he attributes to music videos. He highlights: "Music videos routinely resemble other media forms, including silent cinema . . . computer games . . . Google's search engine . . . concerts . . . and others" (Korsgaard 2013: 508). Like Vernallis, he describes the concept of hybridization as a constitutive element of the music video genre.

When it comes to the question of the hybridization between music videos and other formats—not only historically but also in the context of contemporary social media and their reception practices—Korsgaard provides a useful approach via the constantly transforming music video genre. He writes: "As with other areas of contemporary culture, music videos have long been involved in processes of media convergence and 'participatory culture'; they have also accessed different media technologies,

hybridized with other media forms, and functioned as part of cross promotional processes. But the new forms accelerate trends latent in the past" (Korsgaard 2013: 507). The resulting usage of mixed media becomes especially prevalent as the modes of production, distribution, and reception change after the era of MTV, and it clearly distinguishes these later music videos from earlier productions as new audiovisual forms emerge through a change in the artistic relationship between image, music, and text (Vernallis 2004: 44). At least since the beginning of the YouTube era, the music video has no longer been tied to the technological reception modes of television—instead it has transformed and evolved under the influence of digital and social media which allow interactive participation: "Music videos appear in new and unexpected media, interactive games, and iPhone apps. A dizzying array of user-based content ranges from vidding and remixes to mashups. It still makes sense to call all these 'music videos'" (Vernallis 2013: 208). Vernallis clearly emphasizes the progressing hybridization of music videos and reminds us of the fact that hybridization has always been a characteristic of this format:

> At the same time that we define music video inclusively and expansively, we may wish to restrict the focus. In the 30 years of music video, various sorts of "canon" have emerged. We can see why it is useful to flag some musicians' and directors' bodies of work, as well as particular historical moments. It is hard to be rigorous about what exactly is within this genre, and what is an outlier. (Vernallis 2004: 209)

Vernallis compares the openness of the genre structures as well as the remediations to Wittgenstein's "ideas that genres are made up of family resemblances" (Vernallis 2004: 209) and takes into account the tradition of the short clip, of film, and of video. This observation refers not only to genres, however, but also to content which often seems to either be interconnected historically or seems synchronously circulate through contemporaneous productions. Of course, such hybrid structures are quite commonly displayed in pop cultural productions of any format, not only in music videos, and individual music videos also often reference the genre and its history within a single work.

The works of Janelle Monáe, Beyoncé, and Lil Nas X certainly belong to this group of current media productions that constitutively reflect upon the aesthetics of hybrid media between pop, art, and video. Remarkably, echoing Christian and ancient iconography, they also include references to visual art, early film, and the avant-garde. Janelle Monáe is a particularly wonderful example of an artist who embodies hybrid aesthetics. Her references incorporate familiar poses, images, film aesthetics, pop history, and cultural theories; in the process, she creates new works infused with a momentum of Black Empowerment. Monáe references Sun Ra's Afrofuturism, poses and positions reflected in gender theory, as well as zeitgeist and pop cultural role representations.

In a *But Magazine* article released in 2013, she uses pop historical poses from Grace Jones' album cover "Island Life" (1985). This is quite typical for her own aesthetic—fashion poses as well as antique statue postures are recited in equal measure. In the album

"Archandroid," (2012) inspired by the film *Metropolis* by Fritz Lang (1927), she takes up cyborg theories by Donna Haraway (1985) and combines them with post-gender themes.

She perfected the assembled aesthetic years later in her album "Dirty Computer" (2018), in which she not only directly references Prince, Michael Jackson, David Bowie, and Grace Jones, but also Mary Douglas' "Purity and Danger" (1966) as well as Donna Haraway's "Cyborg Manifesto" and sketches out perspectives between performance, video, and visual art in the music videos.

Throughout these videos, which are part of the film for the concept album, Monáe alludes to Afropunk, Botticelli's *Birth of Venus*, *tableau vivants*, video art, and formal aesthetic media theory discourses. She develops her own concept between queer Black Empowerment, pop cultural citation practice, and scientific cultural theory. This marks hybridization strategies that are paradigmatic for the concept of the present volume.

With regard to digitalization and globalization, this book considers far-reaching developments at the boundary between music video and video art. The different contributions to every chapter incorporate the perspective of media theory as well as that of art practice itself. This logic is maintained throughout all chapters. Mediation between the diverse topics is achieved through the addition of an active discussion at the end of every chapter. This adds a new perspective and leads to the possibility of not only reflecting upon media technology but also upon the complex logic of citation between postcolonialism, posthumanism, gender, race, and class. Also addressed are

1) questions regarding the hybrid media structure of video, and
2) The diffusion between content and form, art, and commerce as well as pop culture and counterculture.

First and foremost, the book offers a diverse selection of different theoretical approaches and therefore addresses a broad public that might never have come into contact with research on music video otherwise. Through this inherent diversity, it manages to build on an early perspective on music video (one that shows its specific dispositive and aesthetic) that has only recently regained popularity. Consequently, the topic of the book and the approach chosen by its authors reflect a current trend in the academic community. Furthermore, interviews with important personalities from the context of music video production and video art complete the theoretical insights of each chapter by adding some practical and historical background.

The first part combines entries by established researchers (Henry Keazor and Chris Meigh-Andrews) who have engaged in research of hybrid audiovisuality since the media artists' early videos and music. The purpose of this part is to embed the present volume in the context of previously established research as well as to get a fresh look on well-accepted theories. The concluding interview confronts video art pioneer Ulrike Rosenbach with current positions of media theory.

The second part focuses on different perspectives on video in museums and the question of their archiving strategies. To this end, Mathias Bonde Korsgaard first takes a look around Danish museum exhibitions. In the field of tension between questions of curation, discourses of art, and intermedial relations, he asks how and why music

videos have found their way into museums. While he focuses on the space of public exhibition, Linnea Semmerling looks for traces within the intimate setting of the video shelves in the living rooms of the 1980s. She rummages through archives beyond the criteria of economic success and thus yields an early glance at a domestic buyers' market for uneditioned video art *avant la lettre*. A concluding interview with curator Wulf Herzogenrath takes up both perspectives—looking back to the origins of video art and looking forward to current questions of curation, discussing the multiple practices of conservation of digital media art in the process.

Part III concentrates entirely on hybrid identity constructions with a focus on questions of visual aesthetics—in the field of tension between social media, feminism, and techniques of representation: While Elfi Vomberg interprets the current music video as an audiovisual protest banner and analyzes diffusion processes between digital phenomena and artistic strategies, Laura Leuzzi devotes herself to the topoi of bodies, self-portraiture, portraiture, and identity in videos by women artists in the late 1960s and the 1970s. In the final interview of the part, artist AnAkA also investigates questions of identity and subjectivity. She reflects on identity processes in her art as a hybridity of global communities, digital and analog materialities, and hybrid role models. Part IV pursues these ideas further and deals with strategies that position the music video between avant-garde and commercialization. Jack Halberstam takes up the previous questions of identity and picks up where AnAkA left off: Halberstam discusses the hybrid artist David Bowie from the perspectives of gender and race and asks: "Which Bowie was your Bowie?" Kathrin Dreckmann elaborates on this point by examining Afrofuturist perspectives in current music videos and takes a look at transcultural image programs between the critique of eurocentrism, empowerment strategies, and gaze aesthetics of the art and music of the Afro-American diaspora. An interview with Barbara London (MoMA, New York) examines current trends regarding exhibitions of moving pictures and discusses new spaces and innovative ways of distribution for music and video art.

Part V ("Future Aesthetics on Hybrid Media") offers an alternative viewpoint on subjectivity, ethics, and emancipation. Posthuman discourses often mark current music video productions, as can be witnessed in the videos of Arca and Björk. Depictions of cyborgs often challenge binary forms of thinking regarding categories such as race, class, and gender as suggested in the "Cyborg Manifesto" by Donna Haraway, where human identity adapts to the posthuman endeavors of science and technology studies. Kristen Lillvis points to the mutually constitutive relationship between artist and environment and argues that by highlighting both technological changes and physical transformations, music videos use distortion to emphasize the importance of embodiment for the posthuman subject. In this part, Jami Weinstein predicts the future of an "art of revolutionary life"—art that does not imitate life but creates it. This part looks at Afrofuturism with a queer and/or feminist twist through the work of a range of female, queer, trans*/nonbinary, and Black music video artists. Modu Sesay highlights this approach in his interview by underlining the importance of collaboration and heritage and by showing how these can be used to create a unique aesthetic of (Female) Black Empowerment.

Are the hybrid structures of the music video determined by certain aesthetic dynamics, and if so, in which way? Countless components, yet to be named, show up in diverse practices of video production and make generous use of sources from disciplines such as art, science, and commerce—and all of them become essayistic practices of discourse in themselves and are considered here. This—concluding—part entitled "Media Art Hybrids" examines the hybrid-like constellations in the video genre and questions the boundaries between different artistic formats which have long been liquefied or diffused into a form of equilibrium.

Kirsty Fairclough once again broadens the view by advocating a hybrid approach to the field: she explores how the music video connects with broader histories of audiovisual media and how it feeds on practices from video art to global popular culture. This transformed relationship between contemporary music videos and art history is also the focus of Maren Butte's perspective. She analyzes how current music videos reorganize forms of artistic value and commodity, as well as the relation between representation and authority, museum and media (an-)archive. The part closes with an interview about time-based media art in music videos. Julia Stoschek, owner of the largest collection of time-based art in Europe, reflects upon tendencies of hybridization which are laid out in this part.

We would like to take this opportunity to thank all the authors for their contributions. We are very proud that together with them we are able to add yet another nuance to the renowned series "New Approaches to Sound, Music, and Media." Thank you to the editors Carol Vernallis and Holly Rogers for your great support and for making this valuable collaboration possible! We are also grateful for the advice and support from Bloomsbury—represented by Leah Babb-Rosenfeld and Rachel Moore—we have always felt well looked after and we would like to thank them for their openness and smooth organization.

Thanks are also due to Don MacDonald for his flexibility and tireless efforts and the productive exchanges we had—it has been a great pleasure working with you! As well as our helpers at the Institute for Media and Cultural Studies who actively supported us in the editorial work! We would especially like to thank Fabian Boche for his organizational insight in all phases of the project and his precise eye in all formal matters. Sarah Rüß was also a huge help in the editorial department—cheers to her research skills! A big thank you goes to Bastian Schramm for his editorial work and especially for the stimulating conceptual exchange!

References

Bódy, Veruschka and Peter Weibel (eds.) (1987), *Clip, Klapp, Bum. Von der visuellen Musik zum Musikvideo*, Cologne: Dumont.

Daniels, Dieter (1987), "Die Einfalt der Vielfalt. Ein fiktives Selbstgespräch," in Veruschka Bódy and Peter Weibel (eds.), *Clip, Klapp, Bum. Von der visuellen Musik zum Musikvideo*, 165–80, Cologne: Dumont.

Fiske, John (1986), "MTV: Post-Structural, Post-Modern," *Journal of Communication Inquiry*, 10 (1): 74–9.

Goodwin, Andrew (1992), "From Anarchy to Chromakey. Developments in Music Television," in Andrew Goodwin (ed.), *Dancing in the Distraction Factory: Music Television and Popular Culture*, 24–48, Minneapolis: University of Minnesota Press.

Groos, Ulrike and Marks Müller (1998), *Make It Funky. Crossover zwischen Musik, Pop, Avantgarde und Kunst*, Cologne: Oktagon.

Kaplan, E. Ann (1987), *Rocking Around the Clock: Music Television, Postmodernism, and Consumer Culture*, New York: Methuen.

Korsgaard, Mathias Bonde (2013), "Music Video transformed," in John Richardson, Claudia Gorbman and Carol Vernallis (eds.), *The Oxford Handbook of New Audiovisual Aesthetics*, 501–17, New York: Oxford University Press.

Rogers, Holly (2013), *Sounding the Gallery: Video and the Rise of Art-Music*, Oxford: Oxford University Press.

Rogers, Holly (2017), *The Music and Sound of Experimental Film*, Oxford: Oxford University Press.

Sanjek, Russel (1988), *American Popular Music Business in the 20th Century. The First Four Hundred Years, Volume III: From 1900 to 1984*, New York: Oxford University Press.

Schmidt, Axel, Klaus Neumann-Braun, and Ulla Autenrieth (eds.) (2009), *Viva MTV! reloaded: Musikfernsehen und Videoclips crossmedial*, Baden-Baden: Nomos.

Vernallis, Carol (2004), *Experiencing Music Video*, New York: Columbia University Press.

Vernallis, Carol (2013), *Unruly Media: YouTube, Music Video, and the New Digital Cinema*, New York: Oxford University Press.

Zielinski, Siegfried (2010), *Zur Geschichte des Videorekorders*, Potsdam: Polzer.

I

Media Archaeology
The Beginning of Hybrid Media

1

Music Video and Its Convergence Potential

From the Hybrid to the Permeable

Henry Keazor

Prologue

"Somewhat like Italian operas in the nineteenth century or MGM musicals in the twentieth, music videos are a hybrid, impure form," the American philosopher and cultural critic Steven Shaviro writes in his volume on *Digital Music Videos*, published in 2017 (Shaviro 2017: 7).

This association of the concept of the hybrid with the music video can be found almost since the beginnings of academia's engagement with the medium from the end of the 1980s and the beginning of the 1990s onward, whereby (as will become clear in the further course of this text) the hybrid here is meant to designate on the one hand the origin, then, on the other hand, the facture of the clip itself, and ultimately also one of the types by means of which the various manifestations of the music video are to be classifiable.

In almost all cases, however, something of a qualitative-moral evaluation is mixed into this seemingly purely formal determination—intentionally or unintentionally—via the concept of the hybrid, to which Shaviro's use of the term "impure" significantly refers. The latter seems to be consequently coupled with the concept of hybrid inasmuch as this notion is etymologically derived from judgmental expression, of which one should be aware when working with the concept of hybrid. Derived from the Greek ὕβρις (= *hýbris*, i.e., "wantonness" or "presumption"), it denotes with the Latin *hybrida* a "half-breed," a "bastard," respectively even a "mongrel" (*A Standard Dictionary of the English Language* 1899: 878, entry "hybrid"), all judging colorings that still resonate today in a timbre between fascination and indignation because of this constitution, up to Carol Vernallis's words on YouTube and music video (both, as we will see later, meanwhile even more closely associated with each other under the signum of the hybrid) as "unruly media" (Vernallis 2013).

However, already in Veruschka Bódy's preface to the book *Clip, Klapp, Bum: Von der visuellen Musik zum Musikvideo*, published together with Peter Weibel in 1987, the association of the hybrid with the immature can be found when the author

pejoratively readapts the philological term "Chrestomathy"—a term used for a compilation of (mostly prose) texts or text excerpts produced for didactic purposes—to "Chrestomania" and "Cliptomathy" (Bódy 1987: 12): according to Bódy, clips are, as "sound and image collages," "a random selection of sketches, etudes, and gags" that "like kleptomaniacs," appropriate everything they can get (Bódy 1987: 12),[1] thus hybrid by their randomness alone. As opposed to the "Chrestomathy," however, they do so—beyond the indoctrination to mindless consumption Bódy accuses them of (Bódy 1987: 13-14)—no longer with didactic goals, but without any pretensions: "Neither makers nor recipients pose the question of an overarching entity—video clips can be understood without" (Bódy 1987: 13).[2] The equation of makers and audience is programmatic here because, according to the author, the music video levels everything and everyone, and she makes one medium, television, responsible for this, which she—in contrast to other authors—identifies as the direct ancestor of the music video and which she sets apart from media such as radio or cinema:

> Radio and even more so cinema became a political issue. Television, like the Clipworld, on the other hand, has the characteristic of being constantly available, an eternal companion of our everyday life, without us having to make a special effort to get it. When you read a book or listen to the radio, you can still think about something else. Going to the movies is something you have to do. Television and video clips, however, take up the viewer completely, dull him, seduce him into passivity. (Bódy 1987: 14)[3]

Questions of Origin(s)

In his "Introduction: Opera in the Distraction Culture" to the volume he edited in 1994, *A Night in at the Opera. Media Representations of Opera*, the British comparatist Jeremy Tambling writes that the music video is hybrid in that it owes its origin equally to film and television: two, in his view, virtually opposing media concerning their visual terms, since film for him owes its origin to an interest in reproducing movement, while television is, according to Tambling, "poor in visual terms" and is rather "a growth dependent on radio" (Tambling 1994: 19). Consequently (although debatably) for the author, film promotes the director, while television promotes the author—the music video, on the other hand, sitting between the stools of these two metaphorical parents, is, as he writes with reference to a statement by the British film scholar Roy Armes from 1988, "recording material in search of a mode of production" (Tambling 1994: 20; Armes 1988: 166), which is why it also remains for Tambling "a music-driven medium" (Tambling 1994: 19). He thus also attempts to distinguish opera from music video,

[1] Own translation.
[2] Own translation.
[3] Own translation.

both of which he characterizes equally (like Shaviro in the quotation at the beginning) as hybrid: "Opera is hybrid. So is video hybrid" (Tambling 1994: 19). According to him, however, within the opera the elements of music (concert), libretto (literature), and staging (theater), which originate in different genres, enter into a symbiosis in which the components mutually enhance each other and generate "plenty of 'meaning'" (Tambling 1994: 18). In the case of the music video, however, the dominance of the music preceding the other components (the lyrics interpreted at the same time are not taken into account by him) results, in his view, in "insufficient meaning," for which Tambling also holds the pragmatic purpose of the medium responsible, because he also sees the "insufficient meaning" as a consequence of the fact that the music video is "all profit and presentation" (Tambling 1994: 18).

Criteria

It is interesting to find these aspects still ventilated decades later in relation to the music video, whereby, however, on the one hand the virtues of opera, to bring about an interrelationship between its components, are now transferred to the music video; on the other hand, the reproach of the original purpose of the music video is still brought unchanged into play as a possible argument against its claim as an art form in its own right.

For example, in their 2019 paper "The Music Video in Transformation: Notes on a Hybrid Audiovisual Configuration," Czech comparatist Tomáš Jirsa and Danish media scholar Mathias Bonde Korsgaard see that "the Bakhtinian concept of intertextuality involving the multitude, co-presence, and overlapping of mutually clashing voices comes out as a defining feature of music video, which is a hybrid audiovisual configuration driven by the interaction of recorded sounds, moving images, and lyrics; an intertextual space of perpetual remediations where one medium transforms the other" (Jirsa and Korsgaard 2019: 117).

Tambling's dominance of the musical as well as, according to him, the "insufficient meaning" resulting from it (Tambling 1994: 18) has now given way to that interaction which interweaves the meanings originating from the various constituents to the genesis of "plenty of 'meaning'" made possible by it (Tambling 1994: 18), which Tambling had still reserved for opera in 1994.

Nevertheless, in the volume mentioned at the beginning of this article and published only two years earlier than Jirsa's and Korsgaard's paper, one encounters Shaviro's arguments (as will be seen below in an admittedly adversative context),[4] which can be seamlessly integrated into Tambling's structure of argumentation—and if the following paragraphs focus so heavily on Shaviro's text, it is only since he perfectly sums up the common view on music video as hybrid and the resulting various facets,

[4] Shaviro, in the further course of his book, then contrasts these arguments with the *fascinosa* of the music video, though without refuting his previous arguments—see here under "4) Concession."

some of which, as seen, can already be encountered in earlier texts such as those by Bódy or Tambling. Perhaps even more than the latter, Shaviro makes it clear that the hybrid here, understood in the sense of the impure, is also turned as a criterion against the possible qualities of the music video, which from his point of view is not only not exclusively committed to pure, higher, and absolute interests, but also serves pragmatic purposes and is thus judged as hybrid/impure, that is, compromised and thus deficient:

A) "They almost never have the status of independent, self-subsisting works" (Shaviro 2017: 7). Apart from the fact that this also applies only very conditionally to other works of art, which even from the nineteenth century on, when the autonomous work of art was propagated, were still mostly created and presented in compliance with as well as dissociation from, for example, public interests: what does "almost never" mean here precisely? If one thinks, for example, of the fact that in recent decades music videos have not only been exhibited chronologically and genealogically for their own sake and as art in exhibitions,[5] but have even been and are shown as a matter of course at art exhibitions alongside the creations of artists generally recognized as such,[6] it becomes clear how antiquated and unsustainable this argument is.

B) "Even more than other pop-cultural forms, they are subject to whims of marketers and publicists" (Shaviro 2017: 7). Here, too, one could ask what exactly is to be understood by "even more than others" respectively and would have to ask back: "How much *more*?" One does not have to think only of film to see a sphere of activity in which the "whims of marketers and publicists" dominate the corresponding works at least as much, if not even more—in view of the budgets invested: even art exhibitions were and are treated in the same way at the very latest since the advent of the "blockbuster exhibitions" (Lüddemann 2011).

C) "And they most often serve the derivative purposes of advertising songs for which they were made and of contributing to the larger-than-life, transmedia personas of their performers" (Shaviro 2017: 7). Here, too, one could not only cite counter-examples (Michael Jackson and Björk, for example, did not have their clips for *Thriller* and *Bachelorette* filmed as advertisements for the songs, but commissioned them after the respective pieces had become hits),[7] but could again refer to the realm of serious classical music supposedly untainted by such apparently abject and base motivations. Ludwig van Beethoven had no problem

[5] See exhibitions such as *look at me. 25 Jahre Videoästhetik* at the NRW-Forum Kultur und Wirtschaft in Düsseldorf in 2004 (Poschardt 2004), *the art of pop video* in 2011 at the Museum für Angewandte Kunst Köln (Aust and Kothenschulte 2011), *Imageb(u)ilder: Vergangenheit, Gegenwart und Zukunft des Videoclips* at the rock'n'popmuseum Gronau also in 2011 (Keazor, Mania and Wübbena 2011), and most recently *The World of Music Video* at the Völklinger Hütte in 2022 (Beil 2022).

[6] See, for example, the case of Chris Cunningham's video for Björk's song *All Is Full of Love*, exhibited at the Venice *Biennale* in 2001 (Keazor and Wübbena 2014: 335).

[7] For example, John Landis's music video for Michael Jackson's *Thriller* (1983) was not a real advertising vehicle for this particular song since it was already successfully performing in the charts—it thus has rather to be considered as a sort of general "image-cultivation" for Jackson (Keazor and Wübbena 2014: 252).

with the fact that his composition *Wellingtons Sieg oder die Schlacht bei Vittoria*, op. 91 of 1813 was to be performed by the mechanical panharmonicon of the inventor, mechanic, and designer of mechanical musical instruments Johann Nepomuk Mälzel, a kind of mechanical orchestral apparatus, as part of a large-scale European tour with mass appeal—on the contrary, Beethoven initially even agreed to organize a large-scale world premiere conducted by him as an audience-oriented spectacle to finance the tour, in which all the great composers of Vienna participated in the sense of a "supergroup": Antonio Salieri took on one of the conducting duties, and Giacomo Meyerbeer and Ignaz Moscheles played in a huge orchestra (Mathew 2006: 17–61). And the Italian violin virtuoso and composer Niccolò Paganini also composed his pieces as a vehicle to promote his virtuosity and fame (Kawabata 2013: 71–5).[8]

D) "They are also generally based on pre-existing musical material, which was not created with them in mind" (Shaviro 2017: 7). This also applies to film musicals and sometimes even operas in which musical material is also used that was not written specifically for the opera in question.

Typology

As briefly touched upon earlier, the concept of the hybrid was also repeatedly used as a criterion, especially in the early days of academia's examination of the phenomenon, to characterize one of the various manifestations of the music video, which indirectly have to do with the traced as well as further genealogies of the genre. Thus, since the 1970s, a distinction has been established between (a) performance videos, (b) narrative clips, (c) concept videos, and (d) hybrid mixed forms[9] as manifestations of the music video. Performance videos, which focus on a (real or staged) studio or live performance by the artist(s) in question, are indebted to the tradition of cinematic documentaries of such performances. Narrative clips in which the lyrics of the song are used in the sense of a cinematic script-like basis are in turn in the tradition of the film musical, in which individual songs are also usually integrated as a dramaturgical element in the narrative structure of the plot. Concept videos are understood as collages of, at first glance, unconnected, sometimes abstract visual and sound elements that are intended to trigger associations in the viewer and are in the tradition of so-called "visual music," a genre that became established with film at the beginning of the twentieth century, among other things, and which focuses on the creation of a visual, moving image analogue to musical forms.[10] Finally, a clip is called hybrid if it combines all of these formal elements. Even though this distinction is now taken up in tutorials to increase the appeal of homemade YouTube videos—users are advised to become aware of the

[8] See especially the chapter "Paganini as Rock Star" (Kawabata 2013).
[9] For this and the following, see Wulff 1999: 262–78 and Behne 1987: 113–26.
[10] See, for example, Mollaghan 2015.

respective strengths of these different forms and then pursue them consistently (Gielen 2019)—it is worth asking how meaningful such a strict differentiation ultimately is, since if applied strictly most videos fall under the category of hybrid clips. Only rarely do they limit themselves to implementing only one of the three forms in the strict sense of their definition, but they gain their appeal precisely from the fact that the stars presented in them appear once as performers and then again shortly afterward as protagonists of a narrated story, occasionally also recalling elements of the concept clip for their staging. As an example, consider a comparatively unambitious clip such as the one for George Benson's song *Give Me the Night* from 1980: right at the beginning, Benson appears here as a performer, once in the context of a enacted scene in which he glides in an elegant white jacket on roller skates through an evening park located on a seaside promenade, seemingly accompanying the performance of his song on his guitar; a few seconds later he appears in the same clothes, but now apparently in a concert situation with other musicians who—like him—have microphones in front of them. Only a few moments later, however, we see the performer at the wheel of a car, apparently again wearing a white jacket, and accompanied now by a woman who familiarly holds his hand (played by Ola Ray, who would become known three years later as Michael Jackson's girlfriend in the music video for his song *Thriller*). As is revealed a little over a minute later, the car is a Rolls Royce convertible, which contrasts with where Benson initially leads his female companion: brief intercut footage of another couple kissing and holding hands over candlelight and red wine additionally suggested a more elegant ambience, but the singer actually leads his dinner companion to the famous Tail O' the Pup, a Los Angeles hot dog stand built in 1946 in the shape of a hot dog. Although the couple, elegantly dressed in evening attire, then actually grab the purchased hot dogs with a laugh, after a short concert-performance intermezzo they are suddenly seen with roses and champagne in an obviously now more sophisticated ambience. The clip ends with Benson and his companion driving along a nocturnal boulevard in the convertible and a huge billboard appearing behind them, advertising George Benson's album, also titled *Give Me the Night*, from which the song accompanied by the video was taken (Figure 1.1a). The performer appears here thus twice: first—hardly recognizable in view of the nocturnal scenery—as the driver of

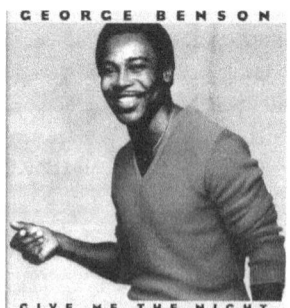

Figure 1.1a The album cover for *Give Me the Night* by George Benson, 1980. Photo by Norman Seeff, art direction by Richard Seireeni. Courtesy of Warner Bros. Records.

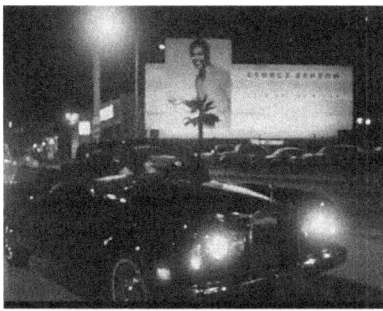

Figure 1.1b *Give Me the Night* by George Benson, 1980. Music video, 3:43. Screenshot from YouTube.

the car and, second—clearly, because he is huge, brightly lit, and also identified by the name—on the photograph of the cover (Figure 1.1b).

It thus becomes clear that such a clip oscillates quite naturally between the typical elements of performance, narration, and even concept (modesty and mundanity as framings of a couple relationship; metalepsis at the end of the clip, when the fictionality of the play plot is broken through by the fact that the product being advertised here is overtly brought into the picture in the very medium of advertising to which the clip also belongs in terms of its purpose). In view of the fact that such a video is, however, rather the rule than the exception, it would have to be asked whether the concept of the hybrid should be used here at all. Or if it should not be used best only as an analytically helpful reminder of the fact that a music video mostly combines elements that can be traced back to different basic forms, but that rather rarely appear in their purest (a limitation that might also apply to the question of the genealogical origin of the music video and the question of the homogeneity of its receptions, which is to be dealt with next).

Hybridity of the Receptions

In his volume, Shaviro cites as another argument against the formal autonomy of the music video: "In addition, music videos frequently remediate older media contents: alluding to, sampling and recombining, or even straight-forwardly plagiarizing material from movies, television shows, fashion photography, and experimental art" (Shaviro 2017: 7). Here, too, hybridity resonates as a sign, for the heterogeneity of the sources referred to here already suggests that a medium that amalgamates all these different forms, ranging from still to moving images and from entertainment to experimental art, must necessarily appear as hybrid in Bódy's "chrestomanian" sense of the word— and be it only because it is able to assemble, if not to synthesize, all these different elements within itself. Here, however, one would have to ask whether the practice of remediating does not apply to every art form: art is actually always art about already

existing art, even when, as in the case of the avant-garde movements, for example, it sets itself apart from previous creations and thus alludes to them *ex negativo*, so to speak. It becomes clear, however, how ill-suited such a characterization is in any case to distinguishing the music video from other art forms, and how polemical the terms used by Shaviro and seemingly specific to the music video ("sampling," "recombining," "plagiarizing" [Shaviro 2017: 7]) actually are, if one applies such procedures to the very forms that Shaviro implicitly plays off as apparently higher ("movies, television shows, fashion photography, and experimental art" [Shaviro 2017: 7]) against the lower representative of the video clip. The inherent "logic" here is that something like the music video must be necessarily inferior in comparison to something it makes use of such as in this case "movies, television shows, fashion photography, and experimental art," moreover passed off as older (i.e., again implicitly: more venerable).

But if we look at a film such as Wes Anderson's *The French Dispatch*, released in 2021, we encounter precisely the procedure of "remediating," "alluding to," or "sampling and recombining, or even straight-forwardly plagiarizing" (Shaviro 2017: 7) of older media contents that Shaviro claims is so characteristic of the music video. This ranges, in the case of Anderson's movie, from individual figures and image motifs to single sequences and entire storylines. To pick just a few examples: the models for individual characters of the journalists portrayed by Anderson in the fictional magazine *The French Dispatch of the Liberty, Kansas Evening Sun* were real employees of the magazine *The New Yorker*. As Anderson's character of the eccentric art historian J. K. L. Berensen (played by Tilda Swinton) in the second episode of the film "Arts and Artists-Section (Pages 5-34)" (*The French Dispatch* 2021: 0:10:22–0:43:50) in particular shows, the director modeled his characters on the real people, sometimes right down to physiognomy, hairstyles, clothing style, and behavioral mannerisms, in this case those of Rosamond Bernier (real name: Rosamond Rosenbaum), who—like her counterpart in *The French Dispatch*—in addition to her journalistic work also gave public lectures on great artists of the twentieth century at the Metropolitan Museum in New York. These lectures, delivered without notes, were distinguished, among other things, by the fact that she presented them in full evening wear and in a pointed mid-Atlantic accent (the way Americans spoke when they pretended to be British) ("The Race Journalists" 2021). In turn, the painter Moses Rosenthaler (Benicio del Toro), also introduced by Anderson in the film's art episode, unites three artists in one. On the one hand he is based on the action painter Jackson Pollock in that he is not only praised by Berensen as "the great painter at the vanguard and heart of the French splatter-school action group" (*The French Dispatch* 2021: 0:12:44–0:12:48), but is also shown later in the film in precisely the same visual staging that became typical for Jackson Pollock: the artist standing broad-legged on the canvas as his "battleground" and dripping paint (in Rosenthaler's case—suited for the context of a jail: "shackle grease" [*The French Dispatch* 2021: 0:27:48]) onto it with a brush.[11] The jail guard Simone (Léa Seydoux), who models

[11] The fact that in the scene the floor on which Rosenthaler paints is filmed as transparent and from below is an allusion to the analog staging of Pablo Picasso in Henri-Georges Clouzot's 1956 film *Le Mystère Picasso*, where the painting grounds are also partly made of glass, so that the audience can

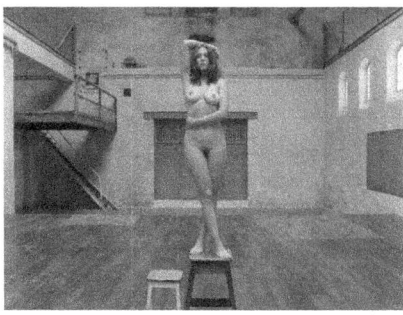

Figure 1.2 Léa Seydoux as Simone. *The French Dispatch* by Wes Anderson, 2021. Screenshot from the feature film.

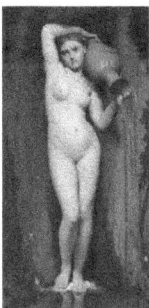

Figure 1.3 *La Source* by Jean-Auguste-Dominique Ingres, 1856. Courtesy of Musée d'Orsay, Paris.

for him, is in turn oriented in her nudity and her pose (Figure 1.2) on the painting *La Source* by Jean-Auguste-Dominique Ingres (Paris, Musée d'Orsay: Figure 1.3), executed in 1856.

That Rosenthaler's work executed on this basis, *Simone, Naked. Cell Block J. Hobby Room*, does not seem to depict the young woman figuratively at all, and that only in the lower right corner of the canvas an identifiable naked leg seems to protrude from the "chaos of colors, tones, undecided nuances, a kind of formless mist" (De Balzac [1846] 2012: 39), is in turn a reference to Honoré de Balzac's 1846 novel *Le Chef-d'œuvre inconnu*. There, the protagonist, the fictional painter Frenhofer, sets out into new, abstract dimensions of visual art, no longer painting what he sees but giving

follow the genesis of the painting unimpeded by the artist's hand and body. The fact that Rosenthaler paints with "pigeon blood" (*The French Dispatch* 2021: 0:27:45), among other things, is surely again an allusion, here to the Viennese action artist Hermann Nitsch and his works of art, which are also sometimes created with animal blood. In Rosenthaler's figure further artists are combined: the fact that he also sometimes paints with fire alludes to the art works created with fire by the German pioneer of light and fire art Otto Piene; Rosenthaler's self-portrait as a madman (*The French Dispatch* 2021: 0:17:47), which can be seen once, in turn clearly alludes to Gustave Courbet's analogous self-portrait *Le Désespéré* from 1843–5 (Paris, collection of Conseil Investissement Art BNP Paribas).

expression to what he feels in the face of it. Beyond this direct visual interpretation of the description of Frenhofer's last painting, cited above not by chance,[12] the naming of the episode in Anderson's film as "The Concrete Masterpiece" also refers to the title of Balzac's novel and parodies it to a certain extent: Balzac's unknown masterpiece has now become the concrete masterpiece, with the concrete furthermore referring to the concrete of the wall on which Rosenthaler has painted a work and which must therefore—following the example of the creations of the British street artist Banksy— be cut out of its original architectural context when the painting is to be moved to the collection of Upshur "Maw" Clampette, a *nouveau riche* American collector. With her, another reference the film makes becomes clear, for "Clampett" (without the Frenchizing "e" at the end) is also the name of just that initially poor hillbilly family who, in the American television series *The Beverly Hillbillies* (produced between 1962 and 1971) also comes to sudden wealth through an accidental oil discovery, moves to Beverly Hills and roughs up the old-established and snooty posher millionaires residing there. But in addition to references to television, *The French Dispatch* naturally contains references to film: when, at its beginning, a waiter has to carry various refreshments for the journalists up the labyrinthine set of stairs on the exterior façade of the back of the newsroom building (*The French Dispatch* 2021: 0:01:45–0:02:17), Anderson virtually copies the visual joke of the less-than-efficient house structure directly from French director's Jacques Tati film *Mon Oncle* (1958), where the title character, played by Tati, resides in an old-fashioned house whose irrationally inefficient communication structure is presented in the same humorous way as charming-sympathetic, thus setting the building in opposition to the cold, modernist-rational architecture in which the uncle's relatives live.

Did such and countless other references to, among other things, also comics,[13] lead to the film being perceived as deficient, as one might assume according to the criteria compiled by Shaviro? If one looks at the multitude of very positive reviews and awards for which the film was nominated or which it won, this does not seem to be the case.[14]

This casts further doubt on Shaviro's criteria for the music video, as well as on his argument regarding the use of the references he incriminates: "In utilizing so many allusions and outside sources, as well as in focusing on actual musicians, music videos

[12] The art dealer's dialogue with his uncles in front of the painting regarding the question whether the young model is recognizable in it (*The French Dispatch* 2021: 0:24:08–0:24:10. "You see the girl in it"? "No." "Trust me. She's there.") also goes back to an analogous passage in Balzac's novel ("Il y a une femme là-dessous" [Balzac [1846] 2012: 39]). Also the fact that Rosenthaler is characterized as a mentally disturbed genius can also be traced back—in addition to the general artist cliché satirized by this—to Frenhofer, who is also perceived as crazy by his environment toward the end of the novel.

[13] Since the exterior shots of the film were done in Angoulême, famous for its Festival International de la Bande Dessinée d'Angoulême, an annual festival on comics, Anderson's movie also features, as a *homage*, an animated sequence, drawn in the "ligne claire"-style of Belgian comic artist Hergé (*The French Dispatch* 2021: 1:34:27–1:37:09).

[14] See, for example, the won awards and nominations listed in the film's Wikipedia article (https://en.wikipedia.org/wiki/The_French_Dispatch#Accolades [accessed February 27, 2022]).

generally remain illustrative and externally referential—the cardinal sins according to high-modernist theories of art" (Shaviro 2017: 8).

Apart from the fact that since postmodernism the reign of such "high-modernist theories of art" has been strongly questioned and relativized (Keazor 2014: 261–87), one can ask whether they could not also be applied in this direct manner to film, which is to some extent an externally referential medium per se, if one does not want to understand it exclusively as abstract film. With Shaviro, however, even a film by, for example, Jean-Luc Godard, no matter how sophisticated, could be seen as illustrative and externally referential. One must therefore ask whether nonabstract form is not being mixed up with illustrative here, since the decisive factor is not only the nature of the images (figurative or abstract?) but also the structure to which they are combined. Here (admittedly also questionable, but in this case meaningful) readings such as that of the British media scholar John Fiske of the music video as something that "fragments" and "zaps" everything—"academic theory . . . adulthood . . . the White House"—because of its visual heterogeneity "into smithereens" (Fiske 1986: 77)[15] makes it clear that the visual side of the video clip is perceived as by no means purely illustrative, precisely because of the sometimes heterogeneous facture of its references and its appearance.

Concession

It should, however, also be emphasized that Shaviro ultimately concedes that music videos are "deeply self-reflexive and strikingly innovative in form and technique" "despite" or "rather *because*" (Shaviro 2017: 8)[16] of the hybridity and heterogeneity he has elaborated.

Other authors also lament the music video as the gravedigger of media specificity and at the same time celebrate it: Jirsa and Korsgaard date one of media specificity's deaths

> in the second half of the 1990s when MTV gradually ceased to broadcast music videos, suggesting that the days of music video were numbered. But even before that, however, death made its appearance only shortly after the music video's televisual birth, in the decade inaugurating an era which is usually—and with a hardly unhearable elegiac tone—referred to as a "post-media condition," an era in which any notion of medium specificity dissolves in favor of the new media hybridity. (Jirsa and Korsgaard 2019: 113)

[15] Only because Fiske ignores the music that binds everything together and in view of a thus, so to speak: muted music video, can he come to such statements—but since Shaviro argues here just purely on the level of the visual, Fiske's interpretation serves here as a valid counterargument. On Fiske and a critical discussion of his view, see Keazor and Wübbena 2014: 18.

[16] He moreover formulates the wording "or is it rather *because* of all this?" as a question.

The authors, however, see this media hybridity at the same time as something that is to be appreciated as productive and which ties the music video back to one of its ancestors, the cinema, which, as they recall with reference to a formulation by Vinzenz Hediger and Miriam De Rosa, "from its very beginning . . . has always already been a 'medium in permanent transformation'"—a formulation that, according to Jirsa and Korsgaard, "can be easily applied to music video whose various notions also tend to underline the transmedia and genre hybridity"(Jirsa and Korsgaard 2019: 114).

As important as it may seem to focus on the productive aspects of the media hybridity of the music video, the question also arises as to whether a fixation on the immediate precursors of the video clip, such as film, does not tend to obscure this view. For if one looks at the characterization of an even earlier precursor of the music video, the *Eidophusikon*, a mechanical picture theater of the eighteenth century, on which, accompanied by music, identically reproducible visual phenomena were staged,[17] we see that its contemporaries apparently had no problems with the hybridity of this *dispositif*: "He introduced a new art—*the picturesque of sound*," a contemporary visitor extols the merit of the *Eidophusikon* (Hardcastle 1823: 296).[18] This perception makes it clear that perhaps such a combination should be more about making the specific qualities of one medium productive for the other, rather than looking at it with preconceived ideas about media boundaries and notions of hybridity based on them—or, to put it another way, can the hybrid really be used as a productive term here, or does one need it at all?

The Epitome of Hybridity? Mobile Music Videos

In conclusion, this will be discussed on the basis of three examples:

1) In March 2011, Japanese performer Salyu released an app for the title track of her then-recently released album "Su(o)n(d)beams," which alienated images, filmed live with an iPhone camera, by using graphic effects triggered at specific moments, and combined them with pre-produced footage to match the music, allowing each user to view a highly individual and unique music video (Keazor, Giessen and Wübbena 2012: 14).[19]
2) In 2016, director Ryohei Kumamoto shot a music video for the debut track *Run and Run* by newly formed Japanese pop band Lyrical School for the agency TBWA\Hakuhodo Japan, which made the display format and context of a smartphone the subject and frame of the clip. Since, according to the agency's rationale for this aesthetic, Japanese teenagers now often prefer to watch music

[17] Concerning the *Eidophusikon* as a precursor of the music video, see Henry Keazor and Wübbena 2010.
[18] Ephraim Hardcastle is a pseudonym for William Henry Pyne. The emphasizing italics are already in the original.
[19] For the video, see the demo clips (TOYSFACTORYJP 2011).

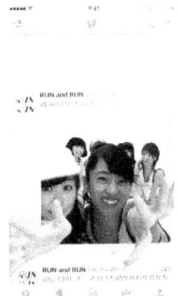

Figure 1.4 *Run and Run* by Lyrical School, 2016. Directed by Ryohei Kumamoto. Music video, 3:47. Screenshot from YouTube.

videos on their cell phones, they sought to appeal to precisely this generation of handheld users by offering a video that was not only, in the sense of mobile-only marketing, offered directly for consumption on smartphones, but also, when played, gave the impression that it had hacked users' smartphones in order to insert the six members of Lyrical School into the audience's various smartphone apps—email, text messaging, camera, social media, and other functions used daily, particularly by teenagers:[20] Images apparently stored on their devices are called up to match the lyrics, and the band members seemingly take over the device to use it to photograph and film themselves, upload the videos to an online platform, video call each other via an instant messaging service installed on the device, and send each other text and video messages in which, among other things, the lyrics are visualized.

The illusion created in this way is occasionally deliberately interrupted when the band members, for example, apparently break through the frame of the text messages (Figure 1.4) or when they self-referentially hold a smartphone on which they can be seen holding, in the sense of a classic *mise en abyme*, a smartphone into which the camera zooms in at various stages so that recording and filming smartphones seem to merge.[21]

3) Adapted to current communication conditions during the corona pandemic, the concept of this "world's first native mobile music video, specifically tailored to be watched on mobile devices" (Lynchy 2016) is found in the 2020 music video directed by Erin Murray and Jeremy Schaulin-Rioux for the song

[20] To which extent the user behavior of the target audience was taken as an aesthetic guideline can be also seen by the fact that the music video was shot in portrait format, since it had previously been determined that most users prefer this position and are more averse to rotating the device to a horizontal position (Lynchy 2016). It is also reported there that the video was viewed over 1.3 million times in the first two weeks after its release and took the number one spot on Twitter's Trending Topics in Japan.

[21] See in this context also the movie *Searching*, an American mystery thriller directed in 2018 by Aneesh Chaganty. The films belong to the genre of the so-called screenlife or computer screen movies, a format of visual storytelling where all the movie events occur on the computer, tablet, or smartphone screen.

Phenom by American alternative/folk rock band Thao & The Get Down Stay Down. Responding to the ubiquity and necessity of online meetings during the pandemic, the video presents itself as "the first great Zoom music video" (Kaufman 2020):[22] It all begins with the neon lettering "Temple," which appears here on lead singer Thao Nguyen's desktop, referring to the cover of the eponymous album from which *Phenom* is taken. She then opens a Zoom meeting in which eight dancers participate, with whom she choreographically interprets the piece. The directors play with the visual possibilities offered by the Zoom tile structure, which on the one hand reflects the reality of physical isolation—not only is everyone in different and differently lit rooms, they are also doing very different things when the online meeting begins (one dancer is eating a banana, for example). On the other hand, the clip works with the fact that the geometric tile structure is also able to camouflage the differences and to unite the actors, although they are distributed in different places, when they begin to perform synchronous dance movements after about twenty seconds, for example. This synchronicity, which overplays the different spaces, is further enhanced in the course of the video in that now even flowing transitions between the tiles are simulated, for example when dancers seem to fall through the image space of the Zoom meeting from top to bottom due to their cameras being positioned above each other, when a glass of water is passed down through the tiles, or water is poured down from the upper participants to the lower ones, or—the epitome of hybridity—Thao's body is composed of the various body parts of the participants in a pose where she presents *her* biceps (Figure 1.5).

Despite all the parallels between them, the three clips discussed here also have differences. In the case of the smartphone-only videos, each user is either given, as with the clip for Salyu, a highly individualized and unique video that in some ways affirms and continues the tendency inherent in mobile telephony to serve as a "supplement," "extension," and "augmentation" of the individual (Mills 2012: 34–47). In the case of the music video for Lyrical School, it is instead only suggested that the band has taken over the user's smartphone and is establishing direct contact with him or her by transcending media boundaries. In the case of Thao & The Get Down Stay Down, on the other hand, the choreographic potential of an online platform is explored that is also, but not only, available on smartphones, albeit without the possibility of participation or its suggestion for the viewer.

What is common to all of them, however, is the phenomenon of which one can ask whether it can be satisfactorily described in general terms by the term "hybrid." What is meant by this is in this case characterized by the fact that, compared to other

[22] The "great" in the title seems to refer to the fact that in 2020 also other pop artists had published music videos recorded via online meeting platforms—see, for example, the British girl group Little Mix, which in April 2020 interpreted their song *Touch* in the context of the BBC series *One World: Together at Home* (BBC Music 2020). For the production conditions of the video for *Phenom* see Deahl 2020.

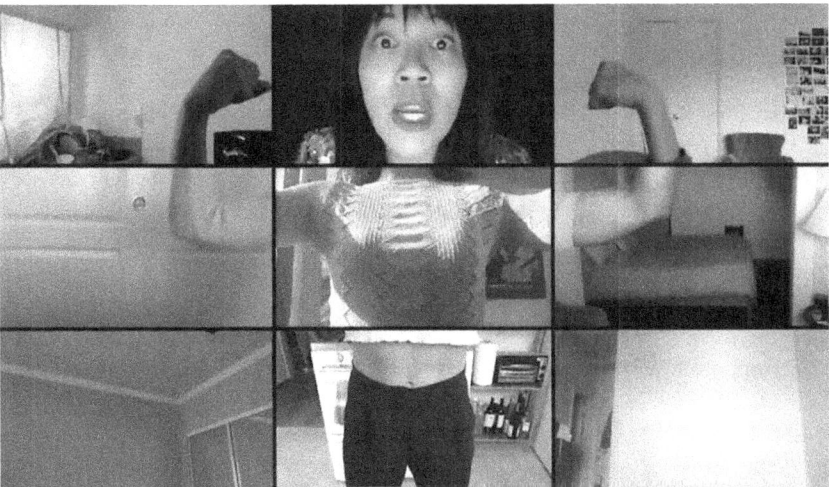

Figure 1.5 *Phenom* by Thao & The Get Down Stay Down, 2020. Directed by Erin S. Murray and Jeremy Schaulin-Rioux. Music video, 2:50. Screenshot from YouTube.

music videos, here the condition of the clip as something compounded out of various elements is even more emphasized.

In addition to the elements provided by the combinations of music, text, and moving images, the recording and playback medium of the clips is here not only added as a more or less essential technical component, but also accentuated meta-referentially in all cases.

It is precisely this inclusion of the playback medium in the clips, however, that at the same time raises the question of how or when it is helpful here to speak of hybridity, which tends to focus just on and emphasize the heterogeneity of the individual elements. In contrast, however, the term "permeability" might be more adequate in this case, since it addresses the fundamental openness of the music video genre. Accordingly, the music video would be understood and appreciated as a per se permeable medium, in terms of both its genesis and its various origins, and in terms of the implications of its components: The lyrics, the images, and the music each in themselves already offer the possibility of, for example, establishing relationships to other texts, images, and music, for example, by way of quotation, parody, or allusion. This effect is further increased in the constitution of the music video to the extent that a quotation, a parody, or an allusion in (for example) the lyrics can in turn provoke a quotation, a parody, or an allusion on the level of the other components (such as in this case: the music and/or the images), so that not only the individual elements of the music video prove to be permeable to one another, but also within their respective genres. Since the music video, in the case of the last clips discussed, also proves to be open and permeable with regard to the implications of its recording and/or playback medium, it thus becomes clear that this merely manifests a characteristic that can be observed not only on the level of the music video itself, but also already on that of its

ancestors, for example, the Soundies in the 1940s and Scopitones in the 1960s. These were also already permeable in the sense that they opened up to the feature film, in that the performers shown there were often also film stars who appeared in films in which precisely the music advertised with the Soundies and Scopitones was used.

The new recording and playback media for music videos have merely expanded the radius of possibility for the expression of their inherent permeability in view of the available possibilities for connection and transition. And thus, one can ask whether the resulting phenomenon is also not better described by the term "convergence" than by that of hybridity. The American media scientist Henry Jenkins has defined convergence as the movement "from medium-specific content to content that flows across multiple media channels, toward the increased interdependence of communications systems, toward multiple ways of accessing media content" (Jenkins 2006: 243). In this sense, the music video itself could be seen as a hotbed for such a convergence in which various medium-specific contents (lyrics as eye- and ear-addressing contents, music as primarily ear-addressing contents, images as eye-touching contents) unite toward one content, which in turn has moved away from medium specificity (Soundie-, Scopitone-machine) toward an increased interdependence of communications systems (television, internet, tablet/smartphone). Or in other words: the music video proves to be an ideal medium for this under the header of convergence, precisely because it is itself open to different sides, it is permeable.

Ultimately, it probably depends on what one wants to focus on. If one wants to take a look at the diversity of the components that make up the music video, the concept of the hybrid—bearing in mind the *caveats* presented here—would be appropriate; if, on the other hand, one would rather like to grasp the reasons for the possibility of such hybridity as well as the potentials of the music video that this opens up, the concept of the permeable would be appropriate. Finally, if one would like to consider the dynamics made possible by this, Jenkins's concept of convergence is perhaps recommendable.

References

Armes, Roy (1988), *On Video*, London: Routledge.
Aust, Michael P. and Daniel Kothenschulte (2011), *The Art of Pop Video*, Museum für angewandte Kunst Cologne, April 9–July 3 [exhibition catalog], Berlin: DISTANZ Verlag.
BBC Music (2020), "Little Mix - Touch (One World: Together At Home)," *YouTube*, April 19, 2020. Video, 3:49. Available online: https://www.youtube.com/watch?v=zfqhDtDQPeE (accessed February 27, 2022).
Behne, Klaus-Ernst (1987), "Zur Rezeptionspsychologie kommerzieller Video-Clips," in Klaus-Ernst Behne (ed.), *Film-Musik-Video oder die Konkurrenz von Auge und Ohr*, 113–26, Regensburg: Gustav Bosse Verlag.
Beil, Ralf (2022), *The World of Music Video*, January 22 to October 16, Völklinger Hütte [exhibition catalog], Ostfildern-Ruit: Hatje Cantz.

Benson, George (1980), *Give Me The Night*. Music video, 3:43. Available online: https://www.youtube.com/watch?v=FIF7wKJb2iU (accessed February 27, 2022).

Bódy, Veruschka (1987), "Eine kleine Cliptomathie," in Veruschka Bódy and Peter Weibel (eds.), *Clip, Klapp, Bum. Von der visuellen Musik zum Musikvideo*, Cologne: DuMont.

Deahl, Daniel (2020), "How Thao & The Get Down Stay Down Made a Music Video on Zoom, after They Canceled a Shoot Because of the Pandemic," *The Verge*, April 8. Available online: https://www.theverge.com/2020/4/8/21213608/coronavirus-zoom-music-video-thao-and-the-get-down-stay-down (accessed February 27, 2022).

De Balzac, Honoré ([1846] 2012), *Le Chef-d'œuvre inconnu*, Paris: Hatier.

Fiske, John (1986), "MTV: Post-Structural Post Modern," *Journal of Communication Inquiry*, 10, 74–9.

Gielen, Matt (2019), "The Taxonomy Of YouTube Videos (And How You Can Develop Original Content That Works)," *tubefilter*, December 2. Available online: https://www.tubefilter.com/2019/02/12/taxonomy-youtube-videos-develop-original-content-that-works/ (accessed February 27, 2022).

Hardcastle, Ephiram (1823), *Wine and Walnuts, or After Dinner Chit-Chat*, vol. 1, London: Longman, Hurst, Rees, Orme, and Brown.

Jenkins, Henry (2006), *Convergence Culture: Where Old and New Media Collide*, New York: New York University Press.

Jirsa, Tomáš and Mathias Bonde Korsgaard (2019), "The Music Video in Transformation: Notes on a Hybrid Audiovisual Configuration," *Music, Sound, and the Moving Image*, 13 (2): 111–22.

Kaufman, Sarah L. (2020), "The First Great Zoom Music Video has Arrived," *Washington Post*, October 14. Available online: https://www.washingtonpost.com/entertainment/theater_dance/the-first-great-zoom-music-video-has-arrived/2020/04/22/79a48458-83f4-11ea-878a-86477a724bdb_story.html (accessed February 27, 2022).

Kawabata, Mai (2013), *Paganini. The 'Demonic' Virtuoso*, Woodbridge: The Boydell Press.

Keazor, Henry (2014), "'Baroque irony, as sophisticated as Pop': Auseinandersetzungen mit dem Barock in der Gegenwartskunst," in Victoria von Flemming and Alma-Elisa Kittner (eds.), *Barock—Moderne—Postmoderne: Ungeklärte Beziehungen*, 261–87, Wiesbaden: Harrassowitz.

Keazor, Henry and Thorsten Wübbena (2010), *Rewind—Play—Fast Forward. The Past, Present and Future of the Music Video*, Bielefeld: transcript.

Keazor, Henry and Thorsten Wübbena (2014), *Video Thrills the Radio Star. Musikvideos: Geschichte, Themen, Analysen*, Bielefeld: transcript.

Keazor, Henry, Thomas Mania, and Thorsten Wübbena (2011), *Imageb(u)ilder: Vergangenheit, Gegenwart und Zukunft des Videoclips*, January 23–July 3, rock'n'popmuseum Gronau [exhibition catalog], Gronau: Telos Verlag.

Keazor, Henry, Hans Giessen, and Thorsten Wübbena (2012), "Zur ästhetischen Umsetzung von Musikvideos im Kontext von Handhelds—eine Einführung," in Henry Keazor, Hans W. Giessen, and Thorsten Wübbena (eds.), *Zur ästhetischen Umsetzung von Musikvideos im Kontext von Handhelds/Handheld? Music Video Aesthetics for Portable Devices*, 5–23, Heidelberg. Available online: http://archiv.ub.uni-heidelberg.de/artdok/volltexte/2012/1867/ (accessed February 27, 2022).

Le Mystère Picasso (1956) [Film], Dir. Henri-Georges Clouzot, France: Filmsonor.

Lüddemann, Stefan (2011), *Blockbuster. Besichtigung eines Ausstellungsformats*, Ostfildern-Ruit: Hatje Cantz.

Lynchy (2016), "TBWA\Hakuhodo Japan Teams up with Hip Hop Group Lyrical School to Release World's First Native Mobile Music Video for Their New Hit Song," *Campaign Brief Asia*, May 10. Available online: https://campaignbriefasia.com/2016/05/10/tbwahakuhodo-teams-up-with-jap/ (accessed February 27, 2022).

Lyrical School (2016), *Run and Run*. Directed by Ryohei Kumamoto. April 5, 2016. Music video, 3:47. Available online: https://www.youtube.com/watch?v=g57fYTgVbDk (accessed February 27, 2022).

Mathew, Nicholas (2006), "History under Erasure: "Wellingtons Sieg," the Congress of Vienna, and the Ruination of Beethoven's Heroic Style," *The Musical Quarterly*, 89 (1): 17–61.

Mills, Mara (2012), "The Audiovisual Telephone: A Brief History," in Henry Keazor, Hans W. Giessen, and Thorsten Wübbena (eds.), *Zur ästhetischen Umsetzung von Musikvideos im Kontext von Handhelds/Handheld? Music Video Aesthetics for Portable Devices*, 34–47, Heidelberg, https://archiv.ub.uni-heidelberg.de/artdok/1867/1/Keazor_Giessen_Wuebbena_Zur_aesthetischen_Umsetzung_von_Musikvideos_im_Kontext_von_Handhelds_2012.pdf.

Mollaghan, Aimee (2015), *The Visual Music Film*, Basingstoke: Palgrave Macmillan.

Poschardt, Ulf (2004), *Look at me. 25 Jahre Videoästhetik*, NRW-Forum Kultur und Wirtschaft, January 24 to April 14 [exhibition catalog], Ostfildern-Ruit: Hatje Cantz.

Searching (2018) [Film], Dir. Aneesh Chaganty, USA: Sony Pictures.

Shaviro, Steven (2017), *Digital Music Video*, New Brunswick: Rutgers University Press.

A Standard Dictionary of the English Language, Vol. 1: A to L (1899), New York and London: Funk & Wagnalls Company.

Tambling, Jeremy (1994), "Introduction: Opera in the Distraction Culture," in Jeremy Tambling (ed.), *A Night in at the Opera. Media Representations of Opera*, 1–24, London: John Libbey & Company Ltd.

Thao & The Get Down Stay Down (2020), *Thao & The Get Down Stay Down - Phenom (Official Music Video)*. Directed by Erin S. Murray and Jeremy Schaulin-Rioux. April 3, 2020. Music video, 2:50. Available online: https://www.youtube.com/watch?v=DGwQZrDNLO8 (accessed February 27, 2022).

The French Dispatch (2021), [Film] Dir. Wes Anderson, Germany, USA and France: Searchlight Pictures.

"The Race Journalists Who Inspired Wes Anderson" (2021), *Paudal*, October 30. Available online: https://www.paudal.com/2021/10/30/the-race-journalists-who-inspired-wes-anderson/ (accessed February 27, 2022).

TOYSFACTORYJP (2011), *Muse'ic visualiser(iPhone App) ver.1.0 demo - salyu x salyu*, April 25, 2011. Video, 4:09. Available online: https://youtu.be/65r830HQFRg (accessed February 27, 2022).

Vernallis, Carol (2013), *Unruly Media: YouTube, Music Video, and the New Digital Cinema*, New York: Oxford University Press.

Wulff, Hans J. (1999), "The Cult of Personality—Simuliert-authentische Rockvideos," in Klaus Neumann-Braun (ed.), *Viva MTV. Popmusik im Fernsehen*, 262–78, Frankfurt am Main: Suhrkamp.

2

Sound and Vision

Early Artists' Video and Music

Chris Meigh-Andrews

In this chapter, I will focus on a small number of artists who have produced work during the early period (1970–85) in the development of artists' video in which there is a crucial relationship between the video image and the musical soundtrack. This interactive blend of sound and image has taken many forms and explored numerous possibilities and is an important strand in the history of artists' video. My intention is to provide some significant examples of this approach rather than to attempt to catalog the larger and much more complex field. Beyond the introductory first section, I have chosen to discuss the work of Beryl Korot (born 1945) and her partnership with her husband, composer Steve Reich (born 1936) as well as the musical collaboration between John Sanborn (born 1954) and Robert Ashley (1930–2014) in some detail as examples of the creative synergies that can take place between video artists and composers.

The influence of contemporary classical composers on video art can be traced to its earliest formative roots. Examples of this important early connection include video pioneer Nam June Paik (1932–2006), who originally came to Germany to study musical composition in Freiburg and, because of his growing interest in sound collage techniques and audio recordings, began working at the Studio for Electronic Music WDR (Westdeutscher Rundfunk) in Cologne. This brought him into contact with a number of important contemporary composers such as Karlheinz Stockhausen (1928–2007), György Ligeti (1923–2006), and Cornelius Cardew (1936–81), subsequently embracing Fluxist ideas and approaches that had drawn inspiration from the work and ideas of the American composer John Cage (1912–92). A further example of this direct connection between early video art and avant-garde music is the French video artist Robert Cahen (born 1945), who trained with Pierre Schaeffer (1910–95), the originator of Musique Concrete, drawing on the ideas Schaeffer had developed to compose working with audio recordings (Meigh-Andrews 2014: 10–11, 89–90).

Video and audio recordings are technically interrelated; the electrical and magnetic signals are common constituents. In a video recording the sound is always present unless the operator makes a special and deliberate effort to remove or ignore it.

Videotape recordings consist of sound and vision recorded onto parallel tracks, although the audio is slightly ahead when stored on the tape. For first-generation video artists working in the early period, this fundamental technical relationship had significant aesthetic and creative implications.

> I remember that Jonas Mekas didn't like video very much, and he said "Why don't those video makers just make silent video? We all started with silent films." This was the biggest misunderstanding of the medium I've ever seen. Video always came with an audio track, and you had to explicitly ignore it not to have it. (Meigh-Andrews 2000b)

In Steina Vasulka's (born 1940) video tape *Violin Power* (1978), the artist explored this dynamic relationship, making it the central creative principle of the work. A classically trained musician, Steina superimposed the two signals, creating a series of abstracted television images in which interactions between the two create a video image modified by the audio frequencies of her violin as she performs. This work is a key example of the potential interaction between the performer, the instrument, and the technical processes—the balance and interdependent relationship between form and content. Steina's awareness of the technological processes and principles involved in the creation of the video signal and its relationship to the audio is central to an understanding of the value and significance of this work, while it is also central to its audiovisual impact and power.

Steina and her husband Woody Vasulka (1937–2019) were both very actively involved in the emergent New York video art scene and instrumental in the development of the genre in the United States. They established The Kitchen in 1971, renting a space from the Mercer Arts Center in Greenwich Village. Although originally intended exclusively for the screening of experimental video, the scope of the venue was extended to include music and performance later the same year.

The Kitchen Center for Video and Music provided a unique venue for video artists, musicians, composers, and performers, bringing them into contact with each other, fostering and facilitating creative collaborations and cross-disciplinary experimentation. Many of the most renowned American artists in the fields of new music, artists' video, and performance art working during the 1970s and 1980s either performed, presented, or exhibited work at The Kitchen during this important early period in the development of artists' video and some of the most significant work featured a fusion or blend of image and music. In addition to the Vasulkas, video artists, musicians, and performers including Laurie Anderson, John Sanborn, Nam June Paik, Philip Glass, Peter Greenaway, Michael Nyman, Steve Reich, Brian Eno, Meredith Monk, and David Byrne have all shown work at The Kitchen (The Kitchen Archive). Given The Kitchen's focus on video art, music, and performance, it is not surprising that many of the artists I will discuss emerged from this environment.

An early proponent of multichannel video installation, Beryl Korot first encountered video through her work as an associate editor of *Radical Software*, a New York–based publication devoted to an examination of the so-called "information" environment and

the potential impact of the fledgling medium on society as a whole. Recently introduced to the process of weaving on a loom by a close friend, Korot's first experiments with multichannel video developed as a result of her awareness of a connection between the written texts she worked with as an editor, her developing interest in weaving, and the way that information is organized in video—she noted that all three were based on the presentation of information which was scanned sequentially in lines:

> Being an editor at "Radical Software", one of the interests at the time was to change the information environment we were living in and one of the ways to do that was to get the viewer out of the living room and into a public space. Working with multiple channels was a way of accomplishing that! As soon as you start working in multiples you begin to start thinking about the relationship between the multiples image-wise and sound-wise. (Cott 2004: 174)

Exploring the potential of the multichannel format that video enabled, Korot developed the four-screen video installation *Dachau 1974*, based on her fascination with rhythm and structure. Each of the four channels of the work has a different rhythm, despite using similar imagery across the four TV screens. Seeking a way to provide a sense of liveness to the static images she had recorded on location in Germany, Korot drew on her experience of working on the loom (Figure 2.1).

Soon after completion, Korot showed this new work to her future husband, composer Steve Reich, whom she had first met at The Kitchen. At the time, Reich

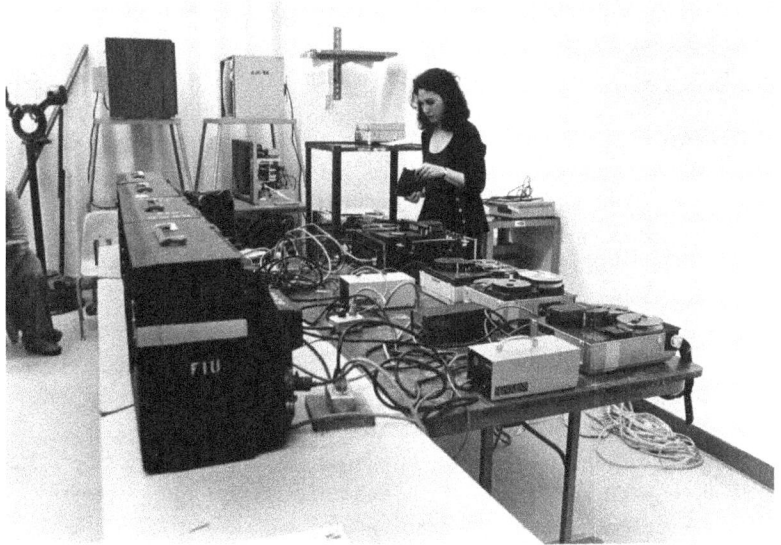

Figure 2.1 Beryl Korot setting up *Dachau 1975* at Brownwood College, Florida. Copyright, Beryl Korot. Image courtesy of the artist.

had remarked on its musical qualities, and although they discussed the work and the potential for the development of a collaborative work, it was not until the beginning of the 1990s that the couple developed *The Cave*, the first of two large-scale collaborative video operas, premiering in 1993 (Cott 2004: 171).

According to Steve Reich, *The Cave* developed out of a mutual interest in developing a musical theater piece based on videotaped documentary imagery. Reich had recently completed *Different Trains*, a composition commissioned by the Chronos Quartet involving the use of recorded speech patterns as a source for melodies which were then introduced via single instruments and played alongside recordings of sound effects including train sounds, sirens, and bells. Reich made extensive use of a sampling keyboard, which according to Reich, was an essential piece of technology in *The Cave*. More significantly, Reich and Korot wanted to extend ideas developed in *Different Trains* to include video sequences:

> The idea was that you would be able to see and hear people as they spoke on the videotape and simultaneously you would see and hear onstage musicians doubling them—actually playing their speech melodies as they spoke. (Cott 2004: 172)

Recordings of speech patterns had long held a fascination for the composer, directly inspiring his early work with tape loops such as *It's Gonna Rain* (1965) and *Come Out* (1966). The experience of attempting to set the poetry of William Carlos Williams to music led Reich to seek out an approach based on the recording of everyday sounds and patterns of speech, declaring that the poet had inspired him to "Go record the street! Go listen to your countrymen and get your music from the way they speak" (Potter 2000: 166).

Beryl Korot and Steve Reich shared a belief that recording devices were the folk tools of the times, and it was Korot's four-channel video work *Dachau 1974* with its blank pauses that created the rhythms in the installation that first inspired the idea to create a collaborative work. Korot explained that it was, however, a gradual process that did not bear fruit until the early 1980s, when they began to consider the potential of developing a video music collaboration.

Drawing on her earlier multichannel works *Dachau 1974* and *Text and Commentary* (1976–7), Korot continued to work with the model of the loom and how information and pattern are composed and the numbers involved in pattern making. *Dachau 1974* has four channels and was the model for the subsequent five-channel *Text and Commentary*:

> each channel had a different rhythm throughout the work. In that way the images had a more "live" quality to them when you viewed let's say the image on channels 1 and 3 slightly out of synch with one another. It was taking the live feedback and time delay and making it more compositional. More like a composer would work with different voices in a composition, and it brought life to the mainly static images. (Meigh-Andrews 2021a)

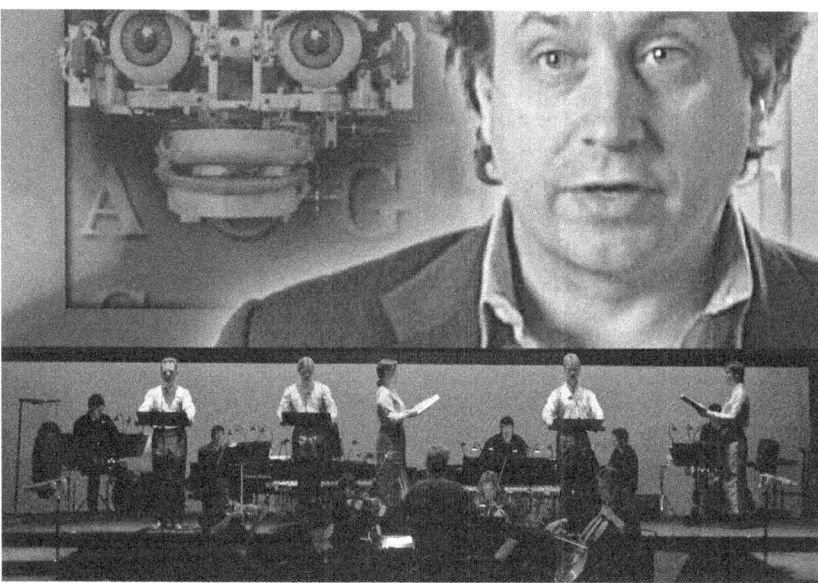

Figure 2.2 *Three Tales*: Act 3 by Beryl Korot and Steve Reich, Rodney Brooks and Robot Kismet. Copyright, Beryl Korot and Steve Reich, image courtesy of the artists.

The Cave extended Korot's approach of presenting video screens as a flat image surface to be read simultaneously—"fiercely frontal" in an allegiance to film, as she herself explained while creating her work for *The Cave*. As with *Text and Commentary*, *The Cave* is presented on five screens, with each channel representing a thread, using precise timing and the juxtaposing of interrelated imagery from the talking head recordings made for it. Korot felt that the five-screen format she had used in *Text and Commentary* provided a variety of possibilities for the interrelationship of the different threads of the narrative while still maintaining the visual field and thus allowing the viewer to perceive all five simultaneously (Cott 2004). Additionally, *The Cave* extends toward theater, as there is a direct relationship between the video imagery and the lighting, costumes, and even to the movement of the musicians and singers on the stage.

In their subsequent collaborative video music theater work *Three Tales* (2002), Korot was able to produce the equivalent visual complexity of *The Cave* within a single screen, thanks to the substantial developments in computer imaging technology in the intervening years (Figure 2.2).

> It's still mind boggling to me that an artist can work at a computer, import the raw materials for the work, and then transfer the finished work to a tape deck sitting next to the computer, and hand it to a projectionist as a finished product for performance. You can make a work with considerably powerful tools at your disposal, sitting at home working alone. (Allenby 2002)

Not only was it important to Korot that she was able to work alone in her own studio when working on *Three Tales* and *The Cave*, it also provided her with the freedom and opportunity to experiment, developing and exploring new techniques, some of which she went on to work with in subsequent solo video work.

Steve Reich also considered the potential of video as a medium, writing about plans for a number of works which were inspired by his musical ideas in his essay "Videotape and a Composer" (Reich 1976). Written in 1975, Reich described two ideas for projects in which he intended to compose specifically for multichannel videotape, both exploring the potential of phasing to create what Reich described as "audio-visual canons" (Reich 1976: 104). *My Name Is (Video)*, a video version of his 1967 musical work for three or more audio tape recorders, and *Portraits*, which although identical in form, would feature recordings of typical gestures and habitual speech patterns, once again played back on multiple recorders to explore the possibilities of phase patterns. Some of these ideas were realized later in his work with Korot described earlier, as well as in his own musical compositions using digital sampling techniques such as *Different Trains* as mentioned earlier.

John Sanborn, another American video artist with important early associations with The Kitchen, has also been highly influenced by musical structures and forms as well as the collaborative process of working closely with composers and musicians. Sanborn's experiences at The Kitchen brought him into contact with many video artists, composers, and musicians experimenting with new forms of music and the potentials and possibilities of the fledgling medium of video as fostered by the Vasulkas and their compatriots.

At the beginning of 1980s Sanborn was involved with programming video in a number of New York dance clubs. Every week Sanborn would show work by video artists and avant-garde filmmakers in a special "video lounge", creating complex creative crossovers—a kind of cultural mash-up of television, music, and video, which was very much his intention and a further example of the way in which the formative period of artists' video is creatively connected to the popular music scene. This attitude toward musical experimentation, creative video, and broadcast television also can be seen in his work with Philip Glass (born 1937) on *Act III*, a composition that Sanborn succeeded in having broadcast on MTV and later as the opening sequence of Nam June Paik's live satellite television event *Good Morning Mr. Orwell* in 1984 (Figure 2.3).

Sanborn acknowledges his early influences in attitude and approach to Paik and the composer Robert Ashley. He identifies Paik's technique of mixing images and sounds from a complex variety of sources and contexts as significant to his own approach, particularly in the way in which it becomes possible to make diverse associations and juxtapositions (Figure 2.4):

> what Paik did was to slam soundtracks together. He picked things that were deliberately tied to their soundtracks—he smashed them together. Many of the early works such as "Global Groove" were mixed live—they weren't actually edited ... he would create these "ABCD" rolls and then switch between them ... Paik's technique of going from say, a Tcho drummer to Mitch Ryder and the Detroit

Figure 2.3 John Sanborn and Phillip Glass, 2016. Copyright, John Sanborn. Image courtesy of the artist.

Figure 2.4 John Sanborn and Robert Ashley, Belgium. Copyright, John Sanborn. Image courtesy of the artist.

Wheels to a Japanese Coca-Cola commercial to John Cage was transporting context, not just image and sound. So when you do it as Paik did it, what you are doing is you are taking one statement, flipping it around in a fraction of a second by follow it with another statement and another and so on. It was a great influence because it could go on forever. (Meigh-Andrews 2021b)

Robert Ashley's way of drawing meaning and structure together and his desire to imbue all the elements of a production with significance also had a powerful impact on Sanborn's approach to working with video. During his collaboration with Ashley on his opera for television *Perfect Lives* (1983), Sanborn was made aware of the power of interconnections between images, words, and music in Ashley's approach and in the way in which the audience would connect the experience of the music to the visual content:

> "Perfect Lives" had a very different structure from a musical standpoint. There was no notation; there were key signatures, there were timings, there was a beat and a cadence. There was also Bob's interpretation of how to lay the words on top of the music . . . When it all came together I thought "OK here's a chance to go in and structure the visuals in such a way that the partitions that he's created episode by episode and within each episode, wouldn't be necessarily visually obvious to people, but they would understand as the work progressed. . . . ["] They would feel how the visual story telling would actually enhance how they attached themselves to the music. (Meigh-Andrews 2021b)

Sanborn is an artist who understands the nature of collaboration in a profound way. He has been particularly involved in collaborative projects with musicians and composers from the earliest period of his career. His ability to work with others in a creative partnership has led him to develop an understanding of collaborative working and the value of what he terms "friction," a way of understanding and coming to terms with the concept of resistance in a collaborative partnership and this extends to the way he views the interconnections between images and music.

> if one is really thinking about the relationship between pictures and music there can be a much greater conversation—a much stronger dynamic between what's happening on the screen and how the music either reinforces it or takes it to a different place or makes you see or feel it differently. (Meigh-Andrews 2021b)

Some composers have drawn on their musical ideas and applied them to video. For example, Brian Eno (born 1948) has explored the medium as a way of extending his creative process into the visual realm. Eno's exploration and development of ambient music embraces his video work, for example in two early installations—*Mistaken Memories of Mediaeval Manhattan* (1981) and *Thursday Afternoon* (1984). In the former work, the artist recorded a series of static views of New York with a skyline of drifting clouds from his apartment on the thirteenth floor with his camera on its side to provide an image with vertical format. The resulting images, recorded in the early low-resolution 525 NTSC color video, have a soft focus impressionistic quality. The two works were released on a DVD entitled *14 Video Paintings* with ambient music tracks from his albums "On Land" and "Music for Airports" (Coulthart 2013).

Eno's exploration of the potential of video draws on his musical ideas, particularly the more formal aspects; he prefers the way that music offers the potential for

abstraction that is often avoided by visual artists who seek to express ideas in more literal—and possibly "literary"—meanings. In an interview Eno made in 2018 in which he was discussing his approach to his aptly titled installation *Empty Formalism* at the Martin-Gropius-Bau in Berlin, he spoke about the influence of music on his visual work:

> It's funny that visual art is expected to have some sort of decodable message, to be translatable into words (which is what art critics think their job is), whereas nobody expects that of music . . . Music has always been a completely abstract art form and nobody minds. (Hubbard 2018)

The composer Michael Nyman (born 1944), best known for his musical scores for films by Peter Greenaway (born 1942) and Jane Campion (born 1954), is also a prolific maker of videos, who perhaps surprisingly much prefers working with his video camera and the subsequent editing process to composing music (Meigh-Andrews and Nyman 2017).

Nyman carries his camera with him constantly, observing his environment and situation, recording material wherever he is and in whatever situations he is in. A keen observer of coincidences, both visual and temporal, his films are playful, witty, and elegant. The editing of his material is his passion, working closely with his editor, the filmmaker Max Pugh. The relationship between Nyman's music and the visual material he has recorded is fluid, but the music is always used as an accompaniment. The film dictates the choice of music, never the other way around and this way of working is contrary to Nyman's experience when working with a film director on a soundtrack:

> The situation with the music is always that we edit the film mute and then Max or I decide we need a soundtrack, and I go through my iTunes library and we select the best music to accompany it. The music always comes second. This immediate, instinctive decision is always correct and we never revise the decision. (Meigh-Andrews and Nyman 2017)

The cross-fertilization of sensibilities from one medium to the other is redolent of synesthesia, of the blending and mixing of the different senses. Michael Nyman has a deep understanding of musical structures, and in his best video works, there is something transferable that can be seen to relate directly to certain filmic structures.

Although most, if not all, of the video work cited or discussed so far has involved music that had been previously available or composed, British video artist Peter Donebauer (born 1947) developed his work in direct and equal collaboration with the composer and musician Simon Desorgher (born 1948). Donebauer's abstract video works of the late 1970s and early 1980s were produced through a process of live creative interaction. Donebauer and Desorgher produced a series of works in which the music soundtrack and the visual imagery were complementary and interdependent. This was achieved through the recording of a series of live improvisations, after which they would select the *best take*. Although they would

agree on a theme or process in advance, the sessions were intended to develop through a live interaction between sound and image, each influencing the other to create the final work. Donebauer did not want to make video work in which the image was dominant, but rather wished to create works in which there was a creative and synergistic balance between sound and image. This approach emerged from Donebauer's refusal to work with preexisting music and the realization of the crucial role that music played in the way that it affected the viewer's perception of visual imagery. He developed an approach that would facilitate the creative interaction between the visual imagery and the music:

> Having realised how much the image was emotively changed by the music—one couldn't then just do it the other way round, that would have been too much. Right from the start we set up a structure where there is a feedback mechanism between the musician and the video artist. This structure was part of the original conception -it was an equal thing, and the process was very much intended to be based on improvisation.
>
> I realised very early that neither the image nor the music should predominate- that neither should be the point of inspiration for the other. We improvised around a common theme or process that was an inspiration or point of departure for us both. What I learned from music was the kinds of ways abstraction had been handled in a time-based medium. I always refused to visualise to any pre-existing pieces of music despite many offers—it misses the point- the most real artistic endeavour for me is a response to life, not a response to art. (Meigh-Andrews 2000a)

This collaborative approach suited Donebauer's interest in working with abstraction, and resulted directly in the development of the *Videokalos Image Processor*, a video instrument suitable for working with live improvisation. Donebauer and Desorgher formed the group Video and Music Performers (VAMP) and toured the UK in 1978–9. During this period Donebauer produced a number of significant videotapes with the *Videokalos*, which facilitated control over both live and prerecorded images in real time. Works produced in this way include *Circling* and *Teeming* (1975), *Dawn Creation* (1976), and *Moving* (1980).

There are numerous examples of so-called crossovers between the genres of the pop music promo and artists' video, and the boundaries between these two modes are blurred and intertwined. Examples of this include work by John Sanborn, previously mentioned above, and many others including the video of Laurie Anderson's *O Superman (For Massenet)* (1981). However, there is a significant subgenre of video art that combines musical form with imagery. Usually referred to as Scratch Video in the UK where it first emerged, this approach most often has a political purpose or intention, but can also be simply playful or rhythmically engaging—creating a kind of physical pleasure in the viewer (as the artist and critic Catherine Elwes once commented in an essay about the phenomenon: "We are left wondering whether to debate the evils of unemployment or get up and dance") (Elwes 1985: 21).

The Scratch Video aesthetic emerged in the early 1980s as a critical antidote to the established broadcast TV, commercial youth-oriented music videos, and gallery-based video art of the late 1970s. While its roots can be traced to avant-garde films constructed from a collage of stock film footage edited to music such as Bruce Conner's (1933–2008) *A-Movie* (1958) and *Rose Hobart* (1936) by Joseph Cornell (1903–72), the genre was also inspired by the cut-up methods of William Burroughs, the sampling practiced by contemporary Black American musicians, and perhaps even more directly influenced by Dara Birnbaum's (born 1946) seminal video *Technology/Transformation: Wonder Woman* (1978). Birnbaum's tape, constructed of multiple repeat image sequences and sounds appropriated from the US television series *Wonder Woman* (1976–9), sought to critique and uncover the stereotyped gender politics of broadcast TV.

Video works such as *Death Valley Days: Secret Love* (1984) by Gorilla Tapes (Jon Dovey [born 1955], Gavin Hodge [born 1954], and Tim Morrison [born 1955]), *Absence of Satan* (1985) and *Yes Frank No Smoke* (1986) by George Barber (born 1958), *Polka Dots and Moonbeams* and *Night of a Thousand Eyes* (both 1984) by Kim Flitcroft (born 1955) and Sandra Goldbacher (born 1960), and *Blue Monday* (1984) by The Duvet Brothers (Peter Boyd Maclean [born 1960] and Rik Lander [born 1960]) were shown in dance clubs and independent cinemas in London such as the Fridge, the Little Bit Ritzy in South London, and The Ambulance Station, but were also distributed in compilations on VHS cassette, for example, George Barber's *The Greatest Hits of Scratch Video Volumes I and II* (1984 and 1985). In his essay "Scratch's Third Body: Video Talks Back to Television," Leo Goldsmith describes the cultural and technological circumstances which enabled the development of the genre:

> Born at the intersection of recently established art-school video production programmes, urban dance clubs, and post-punk music subcultures, Scratch situated itself at the nexus of a number of distinct but related media, including video art, music, and performance. But its primary foil was broadcast television and via the medium of videotape and new technologies to edit and manipulate it, Scratch refashioned TV's images into an unstable union of mass-media critique and music-video/advertising aesthetics. (Goldsmith 2015)

The relationship between the rapid cut and highly processed images that were typical of Scratch Video and the music on their soundtracks was central to the form. The image sampling and remixing mirrored the techniques and style of the soundtracks—the cut and mix, turntable scrubbing, or scratching of mid-1970s hip-hop, postindustrial, and post-punk music created a hybridized form of video art and dance music.

By and large, Scratch Video was made to be presented in dance venues and nightclubs rather than in art galleries and distributed on VHS video cassettes in music shops rather than through the recently established video art distribution organizations such as London Video Arts and Electronic Arts Intermix for example. Although Scratch Video was an early 1980s phenomenon, its influence and impact extended to the pop promo as well as broadcast TV—both areas that it had originally sought to critique. As with many other art movements and approaches that emerged before and

after, Scratch was itself subsumed into popular culture and often deployed in popular media to signify a certain period or political attitude.

This chapter has identified and outlined a few of the most significant ways in which artists' video and music have been combined, become connected, and have influenced each other. However, this relationship is even more complex and varied as they are inextricably interconnected culturally, theoretically, and technologically. Their time-based nature and the way in which emotions can be evoked and engaged underlie a complex and symbiotic relationship that can be traced back well beyond the emergence of early video art in the 1960s and 1970s. It is connected to the roots of creative audiovisual activity of every kind: mainstream and avant-garde cinema, broadcast television, gallery installation, and performance art, the so-called "anti-art" movements such as Fluxus, Situationism, Dada, and Surrealism. New media art, interactive art, mixed and multimedia, and the development of the internet have only served to increase and enhance the potential ways in which these two idioms will continue to interweave, combine and converge, influence and inspire each other.

References

Allenby, David (2002), "A Theatre of Ideas Steve Reich and Beryl Korot interviewed by David Allenby," *Ensemble Modern*, May 1. Available online: https://www.ensemble-modern.com/en/mediatheque/texts/2002-05-01/a-theatre-of-ideas-steve-reich-and-beryl-korot-interviewed-by-david-allenby-2002 (accessed August 15, 2021).

Cott, Jonathan (2004), "Jonathan Cott Interviews Beryl Korot and Steve Reich on the Cave," in Paul Hillier and Steve Reich (eds.), *Writings on Music, 1965–2000*, 171–7, Bloomington: Indiana University Bloomington.

Coulthart, John (2013), "Mistaken Memories Of Mediaeval Manhattan," *Johncoultheart.com*, July 5. Available online: http://www.johncoulthart.com/feuilleton/2013/07/05/mistaken-memories-of-mediaeval-manhattan/ (accessed November 12, 2021).

Elwes, Catherine (1985) "Through Deconstruction to Reconstruction," *Independent Media*, 48: 21–3.

Goldsmith, Leo (2015), "Scratch's Third Body: Video Talks Back to Television," *View Journal*. Available online: https://www.viewjournal.eu/article/10.18146/2213-0969.2015.jethc097 (accessed November 18, 2021).

Hubbard, Moses (2018), "Peek Inside Brian Eno's Meditative Berlin Installation," *Sleek*, April 5. Available online: https://www.sleek-mag.com/article/brian-eno-installation/ (accessed November 12, 2021).

Korot, Beryl and Ira Schneider (eds.) (1977), *Video Art: An Anthology*, New York and London: Harcourt Brace Jovanovich.

Meigh-Andrews, Chris (2000a) "Peter Donebauer," *Meigh-andrews.com*. Available online: https://www.meigh-andrews.com/writings/interviews/peter-donebauer (accessed November 18, 2021).

Meigh-Andrews, Chris (2000b), "Woody and Steina Vasulka," *Meigh-andrews.com*. Available online: https://www.meigh-andrews.com/writings/interviews/woody-steina-vasulka (accessed July 7, 2021).

Meigh-Andrews, Chris (2014), *A History of Video Art*, London: Bloomsbury.

Meigh-Andrews, Chris (2021a), "Beryl Korot," *Meigh-andrews.com*. Available online: https://www.meigh-andrews.com/writings/interviews/beryl-korot (accessed January 11, 2022).

Meigh-Andrews, Chris (2021b) "John Sanborn," *Meigh-andrews.com*. Available online: https://www.meigh-andrews.com/writings/interviews/john-sanborn (accessed November 12, 2021).

Meigh-Andrews, Chris and Michael Nyman (2017), "Decisive Moments: A Conversation between Michael Nyman and Chris Meigh-Andrews," in *Michael Nyman: Images Were Introduced, La Venetia Reale, June 22–July 12* [exhibition catalog], Turin: Fondazione Elisabetta Sgarbi.

Potter, Keith (2000), *Four Musical Minimalists*, Cambridge: Cambridge University Press.

Reich, Steve (1976), "Videotape and a Composer," in Ira Schnieder and Beryl Korot (eds.), *Video Art: An Anthology*, 104–5, New York and London: Harcourt Brace Jovanovich.

The Kitchen Archive (n.d.), "All Artists," *The Kitchen Archive*. Available online: http://archive.thekitchen.org/?page_id=53 (accessed March 29, 2022).

3

The Process of Creating Was More Important than the Object

Ulrike Rosenbach

Ulrike Rosenbach is among the early adopters of video technology for artistic practice—and one of the first artists to combine art and feminism in a pioneering way. Especially in her video actions, Rosenbach repeatedly addresses the search for identity, questions concepts of femininity, and criticizes role clichés of her time. One of her best-known works in this context, apart from *Glauben Sie nicht, dass ich eine Amazone bin* (1975, *Do Not Assume that I Am an Amazon*), is the video work *Reflexionen über die Geburt der Venus* (1976/1978, *Reflections on the Birth of Venus*). For this performance, Rosenbach, dressed in white, steps into the wall projection of Sandro Botticelli's popular painting *Birth of Venus*, in front of which lies a triangular carpet of white salt. With slow movements, she spins around her own axis for twenty minutes before stepping out of the painting.

What did the motif of Venus mean to you at the time?
This image of Venus in the shell has been an image of eroticism throughout the ages—even in ancient Rome. Venus has always been depicted as a particularly beautiful and desirable woman. The original myth of Venus Aphrodite as a goddess of fertility and motherhood stems from Greek mythology: born in Cyprus and then riding on a seashell, she travels to the land where flowers begin to bloom as soon as she arrives. She is therefore the messenger of spring, which is why she is always depicted as a goddess who is close to nature. In the Botticelli painting you see this in the depictions of the winds: they are representations of mother and father, as the ones who bring and move life. To me, this myth of origin is very important because of the fact that Venus, the original goddess of maternity and fertility, has now undergone a negative modernization and degenerated into a profane and decadent image, placing fertility and beauty in a context with immoral ideas of patriarchal men. For example, "Venus" was commonly used in the names of many sex shops throughout America. Today, the youth has many other role models and contexts. But in my days of youth—this work is from the 1970s—that was still a real issue.

These considerations were my starting point at the time. I then collected many examples of advertising and fashion related to this theme, in which you can clearly

see that it is Venus in the shell being referenced and depicted. I kept coming back to this detail of Sandro Botticelli's Venus—with her long, blond-reddish hair standing in the shell. This myth of the origin of the goddess of fertility as well as the positive development and understanding of womanhood underlie my work. To point to the hybrid development, I then combined Botticelli's image with Bob Dylan's *Sad-Eyed Lady of the Low Lands*.

Why this particular song?
I love these lyrics by Bob Dylan. The song describes a type of woman who lives on her own, someone who is really lonely and therefore sad. And then you notice how the loneliness of this type of women is in fact artificially constructed by society—a Christian education would not accept such a female figure. The type of woman Christianity supports is the Holy Mother of Christ, bearing the child on her arm.

Your work *Reflections on the Birth of Venus* was a transgression of the boundaries of different media and a fusion of different technologies. How did you feel about the advent of video technology back then?
Video meant an immense broadening of the possibilities I had. Until 1972 I had nothing in mind with this technology. I was studying sculpture at the Kunstakademie Düsseldorf (Düsseldorf Academy of Fine Arts) when I realized that the process of creating was especially important for me. With the advent of video I was able to reproduce this process in many different ways: the process—for example wrapping the bonnet of my piece *Hauben für eine verheiratete Frau* (*Bonnets for a Married Woman*)—was more important than the object afterwards. The video enabled a new change of perspective for me, I was able to record the live picture and observe it at the same time. For me this was a very important difference to other media (except Polaroid) because I was able to monitor what I deemed good and what not. With photography or film you are always dependent on others, therefore I preferred video. It meant a bigger autonomy for my work.

For my performances the most important peculiarity of video was the fact that I was able to go live into the scene with the camera and relay the pictures that showed the spectators what the camera did in and with my body. This was completely new. Film wasn't able to deliver anything comparable. Closed-circuit video could be directly shown on a TV screen. Today this is something commonplace, but back then, at the end of the 1960s and the beginning of the 1970s, this was brand new and it meant enormously expanding the scope of possibilities.

Have you also been able to make your work process more reflective as a result—in other words, have you also revised more as a result of the direct feedback?
I wish! But I had such a simple recording device and such a simple camera. I couldn't afford anything else. I was not able to edit a cut with my tools or do any cross-fades. Later I got my partner Klaus vom Bruch, as my assistant, to also make recordings with his camera, so that I had two recordings at the same time. There is a beautiful first performance where we also mixed it live, *Die Maifrau* (*The May Woman*), which is in

the collection at Mike Steiner gallery, currently in the collection of Museum Hamburger Bahnhof in Berlin. But what we didn't have was a documentation—neither in film nor video—of this performance, as there was no second camera available. I only had this live recording and what we could create at those times—an overlapping, superimposed mixture of images. That is why I actually only have sequences of photographs from the first performances.

In what sense do hybridity processes play a role in your work?
My whole working process was always hybrid. You couldn't just go to the computer and look up which video still was the best. Everything was analog. So I set up my camera and took photos of the television screen. These photos became a series. And they were also very important because they showed processes in the work that you simply don't see so quickly in the running picture: sequences, exposures, and lighting effects that are sometimes quite abstract. And there were always photo series of these. That means a video work consisted of a video work and a photo series of the video stills. Then there were objects that I made to go with it and the movement—in other words, a total of four hybrid components of the process. Later I was able to implement these hybrid processes on theatrical stages—I did performances in Hamburg or at the invitation of the Frankfurt Theatre. This combination of traditional theater with the live video transmissions from the video performance—these were also hybrid transgressions.

What would *Reflections on the Birth of Venus* look like if you were to recreate it today?
The work on the piece has been completed for me. Nothing has changed—on the contrary, many things have become even more unreflective and the industry more decayed: women still storm the beauty salons to emulate beauty ideals. They get makeup or even surgery—it has all become much worse.

Well, I have to say that I am a die-hard political feminist from the 1970s. I can't at all relate to a lot of what the younger generation understands by feminism or the women's movement. We had a sociopolitical movement back then: women first had to properly establish the right to vote, which had been granted in the first women's movement. So women had to behave quite differently at the universities. Until then, there was not a single female professor in Germany. All that had to be created in the 1960s and 1970s. You shouldn't forget it was still the early post-war period. Whenever young feminists or young women in general ask me about these questions, I always say that of course a lot has happened! But that is normal to you now and isn't of any real help for the younger generation. There are still many regressions.

II

Media Archives on Hybrids

4

It Belongs in a Museum? Music Videos in Danish Museum Exhibitions

Mathias Bonde Korsgaard

Do music videos belong in museums? There are at least two reasons why music videos at first glance seem an unlikely fit with the values of fine art traditionally associated with museums: first, the inherently commercial nature of music video (the video as an ad for the music); and second, that its status as an autonomous work is questionable (the video as derived from another media object, namely the music itself). Nonetheless, music videos have indeed often been exhibited at museums across the world, either alongside other nonmusic video work or as part of exhibitions specifically focused on music videos. In fact, music videos have been exhibited in museums since as far back as at least 1981—incidentally also the year of MTV's inception—when Aarhus Kunstmuseum[1] featured early music videos in the album cover exhibition *Covers* (Sørensen 2008: 5). While the highly commercial and fast-paced world of music videos and popular music may conventionally be considered to be situated at the opposite end of the cultural hierarchy from the cultivated and contemplative world of fine art, such exhibitions thus clearly prove that the answer to the question is affirmative: music videos *do* belong in museums. Perhaps this somewhat tired discussion of what counts as art can simply be brushed aside, if we accept the claim by Danielle Rice—made in relation to Marcel Duchamp's famous urinal—that "the quality identified as 'art' is not something intrinsic to a certain class of objects" but has now rather become "a value or idea that may be assigned to certain objects" (Rice 1991: 127). In other words, it is all about context and art is an operation rather than a quality: if a urinal can be exhibited as art, then surely a music video can be as well.

 Along these lines, it follows that the dull question of whether or not music videos belong in museums is less relevant than related questions of *how*, *why*, and *to what effect* music videos have in fact been exhibited at museums. Perhaps both the museums and the music videos stand to gain something from this seemingly uneasy fit? In bridging the alleged gap between music videos and visual art, museums' music video exhibitions implicitly address questions of cultural hierarchies—and how these change

[1] The name of the museum changed to ARoS in 2004.

over time. Exhibiting music videos at museums has also clearly played an important part in legitimizing music video as an art form of sorts. As might be expected, however, not all music videos are deemed equally artful, and consequently, not all music videos are considered equally eligible to enter into museums, meaning that some form of cultural taste making is surely still involved. Certain kinds of music video have proven more likely to find their way into museums than others—for instance, what Diane Railton and Paul Watson have termed "art music video" (Railton and Watson 2011: 51–5). The curation of music videos at museum exhibitions thus rests on certain values and ideas about the music video as an art form, and this is again further emphasized by the discourses surrounding the exhibitions—as seen, for instance, in the exhibition catalogs. Some of the central arguments and ideas to have been most frequently brought up in the written statements that accompany such exhibitions include a supposed collapse of the division between commerce and art, the conception of music video as a preeminent field of experimental image processing, an idea of an increasing cross-fertilization between popular music and visual art, the notion of the (music video) *auteur*,[2] music video's direct aesthetic connections to art history (and to other media in general), as well as the tendency toward collaborations between prominent visual artists and musicians. Of these discursive strategies, there are three particular notions that dominate the argumentative framing of music video exhibitions—and that are also equally present in many academic assessments of *the art of music video*:

1) the notion of music video as its own independent medium or art form,
2) the notion of the aesthetic ties of music video with video art and art history, and
3) the notion of the music video *auteur*.

This chapter sets out to interrogate concrete examples of such music video exhibitions, with an eye to the exhibitions themselves and the videos on display as well as to these curatorial approaches to and discursive strategies behind the exhibitions. The chapter provides a case study of two past museum exhibitions in my native country of Denmark: *Music To See* at ARoS in Aarhus in 2008, and *My Music* at Arken in Ishøj in 2017—based not simply on an analysis of the exhibitions and the relevant videos, but just as much on the exhibition catalogs and on personal interviews with the relevant curators.[3] This somewhat narrow national focus is mostly a forced practical precaution: not only have I attended both of these exhibitions (as opposed to exhibitions in other countries—and music video exhibitions do tend to be temporary), but access to

[2] The concept of the *auteur* has its origins in French film culture in the 1950s and 1960s, and refers to the idea that certain film directors exhibit a distinctively personal approach to filmmaking, meaning both that they can be considered the real author of the film (and not, for instance, the screenwriter) and that certain aesthetic traits can be traced across their body of work. While this concept originated in the world of cinema, it has since entered into other spheres of audiovisual media as well, including that of music videos.

[3] On June 2, 2021, I made personal interviews with both the head curator on *Music To See*, Lise Pennington (Lise Mortensen, in the catalog), and with the head curator on *My Music*, Dorthe Juul Rugaard.

interviewing the curators about the process of putting the exhibitions together was also all the more feasible—and in conducting qualitative interviews with so-called exclusive informants, this question of access is indeed pivotal (Bruun 2016: 137–8). Even though the rationales and values behind such exhibitions are, of course, likely to vary somewhat from exhibition to exhibition, museum to museum, and country to country, I nevertheless take these two exhibitions to be fairly representative of some of the prevalent global strategies of music video exhibition—as I will demonstrate by drawing historical lines to a few other international music video exhibitions as well.

Music Videos in Museums from the 1980s to Today

In his now-classic book on music television, Andrew Goodwin is perhaps the first scholar to take note of the fact that music videos have become associated with museums. His book ends with what he calls a "music television time line," and among many other incidents he notes that MoMA in New York had its first music video exhibition in September 1985 (Goodwin 1992: 196). As already indicated, this exhibition was not the first of its kind; however, MoMA's association with music video is still especially significant since the museum has also established its own music video collection, and they have similarly been known to premiere music videos. While this exhibition, titled *Music Video: The Industry and Its Fringes*, curated by Barbara London, is, of course, no longer available for study, the exhibition's press release is readily available online, providing insight into some of the underlying arguments behind the exhibition as well as a complete list of works, thirty-five in total, including videos for The Beatles, Queen, David Bowie, Michael Jackson, and Talking Heads, among others (MoMA 1985).

The press release draws up two main arguments for the exhibition—indeed, two of the same framing devices as already indicated above. The first argument points to the fact that "music videos have brought to public attention some of the experimental image process techniques . . . developed by independent artists in the 1960s, such as Woody and Steina Vasulka, Nam June Paik, and Ed Emshwiller" (MoMA 1985). By stating how music videos exhibit an aesthetic affinity with other types of experimental visual art and by explicitly mentioning early pioneers of video art, the implicit argument seems to be that music videos enter consciously into a certain tradition and share particular qualities with other objects already designated as art, despite the music videos' inherently promotional nature. This argument is further supported by bringing attention to the fact that the exhibition comprises both "[p]opular tapes such as 'Beat It'" and "more experimental works" (MoMA 1985). In other words, the exhibition shows traditional and actual music video works alongside works that are not necessarily clear-cut music videos, but indeterminately situated somewhere in-between music video and video art.

Conversely, the second argument is one that emphasizes the general cultural value of music video, in stressing how the music video has grown to become "a cohesive medium" and "a major force in popular culture" (MoMA 1985). In a certain sense, this is thus the opposite argument of the first one: here, music video is posited as something

that has value as art *in itself* and thus in its own specificity as a medium, and not merely in its likeness with and inheritance from other media or art forms. When the exhibition was running, James Hoberman used it as an occasion to discuss not only the exhibition, but also the status of music video more generally in a piece published in *The Village Voice*. In Hoberman's assessment, it would seem that the first argument— that music videos are artful due to their aesthetic ties to video art—carried more weight in the exhibition itself than did the second argument about music video's own artistic merits. Hoberman writes that, with the exception of *Beat It*, "the MOMA show de-emphasizes narrative" (Hoberman 2008: 818). He moves on to state that the curator Barbara London seems "inclined to demonstrate music video's affinities with video art rather than with film" (Hoberman 2008: 819), and as such, most of the videos in the exhibition would indeed seem to belong to the tradition of the already mentioned "art music video," notable precisely for the way in which it "stands in relationship to video art" (Railton and Watson 2011: 52). Other long-established genre divisions of music video—also dating back to the time of the exhibition, as introduced by Marsha Kinder and Joan D. Lynch, respectively—operate with a three-way division of music video into the two mainstream genres of narrative videos and performance videos, opposed with a third genre that corresponds more or less to this notion of "art music video," a genre of videos characterized as dreamlike, fragmented, experimental, and conceptual (Kinder 1984; Lynch 1984). Kinder and Lynch frame these genre divisions in highly normative terms, and thus, both authors clearly favor this third type of music video and hold it in higher esteem than the first two genres: Kinder claims that such videos "make the richest use of the medium" (Kinder 1984: 9) while Lynch states that the "most interesting videos are those influenced by experimental film" (Lynch 1984: 55–6). The view that a certain kind of music video—and specifically one indebted to the visual arts—is more artful than other kinds of music video, thus seems to have already taken hold in the mid-1980s in both the world of museums and that of academia.

 Finally, Hoberman also points to the third equally common discourse of legitimization, even though it is only halfway present: namely, that of making reference to the notion of the *auteur*, a concept originally used as a means for the artistic legitimization of film in the 1950s in France but also more recently employed in relation to the contemporary boom of so-called quality TV (Newman and Levine 2012: 161). Hoberman notes that the exhibition does in fact acknowledge "many of the most talented video-makers" but simultaneously remarks that the musicians appear to be the real focal point as "the strongest auteurs are the performer-artists" (Hoberman 2008: 819). This discursive summoning of the *auteur* as a high-mark of cultural legitimacy is also a recurrent element, both implicitly and explicitly, in other later discussions of the music video as an art form; but contrary to the situation in 1985, it has become just as common to give credence to the director as to the musicians (as also evidenced by the fact that MTV did not credit the music video directors until seven years after 1985 in 1992 [Jullier and Péquignot 2013: 106]). Today, many music video directors are famous for their work within the medium and some museum exhibitions have indeed used the *auteur* as a prime curatorial principle (including *Music To See*; see later in this chapter). The inclusion of Andy Warhol's video for The Cars' *Hello Again* in the MoMA

exhibition also points to the way in which these discourses occasionally intermingle with each other—the implicit argument being that this video is worthy of inclusion precisely because it was directed by a well-known visual artist who is certainly no stranger to the museum world, but comes from outside the world of music video.

As one of the earliest music video exhibitions, the MoMA exhibition draws up some of the discussions and questions that are still relevant to music video exhibitions to this date. Since Goodwin mentioned the MoMA exhibition in 1992, quite a few other scholars have noted how music videos have crept into museums, often with the accompanying claim that this is something that is happening more and more often.[4] The exhibition of music videos thus appears to have become a truly global phenomenon that has only become all the more common in recent history. However, the tendency for music videos to enter museums and art galleries is almost always brought up only in passing in these writings, which is also true of my own work (Korsgaard 2017: 28-9, 71). I have only been able to identify two previous studies that provide a sustained analysis of music video exhibitions, both of which are in French. The first by Julien Péquignot is about the exhibition *Playback* at Musée d'Art Moderne de la Ville de Paris in 2007–8 (Péquignot 2012), while the second by Marie Vicet addresses the same exhibition in comparison with two other French exhibitions held more than twenty years earlier in 1985, both at the Centre Georges Pompidou in Paris (Vicet 2017).

Apart from providing concrete information about the exhibitions in question, these two articles also lend further support to the claim that some of the discursive strategies of music video exhibitions are quite similar across time and place—indeed, the very same three discourses of legitimization that I have already identified (music video's own artistic merits, its ties to the visual arts, and the notion of the *auteur*). Vicet mentions how the first exhibition, *Les Immatériaux* (*The Immaterials*), wanted to bring to light some of the "recurrent stylistic figures of music video" in order to demonstrate that music video was "a new audiovisual genre, which had its own style" (Vicet 2017).[5] In other words, the music video is framed in a way that is very similar to the second argument in relation to the MoMA exhibition about music video's cohesion as an autonomous artistic medium. The same goes for the second exhibition, *Paysage du clip* (*The Landscape of Music Video*), which is said to focus on music video as "one of the most innovative artistic forms of the moment" (Vicet 2017).[6] At the same time, Vicet notes that both exhibitions also focus on the music video *auteur*. In the first exhibition, the directors—who, as mentioned, were most often unknown to the public back then—were simply named, whereas in the second exhibition, there was an explicit focus on specific directors, also in the accompanying catalog. Both Vicet and Péquignot describe the third and more recent exhibition as drawing mostly on the

[4] See Daniels 2021: 26; Dreckmann 2021: 122–3; Fleig 2021: 128–31; Jullier and Péquignot 2013: 60, 108; Kaiser and Spanu 2018: 7; Keazor and Wübbena 2011: 9; Napoli 2012: 39; Railton and Watson 2011: 6–7.
[5] Own translation.
[6] Own translation.

third discourse about music video's ties to and hybridization with the visual arts, as the exhibition consisted exclusively of clips made by visual artists, including Damien Hirst and, again, Andy Warhol.

As this brief historical overview shows, music video exhibitions have been a recurrent phenomenon for four decades, just like the discursive framings of the exhibitions make recourse to similar arguments. Even as they are quite different from one another, the two Danish music video exhibitions that the chapter now turns to will be shown to revolve around the selfsame discursive strategies—sometimes with these strategies supporting each other even as they may seem to partly contradict each other, particularly the simultaneous insistence on music video's value as an independent medium vis-à-vis its value as resting on its intermedial relations to and dependency on other art forms. Somewhat paradoxically, music video is art because it has developed its own artistic language *at the same time as* music video is art because it owes a debt to the visual arts.

Music To See (ARoS 2008) and *My Music* (Arken 2017)

The first of these exhibitions is *Music To See* at ARoS in Aarhus in 2008, and indeed, it makes reference to all three discursive strategies, even though they are, of course, not employed in equal measure. The exhibition had a specific music video focus, meaning that all the works presented were actual music videos. The exhibition consisted of two different elements:

1) a living music video timeline with historically significant videos shown on small screens with headphones, and
2) a selection of music videos from five different music video directors, with five videos for each director displayed on larger screens with speakers in separate rooms.

The directors in question were Anton Corbijn, Chris Cunningham, Michel Gondry, Spike Jonze, and Mark Romanek. The most immediately noticeable curatorial principle is thus self-evidently that of the music video *auteur*, a notion also brought up explicitly in the accompanying exhibition catalog (Sørensen 2008: 17). But why exactly the work of these five directors and not five others? When asked this particular question, the head curator, Lise Pennington, replied that the directors were chosen because their videos make explicit aesthetic reference to art history and/or film history, mentioning the baroque still lives in Mark Romanek's video for Nine Inch Nails' *Closer* (1994) as an example (Korsgaard n.d. Interview Pennington). Interestingly, this indicates that part of the motivation behind the selection of these particular directors rests on another favored strategy, that of connecting music video to other art forms.

This line of reasoning is also evident throughout the exhibition catalog: the foreword by the museum director, Jens Erik Sørensen, mentions how the directors

"all work in the field of exchange between visual art and the visual form of expression found in film" (Sørensen 2008: 5). The second text of the catalog, by associate professor of art history Jens Erik Sørensen, also explicitly places the directors' work into an art historical lineage: Chris Cunningham "owes more to avant-garde film and installation art than music video," whereas the work of Corbijn is connected to both the sand people in *Star Wars* and Caspar David Friedrich, while Romanek is associated with Joel-Peter Witkins, Man Ray, Gustav Klimt, Francis Ford Coppola, Stanley Kubrick, and Erik Wurm, with Spike Jonze and Michel Gondry both being related to Busby Berkeley (Sørensen 2008: 21–5). As such, the value of these directors' music video output is linked to their connections with certain film and art historical traditions. In my interview with Pennington, she exhibits a clear awareness of the potential double-sidedness of this framing and thus of the interconnectedness of the discursive strategies: on one hand she describes music video as having "developed its own language" and as forming "a major part of our common cultural frame of reference," while on the other, she maintains that many music videos excel at making explicit references to baroque, surrealist, or modernist art (Korsgaard n.d. Interview Pennington). However, in both the exhibition catalog and in the interview with Pennington, the art historical references seem to outweigh the medium specific qualities as curatorial principle.

In the interview, Pennington indirectly indicates that part of the reason behind this approach was related to the fact that the main audience of the museum at that point in time was elderly. The strategy is to place the music video into an art historical tradition that the audience is already familiar with instead of insisting too much on its own qualities as a specifically new art form. That being said, however, the choice of directors is simultaneously fully consistent with the canonization of music video *auteurs* outside the world of museums, and this emphasis on the directors' contributions to the art of music video is also distinctly present in the framing of the exhibition (in the catalog, Sørensen states that the directors make up "five of the most innovative and experimental image-makers" [Sørensen 2008: 5]). The five relevant directors are surely among the most famous and esteemed music video directors of all time and were already held in high regard at the time of the exhibition. This is not least due to the fact that all five directors had already had some of the highlights of their music video output released on DVD on the so-called *Directors Label* by Palm Pictures in 2003 and 2005. In fact, this DVD series can be said to constitute an act of self-canonization, as it was initiated by Spike Jonze, Michel Gondry, and Chris Cunningham—also the first three directors to have their work released in the series. Since then, and probably due in part to the DVD series, these three directors have come to form a sort of holy trinity of music video *auteurs*, as also witnessed by the fact that many studies of music video touch upon their work, both academic and nonacademic.[7] Heidi Peeters even asserts that

[7] On Cunningham, see for instance Lockwood 2017: 195–207; Shaviro 2002: 1–19. On Spike Jonze, see for instance Beebe 2007: 303–27; Fleig 2021 (obviously, also on Gondry). On Gondry, see for instance Buckland 2018; McQuiston 2020. All three directors are also among the featured directors in Neil Feinemann and Steve Reiss' book on "the art of music video." See Feinemann and Reiss 2000.

there is a "cult around music video directors such as Michel Gondry, Spike Jonze and Chris Cunningham" (Peeters 2004). In his book on the digital reconfiguration of music video, Mark Hanson also enlists all three directors as belonging among five "icons of the genre" (Hanson 2006: 15–19). And finally, Carol Vernallis uses the *Directors Label* DVD series as her analytical case in her chapter on music video canonization (Vernallis 2013: 262–76). The inclusion of particularly these three directors in the exhibition—if not in any other way, then at least implicitly—also speaks to the conception of music video as its own independent medium with its own batch of celebrated and canonized *auteurs*.

The second exhibition, *My Music* at Arken in 2017, differs from *Music To See* on a number of levels. First of all, the exhibition was much less of a full-blown music video exhibition. Instead, it placed music videos alongside other objects that point to the various cross-fertilizations between popular music and the visual arts. The exhibition thus consisted of actual music videos alongside paintings, sculptures/installations, and other kinds of video work apart from music video proper, with no clear hierarchical logic dominating the order of the works of their physical placement in the exhibition space.[8] Here, the first curatorial principle and discursive strategy to spring to mind is thus clearly not that of the *auteur* nor that of the music video as an independent art form. As stated by museum director Christian Gether in the exhibition catalog, the exhibition instead placed its main emphasis on the "intersections, alliances and cross-fertilizations between music and art" (Gether 2017: 3) as also supported by the text in the catalog by head curator Dorthe Juul Rugaard, which states that the exhibition zooms in "on the contemporary boom in alliances and collaborations between pop music and contemporary art" (Rugaard 2017: 30) and thus traces movements both "from pop to art" and "from art to pop" (Rugaard 2017: 30). Thus, the main curatorial principle for the music video component in this exhibition is the interrelations between music video and the art world.

In my personal interview with Rugaard, she reaffirmed this framing of a general "intersection between the visual arts and popular music" (Korsgaard n.d. Interview Rugaard) just like she restated another observation also present in her catalog text about the exhibition consisting of three types of works, namely, "music videos that use the codes of visual art; artworks that use the visual aesthetics and identity processes of pop music; and close, mutual collaborations that generate new value and meanings" (Rugaard 2017: 30). Among these works, the music videos would typically also be chosen with indirect reference to the principles mentioned throughout this chapter: either, they were directed by established visual artists like Roger Ballen or Jeremy Blake, or they were thought to have "an artfully conceptual quality in a way you do not typically see in music videos," with Rugaard mentioning Lady Gaga's *Born This Way* as an example of this (Korsgaard n.d. Interview Rugaard). Again, as with *Music To*

[8] In my personal interview with head curator Dorthe Juul Rugaard, she explains how this exhibition design was meant to simulate what it would look like to walk around *inside YouTube*—but also that they took inspiration from the hypermediated space of Times Square (Korsgaard n.d. Interview Rugaard).

See and all the other exhibitions mentioned, the three main curatorial principles and discursive strategies are all present, but with a certain change of emphasis.

As with the *auteur* focus of *Music To See*, the exhibition's view that music videos "often borrow from and find inspiration in the art world" (Rugaard 2017: 30) is also equally present in some of the extant research on music video as art.[9] Indeed, Henry Keazor and Thorsten Wübbena have noted in a strikingly similar formulation how "the music video always goes back to the visual arts in search for inspiration" (Keazor and Wübbena 2011: 329)[10] just like Lars Movin and Morten Øberg have suggested that it is "almost impossible not to speak of art in relation to music videos for the simple reason that the majority of the videos make references to concrete works of art or traditions in art history" (Movin and Øberg 1990: 172).[11] Sometimes, this argument is also framed normatively, as, for instance, when Maureen Turim claims that it is mostly "some of the best work in music video" that enters into such a "dialogue with the history of twentieth-century art and current trends in video art and installation" (Turim 2007: 107). The battle over what counts as music video art is thus clearly not only fought in the museum exhibitions but also simultaneously in the academic writings on music video—and with recourse to much the same arguments.

Bridging the Gaps?

Judging from the description of the French exhibition *Playback*, by Péquignot and Vicet, it appears that its concept and framing strategies were somewhat similar to those of *My Music*. But both Péquignot and Vicet level a criticism against the particular way this exhibition was designed—with rooms in the museum converted into resembling some of the real-life locations in which music videos would normally be encountered, such as a gym complete with treadmills. Paraphrasing Péquignot, who notes the mismatch between the museum setting and the intended audience for the exhibition, Vicet states that "music video enthusiasts are not necessarily those who go to the museum and vice versa" (Vicet 2017).[12] Noting how the exhibition thus neither manages to fully bring about a democratization of art nor to legitimize popular culture, Péquignot states that for the exhibition to have truly bridged this cultural gap, the artistic videos on display would have had to be exhibited at an actual gym or at an actual mall. Interestingly, however, this was exactly the case with *My Music*, in that it extended the exhibition to take place "both within and beyond the confines of the museum" (Gether 2017: 3), with part of the exhibition taking place at the mall Rødovre Centrum and being co-curated with young people from a local school. In my interview with Rugaard, she states how this outreach was in a sense the most valuable long-term benefit from the exhibition— that they had established a collaboration with an external partner organization that has

[9] See for instance Napoli 2012; Frahm 2010: 156–7; Taylor 2007: 230–1.
[10] Own translation.
[11] Own translation.
[12] Own translation.

also been repeated at future occasions. In this way, the incursion of music videos into (and subsequently out of) the world of museums seems to have actually helped bridge a gap between otherwise incompatible institutions and cultural spheres.

However, this collaboration also points to another gap that could not be fully bridged: the issue of license negotiations in relation to the videos. While a seemingly simple practical issue, this is nevertheless an important one that both curators address in my interviews with them. Rugaard stated that the collaboration with Rødovre Centrum allowed them to show some of the videos that the museum itself failed to secure the rights to, as the public space of the mall location did not impose the same licensing restrictions as the museum setting. Both curators detail how the licensing work was extremely complex and time-consuming, and that there were cases of concrete works that they were unable to secure permission to exhibit. Pennington further explains how they had employed someone (with a background working in a film production company in London) for four months to do nothing but license negotiations, resulting in a total of "five to seven very large ring binders of documentation" (Korsgaard n.d. Interview Pennington). Without going into concrete numbers, Rugaard also dryly remarked to me that it "was not exactly cheap" (Korsgaard n.d. Interview Rugaard) to exhibit the relevant works. By contrast, Vicet describes how the videos in 1985 were offered to one of the Pompidou exhibitions free of charge. Maybe this is the clearest indication of the growing consolidation of the "value" attributed to music video as an art form: that museums now have to pay large sums in order to exhibit them.

Finally, the complexity of these licensing issues also potentially casts into doubt the validity of the *auteurist* framing. Permission to display the works had to be obtained from three different players: the directors, the musicians, and the production companies. This indirectly speaks to the complexities of music video authorship—with music video not necessarily being the simple directors' medium that it is often framed as, both in museums and academia. Recently, Emily Caston has therefore insisted on "the urgent need to reframe music video as collaborative authorship embedded in both the music industry and film industry" (Caston 2020: 165), suggesting among several alternatives to the director-as-*auteur* approach to focus on "long-standing partnerships between filmmakers and musicians" (Caston 2020: 165). Since music videos result from complex collaborations between different creative and managerial agents, the attention thus "needs to move away from the focus on individuals as determining agents and towards cultures of production and genre" (Caston 2015: 152). As a framing device, the focus on the music video director as *auteur* is certainly convenient, but at the same time it belies the complexity in music video production.

References

Beebe, Roger (2007), "Paradoxes of Pastiche: Spike Jonze, Hype Williams, and the Race of the Postmodern Auteur," in Roger Beebe and Jason Middleton (eds.), *Medium Cool: Music Videos from Soundies to Cellphones*, 303–27, Durham: Duke University Press.

Bruun, Hanne (2016), "The Qualitative Interview in Media Production Studies," in Chris Paterson, David Lee, Anamik Saha, and Anna Zoellner (eds.), *Advancing Media Production Research: Shifting Sites, Methods, and Politics*, 131–46, London: Palgrave Macmillan.

Buckland, Warren (2018), "The Unnatural and Impossible Storyworlds of Michel Gondry's Music Videos: The *Mise en Abyme* of 'Bachelorette,'" *Volume !*, 14 (2): 83–96.

Caston, Emily (2015), "Not Another Article on the Author! God and Auteurs in Moving Image Analysis: Last Call for a Long Overdue Paradigm Shift," *Music, Sound, and the Moving Image*, 9 (2): 145–62.

Caston, Emily (2020), "Conservation and Curation: Theoretical and Practical Issues in the Making of a National Collection of British Music Videos 1966–2016," *Alphaville: Journal of Film and Screen Media*, 19: 160–77.

Daniels, Dieter (2021), "Zur Musikalität des Visuellen: Thesen zur Videospezifik des Musikvideos," in Kathrin Dreckmann (ed.), *Musikvideo Reloaded: Über historische und aktuelle Bewegtbildästhetiken zwischen Pop, Kommerz und Kunst*, 25–42, Düsseldorf: Düsseldorf University Press.

Dreckmann, Kathrin (2021), "Notes on Pop: Campy Popasthetiken in Musikvideos," in Kathrin Dreckmann (ed.), *Musikvideo Reloaded: Über historische und aktuelle Bewegtbildästhetiken zwischen Pop, Kommerz und Kunst*, 109–24, Düsseldorf: Düsseldorf University Press.

Feinemann, Neil and Steven Reiss (2000), *Thirty Frames Per Second: The Visionary Art of Music Video*, New York: Harry M. Abrams, Inc.

Fleig, Michael (2021), "Michel Gondry und Spike Jonze – Auteurs des Musikvideos," in Kathrin Dreckmann (ed.), *Musikvideo Reloaded: Über historische und aktuelle Bewegtbildästhetiken zwischen Pop, Kommerz und Kunst*, 125–44, Düsseldorf: Düsseldorf University Press.

Frahm, Laura (2010), "Liquid Cosmos: Movement and Mediality in Music Video," in Henry Keazor and Thorsten Wübbena (eds.), *Rewind, Play, Fast Forward: The Past, Present and Future of the Music Video*, 155–78, Bielefeld: transcript Verlag.

Gether, Christian (2017), "Foreword," *My Music, Arken*, October 7, 2017 to March 25, 2018 [exhibition catalog], Ishøj: Arken.

Goodwin, Andrew (1992), *Dancing in the Distraction Factory: Music Television and Popular Culture*, Minneapolis: University of Minnesota Press.

Hanson, Matt (2006), *Reinventing Music Video: Next-Generation Directors, Their Inspiration and Work*, Hove, Brighton: RotoVision.

Hoberman, James (2008), "What's Art Got to Do with It?" in Judith Tick and Paul Beaudoin (eds.), *Music in the USA: A Documentary Companion*, 814–19, Oxford: Oxford University Press. Originally published in *The Village Voice* September 17, 1985.

Jullier, Laurent and Julien Péquignot (2013), *Le Clip: Histoire et Esthétique*, Paris: Armand Colin.

Kaiser, Marc and Michaël Spanu (2018), "'On n'écoute que des Clips !' Penser la mise en tension médiatique de la musique à l'image," *Volume !*, 14 (2): 7–20.

Keazor, Henry and Thorsten Wübbena (2011), *Video Thrills the Radio Star. Musikvideos: Geschichte, Themen, Analysen*, Bielefeld: transcript Verlag.

Kinder, Marsha (1984), "Music Video and the Spectator: Television, Ideology and Dream," *Screen*, 38 (1): 2–15.

Korsgaard, Mathias Bonde (2017), *Music Video After MTV: Audiovisual Studies, New Media, and Popular Music*, New York: Routledge.

Korsgaard, Mathias Bonde (n.d.), *Personal Interview with Dorthe Juul Rugaard*.
Korsgaard, Mathias Bonde (n.d.), *Personal Interview with Lise Pennington*.
Lockwood, Dean (2017), "Blackened Puppets: Chris Cunningham's Weird Anatomies," in Gina Arnold, Daniel Cookney, Kristy Fairclough and Michael Goddard (eds.), *Music/Video: Histories, Aesthetics, Media*, 195–207, London and New York: Bloomsbury Academic.
Lynch, Joan D. (1984), "Music Videos: From Performance to Dada-Surrealism," *Journal of Popular Culture*, 18 (1): 53–57.
McQuiston, Kate (2020), *Music and Sound in the Worlds of Michel Gondry*, New York: Routledge.
MoMA (1985), "Music Video: The Industry and Its Fringes. Press Screening Announcement," *MoMA*. Available online: https://assets.moma.org/documents/moma_press-release_332944.pdf?_ga=2.196391211.607129136.1632129578-394799054.1630501369 (accessed September 20, 2021).
Movin, Lars and Morten Øberg (1990), *Rockreklamer: om musikvideo*, Copenhagen: Amanda.
Napoli, Maria Donata (2012), "Short Review of the Relationship Between Video, Music and Art," *CITAR Journal of Science and Technology of the Arts*, 4 (1): 33–40.
Newman, Michael Z. and Elana Levine (2012), *Legitimating Television: Media Convergence and Popular Culture*, New York: Routledge.
Peeters, Heidi (2004), "The Semiotics of Music Videos: It Must Be Written in the Stars," *Image & Narrative*, 8 (1). Available online: http://www.imageandnarrative.be/inarchive/issue08/heidipeeters.htm (accessed March 25, 2022).
Péquignot, Julien (2012), "Le clip au musée: democratisation de l'art ou légitimation d'une pratique Populaire ?" *Marges: Revue d'art Contemporain*, 15 (1): 10–26.
Railton, Diane and Paul Watson (2011), *Music Video and the Politics of Representation*, Edinburgh: Edinburgh University Press.
Rice, Danielle (1991), "The Art Idea in the Museum Setting," *The Journal of Aesthetic Education*, 25 (4): 127–36.
Rugaard, Dorthe Juul (2017), "Pop Pictures and Art Beats: The Crossovers between Pop Music and Visual Art," *My Music, Arken*, October 7, 2017 to March 25, 2018 [exhibition catalog], Ishøj: Arken.
Shaviro, Steven (2002), "The Erotic Life of Machines," *Parallax*, 25 (1): 1–19.
Sørensen, Jens Erik (2008), "Foreword," Music To See, ARoS, June 7 to September 7 [exhibition catalog], edited by Lise Mortensen, Aarhus: ARoS.
Taylor, Pamela G. (2007), "Press Pause: Critically Contextualizing Music Video in Visual Culture and Art Education," *Studies in Art Eduction: A Journal of Issues and Research*, 48 (3): 230–1.
Turim, Maureen (2007), "Art/Music/Video.com," in Roger Beebe and Jason Middelton (eds.), *Medium Cool: Music Videos from Soundies to Cellphones*, 83–110, Durham: Duke University Press.
Vernallis, Carol (2013), *Unruly Media: YouTube, Music Video, and the New Digital Cinema*, Oxford: Oxford University Press.
Vicet, Marie (2017), "Quelle Place pour le clip vidéo au musée ? De sa reconnaissance muséale à sa remise en question, à travers trois expositions françaises (1985–2007)," *exPosition*, October 2. Available online: http://www.revue-exposition.com/index.php/articles3/vicet-clip-video-musee-expositions-france/%20 (accessed September 20, 2021).

5

No Returns for Dislike[1]

How Music Videos and Video Art Entered the Living Room in the 1980s

Linnea Semmerling

Today platforms like YouTube and UbuWeb function as rabbit holes down into the early histories of music videos and video art reaching all the way back to the 1980s and far beyond the mainstream. But how could the 1980s contemporaries access those alternative music and artists' videos in particular? In Germany and the Netherlands, lending libraries rarely included music videos and MTV Europe only started in 1987. Instead, video enthusiasts might consult their local record score, subscribe to a zine, or get the mail order catalog from the Cologne-based music and video distributor 235. In order to make a purchase, clients of 235 had to fill in the order form in the back of the brochure and either pay through bank transfer in advance or cash on delivery. This way, a 1987 client could acquire video concert recordings of bands like Throbbing Gristle (DM 89), Einstürzende Neubauten (DM 79), or Der Plan (DM 39) together with a video documentation about Die Tödliche Doris (DM 79), a video painting by Brian Eno (DM 89) or a limited and signed video edition by Bruce Nauman (DM 480). What 235 offered throughout the 1980s was a curious combination of audio and video cassettes of independent music as well as video art (235 1987a and 1987b).[2]

This chapter intends to show that the peculiar orientation of this program in between independent music videos and video art also made for a specific approach to distribution that has yet to be considered in the art historical, media, and technology studies literature on the distribution of alternative moving images. So far, the distribution practices of video art have been contextualized in the framework of the alternative moving image industry (Knight and Thomas 2011) and their relationships to the contemporary art world (Balsom 2017) as well as publishing (Buschmann and Nitsche 2020). This chapter takes the music industry into view, which by the 1980s

[1] (235 1988: 46). Own translation.
[2] All prices mentioned in this chapter are given in the original currencies of DM and NLG. For comparison, DM 100 in 1987 equals about EUR 94.25 today and NLG 100 in 1987 equals about EUR 85.55 today (both factoring in inflation).

already had a firmly established culture of circulation and exchange for independent music cassettes. Against this background, the spread of VHS tapes and video cassette recorders (VCRs) across European living rooms over the course of the 1980s has to be interpreted not just as having been a new possibility for the distribution of moving images into the home, but also as an enhancement of music distribution with an audiovisual component. Consequently, this chapter sets out to investigate how the market entry and consolidation of the VHS tape shaped the distribution practices of music videos and artists' video in the 1980s.[3] How has the new distribution medium influenced alternative distribution programs as well as their distribution methods? How have these distribution practices in turn defined the public and cultural perception of the VHS tape?

I am going to answer these questions by analyzing the mail order catalogs of 235 in Cologne, MonteVideo and Time Based Arts in Amsterdam as well as Kijkhuis in The Hague. I have chosen these distributors because they represent a variety of artistic approaches to video in Europe with 235's commitment to independent music, MonteVideo's investment in media-reflexive productions, Time Based Arts' treasure of performance documentations and conceptual art, and Kijkhuis's dedication to community video and sociocultural documentations. In my analysis of their 1980s catalogs, I am evaluating not only the products and services the different distributors offered but also the ways in which they addressed their audiences. By combining these three aspects, I aim to shed light on the intricate dynamics of technology adoption and cultural production, specifically the distribution of VHS tapes by independent musicians and artists in West Germany and the Netherlands in the 1980s.

Cataloging Video Art Distribution across Europe in the 1980s

By the 1980s, video was a beloved medium among artists, musicians, and activists alike. It tied in well with their ongoing questioning of traditional art objects through non-marketable art forms as well as with their critique of the ever-increasing power of the mass media and television in particular. But it had also already become clear that a new medium is only ever as good as its users, who by that time had learned to make good money from anti-capitalist art and have their critiques of mass media aired on television. It was the time that the radical democratic utopia of an instantly reproducible medium with unprecedented powers of transmission of information seemed to gather momentum among a growing community of subcultural practitioners while at the same time starting to disintegrate under practical concerns including financial constraints, production values, and public recognition. This was the time that distribution initiatives were founded by artist collectives as well as cultural organizers

[3] In line with David Antin, I prefer the term "artists' video" to describe artistic video practices of the 1980s, as many videos from the 1980s that are now considered canonical to the genre of "video art" have not been conceived as such (Antin [1975] 1986).

and entrepreneurs in order to formalize circulation activities through services and programs aimed at remunerating the artists for the use of their works (Sturken 1990; Drew 2007; Brunow 2011).

In the Netherlands, different video distribution initiatives were founded over the years, the most prominent ones being MonteVideo and Time Based Arts in Amsterdam as well as Kijkhuis in The Hague. MonteVideo was founded in 1978 by former television producer and director René Coelho together with his wife Yolande as a video art gallery that supported the production, exhibition, and distribution of video artists out of their own home. Time Based Arts (TBA) was established in 1983 on the initiative of De Appel, inviting the local Vereniging van Videokunstenaars (Association of Video Artists) to take charge over the institution's increasing video collection. While the organization was officially run by Aart van Barneveld, it retained a bottom-up dynamic, so the Amsterdam community of video artists was involved in many of the institutional decisions. Throughout the 1980s, the two Amsterdam institutions remained competitors and were frequently played off against each other by the funding authorities despite their different emphases—MonteVideo having the media reflexive Dutch-centered program while TBA had the more internationally oriented performance-centered program. Kijkhuis in The Hague was an initiative that focused on presenting and distributing art videos as well as socially engaged tapes and documentaries. Already founded in 1974, their director Tom van Vliet only started to incorporate artists' videos into their "videotheek" (video rental library) in the early 1980s when Kijkhuis also became the European representation of the New York distributor Electronic Arts Intermix (van Hal n.d.; Perré in Boomgaard and Rutten 2003; Fauconnier 2010).

Distribution catalogs played an important part in the distribution strategies of all three institutions. In 1982, MonteVideo proclaimed more proudly than accurately that "MonteVideo is the first video gallery to release a full-blown video art catalog. This special catalog is packaged in the box of a U-matic cassette and includes more than 100 video works from the Netherlands and abroad" (MonteVideo 1984).[4] The box was filled with large library cards dedicated to the individual artists and their works, complete with images and work descriptions. In 1984, TBA published a similar catalog with loose index cards and in 1988, Kijkhuis published a large ring binder with all the works from their distribution program (Time Based Arts 1984; Kijkhuis 1988).[5] All of these catalogs were purposefully designed to be expandable, so the distributors were issuing supplements every so often so that the owners could keep their catalog up-to-date. Besides these expandable publications, TBA and Kijkhuis also issued smaller catalog booklets every few years (Time Based Arts 1985; Time Based Arts 1987; Kijkhuis 1985).

What is striking about the MonteVideo and TBA catalogs in particular is that the reader is hardly addressed at all. While the MonteVideo catalog contains a short

[4] Own translation.
[5] There must also be a Kijkhuis catalog published in 1981 to which the archives I consulted only had the supplements.

introductory statement about the history and medium specificity of video art, the TBA index cards that I consulted in different archives did not come with any such contextual information. Neither of the catalogs provides any information with regard to the practicalities of the ordering process, such as information about the purchase or rental conditions, and only the TBA catalog provides information about the formats in which the videos are available, which is exclusively on U-matic. Instead, the MonteVideo catalog lists detailed screening and exhibition histories of the individual works, which include several sculptures and installations alongside tapes. All of this suggests a focus on institutional rather than individual customers, which is confirmed in newspaper articles of the time ("Als TV-kijker" 1984; "Video als kunst in MonteVideo" 1984; "Voor videokunst" 1984). A journalist from the national daily newspaper NRC assessed in 1982 that "interest in MonteVideo on the part of museums is growing, but private individuals still find the rental price of 100 Dutch guilders per videotape too high and buying it is not considered an option at all" (Libbenga 1982: no page).[6] Other articles suggest that the prices started even higher at NLG 500, that the owners of video recorders were spread too thin to constitute a sales market, and that individual owners of VHS tapes would nip an alternative sales market in the bud with illegal copies (Jongeneel 1981: 45; "Voor videokunst" 1984).[7]

In the much more affordable Kijkhuis catalogs, there is some more information available for potential customers. The publications explain that the videos from their lending library are available to be viewed at Kijkhuis for free, that a location at Kijkhuis can be booked for communal screenings for a fee of NLG 1 to NLG 2 per person, and that the videos can be borrowed as U-matic, Betamax, or VHS for a fee of NLG 25 up to NLG 100 excluding taxes, transportation, and possible equipment rentals (Kijkhuis 1983: 3). Together with the practical information, the Kijkhuis catalog also comes with plenty of different indexes to help orientation. The catalog is divided into "independent video productions" organized by country and "other independent productions" as well as "television productions," but there is also an elaborate index by categories such as "art," "men," "minorities, racism and fascism," "music," or "women" and an index by title. The index by categories comes with a note that some of the video art productions defied classification and have therefore remained exempt (Kijkhuis 1983). In comparison with MonteVideo and TBA, the Kijkhuis program is considerably more diverse as it includes many documentary and journalistic works alongside artworks.

Besides the catalogs and their supplements, MonteVideo and Kijkhuis both issued magazines at least for a limited period of time. MonteVideo started publishing a bimonthly brochure for their screening programs in 1984 that turned into a magazine in 1985. While the brochure was mostly aimed at artists with information on subsidies, festivals, and equipment rentals similar to a newsletter, the magazine was primarily

[6] Own translation.
[7] This only seems to have changed in the 1990s with the "Editions a voir" [sic] series ("Kunstvideos" 1994). In an undated flyer Coelho also offers videotapes by Nan Hoover on VHS, Beta, and Video-8 in a limited edition of fifty, numbered and signed for NLG 350 "alleen aan particulieren" (for private individuals only) (Flyer Galerie Rene Coelho [sic] n.d.: no page).

aimed at curators and museum professionals, stating that "it is high time that the Dutch exhibitors of modern art were made aware of this video offer. This magazine is primarily intended for them" (MonteVideo 1985).[8] MonteVideo also rented out video magazines such as the LVA tape *Videomusic* from 1983 and *Infermental*, first issued in 1982, but these video magazines were always framed as a distribution category distinct from video art, with specific screening requirements. An issue of the MonteVideo magazine explains how

> the detrimental effect [of linear presentations of video magazines in institutional screenings] can be avoided by publishing video magazines on affordable cassettes in "living room format", comparable to the distribution of printed magazines, so that individuals can also buy or rent them; this is already the case with the German *Videocongress*. There is a lot to be said for such distribution because it has been shown that video magazines are especially liked by an audience that has not had much exposure to video art. This audience likes to make their own choice from a pre-selected offer and wants to watch a number of productions again. A problem still to be solved concerns the copyright for artists because their work can be copied quite easily by private individuals. The solution is sought by . . . institutions aimed at distribution among individuals. (MonteVideo 1986a: no page; MonteVideo 1986b: no page)[9]

Here it becomes most apparent that MonteVideo, similar to TBA, focuses their activities on renting U-matic tapes to institutions, while Kijkhuis rents but does not sell VHS tapes primarily to individuals.

From Audio Cassettes to Music Videos to Video Art with 235

The distribution catalogs that the Cologne distributor 235 published throughout the 1980s tell a different story. 235 was founded in 1979 by Axel Wirths and Ulrich Leistner as a tape label and distribution with a focus on underground and independent music, specifically punk, post-punk, new wave, and industrial, before venturing into the distribution of music videos and artists' videos over the course of the 1980s. While their mail order publications from the early 1980s are usually referred to as catalogs (235 1983b: 2), the format is more reminiscent of DIY zines with typewritten text, cut-and-paste images, and photocopied drawings. The earliest edition that is institutionally archived was published in early 1983 and introduces the medium of video as follows:

> Here now a completely different medium, which is or *can* currently be used only by few, especially in independent music. Clearly, hardly anyone has their own video

[8] Own translation.
[9] Own translation.

equipment, and the prices are also quite steep. But there are ways to work more and more cheaply here. And maybe you know someone who has a V. recorder, and you can borrow the videos. (235 1983a: no page)[10]

The distributors thus introduced the medium of video alongside a rental service that had not existed as part of their music distribution program. This seemed an essential service to safeguard the spirit of accessibility and democratization in independent music, even though the 235 audience rarely made use of it (Wirths 2021). In the 1980s, the music videos that were available through 235 were obtained almost exclusively through sales and, accordingly, the catalogs list specific sales prices for each and every tape.

235's first publication dedicated exclusively to video and boasting the title of a "catalog" dates from 1984 (235 1984).[11] While the videos listed in the 1983 zine catalog were mostly documentations of live concerts and music documentaries,[12] the 1984 catalog program is considerably more highbrow with video adaptations of theater and dance productions by Heiner Müller, Heiner Goebbels, and Meredith Monk as well as a video piece by Nam June Paik and Shigeko Kubota, each for around DM 200. Alongside these, 235 offered limited editions of a John Cage concert and a Christo wrapping, which came numbered and signed in special boxes together with photographs, audio cassettes, and scores and/or prints for the price of DM 2,500. At the back of the catalog, a few pages are dedicated exclusively to the category of "music videos" with shorter information listing, among others, Abwärts, Berlin Atonal, Die Tödliche Doris, and Throbbing Gristle, all on the verge of contemporary art and musical countercultures like punk and industrial. While the rental prices are the same for all videos, the sales prices for the music videos are significantly lower with roughly DM 60–80 in comparison to the art videos, which mostly cost around DM 200.

In the following years, videos became essential to every 235 mail order publication. While "music videos" remains a distinct category in every such publication, other video categories appear and disappear. These categories include "edition 235" alongside other editions such as edition markgraph and edition salon concept as well as "235 distribution series," "literature video," "film classics," and "art, architecture, literature" (235 1988: 21, 26).[13] In 1989 a new video category entitled "ambient videos" was introduced. The preface announces that "For those who always have the TV on anyway, ambient videos are just the thing. The TV with its already grueling program structure is given a completely new function as a moving background image, room environment, sculpture or relaxation aid. By the way, the artistic version of the ambient

[10] Own translation.
[11] There are several references to a dedicated music video catalog by 235 from 1983, but this catalog seems to be missing.
[12] For example, Malaria *Live in GB* for DM 90, DAF *Documentary* for DM 90, or Abwärts *Original Demo Video* for DM 60 (235 1983).
[13] Some videos also appear in several categories, for example *Decoder* from 1984. In the 1988 catalog, it is listed under "Edition 235" as well as under "music videos" (235 1988: 21, 26).

videos is by Brian Eno (see videos)" (235 1989: 3).[14] The videos by Brian Eno were available for purchase for DM 89 together with the aforementioned limited and signed edition of Bruce Nauman's *Violent Incident* for DM 480. From this moment onward, 235 started venturing into the field of contemporary art and exploring the sculptural and performative dimensions of video. For most of the 1980s, however, the boundaries between video art, video documentation, and music video remained blurred.

Through their long-standing involvement in music distribution, 235 had considerable expertise when it came to copyrights and licensing agreements. They were keenly aware that they could issue and re-issue tapes for licensed screenings rather than sell objects and use this model to edition audio tapes as well as music videos and artists' videos. Their first video catalog made it very clear that "the purchase does not include any rights to perform, copy, lend or the like!!" (235 1984: 71).[15] Wirths emphasized that throughout the 1980s, music videos were primarily sold and rarely rented to private customers on VHS. By owning the tapes, buyers could bring concerts home into their living room and be able to relive them anytime they liked. "There's always this moment: I was there and I want to capture that visually. There's an identity aspect in it: I was a part of it, I belonged" (Wirths 2021; Knight and Thomas 2011: 121).[16] The 235 program thus provided a legal alternative to the common practice of illegal concert documentation at the time (Wirths 2021).

The catalogs suggest that VHS was 235's standard distribution format throughout the 1980s, especially for sales (235 1983a).[17] Betamax tapes are only referred to at the end of some of the catalogs as a possible alternative that customers may inquire about. As the distribution of artists' video as "video art" gains momentum toward the end of the 1980s, the rental model is used more often. While VHS tapes remain the go-to format for private screenings, U-matic is offered as an alternative for public screenings. U-matic tapes are also specifically listed as alternatives for the purchase of specific videos and limited editions in particular (235 1984: 71). As of 1987, 235 referred not just to its music video catalog but to its "video art catalog"—a binder similar to those from MonteVideo, TBA, and Kijkhuis—that could be ordered for DM 40 and that came with annual supplements (235 1987c).

There Is a War Going On in the Living Room

The VHS tape thus seems to have played an important part in those early distribution practices, but it would not have been possible without the VCR. After all, it was the increasing affordability of VCRs that allowed more and more households to play videotapes at home. Throughout the 1970s, most artists worked either with open-reel

[14] Own translation.
[15] Own translation. This is something that did not seem to be required to mention in the cassette catalogs, nor is it mentioned again in the catalogs thereafter.
[16] Own translation.
[17] "Alle Videos auf VHS" ("All videos on VHS") (235 1983a).

tape or with U-matic cassettes. For distributors this meant that screenings could only be organized in public institutions, where playback machines were available. In order to facilitate independent screenings, most distributors, including Kijkhuis and 235, also rented out U-matic playback equipment together with their tapes.

By the late 1970s, three alternative cassette-enclosed tape formats had become available besides U-matic, and all three specifically targeted amateur instead of professional users: Sony's Betamax, JVC's VHS, and Philips and Grundig's Video 2000. All of these formats provided half-inch tape in a convenient cassette packaging at affordable prices; they quickly took over considerable market share despite their significantly lower quality compared to U-matic. By 1980, VHS had gained market dominance, thereby winning the so-called format war. Historians of technology and business have based this victory on the product's complementarity with related devices—mostly because JVC refrained from charging licensing fees for producers of VCRs—as well as on the product's recording capacity of two hours, which allowed consumers to tape entire movies and soccer games (Zielinski 1986: 238–50; Cusumano 1992: 65).

With the format war having already been decided, the 1980s can be seen as a period of continual consolidation of the VHS format and an extension of the functions of the related devices. Alongside these technical advancements, the prices continually fell so that the VCR became increasingly accessible to predominantly academic middle-income earners and by 1989, 45 percent of West German households owned a VCR (Stockmann 2005: 125–6; Zielinski 1986: 233–50 and Haupts 2014). This meant that a home video retail market developed for the first time. This was a market of movies that were normally shown on television or in movie theaters as much as it was a market of that which was not included in everyday TV broadcasts or movie theater programs: horror, violence, and pornography. The producers were hopeful and produced cassettes in high numbers, but the sales market did not develop as quickly as they had hoped due to the continuing high prices for the individual cassettes. This paradox of overproduction and continuing high costs led to the development of a lively rental market. By 1982, video cassettes were available for rent everywhere in West Germany: in video rental shops, book clubs, corner shops, supermarkets, and gas stations (Haupts 2014: 62–3; Loest 1984: 61–2; Zielinski 1986: 253–4). This is the background against which 235 was carving out its niche mail order market for music and art videos.[18]

For the distribution endeavors of 235, the VHS tape had several advantages. It allowed them to quickly and affordably reproduce videos with little quality loss, which facilitated a culture of circulation and exchange. And it allowed them to target viewers in their home for the very first time. These home viewers were considerably

[18] A 1984 study of video cassette sales in West Germany shows that music presented 1 percent of overall video sales, whereas video art presented less than 1 percent. However, the program shares were higher with 4 percent for music and 2.8 percent for video art (Stockmann 2005: 126–7; Loest 1984: 32). Due to the low cultural reputation of video, West German libraries only developed an interest in the medium much later (Haupts 2014: 74–5).

different from the audiences that moving image distributors knew before, but they were quite similar to the music audiences that 235 already knew. These viewers were in full control of what they watched, when they watched it, and how they watched it. They could pause the video as they pleased, they could fast-forward it if they got bored, and they could rewind it if they wanted to watch something again. If they were so inclined, they could even edit the video or tape over it (Berko 1985: 293). This ties in well with the independent music scene that cherishes intimacy, connoisseurship, earwitness accounts, and insider knowledge. But owning a VHS tape did not just mean that the owner could develop a personal relationship with the audiovisual materials on the tape, she also inscribed her personal experience onto the tape in the process. Every viewing, pausing, and rewinding leaves traces on the tape, which means that "each copy accrues its own unique existence through its individual history of recording, duplication, circulation, and use" (Chabot 2020: 6; Berko 1985: 293). This implies that owning a VHS copy means lastingly shaping it with unique traces of handling and playback. The VHS cassette thus presents a collector's item that is quite similar to the audio cassette.

Video distribution research of alternative and niche markets has definitely taken notice of the introduction of the VHS tape. In particular when it comes to the niche markets on the boundaries of music videos and video art, researchers are well aware of the sales practices of uneditioned VHS tapes, but they have devoted little attention to these practices because they have been economically unsuccessful (see, for example, Balsom 2017: 162; Knight and Thomas 2011: 121–3; Buschmann and Nitsche 2020: 132–3). Just because the practice of selling uneditioned tapes of music videos and artists' videos has proven unprofitable by the 1990s, however, this does not mean that the attempts that were made all over Europe in the 1980s do not deserve investigation. I believe that the study of this particular niche of VHS distribution is essential in order to assemble a history of technology that connects with the cultural aims and social conventions of the time while avoiding the pitfalls of a determinist history of winners. Instead of assessing whether the rental or sales structures for music videos and artists' videos on VHS were successful, I am investigating what ideas and conceptions guided the distributors, how they shaped their distribution strategy, and how they might still be influencing our archival practices today.

Home Videos for Rent or for Sale

I am thus approaching the distribution history of music videos and video art on VHS tapes as a history of failed innovation. This can be understood in the wider context of Science and Technology Studies research on the history of failed technology trajectories and uncertain innovation journeys (Braun 1992; Bauer 2014; Turnheim 2020). Scholars of the social construction of technology remind us that impartiality with regard to successful and unsuccessful developments is required in order to achieve a symmetrical historiography. They warn historians of the ever-looming bias toward accounts of success, and implore them to remain sensitive to setbacks, surprises,

disappointments, deviations, twists, and turns. In this spirit, I am considering the sale of uneditioned music videos and artists' videos on VHS alongside the somewhat more successful practices of selling limited editions or renting video art on U-matic.

Even though it may not have been successful, in the 1980s there definitely was a sales practice with VHS tapes containing both music videos and artists' videos. This has been previously acknowledged by distribution research, but it has not yet been contextualized. So far the explanatory frameworks for distribution practices with video art have been the moving image industry (Knight and Thomas 2011) and its relationships to the contemporary art world (Balsom 2017) as well as publishing (Buschmann and Nitsche 2020). I have taken the music industry into view and by now I hope to have shown the intricate connections between 235's distribution strategies for music cassettes and music videos as well as video art.

Alternative moving image distribution scholars Julia Knight and Peter Thomas also take notice of "a handful of mail order initiatives [in the UK] which suggested that some areas of 'alternative' moving image work might be able to develop modest domestic audiences by catering to particular niche markets.. . . These mail order initiatives started out as small-scale experiments that sought to *sell* the work direct to the home viewer" (Knight and Thomas 2011: 110–11), but they portray them mostly as unsuccessful unrelated instances, with examples like George Barber periodically selling Scratch Videos on VHS all across the world. The practice of 235—which also sold Scratch Videos by George Barber and Gorilla Tapes (235 1987: 23–4)—seems very similar to these initiatives, so further research might have to determine how isolated these instances really were.

It has to be noted that Knight and Thomas's research is about larger-scale distributors and their strategies for reaching audiences. As part of this research, they have described the aims of the video art distributor London Video Arts

> to capitalize on the growing public interest in music video . . . [and try] to find an effective way of distributing the short visual music pieces that a number of video artists were making in the early 1980s. These were typically only two or three minutes in length and thus both difficult to promote individually and expensive for a user to hire. However, as a compilation was only distributed on u-matic, at the time this necessarily limited the scope of the possible market. (Knight and Thomas 2011: 108)[19]

The case of 235 raises the question whether this limitation was really by necessity or whether distribution on VHS had perhaps already presented a possible alternative.

When home distribution of artists' videos first became possible in the early 1980s, distributors had to devise a strategy and carefully decide whether to sell the videos as limited editions, sell them as unlimited editions, or rent them out. The rental model had a long history in the moving image sector at large, so it seemed like the most natural

[19] This compilation on U-matic is the one that is discussed above as part of MonteVideo's distribution program.

approach to many distributors and it has clearly also influenced the historiography and theorization of video art distribution. In practical and academic accounts alike, video is often characterized as a medium that does not fit the conventions of the art market, because the fleeting images that appear on the screen cannot or should not be owned. This argument appears to silently imply that videos that are being sold automatically enter the for-profit art market as limited editions. As the example of 235 shows, the 1980s already knew of a sales practice for artists' videos on VHS that did not reinforce the idea of the unique art object in its auratic materiality but instead forged an alternative community that allowed anybody who had the considerable, but not extraordinary, financial means to own a small share in the sounds and visuals of the independent art scene. Whoever purchased an uneditioned video from 235 possessed it to be able to view it anytime in the comfort of their living room, where they could show it to friends and feel part of a movement.

Home Video Distribution Collection Preservation

By investigating the ways in which alternative moving image distributors made use of the VHS tape in the 1980s, a hitherto understudied history of economically unsuccessful home distribution of music videos and video art has been unearthed. The mail order catalogs from 235 Cologne, MonteVideo, and Time Based Arts Amsterdam as well as Kijkhuis The Hague have therefore been examined as product and service directories and as communication tools with consumers, audiences, and the interested public at large. The VHS tape has clearly paved distributors' ways into living rooms through sales and occasionally also as rentals. The compatibility and increasing affordability of the VHS tape allowed wealthy households to purchase music videos as well as artists' videos. In order to make their programs accessible to users who could not afford to buy tapes, distributors offered VHS rentals, but this service was rarely used. Distributors could thus target a domestic buyers' market for the very first time and they did so through the publishing of mail order catalogs with regular updates and, in the case of 235, many related products such as audio cassettes, literature, and zines. The owners in turn had the chance to permanently access legendary music concerts as well as artworks as they pleased and to thereby feel connected to a specific community as well as continue to build that community during intimate home screenings. The VHS tape thereby became one of several alternative media for aesthetic contemplation, democratic information, and networked communication.

Looking back at this history raises questions about the situation of tapes and distribution structures today. Kevin Chabot has reflected on video collecting in the digital era, assessing that the

> videotape's inscription of its own history of circulation and playback, the degeneration and decay of sound and image that signify its value, is materially preserved on the shelf of the VHS collector. More than just the film's content, then,

a video collector is intent on the preservation of a cultural moment in which the reproduction and circulation of tape reigned supreme. (Chabot 2020: 17)

This suggests that the distribution background of a video should be understood as an integral part of its history today. By now most 1980s distribution initiatives have been merged into publicly funded organizations such as LIMA Amsterdam or IMAI (Inter Media Art Institute) Düsseldorf, where the VHS archives tend to remain understudied. While the VHS tapes are dutifully preserved, they are rarely consulted next to the higher-quality U-matic tapes and the conveniently accessible digital collections. This is a shame as further research into the loan and purchasing history of the tapes and an examination of the viewing histories of archival copies of the tapes would certainly have a lot to reveal with regard to the questions of this chapter. IMAI and LIMA are unique sites, where artists' videos can be studied in their material constitution as well as in their social context through distribution histories. This is a call to exploit this potential more extensively in the future while continually questioning the relationships of technology adoption, artistic practices, and alternative distribution—both then and now.[20]

References

"Als TV-kijker is het even wennen bij videokunst" (1984), *De Waarheid*, November 21, Consulted at Archive of LIMA Amsterdam.
Antin, David ([1975] 1986), "Video: The Distinctive Features of the Medium," in John G. Hanhardt (ed.), *Video Culture: A Critical Investigation*, New York: Visual Studies Workshop.
Balsom, Erika (2017), *After Uniqueness: A History of Film and Video Art in Circulation*, New York: Columbia University Press.
Bauer, Reinhold (2014), "Failed Innovations—Five Decades of Failure?" *Icon*, 20 (1): 33–40.
Berko, Lili (1985), "Video: In Search of a Discourse," *Quarterly Review of Film Studies*, 10 (4): 289–307.
Boomgaard, Jeroen and Bart Rutten (eds.) (2003), *The Magnetic Era: Video Art in The Netherlands 1970–1985*, Rotterdam: NAi Publishers.
Braun, Hans-Joachim (1992), "Symposium on Failed Innovations," *Social Studies of Science*, 22: 213–30.
Brunow, Dagmar (2011), "Before YouTube and Indymedia: Cultural Memory and the Archive of Video Collectives in West Germany in the 1970s and 1980s," *Studies in European Cinema*, 8 (3): 171–81.
Buschmann, Renate and Jessica Nitsche (2020), *Video Visionen: Die Medienkunstagentur 235 Media als Alternative im Kunstmarkt*, Bielefeld: transcript.

[20] This chapter builds on the research project *Die Medienkunstagentur 235 Media in den 1980er und 1990er Jahren*, conducted by Renate Buschmann and Jessica Nitsche at the Düsseldorf Inter Media Art Institute (IMAI) and funded by the Gerda-Henkel-Stiftung from 2015 until 2018. Gaby Wijers, Achiel Buyse and Tzu-Chuan Lin have kindly made the distribution catalogs of MonteVideo, Time Based Arts, and Kijkhuis available to me at LIMA Amsterdam.

Chabot, Kevin (2020), "Tape: Videographic Ruin and the Lure of the Tangible," *Quarterly Review of Film and Video*.
Cusumano, Michael A., Yiorgos Mylonadis, and Richard S. Rosenbloom (1992), "Strategic Maneuvering and Mass-Market Dynamics: The Triumph of VHS Over Beta," *Business History Review*, 66: 51–94.
Drew, Jesse (2007), "The Collective Camcorder in Art and Activism," in Blake Stimson and Gregory Sholette (eds.), *Collectivism after Modernism*, 95–114, Minneapolis: University of Minnesota Press.
Fauconnier, Sandra (2010), "Video Art Distribution in the Era of Online Video," *Nederlands Instituut Voor Mediakunst*, October 12. Available online: https://nimk.nl/nl/video-art-distribution-in-the-era-of-online-video (accessed October 24, 2021).
Flyer Galerie Rene Coelho [sic] (n.d.). Consulted at Archive of LIMA Amsterdam.
Haupts, Tobias (2014), *Die Videothek: Zur Geschichte und medialen Praxis einer kulturellen Institution*, Bielefeld: transcript.
Jongeneel, Laura (1981), "De Kunst van Videokunst," *Videototaal*, May: 45.
Kijkhuis (1983), *Kijkhuis Videotheekcatalogus 1981: Supplement 82/83*. Consulted at IMAI Archive, Stiftung IMAI—Inter Media Art Institute, Dusseldorf and Archive of LIMA Amsterdam.
Kijkhuis (1985), *Kijkhuis Videotheekcatalogus 1984|85*. Consulted at Archive of LIMA Amsterdam.
Kijkhuis (1988), *Video Catalogus*. Consulted at IMAI Archive, Stiftung IMAI—Inter Media Art Institute, Düsseldorf and Archive of LIMA Amsterdam.
Knight, Julia and Peter Thomas (2011), *Reaching Audiences: Distribution and Promotion of Alternative Moving Image*, Bristol: Intellect.
"Kunstvideos volgens principes van de politieke fotomontage" (1994), *NRC Handelsblad*, January 5. Available online: https://www.nrc.nl/nieuws/1994/01/05/kunstvideo-volgens-principes-van-de-politieke-fotomontage-kb_000030793-a3704484?fbclid=IwAR0teQ8l-uKRMtayE_JJMpU5mnxv852TnRwKmShdvM1bmYAs4XJ-EXar1ZU (accessed November 14, 2021).
Libbenga, Jan (1982), "Coelho: Video-kunst op apart tv-kanaal," *NRC*, July 19, Consulted at Archive of LIMA Amsterdam.
Loest, Klaus-G. (1984), *Die Videokassette—ein neues Medium etabliert sich. Videotheken aus bibliothekarischer Perspektive*, Wiesbaden: Harrassowitz.
MonteVideo (1982), *Persbericht november '82*. Consulted at Archive of LIMA Amsterdam.
MonteVideo ([1982] 1984), *MonteVideo* [catalog in the form of a U-matic tape, texts by Tineke Reijnders]. Consulted at Archive of LIMA Amsterdam.
MonteVideo (1985), *NIEUWS! Oktober 1985 Redactioneel Blaadje, MonteVideo, jaargang 1, nummer 1*. Consulted at Archive of LIMA Amsterdam.
MonteVideo (1986a). *NIEUWS! Januari 1986 Redactioneel Blaadje, MonteVideo, jaargang 2, nummer 2*. Consulted at Archive of LIMA Amsterdam.
MonteVideo (1986b). *NIEUWS! April 1986 Redactioneel Blaadja, MonteVideo, jaargang 2, nummer 4*. Consulted at Archive of LIMA Amsterdam.
Stockmann, Ralf (2005), "Der Videoboom der achtziger Jahre," in Werner Faulstich (ed.), *Die Kultur der 80er Jahre*, 123–36, Munich: Fink.
Sturken, Marita (1990), "Paradox in the Evolution of an Art Form: Great Expectations and the Making of a History," in Dough Hall and Sally Jo Fifer (eds.), *Illuminating Video: An Essential Guide to Video Art*, New York: Aperture/BVAC.

Time Based Arts (1984), *Time Based Arts* [catalog in the form of loose index cards]. Consulted at IMAI Archive, Stiftung IMAI—Inter Media Art Institute, Düsseldorf and Archive of LIMA Amsterdam.
Time Based Arts (1985), *Video Tape Catalog*. Consulted at IMAI Archive, Stiftung IMAI—Inter Media Art Institute, Düsseldorf and Archive of LIMA Amsterdam.
Time Based Arts (1987), *Video Tape Catalog 1986–1987*. Consulted at Archive of LIMA Amsterdam.
Turnheim, Bruno and Benjamin K. Sovacool (2020), "Exploring the Role of Failure in Socio-Technical Transitions Research," *Environmental Innovations and Societal Transitions*, 37: 267–89.
Van Hal, Marieke (n.d.), "About Art, Media, and Media Art: An Interview with René Coelho," *MonteVideo*. Available online: http://www.MonteVideo.nl/second/interview.html (accessed October 24, 2021).
"Video als kunst in MonteVideo" (1984), *Amsterdams Stadsblad*, February 1, Consulted at Archive of LIMA Amsterdam.
"Voor videokunst moet je een andere bril" (1984), Consulted at Archive of LIMA Amsterdam.
Wijers, Gaby (2019), "Taking Care of Media Art in the Netherlands: A Brief History," in Sanneke Huisman and Marga van Mechelen (eds.), *A Critical History of Media Art in the Netherlands: Platforms, Policies, Technologies*, Prinsenbeek: Jap Sam.
Wirths, Axel (2021), *Interview with Linnea Semmerling*, October 15, 2021 by phone.
Zielinski, Siegfried (1986), *Zur Geschichte des Videorecorders*, Berlin: Wissenschaftsverlag Volker Spiess.
235 (1/1983), 235 [Tapes, fanzines, comics, books, postcards, videos], January 1983. Consulted at IMAI Archive, Stiftung IMAI—Inter Media Art Institute, Düsseldorf.
235 (5/1983), 235 [Tapes, literature, cassettes, newspapers, LPs, music magazines, DinA3-magazines, books], May 1983. Consulted at IMAI Archive, Stiftung IMAI—Inter Media Art Institute, Düsseldorf.
235 (12/1983), 235 [Tapes, literature, records, printed matter (fanzines, music magazines, magazines, agendas), videos], December 1983. Consulted at IMAI Archive, Stiftung IMAI—Inter Media Art Institute, Düsseldorf.
235 (1984/1985), *Video Katalog* [Videos, video congress, music videos]. Consulted at IMAI Archive, Stiftung IMAI—Inter Media Art Institute, Düsseldorf.
235 (1987a), *Katalog* [Tapes, records, musik videos, video literature, books, magazines and fanzines]. Consulted at IMAI Archive, Stiftung IMAI—Inter Media Art Institute, Düsseldorf.
235 (1987b), *Video Audio Literatur Programm Herbst 1987* [Edition, distribution series, literature video, audio, magazine, literature]. Consulted at IMAI Archive, Stiftung IMAI—Inter Media Art Institute, Düsseldorf.
235 (1987c), *Gesamtkatalog*. Consulted at IMAI Archive, Stiftung IMAI—Inter Media Art Institute, Düsseldorf.
235 (1988), *Katalog* [Tapes, edition 235, 235 distribution series, "Dumont creativ," music videos, film classics, video literature, records, books, magazines and fanzines]. Consulted at IMAI Archive, Stiftung IMAI—Inter Media Art Institute, Düsseldorf.
235 (1989), *Programm 1989* [Records, videos (edition 235, art, architecture, literature, musik videos, film classics), books, magazines, software]. Consulted at IMAI Archive, Stiftung IMAI—Inter Media Art Institute, Düsseldorf.

6

An Aura with Pencil, Brushes, and Pixels

Wulf Herzogenrath

Wulf Herzogenrath is one of the most important pioneers of video art in Germany. He was in his mid-twenties when he came into contact with the newly emerging art form in the early 1970s, and has since made a decisive contribution to establishing video art as a new artistic medium in Germany. His legendary guest books are witness to his curatorial work—artists such as Nam June Paik, John Cage, Rebecca Horn, and Sigmar Polke, with whom Herzogenrath worked, have made their mark in the books. In conversation with the editors, the curator talks about snobbish attitudes and auratic works of art.

In your opinion, do music videos have a place in museums?
Music videos—just like outstanding documentary films—belong in the collections of art museums. Among the best are *O Superman* by Laurie Anderson, many by David Byrne, Dieter Meier, and Pipilotti Rist. They are independent, formally lively, and coherently composed works on the pictorial level. And if you apply these parameters, then *Global Groove* by Nam June Paik, one of the most famous works of video art and one that is in almost every collection, is actually also a music video. If you look back into the art history of animated film as a precursor, the history of the music video begins with Oskar Fischinger and his object-free, geometric animations to mostly classical music: in his works, form and sound as well as the visual and the acoustic go together and form an increasing unity. Even though this is of course not electromagnetic image production—the films are each created from hand-drawn animations—the basic idea is comparable: a completely new rhythmic unity of moving image and sound is created at that time.

You referred to *Global Groove* by Nam June Paik, who is considered to be one of the founders of video art. In your opinion, what is the difference between video art and music video? Do the two media have the same artistic value or is there a differentiation?
Works of art are not just illustrations of ideas, they shape the consciousness of the viewer. Whether with or without music: sound is always a weighty component, on a par with the visual. But if it is only an illustration of music, then it does

not belong in art museums or collections. A music video is only a music video if the artistic part is atrophied, barely visible. This also happens with great artists: Beuys, for example, deliberately avoided any artistic appearance with his music video *Sonne statt Reagan* in the rather naive performance and wanted to deliver a pure music video.

The music video seems to be caught in a process of legitimization, in which it has to assert itself as an independent art form that does not just add commercial visuals to music. From your perspective as a curator: why is the music video still not accepted by the art world and why is it so hard for curators to emancipate it from its commercial context?
One of the "problems" is the old battle between "high" and "low": when avantgardists have a lot of success, they often turn away from this attribution because they don't want to belong to the masses or don't want to serve mass tastes. Laurie Anderson and Robert Wilson, for example, were considered avant-garde in the 1970s when they performed in front of small audiences of fifty to one hundred people. These were people that considered themselves avant-garde. When these two artists then sang or played in front of large audiences of thousands, these people turned away and declared their performances to be mere repetitions, "popular," "easy to get" and thus "unartistic"—in my eyes a wrong, snobbish attitude!

From your point of view, why has it not been possible to establish video works and music videos in non-market-oriented art structures?
Until recently, my colleagues' shyness about sound and moving image prevented moving images from entering museums. There is actually a large interest in moving images in the general audiences of museums—larger than many of my colleagues think.

Nowadays—and especially in these pandemic times—exhibitions are increasingly accessible digitally. Does it make a difference for you to look at a work of art in the Louvre or on the computer? And how about in relation to video art: is there a difference for you in viewing video art in the museum space or on the screen at home?
There is a huge difference! The originals on the wall have an aura that is indivisible from the specific presentation: starting with the room, light, frame, and surroundings and ending with the painstaking journey the visitors have to take through the museum to see the individual but related artworks. Contrast this with the 539,999 digital works that the Louvre has put online—they all seem equally large, equally luminous, somehow similar to one another. For conveying the work, however, a digital reproduction rich in detail is very suitable. But this never replaces the experience of the original *in situ*: there is no substitute for the experience of the self in front of the original. That's why I curated *NOTHINGTOSEENESS Weiß Stille Nichts* with Anke Hervol. There you had to get close to the originals, which could have seemed empty and similar from far away. And yet not only were all the media there, but seemingly similar things were

fundamentally different upon closer inspection. In most of these pictures, only a white/gray surface can be seen in reproductions; in front of the original the surface becomes alive. It's possible to grasp that every surface was treated differently in each case, even designed materially differently: figurative depictions appear in shadowy form, shadows and lights, the environment of the exhibition room is reflected in color, spatially—all this can only be recognized directly by the individual viewer in the exhibition in front of the original. The voyage of discovery only starts with a close look—nothing happens quickly, very little digitally.

Can video, or rather *how* can video develop an aura at all, considering that we are dealing with a work of art that can be reproduced at will?
Every medium, whether "multiple" or unique, whether reproduced hundreds of thousands of times, known or seen for the first time, has its own aura.

What atmosphere does video art need for reception in this case?
Like any work of art . . . the ghetto situation of isolating artworks by their specific media is always only a makeshift. It is always more interesting to proceed in terms of content. The media are secondary because the artistic statement in terms of content can be made with pencil, brush, or pixels.

Video art is also appearing more and more frequently in concert halls and theaters—not in the form of music video, but for example as video art with live music. How do you assess this development?
It has become a matter of course, both in concerts for tens of thousands of fans in the context of pop music, as well as in plays, opera, and theatre. Since Wolf Vostell and Hansgünther Heyme's magnificent *Hamlet* in Cologne in 1979, there have been effective content-related uses of video on stage. And during the last two years, by necessity, a new kind of symbiosis between television and theater has developed with streaming, combining the screen of the TV set and the depth of the stage space in a new way.

How does the archival practice of historical video art and historical music videos influence curatorial practice? How does one deal with the "gaps" of the archive?
There are valid selection programs of archive-like collections. The first was the *Videothek* with over fifty early video tapes, compiled by an international jury of colleagues that I assembled for *Documenta 6* in 1977. Most recently, there was a résumé for the German scene entitled *40 Jahre videokunst.de* (*40 years of videokunst.de*), for which five German museums joined forces in 2005 on my initiative. For an interested public, these juried selection presentations already constructed a valid canon of artworks. The selection reflects a broad spectrum and that is why I chose colleagues with different educational backgrounds, ages, and geographical networks to serve on the jury. Music videos are included as a matter of course, even if sometimes only hinted at.

Would you be interested in curating a music video exhibition yourself?
I always preferred exhibition concepts that were about content in the first place and not about the media. Because there is always the danger of ghettoization: media one-sidedness distracts from the artistically designed content that is actually at stake. But of course there is always the desire for the medium as a theme—whether painting, drawing, or even video, film, or photography. See our *Media Documenta 6, 1977*: at that time, we consciously looked at the respective possibilities of the individual media and so photography (after almost 150 years of interesting existence) and video (only twelve years old) were included for the first time in what was already the most important art exhibition at that time.

III

Hybrid Imagines

Media Aesthetics between Pop and Identity

7

You Need to Calm Down—Stardom and Cancel Culture

The Music Video as an Audiovisual Protest Poster

Elfi Vomberg

Welcome to Taylor Swift's trailer park, where the grass is greener, the sky bluer, the candy floss fluffier and everything is in harmony. In her music video *You Need to Calm Down* (2019) she envisions an ideal world—and shows it through a kitsch filter: the colors are saturated and amplified so that the idyllic scenery glows in all the shades of the rainbow. With the help of pink plastic flamingos, dazzling cameos, and sticky cakes, Swift attempts to lull and quiet the critics that have become her constant companions and deride her every move in the music video. The song makes the case for an equality-minded attitude, criticizing both online haters and homophobes, and ends with a call to support Taylor Swift's petition to the Senate in favor of the Equality Act, which is linked to Pride Month celebrations in the United States in June 2019.

Pop star Taylor Swift's sugar-coated offensive in *You Need to Calm Down* can be seen as a direct reaction to her own experiences with calls for boycott and protest through digital cancel culture. She faced a major cancel attack in 2016: under the hashtags #TaylorSwiftIsOverParty, #TaylorSwiftIsASnake, and #TaylorSwiftIscanceled, Twitter users called for a boycott of Taylor Swift and staged a swansong of the singer's career in thousands of memes, videos, and tweets.[1] Since then, Swift has been in a constant "cancel storm," so that the hashtag #taylorswiftisoverparty keeps evoking new calls for boycotts on the net.

On the distribution level, there were ultimately never any negative economic effects for the singer; that is, there were no slumps in sales figures or any successfully boycotted concerts. Nevertheless, the calls against her person seem to have left their mark on the artist's work, so that in 2019, she was taking a productive stand against

[1] The backdrop to the online attacks was provided by videos posted by Kim Kardashian on Snapchat in which Kanye West and Taylor Swift discussed his song *Famous*. In the video, Swift agrees with the lyrics "To all my southside n***s that know me best, I feel like me and Taylor might still have sex." From these videos and the debate, a rivalry develops between fans of Kim Kardashian and Taylor Swift.

the unproductive opinion-making on social media with the song *You Need to Calm Down*. This is the first time that Taylor Swift has taken a political stance and expressed it in her art.

And the music video, too, diffuses into the sphere of activist commitment through its appropriation in digital culture and transforms itself from a commercial billboard to a protest poster. The intermedial mutability of the music video toward other genres and formats has been inscribed in the DNA of this specific pop product from the very beginning. Not least because of its adaptability to its storage and playout channels, the music video can be regarded as a hybrid medium. Dieter Daniels also describes the chameleon-like character of video: "in a sense, video vagabonds through media-technical formats, through cultural and industrial contexts; on the internet it goes viral, it has no stable dispositive" (Daniels 2021: 25–6).[2] Digitalization has thus not only changed the formal prerequisites for the distribution channels, but also in aesthetic terms, digitalization processes influence the genre and equip it with altered modes of functioning.

Since the focus of this chapter is also to discuss the current discourse phenomenon of cancel culture in the context of the current music video, the theoretical focus will also be placed on the media of protest, so that in the following the view will be broadened to include the aesthetics and affectivity of video activism or activist web videos. For this development through digital technology is accompanied by a democratization thrust for the medium of video, which not only promotes broader participation in the production as a whole but also exerts its effect on the music video through a multidimensional commenting function on the platforms (liking, sharing, commenting) by the recipients.

This chapter will thus analyze the hybrid processes between current digital culture and the aesthetic modes of adaptation in the music video. Taylor Swift's *You Need to Calm Down* will be understood as an example that can be used to clearly and precisely illustrate these processes and will enable a discussion about the extent to which stars position their own art sociopolitically through current forms of protest in digital culture and their interrelation with questions of authenticity and reception.

To this end, the music video will first be reflected upon in its function as a protest poster; this is done in order to then draw conclusions about the star persona with an outlook to the current phenomenon of cancel culture, which seems to be confronted with new role attributions and areas of responsibility in the digitalized twenty-first century.

The Music Video as Audiovisual Protest Poster

After the final chord, Taylor Swift's music video *You Need to Calm Down* features a personal appeal from the star. In yellow lettering on a pink background it reads:

[2] Own translation.

"Let's show our pride by demanding that, on a national level, our laws truly treat all of our citizens equally. Please sign my petition for Senate support of the Equality Act on Change.org" (Swift 2019: 3:20). It's the conclusion after three minutes and twenty seconds of colorful wishful thinking about a queer neighborhood—complete with a wedding, a pop queen pageant, and a cake fight. It is, as it were, the answer to the 13-strong protest community that repeatedly tries to disrupt the idyll in the trailer park with placards like "HOMASEKUALTY IS SIN! [sic] " or "Adam + Eve NOT Adam + Steve" as well as chants. And it is altogether a further development of the music video as an audiovisual protest poster and billboard for a political petition, so that the work of art is here endowed with a function that goes beyond its previous aesthetic purpose.

But it is not only the star who transcends his artistic field of activity in the digital age. It is also the recipient of pop culture who transcends his previous traditional and rehearsed role attribution and whom Taylor Swift addresses here directly with the call "You Need to Calm Down" (Swift 2019: 0:50–0:53).

In an interview with Vogue, Taylor Swift talks about her own experience of being canceled in 2016, which she processes in the song: "a very isolating experience.. . . When you say someone is cancelled, it's not a TV show. It's a human being. You're sending massive amounts of messaging to this person to either shut up, disappear, or it could also be perceived as, kill yourself" (Aguirre 2019).

Originally, the term "cancel culture" was negotiated within the US queer community, with the notion of "canceling" first being spread via Black Twitter as a critical meme in the discourse of systematic inequality. Meanwhile, "canceling" is mostly directed at a prominent individual to be collectively excluded from the public sphere, which "should be read as a last-ditch appeal for justice" (Clark 2020: 89). The courtrooms are social platforms, while every user can act as a judge. On the digital noticeboards and with the commentary tools of the networks, the alleged violation of norms by the celebrity is discussed, morally evaluated, and finally the "verdict" is publicly announced: #youarecanceled is often the performative award in the United States which is subsequently accompanied by demands for dismissal, resignation, deletion, as well as deprivation by the network collective of time, money, and publicity, or media presence. Meredith D. Clark speaks of a "mob mentality" in this context (Clark 2020: 89).

Platforms such as Twitter and Facebook move in the charged field of digital, discursive communication, attention economy, and power dynamics and thus reveal an ambivalence between democratization of discourse and debates on censorship. The reasons for the strengthening of this digital protest culture can be read, on the one hand, in the course of a general change in media culture—accompanied by a lower-threshold participation via social media—(Baringhorst, Kneip, and Niesyto 2010: 397), and on the other hand in an overall heated political climate that strives for change from within society—just as the #Metoo and #BlackLivesMatter movements have paved the way for a new climate that proved enabling for protest.

In cancel culture, the protest potential of the disempowered goes hand in hand with a shift in the digital practice of responsibility: fractal publics come together in fluid spaces and discourses to form a digital counterpublic, but in doing so they offer neither

a solution-oriented approach to reform nor a constructive discussion—the focus is only on abstracting a person or institution. A circumstance that Taylor Swift also addresses in her first verse of *You Need to Calm Down*. She alludes to her own experience of being canceled and addresses the behavior of internet trolls ("You are somebody that I don't know / But you're taking shots at me like it's Patrón" [Swift 2019: 0:11–0:17]). On the visual level, Swift throws her mobile phone—as a medium for transmitting hate speech and cancel culture—onto the bed, which then sparks and finally starts a fire in the trailer. She thus manifests the image of trolls as arsonists who radically change the culture of debate on the net and set social fires. In her work *You Need to Calm Down*, Swift responds to the digital shitstorm with a candy storm: she contrasts the unkempt protesters and the anonymous protesting net community with a dazzling counter collective of celebrities from the queer community (including Katy Perry, Laverne Cox, RuPaul, Ryan Reynolds, numerous *Queer Eye* actors, and Ellen DeGeneres), which is staged as a colorful, happy, and peaceful neighborhood community.

Swift soothes, calms with a slow beat, and lays a kitsch filter over the entire scenery, which is superimposed on the supposed reality: the camper is decorated with pink floral wallpaper and frilly curtains. For breakfast, she mixes a broth of pink prosecco with a sticky puff of pink candy floss. But the audience also experiences ironic refractions again and again: the candy floss is put in a blender and the floral wallpaper catches fire (Figure 7.1).

The "ideal world" look is staged as a façade that is apparently easily ignited and goes up in flames from exploding hate comments. Last but not least, the trailer park is also just an artificial backdrop: with manicured artificial lawn front gardens and colorfully painted fences, the neighborhood in the video is far removed from the US reality of life in these precarious settlements. Only the protest community that positions itself against Swift's community is reminiscent of real protest groups that Swift usually experiences before her concerts (a reference to a real religious group that

Figure 7.1 A sticky mixture: candy floss + pink prosecco = kitsch offensive. *You Need to Calm Down* by Taylor Swift, 2019. Screenshot from YouTube.

Figure 7.2 Two worlds collide: queer community and protest group. *You Need to Calm Down* by Taylor Swift, 2019. Screenshot from YouTube.

regularly protested in front of Swift's concert venues). The protest group runs like a common thread through the video and repeatedly interrupts the kaleidoscopic series of individual scenes of an ideal world, so that the potential for protest through the digital debates embodied by the collective is always present (Figure 7.2).

The reality of the debates usually taking place in digital media has broken into the pink dreamworld and threatens the staged paradise. This shows that cancel culture no longer remains only on the dark side of social media, where it tries to silence musicians and move censorship debates as a constituent element into the focus of social negotiation processes. With this aesthetic confrontation in pop music, cancel culture is no longer a mere online phenomenon, but becomes a topic of debate and a cultural phenomenon. What we see in this video is a digital hybridization process: a social media phenomenon diffuses into the sphere of music and clip production and is reinterpreted from the unproductive disruptive factor cancel culture to a productive art product.

The process of hybridity can also be traced on the musical level in the song *You Need to Calm Down*: while the hashtags with which cancel calls are provided can be identified as performative speech acts (#TaylorSwiftIsOverParty and #Youarecanceled are passive constructions which, as disguised imperatives, all imply demands, set the boycott process in motion, and make it visible as such performatively), the beat, which both opens the song and runs through the entire piece as a foundation, is to be seen in its monothematism and retardation as a performative rhythmic act in response to the performative speech acts of the cancel hashtags. "A felicitous performative is one in which I not only perform the act, but some set of effects follows from the fact that I perform it," defines Judith Butler in *Excitable Speech: A Politics of the Performative* (Butler 1997: 17). The act of boycotting or canceling is thus already carried out with

the utterance of the hashtag in the social networks. The physical performance in public for a protest action is replaced here in the digital space by the hashtag, as the equivalent for the leaflet or the poster, and thus becomes the catalyst for the outraged protest mood. But because the cancel culture is fluid and hybrid in its structure and in the composition of its collectives, it is also opposed to an organized protest culture. Even through the acts of communication that are provided with shitstorms and hate speech, cancel culture cannot be observed as a discursive process of exchange, but rather as a collective outcry, as a simultaneous expression of affect by network actors who are independent of each other (Figures 7.3–7.5).

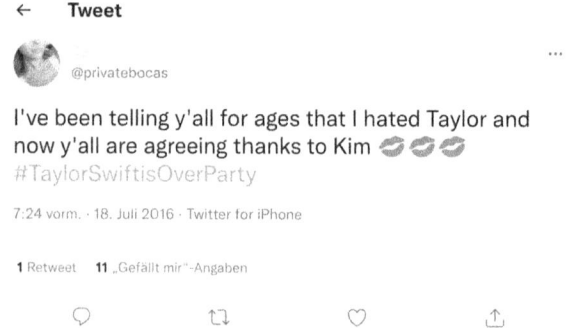

Figure 7.3 A Twitter user brings the word "hate" into play. Screenshot from Twitter.

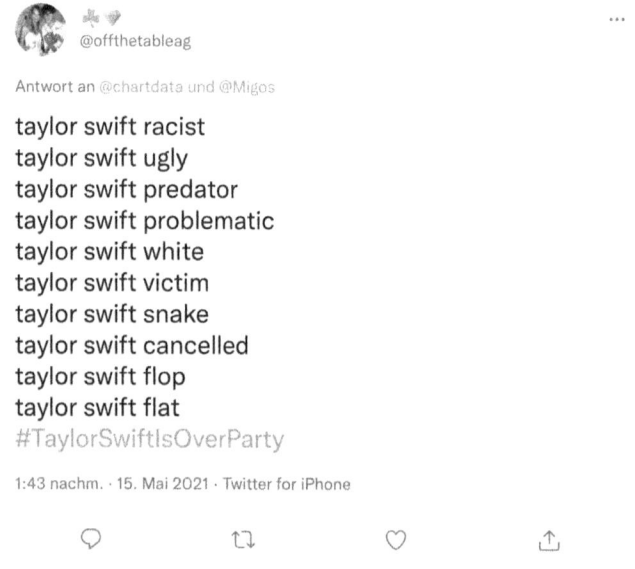

Figure 7.4 A row of accusations against Taylor Swift. Screenshot from Twitter.

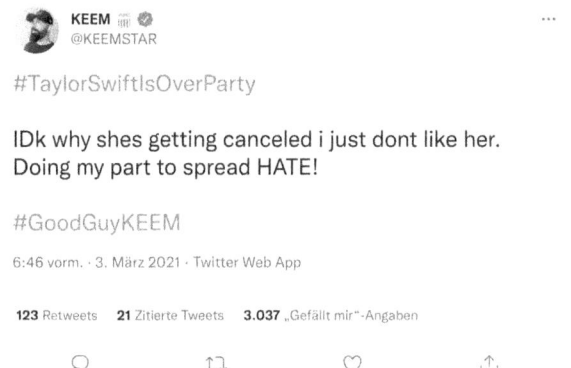

Figure 7.5 "Hate" is a term that is utilized again and again in concurrence with #TaylorSwiftIsOverParty. Screenshot from Twitter.

By giving a musically performative answer to the performative hashtags of her opponents in *You Need to Calm Down*, Taylor Swift also achieves an aesthetic hybridity moment between digital debate and musical work; but overall, the musical level seems to take a back seat to the visual level. Even more: in part, the visual level provides the key to the message even before the lyrics give the context. For example, when Swift switches to the collective "You are somebody that we don't know" (Swift 2019: 1:18–1:20) in the second verse, the video has long since shown which community is meant, while the lyrics only later specify "'Cause shade never made anybody less gay" (Swift 2019: 1:49–1:53). While Schmidbauer and Löhr in their definition of the music video still speak of the fact that "the visualisation [has] the task of propagating the music and enabling a 'seeing of sounds'" (Schmidbauer and Löhr 1996: 12),[3] in Taylor Swift's case the hierarchical levels between image and sound also seem to be shifted—but in favor of the visual level: the song, which has a rather banal structure with its narrow melody line and a repetitive character, seems to take precedence over the video and to leave the stage to the rich, highly referential world of images. The video also overtakes the musical possibilities where quotations and references are used to deepen the political message and anchor it in various discourses: Users have to decipher broad pop cultural references. Examples include cameos from the Netflix reality show *Queer Eye*, a quote from Cher in a picture frame ("Mom, I am a rich man."), a tea party alluding to "hot gossip" (=tea) and the appearance of *Pose* star Billy Porter. These references to pop cultural themes from the surroundings of the LGBTQIA+ community are another sign of hybrid processes of the video, which can thus be anchored in current discourses.

In this way, the sociopolitical message of the work is transported more via the visual level than via the musical or textual level with the help of symbols and metaphors. "Symbolising condenses," state Jens Eder, Britta Hartmann, and Chris Tedjasukmana

[3] Own translation.

in their book *Bewegungsbilder* (Eder, Hartmann, and Tedjasukmana 2020: 60).[4] Although they explicitly refer to the affective potential of political videos, Taylor Swift also appears here as an activist for the LGBTQIA+ community and tries to use her video as an empathy amplifier to promote her petition. Precisely because of the appealing character of her work, Swift's video also has activist potential: "ideally, activist videos fight 'epistemic injustice': they make the previously unheard heard and make oppressed people aware of their rights. At the same time, they give viewers the feeling that they should and can act—on the net, on the street or in the voting booth" (Eder, Hartmann, and Tedjasukmana 2020: 62–3).[5]

Social media has given rise to a new video activism that is changing the way it is received, initiating processes of negotiation in society, and driving protest movements: "The possibilities for action involved make them [author's note: web videos] important elements of interpersonal relationships. By watching, liking, sharing or commenting on videos, viewers become means of struggle for attention and recognition" (Eder, Hartmann, and Tedjasukmana 2020: 24–5).[6] The charging of the medium video with political or socio-critical potential is also expanding to the genre of music videos in the digitalized media age—prominent examples such as *This is America* (Childish Gambino), *Apeshit* (The Carters), *Formation* (Beyoncé), *All Day* (Kanye West), and *Born Free* (M.I.A.) bear witness to this development. According to Arnold et al., music videos are now "infused with a new spirit of understanding, both political and aesthetic" (Arnold et. al 2017: 9).

But while Childish Gambino himself takes up arms in his video *This Is America* to draw attention to grievances in the United States, Taylor Swift's activist demeanor in her video *You Need to Calm Down* is much more passive: she lies in the pool, attends a tea party, suns herself in a deck chair, and appeals to the net community with serenity. The video is the result of an emotional process Swift has gone through since her cancel experience. The Netflix documentary *Miss Americana* (2020) is not only a documentation of Taylor Swift's career but can also be read as a companion piece to *You Need to Calm Down* because it also details Swift's cancel experience, which ultimately concludes in the documentary with the filming of *You Need to Calm Down*, thus concluding her psychological processing of the painful cancel experience.

Miss Americana stages a hero's journey par excellence with the stations of departure, initiation, and return: The Call of the Adventure (Vogler 1997: 36–8) shows a desperate Taylor Swift facing a shitstorm.

> We're people who got into this line of work, because we wanted people like us, 'cause we were intrinsically insecure, because we liked the sound of people clapping 'cause it made us forget how much we feel like we're not good enough. And I've been doing this for 15 years, and it's just, I'm tired of it. I'm just tired of

[4] Own translation.
[5] Own translation.
[6] Own translation.

the [sniffles] . . . it just feels like it's more than music now at this point. [crying] . . . it just gets loud sometimes. (*Miss Americana* 2020: 00:35:17–00:35:57)

There are dazzling images and glamorous performances in front of thousands of fans; and then, thirty-five minutes into director Lana Wilson's documentary a breaking point is revealed—in the form of the injured star Taylor Swift bursts into tears. Single piano chords accompany the cancel tweets that are shown and tell of the digital break that has led to Taylor Swift being portrayed as a vulnerable, almost broken star. In the documentary, the cancel experience is staged as a turning point in Swift's career. "When people decided I was wicked and evil and conceiting and not a good person, that was the one that I couldn't really bounce back from 'cause my whole life was centered around it" (*Miss Americana* 2020: 00:34:30). On the one hand, the recipient enters the artistic sphere of the star and influences the star persona—on the other hand, the injury is included here as an authentic part in the repertoire of star staging: The documentary shows how Swift withdraws from the public, how she reflects on her role—lonely at home, with a guitar, in a hoodie at the piano, and accompanied by melancholic melodies: "I figured I had to reset everything . . . I had to deconstruct an entire belief system for my own personal sanity" (*Miss Americana* 2020: 00:37:25–00:37:55). This statement shows the power of the digital user community and the power of cancel culture, which is able to turn an "entire belief system" (*Miss Americana* 2020: 00:37:51–00:37:53) upside down and influence the star persona. But is the star persona sustainably influenced by the digital negotiation processes of collectives? Or are they brief appearances that show the purification process of the star in a media-effective way and then have no further impact?

The Star in the Cancel Storm

In the midst of shitstorms, insults, hostility, and calls for boycotts under specific cancel hashtags, star and recipient have entered into a new, reciprocal relationship in the social media age, so that the star seems to be in crisis in the midst of cancel storms. Already with the establishment of the star phenomenon in the context of the Hollywood machinery at the beginning of the twentieth century, artists are confronted by society with new role attributions and social responsibility and are no longer only associated with their work. Since then, artists as private individuals have also become the focus of consumer attention with their personal backgrounds (Estefan 2017: 11).

In the words of Philip Auslander: "What musicians perform first and foremost is not music, but their own identities as musicians, their musical personae" (Auslander 2006: 102). The star can thus construct his or her own "musical persona" on the basis of his or her own staging of narratives and thus actively shape his or her image.

The intertextual network of cultural practices and media laid down in classical star theory (Dyer 1986, among others) has now expanded in the digital age to include the network of social media, which with its own laws—such as new techniques of staging

(Hickethier 1997: 31) and new direct possibilities of participation—also expands and rebalances the star construct.

Cancel culture has an accelerating effect on changes that concern the star image or may lead to the dismantling of the star (depending on the severity of the norm violation). New role models thereby constitute the star-user structure: while in the star theory the fan initially dominates in his role as imitator and admirer, in cancel culture the fan can be reinterpreted as a critic. What's more, a new species has emerged within social media: the anti-fan, which is why the more neutral concept of recipient will be used in the further course, although it must also be conceded that the anti-fan is only rarely actually a recipient of the criticized work. In the participation network of social media, it is difficult to distinguish whether the critics are fans, anti-fans, or destructive haters and trolls. In her hit song *You Need to Calm Down*, Taylor Swift sings "You are somebody that I don't know" (Swift 2019: 0:11–0:14), raising the question of whether the net critics are in any way recipients of her art.

Melissa A. Click even goes so far as to claim that the anti-fan is the new fan type par excellence (Click 2019: 17):

> While convergence culture has normalized affective and interactive fan practices typically considered to be cult or subcultural and media producers have increasingly sought niche audiences to build long-term relationships through media texts, audiences' affective engagements with media texts have also led to the increasing visibility of fans' negative affective evaluations of media texts and media audiences. (Click 2019: 9)

Cancel culture thus expands star theory to include the type of star that expresses itself in a politically (correct) way and the type of recipient that exerts a decisive influence on this process. In this way, the user now also actively inscribes himself in the artist's image construction—a border crossing that turns the recipient and critic into a prosumer and the star into a produced text in the sense of cultural studies. In the case of Swift's *You Need to Calm Down*, even the recipients are involved in the construction of the original text. They have no longer only penetrated the singer's digital-private sphere but also her artistic-creative world and have crossed the border from mere recipients and critics to "prosumers"—and thus ultimately also to active bearers of meaning for art.

Dissent and conflict have thus become constituent elements in this negotiation of the artist's personality. Whereas in the past the fan aligned himself with the star and aligned his values with the star as a prototype and identification figure, today in the age of cancel culture it is the case that the recipient questions, criticizes, and punishes the star's canon of values for supposedly false opinions. All in all, a paradigm shift has taken place within cancel culture with regard to the star type. Desire and identification (as they were still desirable for the fan in star theory) become less important in contrast to discourse, negotiation, and conflict. This gives the recipients an influential role through social media platforms and thus also exerts a lasting influence on stardom (Robertson-von Trotha 2013: 8).

The cultural communication function of stars in the digital media society has thus been upgraded, on the one hand, but has also become more complex with the diverse, new spaces of self-representation. While previously the natural habitat of the star was the main stage that allowed the public exhibition of an artificial image of self, the star needed the press to provide insights into his or her private life. Today this has changed: the star can exhibit and stage himself or herself on the "backstage social media" to provide the coveted glimpse of privacy.

In order to meet the authenticity needs of the recipients and to make the development potential of the stars transparent, music documentaries about stars have been a very popular instrument to further develop the public image of stars (e.g., Justin Bieber's *Next Chapter*, Aviici's *True Stories*, Billie Eilish's *The World's a Little Blurry*, Lady Gaga's *Five Foot Two*).

Carol Vernallis's article "Wer braucht schon Musikdokumentationen, wenn es TikTok und Carpool Karaoke gibt?"[7] asks what authenticity gains music documentaries can still offer the audience, given the "private" insights that are circulated via social media platforms (Vernallis 2021). Kathrin Dreckmann also notes that authenticity is only used as an effect strategy (Dreckmann 2022: 84): "A connection to the 'real life' of the artist enables an experience of greater authenticity, which is further enhanced by the truthfulness of the document in the documentary" (Dreckmann 2022: 85).

In *Miss Americana*, a reformed Taylor Swift can be seen after the breaking point left by her cancel experience. A star who goes through several stages of development and changes from an apolitical star to a supposedly politically engaged star. An over-staging that finally delivers the flawless star with a white waistcoat as demanded by the network collective—after a difficult hero's journey. After the first phase, in which Swift leaves her "familiar world" (Vogler 1997: 137)[8] and is confronted with the "call of adventure" (= cancel storm), *Miss Americana* leads into the phase of struggling and reorientation. To this end, a parallel plot line is introduced in the film with news images that address the midterm elections in Tennessee, where Marsha Blackburn, among others, is running as a Republican for the position of first female senator—a hardliner when it comes to equality issues. Taylor Swift struggles with her role: "But a nice girl doesn't force her opinions on people.. . . A nice girl doesn't make people feel uncomfortable with her views" (*Miss Americana* 2020: 00:50:48). In the documentary you see her advisory board advising her against taking a political position in connection with the election "Stay out of it!" (*Miss Americana* 2020: 00:51:36). In the classic hero's journey, the mentor is actually seen as playing an empowering, encouraging role, but Taylor Swift decides to go against the advice of her advisors, crosses the "first threshold" in the spirit of the hero's journey theory and transforms into a politically engaged star. She posts a tweet on October 8, 2018, that heralds her return to the public eye: "Don't put a homophobic racist in office" (*Miss Americana* 2020: 01:04:07–01:04:10).

In the documentary, the crucial test (Vogler 1997: 45–7) in which the heroine overcomes her greatest fear is staged as a private and intimate moment on the living

[7] Own translation: "Who needs music documentaries when there's TikTok and Carpool Karaoke?"
[8] Own translation.

room couch with her mother and her PR manager—Taylor Swift in sweatpants, holding a glass of wine, excitedly counting down to her landmark post. After this private scene, a hard cut in the documentary is followed directly by the news, in which a spokeswoman announces, "Taylor Swift broke her silence on politics over the weekend publicly backing two Democrats in Tennessee" (*Miss Americana* 2020: 01:05:08). And even Trump is confronted with the tweet, stating: "Let's say that I like Taylor's music about 25% less now, ok?" (*Miss Americana* 2020: 01:05:32). Can Taylor Swift's own political positioning from the living room couch be understood as a relevant turn for nationwide politics? The incorporation of news in *Miss Americana* is meant to support authenticity and add credibility. At the very least, Taylor Swift proves to her critics that after this crucial test, she is becoming the star that the networked collective demands and has matured into a new personality through the "adventure" of the hero's journey: "I've educated myself now . . . and it's time to take the masking tape off of my mouth . . . like forever" (*Miss Americana* 2020: 01:17:09–01:17:19).

As early as 1997, star theory scholar Knut Hickethier observed the tendency that star attachment is also linked to certain currents and trends: "With the change of circumstances, stars lose their attractions, are replaced by others if they cannot credibly undergo a change themselves, which then makes them appear again as the embodiments of a new age" (Hickethier 1997: 31).[9] This connection with a zeitgeist or a social current also seems to be important in relation to cancel culture: the recipients demand a politically engaged star who acts in a morally compatible and politically correct way. Taylor Swift delivers the new type of star and presents it to the public artistically with *You Need to Calm Down* and underpins the image change with an offensive of authenticity in *Miss Americana*. This hybridity of music video and music documentary shows that the star produces a new multimodality as a reaction to the expectations of the recipients as text: the actual work, the music video, is accompanied by tweets, statements, postings, documentaries, and journalistic news.

But how far does Taylor Swift's political protest really go? In the music documentary *Miss Americana*, a tweet from the couch is enough to bring about political change. Viewed soberly, the fact that she dedicates her music video to a topic that has long been widely discussed in public discourse and is no longer considered contentious could be understood as mere "click activism"—as a harmless protest that comes along without great cost and that often remains only in the sphere staged by the media without having any consequences for actual change (Vomberg, Stauss and Schürmer 2021: 21). The aesthetic level also supports this thesis: both components—music documentary and music video—are over-staged wishy-washy offensives. While the documentary tries to establish credibility and objectivity through the aesthetic inclusion of news clips, *You Need to Calm Down* shows an over-staged candy storm response to the cancel reaction. It's a dreamworld that doesn't go very far with its ironic refractions, leaving the empowerment of the canceled star in the sphere of the unreal trailer park. The heroine Taylor Swift returns at the end of her hero's journey with the "elixir" (Vogler

[9] Own translation.

1997: 339): "I want to wear pink and tell you how I feel about politics" (*Miss Americana* 2020: 01:18:02–01:18:06). Or put another way: I'm a victim too, and that's why you can't cancel me anymore. With this "package of measures" in the combination of music video and music documentary, Swift re-positions her "musical persona": she looks for a topic that is en vogue anyway and thus poses pseudo-politically—biographically in *Miss Americana* and aesthetically in *You Need to Calm Down*.

Kerstin Schankweiler, on the other hand, defines successful protest campaigns through the "skilful links between the 'analog' public space and the spaces of the internet, which intertwine in many ways" (Schankweiler 2019: 57).[10] But it is precisely this interpenetration of reality and the art world that is completely missing here, because even the supposedly authentic music documentary *Miss Americana*, which is supposed to represent the level of reality, is just as staged as the music video. The whole package is an internalization of cancel culture, which in this staged way, however, can hardly provide impetus for critical reflection on the true nature of cancel culture.

References

Aguirre, Abby (2019), "Taylor Swift on Sexism, Scrutiny, and Standing Up for Herself," *Vogue*, August 8. Available online: https://www.vogue.com/article/taylor-swift-cover-september-2019 (accessed April 30, 2022).

Arnold, Gina, Daniel Cookney, Kirsty Fairclough and Michael Goddard (2017), *Music/Video. Histories, Aesthetics, Media*, New York and London: Bloomsbury Academic.

Auslander, Philip (2006), "Musical Personae," *TDR*, 50 (1): 100–19.

Baringhorst, Sigrid, Veronika Kneip and Johanna Niesyto (2010), "Unternehmenskritische Kampagnen im Netz. Zum Wandel von Protest- und Medienkulturen," in Andreas Hepp, Marco Höhn and Jeffrey Wimmer (eds.), *Medienkultur im Wandel*, 385–400, Constance: UVK.

Butler, Judith (1997), *Excitable Speech. A Politics of the Performative*, New York and London: Routledge.

Clark, Meredith D. (2020), "Drag Them: A Brief Etymology of So-Called 'Cancel Culture,'" *Communication and the Public*, 5 (3–4): 88–92.

Click, Melissa A. (2019), "Introduction: Haters Gonna Hate," in Melissa A. Click (ed.), *Anti-Fandom. Dislike and Hate in the Digital Age*, 1–22, New York: University Press.

Daniels, Dieter (2021), "Zur Musikalität des Visuellen. Thesen zur Videospezifik des Musikvideos," in Kathrin Dreckmann (ed.), *Musikvideo Reloaded. Über historische und aktuelle Bewegtbildästhetiken zwischen Pop, Kommerz und Kunst*, 25–40, Düsseldorf: Düsseldorf University Press.

Dreckmann, Kathrin (2022), "In Bed with… Über den Zusammenhang von Authentizitätseffekten und Pathos in aktuellen Musikdokumentationen," in Kathrin Dreckmann, Carsten Heinze, Dagmar Hoffmann and Dirk Matejovski (eds.), *Jugend, Musik und Film*, 81–98, Düsseldorf: Düsseldorf University Press.

Dyer, Richard (1986), *Heavenly Bodies. Film Stars and Society*, London: bfi.

[10] Own translation.

Eder, Jens, Britta Hartmann and Chris Tedjasukmana (2020), *Bewegungsbilder. Politische Videos in Sozialen Medien*, Berlin: Bertz + Fischer.
Estefan, Kareem (2017), "Introduction: Boycotts as Openings," in Kareem Estefan, Carin Kuoni and Laura Raicovich (eds.), *Assuming Boycott. Resistance, Agency, and Cultural Production*, 11–17, New York and London: OR Books.
Hickethier, Kurt (1997), "Vom Theaterstar zum Filmstar. Merkmale des Starwesens um die Wende vom neunzehnten Jahrhundert zum zwanzigsten Jahrhundert," in Werner Faulstich and Helmut Korte (eds.), *Der Star. Geschichte—Rezeption—Bedeutung*, 29–47, Munich: Fink.
Miss Americana (2020), [Film] Dir. Lana Wilson, USA: Netflix.
Robertson-von Trotha, Caroline Y. (2013), "Vorwort," in Caroline Y. Robertson-von Trotha (ed.), *Celebrity Culture. Stars in der Mediengesellschaft*, 7–10, Baden-Baden: Nomos.
Schankweiler, Kerstin (2019), *Bildproteste. Widerstand im Netz*, Berlin: Klaus Wagenbach.
Schmidbauer, Michael and Paul Löhr (1996), "Das Programm für Jugendliche: Musikvideos in MTV Europe und Viva," *Televizion*, 9 (2): 6–32.
Swift, Taylor (2019), *You Need Do Calm Down*. Directed by Drew Kirsch and Taylor Swift. June 17, 2019. Music video, 3:30. Available online: https://www.youtube.com/watch?v=Dkk9gvTmCXY (accessed April 30, 2022).
Vernallis, Carol (2021), "Wer braucht schon Musikdokumentationen, wenn es TikTok und Carpool Karaoke gibt?" in Kathrin Dreckmann (ed.), *Musikvideo Reloaded. Über historische und aktuelle Bewegtbildästhetiken zwischen Pop, Kommerz und Kunst*, 205–20, Düsseldorf: Düsseldorf University Press.
Vogler, Christopher (1997), *Die Odyssee des Drehbuchschreibers*, Frankfurt am Main: Zweitausendeins.
Vomberg, Elfi, Sebastian Stauss and Anna Schürmer (2021), "Einleitung: Von konzertierten Ausnahmezuständen," in Elfi Vomberg, Sebastian Stauss and Anna Schürmer (eds.), *Krise—Boykott—Skandal. Konzertierte Ausnahmezustände*, 11–33, Munich: Edition Text + Kritik.

8

Facing the Lens of the Camera

Bodies, Self-portraiture, Portraiture, and Identity in Women Artists' Video

Laura Leuzzi

The availability and commercialization of the portable video recorder in the late 1960s and early 1970s coincided with an important phase in the feminist movement: women worldwide were fighting for civil rights and a change in the recognition of the role of women within society. Many women artists saw the advantages arising from the new technology as offering an opportunity to explore feminist issues in a new guise.

The "new" apparatus, free as it was from the burden of a patriarchal tradition, offered several technical features that made it particularly flexible and well-suited to independent, limited budget and autonomous productions. It was transportable (although still relatively heavy), it did not need printing or a large crew, and, at first, editing was not available. Also, feedback on a small monitor made it possible to check the shot constantly, whereas the video was immediately available to be played once the shoot was finished. Since then, thanks to major improvements in the technology, many artists have been led to choose video for the autonomy and the low-budget opportunities it allows (San Francisco Museum of Modern Art 2011).

Looking at the body of work produced with video by women artists in the 1960s, 1970s, and later in the 1980s, it becomes clear that in connection with the aforementioned feminist movement, a major recurring theme is identity and representation of the self from both an intimate and a public perspective: for example, women artists engaged with notions of how women had been misrepresented and objectified in the visual arts and media, and how their role in society was reduced to that of mothers and spouses. Their themes and approaches reflected second-wave feminist battles: they rejected the sanitized and aiming-to-please representations of women's bodies, sexualities, and roles—that had been perpetuated for centuries by male colleagues—in many different mediums and art forms. Video served as a powerful tool to question and explore identity and self-portrait, to reflect and self-reflect on women's bodies, their status, and their inner selves, echoing the popular metaphor of video as a mirror. From the 1960s to today, women's approach and these themes have endured and evolved with the medium, echoing current battles for civil rights as developing from the pioneers.

As discussed in a large body of literature, women have profoundly innovated the genre of portraiture and self-portraiture in the twentieth and twenty-first centuries (Meskimmon 1996; Borzello 1998). In the 1970s, a heated debate regarding approaches to representing women in traditional Western art history was prompted by a number of different writers, thinkers, activists, and critics—including, for example John Berger in *Ways of Seeing* (1972) and Marina Warner with her famous *Alone of All Her Sex: The Myth and the Cult of the Virgin Mary* (1976). These books and theories have informed and inspired and have been complemented by the work of women artists active at the time and many who came thereafter.

In this chapter, I will explore the reception of these instances in women's contemporary video art through the analysis of three key case studies: three European women artists—born in the 1960s, two in particular in the wake of the 1968 protests.[1] My aim is to show how video has been a pivotal medium for exploration and innovation in the fields of portraiture and self-portraiture for a generation that has been deeply informed—consciously or subconsciously—by the very early feminist video pioneers, performers, and theorists of the 1970s and who have developed different approaches to common issues arising from the renegotiation of the representation of their body and image. This chapter will focus on identity as a theme that has been developed, how this approach innovated the genre of self-portrait, questioning its tropes and *topoi* with tradition-defying approaches and perspectives and ultimately contributed in a distinct fashion to the development of video as an art form.

Engaging with the Body: Desire and Pleasure at the Intersection of Portraiture

Women artists have traditionally worked in the genres of portraiture and self-portraiture, exploring identities, bodies, and representation with a particular focus on the self, fellow women and children, and intimate and personal emotions and attitudes. Women's self-portraits have been more than mere representations of the portrayed person's physical features: they conveyed a deeper exploration of identity and inner life but were also conceived as a statement of their professional status.

In the twentieth century this tradition was continued by several artists who used it as a tool to challenge conventions and stereotypes in relation to roles and aesthetic canons, to renegotiate representations, to reject stereotyped models, and to reclaim their own perspective and voice. Video served as a potent medium for several women artists exploring and renewing portraiture and self-portraiture, although in many cases not specifically referencing the traditional genres in either their titles or statements.

[1] This chapter draws inspiration from and elaborates upon an earlier chapter by the author (Leuzzi 2019). I would like to thank all the artists and authors who have supported me and helped me in this research, including Pilar Albarracín, Cinzia Cremona, Elisabetta Di Sopra, Giulia Casalini, and Diana Georgiou.

As mentioned, a key feature of video was the possibility of working alone, allowing intimacy and enhancing control over the material—something that was key when working with their own bodies, especially for nudes. This greatly empowered many women artists working with performance and specifically with body art.[2]

Since its inception, video has been employed to question and challenge what Laura Mulvey (1975) so famously defined as the "male gaze," adopting a medium that was already being utilized by broadcast TV. The rejection of the male gaze and the adoption of the female gaze in women's video art—as well as in feminist filmmaking of course—have involved what could be defined as an ongoing fight and struggle for the reappropriation of women's own image as a way of self-representation. This feminist approach to the moving image has given rise to profound innovations within the genre of portraiture, understood in the broadest possible terms, engaging with many different themes including identity, eroticism, motherhood, and professional status.

Already in the 1970s, utilizing naked bodies in their works, however, raised several issues relating to the possible objectification and sexualization for women. Might such uses of nudity in fact serve to perpetuate the male gaze? Several women artists—as discussed for example by British artist and theorist Catherine Elwes—were profoundly aware of these problems and tried to explore and negotiate "new forms of visibility," adopting different strategies to avoid "sexual representation" (Elwes 2005: 48–9).

Video performers, and in particular those women artists who were using their own body, were also aware of the issues raised by Rosalind Krauss's foundational essay, "The Aesthetics of Narcissism" (1976). Developing her points from an analysis of Vito Acconci's *Centers* (1971), Krauss, utilizing a mirror-like metaphor, associated the loop created by the camera and the video feedback to a narcissistic quality that in her view would in some way be intrinsic to video. Although at the end of her essay Krauss seemed to mitigate this opinion, it cast a shadow over the perception of the use of bodies in video art. Although Krauss's piece remains a milestone in the field, since then much ink has been spilled in questioning and debunking it. For example, Michael Rush reinterpreted Acconci's approach, insisting that the artist was instead addressing an invisible audience located somewhere beyond the camera. In *Sexy Lies in Videotapes* (2003), Anja Osswald also observed that the metaphor of video-as-mirror is not completely accurate because video doesn't offer a reversed image (as a mirror would), but instead a double one. Therefore the "other" breaks the narcissistic loop (Westgeest 2015: 55). Osswald argues that only a few videos include the term "self-portrait" in their title and that the artist would be relegated to the depersonalized role of "an empty container," exposing the "rhetorical artificiality of self-images" (including the doubling or splitting that is an integral part of our analysis) and what she defines as the "paradox of 'self-less self-images'" (Westgeest 2015: 56). Nonetheless, we might argue that several early videos as well as other, later works engage with notions of representation and portraiture, especially those by feminist artists.

[2] Already in 1976, the American video artist Hermine Freed had pointed out that artists used their own bodies because it enhanced a sense of control, allowing the artist to work alone.

Over the course of her career, and on several different occasions, Swiss feminist video art pioneer Pipilotti Rist (born 1962) has worked with the body, utilizing close-ups of body parts, mostly involving uncanny and destabilizing effects. She has thus placed her own image or portrait in front of the camera, adopting unusual (and non-hierarchical) points of view and thereby offering a profound investigation into desire, pleasure, and the human sensorial experience. Her approach and imagination have freed the representation of the body from the canon and delved into the use of the body as a vehicle for sensations and emotions

In the last decade, in her most successful and important exhibition retrospectives, Pipilotti Rist has worked on installations that place the experience and the body of the viewer as a part of—and at the center of—the artwork: environments with large-scale projections and with reflected light "caress ourselves" (FADlive 2011) envelop the visitors' bodies in an immersive experience and turn them into a sculptural part of the work.

As discussed by David Riley, Pipilotti Rist has transposed sound and image features—"the language of the anti-elite"—that were already popular in the "outside world"—into the art world, in the space of museums and galleries. In installations such as *Do Not Abandon Me Again* (2015), both the environment and the audience become the screen for the projection: "The viewer having a physical lived experience, one to one, being in the space with the work, being three-dimensionally in the work. Being of the work. . . . You are the screen" (Risley 2019: 73).

The theme and the use of the body has evolved from Rist's early practice of the 1980s and 1990s, where she had more explicitly engaged with empowerment, the female body, sexuality, desire, and the self, offering in many of her works—especially in the first two decades—a portrait of women in charge of their pleasures, their emotions, and their representation.

In 2005 in *Homo Sapiens Sapiens*, Rist explored feminist empowerment through a Garden of Eden inhabited by two Eves (the Catholic Church forced the closure of the exhibition in the Church of San Stae when the work was presented for the first time at the Venice Biennale). The bodies, captured with close-ups and unusual perspectives, intermingled with plants and objects in a glorious feast of colors and sounds; the work, with its erotic charge, tactile quality, and sumptuousness, overwhelmed the viewers who lay on the floor in a state of relaxation. As Massimiliano Gioni has observed, "The fact that this work aroused the ire of the ecclesiastic patriarchy shows the subversive charge of Rist's imaginary, which with a few twists transforms the passive depiction of women found in traditional Christian iconography into the paean to a newly empowered femininity" (Gioni 2019: 57).

A key work that engages with these themes and notions is the famous *I Am Not The Girl Who Misses Much* (1986) by Pipilotti Rist. The artist modifies some famous lyrics from the renowned Beatles song *Happiness is a Warm Gun* (1968, "she's not the girl who misses much," which refers to Yoko Ono, a model and inspiration to the artist) and sings them, dancing frenziedly in front of the camera, dressed in black and with her breasts exposed (the dress might have been falling due to the dancing or might have been deliberately pulled down).

In post-production, the artist manipulates the image (changing the color balance) and the velocity (speeding up and slowing down some segments), therefore distorting the sound (with low and high pitches) to the point of rendering the lyrics unrecognizable and fragmenting the image. Instead of offering a sexualized image of the female body for the male gaze to peruse, objectification and fetishization are defied by blurring the image and by using signal disturbance. This strategy might have followed or been inspired by those devised by several women video pioneers, among them Nan Hoover (*Landscape*, 1983), who used close-ups of body parts to disrupt the unity of the female body with the same de-objectification/de-sexualization effect—a strategy deployed by Pipilotti Rist herself in a number of later works in which she utilizes body parts and close-ups that, despite the use of tactile and sensory effects, manage to avoid the pitfalls of voyeurism and a pornographic imaginary (e.g., in *Pickelporno* [*Pimple Porno*], 1992).

Although the artist herself has rejected the notion that contemporary music videos furnished a direct inspiration for *I Am Not The Girl Who Misses Much*, nonetheless, as Cinzia Cremona notes, Rist "responds directly to the ubiquitous male pop artist in the language of the pop promo" (Cremona 2019: 47). The modification of the original lyrics, of the "she" into "I," marks the empowering process that the artist is reclaiming. Enhanced by the repeating of this mantra, we witness the shift of paradigm from the other's representation to self-expression and self-portraiture.

Rist has used these same strategies in many of her other videos shown since the 1980s. One example is the little known *Japsen* (1988), a video made in collaboration with Muda Mathis—founding member of the Basel-based feminist pop band and performance group Les Reines Prochaines that Pipilotti Rist joined from 1988 to 1994. The work is divided into five acts that develop the love story of the female protagonist (the delusion, the hysteria, the escape, the love, the laughter) (Zwick 2016). We note how the work displays several stylistic features that have been widely utilized by Pipilotti Rist in her work, including for example the aforementioned close-ups and unusual perspectives. In all the segments, for example, the camera follows the woman (Pipilotti Rist)—characterized by red boots and tights (the artist's statement says "the red colour is important")—with a close-up of her legs walking or cycling through the city. In "the Hysteria" stage, we find once again Pipilotti Rist moving/dancing frenziedly to the music, in images and sound manipulated in post-production.

More recently, unfiltered and unsanitized portraits of sexuality, pleasure, love, and desire have been explored and engaged with by American Glasgow-based artist Margaret Salmon in her 16 mm film *Two*. Salmon's work has been deeply influenced by Laura Mulvey and has adopted and explored the "female gaze" as an alternative model to perpetuating the male gaze in media and the culture at large. In *Two*, the artist manages to portray couples in the act of lovemaking while at the same time avoiding the male gaze and embracing a point of view that brings on the screen a true, loving, intimate, and connected relationship and mode of human contact. The bodies in the act are a conduit for deeper emotions, rejecting the machine-like sex-making of the pornographic imaginary. Close-ups and the gentle caress of the camera on the body offer the viewer a way to reflect upon the performers' touch instead of adopting a voyeuristic gaze.

The artist has also investigated the theme of relationship in her work *I You Me We Us* (2018, likewise filmed in 16 mm and then available in HD). The title of this double-screen installation represents the bond between people portrayed through images of contacts, objects, and words in a sort of progression and shift of focus from the individual to the couple. Although made with film, Salmon's *I You Me We Us* was installed in the galleries at the Dundee Contemporary Arts in 2018 on two monitors engaging with the domestic setting of the broadcast TV imaginary in a manner bearing some relation to what early women's video art sought to do.

The Cultural Imaginary, the Body, and Feminist Representation

The role of women in society and culture at large as well as the fetishization and objectification of bodies and body parts has been and continues to be at the center of much of women's art and video, the aim being to challenge cultural stereotypes deeply rooted in tradition and visual canons.

Since the 1990s, the Spanish artist Pilar Albarracín (born 1968) has been addressing these issues of identity, representation, and the role of women in traditional and modern culture—Spanish culture specifically, but with a message that can be translated into more universal terms—through multiple media. Albarracín truly embodies in her practice and work the fight for rights and recognition of those years of civic action and revolution (Albarracín 2018: 22).

The artist has used her own body as a field serving to represent the oppression of and the violence against women; the body becomes the actual territory where this violence and oppression—be it intangible, or physical—is enacted and therefore represented and exposed.

In her video performances,[3] Albarracín uses traditional Spanish visual tropes from popular culture as well as art history, and consequently the stereotypes attached to them, to address the liberation of women in their pursuit to regain power over their role, their bodies, their sexuality, and their relationships with the other sex in modern society. Her reflections upon identity range between the individual and the collectivity.

In the video *Punto de fuga* (*Vanishing Point*, 2012, Figure 8.1), the artist proposes several close-ups of women's crossed legs that open so as to reveal their underwear. The performers chosen for the video as well as the underwear and clothes aim to defy patriarchal objectification of women's bodies and normative canons of beauty

[3] Ana Sedeño Valdellós argues that we encounter video performance in Albarracín that is "intended" to be documentation of a performance in an approach that focuses on the action—such as in *Furor Latino* and *Viva España*—and "as a genre where action and video as material go through a hybridization in an inter-dependent way" as in *Musical Dancing Spanish Doll* (2001) (own translation, Sedeño Valdellós 2011: 38). Nonetheless, the relationship with the camera—the importance of the shot—in a work such as *Furor Latino* is fundamental and makes the work a video performance (and not mere documentation) in the strict sense.

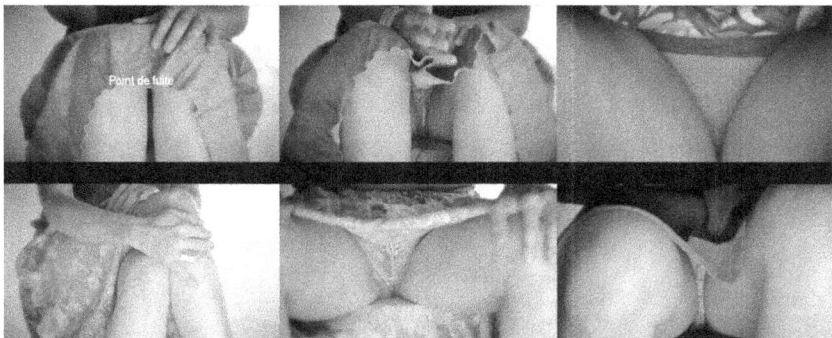

Figure 8.1 *Punto de fuga* by Pilar Albarracín, 2012, color video with sound, 3:34, format 16:9. © Pilar Albarracín Courtesy of: Galerie Georges-Philippe & Nathalie Vallois, Paris (Fr) and DACS/Artimage, London 2022.

that promote perfection and youth: the skin that reveals signs of aging as well as the colorful and normal everyday clothes reclaim a feminist representation of women's bodies. The inquisitive camera explores between the legs, revealing real bodies in a spirit of inclusivity and a mode of representation that defies stereotypical points of views and portraiture.

For some visual and conceptual elements, one might recall Albaraccín's video *Furor latino* (*Latin furor,* 2003) that specifically rejects the eroticization and fetishizing of the male gaze on women's bodies and openly addresses cultural stereotypes that place women—especially Latin women—as objects of masculine desire and erotic possession. The artist conveys these concepts using a very basic bodily manipulation and visual plot: the video shows the torso of a woman with large breasts dancing to Latin music, completely objectified through the close-up on the breast that does not allow her face to be seen. The music approaches a crescendo that reflects the voyeuristic arousal in the viewer that is doomed to be shattered when it reaches its peak: the breasts are deflated with a pin that reveals them to be just balloons. The video—besides putting into question the objectification of bodies and the "male gaze"—also comments on constructed, stereotypical canons of beauty and the use and abuse of plastic surgery creating bodies that are ultimately "fake."

In the video performance *Le Duende volé*[4] (2012), for example, we witness the awkward scene of a flamenco dancer (the Spanish term *duende* refers to the state of exaltation the dancer attains during their performance)—dressed in a traditional costume climbing down the side of an apartment building (Albarracín 2018: 69). The sense of surprise is enhanced by a *rumba flamenca* popular in the 1970s that tells the story of a group of common criminals who fled from the police.

The figure of the traditional flamenco dancer is recurrent in the artist's work. In *Musical Dancing Spanish Doll*, the real body of the artist, with her sensual movements, becomes

[4] The artist prefers to leave the title untranslated.

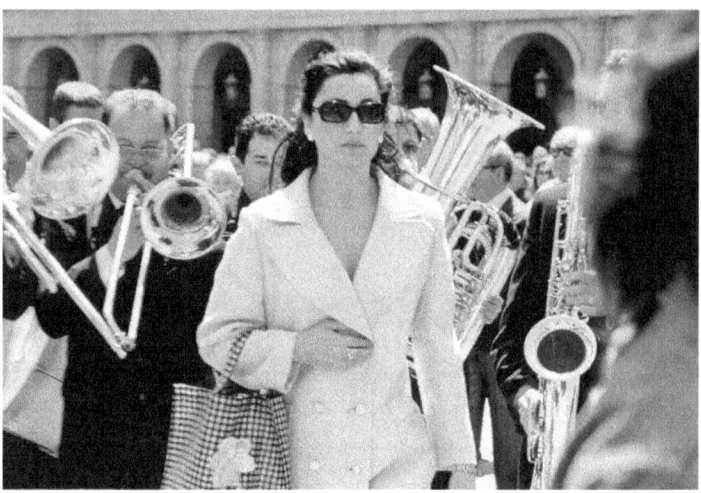

Figure 8.2 *Viva España* by Pilar Albarracín, 2004, performance, video and photo documentation, color sound, 3:30, format 4:3. © Pilar Albarracín Courtesy of: Galerie Georges-Philippe & Nathalie Vallois, Paris (Fr) and DACS/Artimage, London 2022.

confused with plastic dolls that are in movement—the viewer is at first not sure if one of the dancers is real—Albarracín is once again engaging with objectification, sexualization, and cultural stereotypes. Cuauhtémoc Medina commented: "The image eloquently suggests the meaning of the notion of 'intervention': this entering of the territory of signs, in order to breath a new power of seduction into the seemingly inert" (Medina 2004).

A key work in Albarracín's career is the celebrated *Viva España* (*Long live Spain*, 2004, Figure 8.2), a video performance that was shown at the 2005 Venice Biennale and is now in the Louis Vuitton Collection. In the piece, the artist strides through the streets of Madrid, dressed in a bright yellow coat, her eyes covered by stylish dark sunglasses, her face initially expressing a vague anxiety. She is followed by a male-only music band playing the tune *Eviva España/Y Viva*—a famous song popular in the 1970s that remind us of summer holidays in Spain. At first the men merely seem to be following her but little by little they become more invasive and harassing, and she clearly tries to escape and lose them. The artist increases the pace, and in the end, she actually breaks into a run. This visually compelling scene symbolizes the violence of patriarchal culture on women and their struggle to evade it, as well as engaging with stereotypes about Spanish culture.

Albarracín's works in video and performance—as well as in other media—reflect the artist's profound knowledge of feminist art, in particular video art from second-wave feminism and its lexicon. Her attempts to engage with that vocabulary involved visual and conceptual references as well as homage, in the course of which she "deconstructs" it and "claims and reworks [it] as if it were her own" (Albarracín 2018: 78).

Several critics and historians have suggested some common elements between Albarracín's performance documented on photography and video as *Tortilla a la*

española (*Spanish tortilla*, 1999) and the now historic feminist video masterpiece by Martha Rosler, *Semiotics of the Kitchen* (1975), with which the Spanish artist was no doubt familiar. Both works—beside the kitchen setting, an implicit reference to the traditional role and space (both physical and metaphorical) in which society has confined women—are marked by a similar degree of staged violence that symbolizes violence against women as well as the need to combat and subvert this paradigm through empowerment and the feminist movement.

Body, Portraiture, and Collective/Personal Memory

The innovation in portraiture led by women artists in video encompasses the possibility of incorporating memory—be it personal or collective—in order to explore identity at a deeper level. The body is transformed into a powerful vessel of this memory, once again defying the sanitized image of beauty perpetuated in the traditional canon and media.

A significant example of this approach is *Dust Grains* (2014, Figure 8.3) by the Italian artist Elisabetta Di Sopra (born 1969). The body and the genres of portraiture and self-portraiture are very much at the center of Di Sopra's work and the artist—as previously discussed in the case of Rist and many other women in video—likewise uses body parts in some of her videos: in *Dust Grains*, for example, the camera focus on a detail—the eye that stands for the artist in a visual synecdoche. The eye of the artist with its wrinkles and folds shows aging, the mark that time has passed. The passing of time evoked in the moving images sequence is shown in the artist's greenish pupil: we seem to be viewing old amateur footage showing Di Sopra's childhood memory of time spent with her mother and father in the countryside. The sound is a distant echo of those moments. At the end of the work, the eye closes and a tear runs down her cheek.

Analyzing the use of the eye in this specific work, one might recall the popular phrase "the eyes are the mirror of the soul." Besides its popularized and even trite meaning, this phrase evokes in some way the metaphor of the mirror/video once again,

Figure 8.3 *Dust Grains* by Elisabetta Di Sopra, 2014, still from video. Courtesy of the artist.

with the eye acting metaphorically like a gateway to the soul, but more materially as a reflection/projection tool. This reference is enhanced by the low-quality image of the footage that recalls the quality of early video and Super 8—that the artist had reused also in her *Mamma* (2008), an extract from an old Super 8 film migrated to digital and complemented by music. Furthermore, it recalls the use of the mirror in traditional self-portraits, an element that has been explored at length in much early women's video art. Examples include Elaine Shemilt's *Doppelgänger*, *Vanitas* by Tamara Krikorian, and *Etre blonde c'est la perfection* (*Being Blonde Is Perfection*) 1980 by Hungarian artist Klara Kutcha.

Body and portraiture are at the very center of Di Sopra's work. In her video *Temporary* (2013), for example, Di Sopra explores self-portraiture: the figure of the artist occupies what seems to be a room in an old Venetian palazzo. The artist starts taking her clothes off and little by little her image starts to dissolve until she is completely naked and disappears. The video once again deals with the passage of time, but at the same time the topic of portraiture seems to be to the fore: her body is completely exposed to the viewer, but the terms of its representation and visibility are renegotiated by the artist through a manipulation of the image and the choice of the background (a strategy utilized more cursorily in her *Variazioni minime* [*Minimal Variation*], 2009).

Di Sopra's work is particularly relevant in the Italian context which is still characterized by a strong macho culture and an objectification of the body of women (the famous found footage film *Il corpo delle donne—Women's Bodies*—by Lorella Zanardo, 2009, is still highly relevant) that relate in a sense to Spanish traditional and contemporary culture, the target of Pilar Albarracín's work.

Many works by Di Sopra explore collective and individual portraits as well as self-portraits, always proposing an investigation of the body that is realistic, unsanitized, and aims to convey the inner world of the person portrayed; one such example is *Why* (2018), in which portraits feature women screaming in nature, regaining their own voice (inspired by the case of one woman who had lost her voice due to trauma).

Motherhood is another key theme in Di Sopra's practice and following the example of many feminist artists in the nineteenth and twentieth centuries—and, indeed, video artists—before her, Di Sopra explores it through the body of women, rejecting the abovementioned myth of the Mother/Madonna discussed by Marina Warner.

In *Untitled* (2007) the artist explores breastfeeding: the camera focuses on a close-up of the breast that starts expressing milk when the mother hears the cry of her baby. The image with the dark nipples and the milk flowing defies the objectification of women's breasts in the media and pornography. The work is somehow a celebration of the relationship and bond between mother and child, without implying unrealistic standards of perfection but rather capitalizing on the exploration of real bodies: it addresses the dependence of the child upon the mother and the labor—emotional and physical—that is an inextricable part of motherhood. The approach of the artist is very far from the traditional representation of breastfeeding in past centuries (the model of the *Madonna lactans* or Nursing Madonna that in no way portrayed the reality of breastfeeding) and relates to the work of many feminists on the topic that has challenged implicitly or explicitly the same tradition (Betterton 2010): a relevant

example is *There Is a Myth* (1984) by British artist Catherine Elwes (born 1952), which shows a close-up of the breast that is stimulated to lactate by the hand of her baby, providing a pioneering video portrait of motherhood and breastfeeding.

Women's labor of love is also portrayed by Di Sopra in her diptych *The Care* (2018), which engages with two prominent Christian iconographies of the Renaissance and the Baroque period: the Pietà—with a young woman bathing an elderly lady, and the Madonna and Child—with a mother bathing her child. Both the elderly body and the reaction of the child normalize and de-glamorize the myths around women as caregiver and pillar of the family—and the close-up to the chest, which crops the caregiver's body, focuses on the action depicted.

In one of her most recent installations—shown at the Venice National Archaeological Museum in San Marco Square (2021), *Il Limite* (*The Limit*, 2019)— Di Sopra investigates once again portraiture and women's bodies in relation to art history in its more traditional forms and mediums, its canons of beauty, and the role of professional women artists.

The three-channel installation shows in the central screen the figure of a female professional model, who is elderly and naked—now retired, her shoulders toward the camera, posing for an invisible audience of students at the Academy of Fine Arts in Venice (who are, we suppose, in the place where the camera is) and on either side, there are screens showing close-ups of her body: a detail of her legs, one bent in accordance with the sort of contrived pose that artists' models assume; and a shot of her profile, her face only partly visible, with her impenetrable expression, and her arm posed as well. The model is testing her body to the limit by holding this complex and tiring pose. Once again, the close-up and unusual (nonfrontal and nonhierarchical) point of view is utilized by the artist to cleverly renegotiate representation and portraiture. The camera does not hide the signs of time passing which are perceptible on the model's skin: the unsanitized and realistic image defies all stereotypes and boundaries concerning the representation of women in the media and in traditional art history (where women models embodied beauty and perfection), following the example of many feminist artists in the nineteenth and twentieth centuries as well as many video art pioneers. A counterpart to the model's body is what seems to be a copy of an ancient Greek male naked sculpture on her left—a copy that itself lays bare the memory of the original work from which it was taken. This clash between the sculpture and the elderly model once again references unattainable and artificial canons of beauty. Also, it is an indirect reference to both the art system and society at large that for centuries have excluded women from becoming professional artists, from having access to education, purchasing materials, or hiring professional models. This effect is enhanced by the installation in the rooms of the Museo Nazionale Archeologico in Venice (Figure 8.4).

In conclusion, the case studies discussed show how portraits are indeed at the very center of many contemporary feminist video artworks and how their approach to the representation of bodies and identity—although with different sensibilities and innovative perspectives—are rooted in and developed from feminist concerns and feminist works that have emerged from the pioneering experimentation of early feminist video art and theory.

Figure 8.4 *Il Limite* by Elisabetta Di Sopra, 2019, video installation at Museo Archeologico Nazionale, Venice. Courtesy of the artist.

Although some of the early videos by women had only a limited circulation, and although it is therefore not possible to trace with certainty their legacy or how they have influenced the succeeding generations, nonetheless they inaugurated, stimulated, and contributed to a discourse that has been developed further in subsequent decades and has reached—sometimes indirectly—younger artists.

The body is the battleground through which the terms of portraiture can be addressed and enacted through fragmentation, manipulation, and the adoption of different perspectives so as to convey an image that defies stereotypes, objectification, and the "male gaze," all still perpetuated by the media.

Video—with its innovations and technological advances—remains a medium that allows a certain degree of autonomy, independence, and freedom, at the same time enabling artists to challenge and engage critically with broadcast TV and mainstream cinema.

Through video women artists have challenged and continue to challenge the stereotypes governing the representation of their role and status, thereby claiming their rightful role as artists in the art history canon and system.

References

Albarracín, Pilar (2018) *Que me quiten lo bailao*, Tabacalera Promoción del Arte, Madrid, Ministerio de Educación, Cultura y Deporte, August 20. Available online: https://issuu.com/elvivero/docs/pilaralbarraci_n-190221-ok-lr (accessed August 26, 2021).

Betterton, Rosemary (2010), "Maternal Embarrassment: Feminist Art and Maternal Affects," *Studies in the Maternal*, 2 (10). Available online: https://www.researchgate.net/publication/290233114_Maternal_Embarrassment_Feminist_Art_and_Maternal_Affects (accessed August 26, 2021).

Borzello, Frances (1998), *Seeing Ourselves: Women's Self-Portraits*, New York: Harry N. Abrams, Inc.

Cremona, Cinzia (2019), "Desire for More," in Laura Leuzzi, Elaine Shemilt and Stephen Partridge (eds.), *EWVA European Women's Video Art*, 41–54, New Barnet: John Libbey Publishing.

Elwes, Catherine (2005), *Video Art: A Guided Tour*, London: I. B. Tauris.

FADLive (2011), *Pipilotti Rist, Eyeball Massage, Hayward Gallery*. Directed by Laura Bushell. October 25, 2011. Video, 3:38. Available online: https://www.youtube.com/watch?v=EmJBdLUN2eQ (accessed August 26, 2021).

Gioni, Massimiliano (2019), "Underwater Love," in Pipilotti Rist, Lærke Rydal Jørgensen and Tine Colstrup (eds.), *Pipilotti Rist: Open My Glade, Louisiana Museum of Modern Art, Humlebæk, March 1, 2019 to June 23, 2019*, [Exhibition catalog], 57–9, Humlebæk: Louisiana Museum of Modern Art.

Krauss, Rosalind (1976), "Video: The Aesthetics of Narcissism," *October*, 1: 50–64.

Leuzzi, Laura (2019), "Self/portraits: the Mirror, the Self and the Other. Identity and Representation in Early Women's Video Art in Europe," in Laura Leuzzi, Elaine Shemilt and Stephen Partridge (eds.), *EWVA European Women's Video Art in the 70s and 80s*, 7–24, New Barnet: John Libbey Publishing.

Medina, Cuauhtémoc (2004), "La Perversión De La Spanish Doll," in *Pilar Albarracín: Del 16 De Septiembre Al 31 De Octubre De 2004, Reales Atarazanas De Sevilla*, Sevilla: Junta de Andalusía, Consejería de Cultura, Caja San Ferdinando. Available online: http://www.pilaralbarracin.com/textos/medina_eng.pdf (accessed August 26, 2021).

Meskimmon, Marsha (1996), *The Art of Reflection: Women Artists' Self-Portraiture in the Twentieth Century*, New York: Columbia University Press.

Mulvey, Laura ([1975] 1999), "Visual Pleasure and Narrative Cinema," in Sue Thornham (ed.), *Feminist Film Theory*, 58–69, Edinburgh: Edinburgh University Press.

Risley, David (2019), "Everything Flows," in Pipilotti Rist, Lærke Rydal Jørgensen and Tine Colstrup (eds.), *Pipilotti Rist: Open My Glade, Louisiana Museum of Modern Art, Humlebæk, March 1, 2019 to June 23, 2019*, [Exhibition catalog], 72–81, Humlebæk: Louisiana Museum of Modern Art.

San Francisco Museum of Modern Art (2011), *Why Pipilotti Rist Works with Video*. Video, 1:43. Available online: https://www.youtube.com/watch?v=br1C5ONEt_c (accessed August 26, 2021).

Sedeño Valdellós, Ana (2011), "El videoarte en España y Andalucía: historia, contexto y artistas más destacados," in Ana Sedeño Valdellós (ed.), *Historia y estética del videoarte en España*, 25–42, Salamanca: Comunicación Social Ediciones y Publicaciones.

Westgeest, Helen (2015), *Video Art Theory: A Comparative Approach*, Chichester: Wiley Blackwell.

Zwick, Sus (2016), *Japsen 1988, Muda Mathis/ Pipilotti Rist*. Video, 11:48. Available online: https://vimeo.com/179321222 (accessed August 26, 2021).

Spirit of Creation—between Documenting, Expressing, and Archiving

Interview with AnAkA

AnAkA is a US-American multimedia artist and anthropologist who works with a variety of media formats, including film, music, and photography—both analogue and digital. The decolonization of media and art practices is a central theme for the founder of Aktiv8. AnAkA's work focuses particularly on documenting and archiving as a means of addressing the erasure and banishment of Afro-Indigenous practices through colonial oppression.

Your work is very complex and you have developed your own media forms and positions and hybridized them to create your own specific aesthetic in your multimedia work. It is remarkable that as an anthropologist you always think about the subject (specifically the relationship between subject and position of media). What are the advantages or disadvantages of having such a reflective approach to theory and practice?

Wow, firstly thank you so much for recognizing the complexities! I am so grateful first of all to my parents and my ancestors for being such supportive and creative beings. I would also like to raise up the names of Katherine Dunham and Zora Neale Hurston, who both showed me how Black women can not only be anthropologists but also iconic artists and cultural practitioners. The advantage of having a reflective approach to theory and practice first and foremost is the ability to be decolonizing the practice while embodying it. I am Black, white and Indigenous American—the most American person ever—so I have a very abstract yet specific idea of how the world works based on how it has been affected by theory and research. I am interested in creating a body of work that serves those who the research is about rather than continuing the colonial culture of us being subjects. Instead of studying through my work, I am using my multimedia practices to embody the works and to continue to be a reflection of my global community. My work is complex and shapeshifts often because it is firstly a spiritual practice in order to honor the ways my cultures have become what they are. It is also a shapeshifting practice because I am very mindful of preserving the sacred wisdoms of the world from a perspective that is empowering.

Your videos often feature a wide variety of media forms. You film not only digitally, but also use analog or older digital cameras, later merging the footage. How important is the use of different materials, which have their own temporalities, for you?

I feel the most at home using analog techniques for music, film, and photography. I tend to also use digital cameras and recording techniques, but I made sure to first learn about the practice from a film perspective. This is because in film and photography, light literally imprints onto the film. I purposefully choose to learn how to create at the source, the beginning point of how things are created. Because my practice is all about honoring the creator first and foremost, the Spirit of Creation, I seek to practice in whatever way is necessary to get to the root of healing. It is important to use materials even such as herbs and tattooing because these are modalities for communicating—not only with other people and cultures but also with the elements themselves and the Spirit World beyond. I use different materials to honor the past, present, and future. Playing between these different temporalities is a way that I communicate with myself beyond the societal structures in order to reclaim the power of myself and my ancestors, who have been severed from true free expression. So, when documenting others through film, I do this from a perspective of honoring all they represent beyond what the eye may see. This way their Spirit can also shine within the frame. Layering digital footage and analog footage creates a conversation of texture within the inner world and outer world of the self, and how we are able to navigate these temporalities.

As an anthropologist working ethnographically, one enters the lives and realities of others, whether as an observer who is actively involved in their environment or as someone who tries to create an objective picture of what he experiences and sees. This depends on the media which is used, but also on how the subject is positioned and depicted in their environment. Where do you see yourself and what role do the media play for you in this context?

As a person who grew up in America, my ancestral practices have been very severed as a result of the colonization of the land and the transatlantic slave trade. As a child, I felt this huge gap in self-awareness in my spirit. I also grew up Black in a very white part of the USA (Portland, OR), so I was feeling very drawn to go out into the world and find the ones who are keeping up their cultural practices and artistic expressions. This is because I had to witness so many moments of when Black and Indigenous American cultures were stomped out, legitimized, and belittled due to colonized cultural beliefs. I see myself first and foremost as the one who seeks to remember everything that has been forgotten in my lineage. I seek to remember what vibrates with me on a spiritual level so I can reprogram my lineage into a decolonized one. So many structures and systems have been put into place to separate us from these memories, and documenting with film and photography is a way to ensure that the memory can be shared with the children and the rest of the community. The media for me plays a role to record my memories as I am entrusted by them to archive their sacred wisdom and movements.

While you work with different media forms you also inhabit different positions. You are a director, a photographer, an editor, sometimes all at once. To what extent do the different media positions you adopt determine your specific aesthetics?
I honestly know how to do multiple positions of filmmaking and photography because that is how I have been able to build myself up in the industry and understand how to create a film and photo production. I think learning how to direct, edit, photograph, and be a director of photography helped me build my aesthetic with a hands-on approach. I honestly did not seek to create an aesthetic, I let it happen organically as I kept creating things. I sometimes believe that a person outside of me can see my aesthetic more easily than I can see it myself. The main consistency I keep alive is the energetic intention of telling the story. This way, it does not matter which role I play as long as I am focused on building the intention. As I've harnessed my powers in these mediums, I have felt called toward directing and photographing as the main actions I am most passionate about. I am even currently starting to do production design for films because my experience of direction and photography has led me to believe in focusing specifically on creative direction.

Do references to avant-garde artists of the 1970s and 1980s play a role in your creative process? Is the fusion of art, video, and performance play inspired by the Afrofuturism movement, a possibility to create a Black video aesthetic?
As I said before, I do not create my works with a specific goal of an aesthetic. I mostly create my works from an organic space of wanting the truth to be told in an authentic way. The beauty of being Black is that we have so many diverse experiences, even when looking particularly at the Black American experience. I am able to see my elders and ancestors who impacted the 1970s and 1980s and witness how their art has made such an impression on the current times. I am particularly influenced by Sun Ra, Laraaji, and Earth Wind and Fire. These are all musicians and overall creatives that have been a part of my life since childhood. The Afrofuturism movement is actually a modern name for what they were doing. In order to create a world where we desire to be here as Black people, we must use our imaginations a lot. I embody this desire and this theme of Afrofuturism just by being Black, so by being an artistic creative it becomes natural for my works to fit within the Afrofuturist framework. However, I do not think it is necessary to say I create a Black video aesthetic because it is more than an aesthetic at that point. I am a part of a culture of people who can use film and photography as a form of expression and archiving. My main intention with my works is to help fill the void where art and archiving of Black culture is nourished by a Black person and not by an institution or colonial entity that is exploiting Black culture. My fusion of art, video, and performance is a way to share the many ways being Black is embodied in the physical, cosmic, and spiritual worlds. I must use many forms of expression in order to embody all the ways my culture communicates with the ancestors, with each other, and with the elements. I think this emotionally is what ties the world to our work and our culture, and what makes people of all races emotionally connect to the arts of Black people: we are able to communicate through our expression

fearlessly to all realms because in order to exist here, we must be masters of our own imagination and belief.

While creating, do you plan to design an aesthetic that is spiritual, that points to something (e.g., nature, energy, healing, dance, clothing and jewelry, and colors)—is this also about overcoming something? Where do your ideas come from?
While creating for a client I am often finding ways to bring an overall spiritual message into the concept that has already been created. This is how I see a way to connect to the collective consciousness despite the individual's background. The nature and the energetic forces of life are two main places I go to in order to find a universal connection point for the creatives and for the audience. However, in my own personal works, I tend to work in a flipped way: I trust that I know what the spiritual meaning is and plan out more the technical elements in order to communicate this. I like to emphasize that my eye is connected to how I receive messages from my Higher Self (my Ori) and from my ancestors. How I see the world is through the beauty and healing elements of nature, of my lineage, and of my ways of expressing myself. My works naturally reflect the action and the faith to overcome oppression in order to live freely. This is because I was born into a system that does not prioritize the freedom of my people and I witness it in so many forms every day. My ideas come from the ability to imagine a world beyond oppression and to imagine the ancient ways that we freely are in tune with the nature and the elements. I tend to try to remember the old ways through my past lives, through my ancestors, and through the elders alive now who can show me healthier ways to live. My ideas also come from my deep studies of herbalism, where I get to learn not only what herbs do for the physical body but also what herbs do for the emotional, mental, and sAs with other areas of Spiritual bodies. The power of energy and nature are elements you will see in all of my works because I consider myself a student of life and I also want to help bring more faith for the lives of those who are marginalized.

You work with many Black female artists like FKA Twigs, OSHUN, and Georgia Anne Muldrow. Female Black Empowerment can be found in almost all your videos. The videos that you directed develop a dynamic and reference structure that is constituted out of certainty. What is the concept behind this?
I work with many Black female artists because I am a Black femme and these are the people in my community I relate the most to. It is quite simple and easy for me to connect with Black femme artists because there are a lot of parts of the process where we don't need to over explain things to each other. This way we can focus on the main intention of the works and share a similar vision. I prefer this dynamic because it also helps bring the needed respect for Black women into the workspace. We desire a certain level of comfortability that isn't usually granted for us by others outside of our community. By having me direct their films, not only am I able to create a concept for the film that suits their values but I can also ensure that the working environment is a safe space for the both of us. I believe this is a really important reason why clients come to hire me.

Nature is an important subject that can be found in many of your videos (*Mufaro's Garden, Understand Yourself*) and your life, as you are also interested in and work with herbalism. What does the incorporation of nature mean to you? Would you describe it as a means to something, an aesthetic, or something else completely?
I believe my connection to nature is more than an aesthetic, it is a lifestyle. I grew up in Portland, Oregon, where there is a lot of nature. I also have farming as a part of both my father's and mother's sides of my lineage. We are medicine people, farmers, earth tenders, and former slaves. So my bloodline is very deeply connected to nature. I am an herbalist by trade as a responsibility of my lineage, where I was initiated by my grandmother who was a medicine woman I grew up with. The incorporation of nature into my visuals is to bring a peace and a cleansing and/or grounding element to the films and photographs. I see everything as a ritual, as a spell, so I am very intentional about the ways that nature is portrayed. I would like to encourage the world to care for nature more and to appreciate the world more. So I hope by incorporating these elements that I am inspiring others to see the many ways we can connect with nature beyond the physical world. The nature helps us on a spiritual, mental, and emotional level. It has the power to connect us individually to a higher purpose and also collectively.

Besides photography, film, and music, you also do tattoos and focus on healing with herbalism. How would you describe your approach to the elements in your art? What inspires you especially in these many different areas? Do you see these areas as individual art forms or do you see them as interrelated and influencing each other?
My approach to all art forms is to honor the root or the original way that the creation happens. For film and photography I began with analog cameras, and for tattooing I began with hand poke technique. As I developed my practices, I learned what modern tools accelerate my vision while keeping an analog tone. My approach to herbalism is to learn how the body works with the nature in order to stay healthy and to live beautifully. I am focused on the organic elements of beauty in all of my works and how the ancient practices of humans more naturally tapped into how beauty and nature are related. I see everything as interrelated and influencing each other because that is now nature works. I am influenced by the healing for myself that herbs have created, and I am able to hold space for other people through tattooing, film, and photography. They all have my essence in them because I am intentionally creating, so they all come together under my energetic pattern. The same effect happens with my music and my dance, as these are the most ancient ways to encourage energetic healing.

Overall, your work can be described as being composed of many components— both in terms of content and media. Is there a particular approach to this kind of hybrid work? How would you describe these hybridization processes?
I would like for my works to be seen as diverse forms to express the power of ritualistic healing. I don't see myself as only an artist but more as a cultural practitioner who focuses on creative expression as a tool for conjuring an individual and collective sense of healing. I have hybridized my work between personal projects and client works in

order to stay afloat as an artist in a capitalist system. I work as a person who creates content for companies while also creating artistic works for myself and for the AKTIV8 Archive. My goal is to be able to share the importance of a true artistic voice in a way that elevates the messages of those who are marginalized and attacked in the current global systems.

Lastly, we would like to know what specific role music plays for you in music videos in general, and what you think about the interaction of image and music with each other.
I think about the connection between music and film often. I enjoy scoring films and creating music because the sonic vibration is the most easily communicated and understood. Sound is the way creation began, so using music in order to illustrate the emotions and the story of the film is crucial. Sound can communicate the feeling directly to the audience so I consider it very important in order to cultivate the message. Music videos are especially fun to create because they have a particular amount of abstract messaging allowed. Music videos have a lot of freedom in how they are meant to "make sense," which I like because then we can play with portraying the spiritual world a lot more easily. The stories of a song are also flexible depending on the perspective, so I like to share how the song makes me feel by coming up with a story to go with it. Overall the power of music and film is so immense and amazing it really inspires me a lot.

IV

Aesthetics of Popular Media Hybrids

10

Trans* Bowie . . . Trans* Prince

Jack Halberstam

Starmen

> Look out your window I can see his light
> If we can sparkle he may land tonight
> Don't tell your poppa or he'll get us locked up in fright.
>
> <div align="right">(Bowie 1972b)</div>

It is not a question of whether you are or were a fan of David Bowie, it is a question of which Bowie was your Bowie. My Bowie, at various times, was the lightning-streaked face of "Aladdin Sane," the dulcet-voiced soul man of "Young Americans," and the rock god of the Orwellian extravaganza, "Diamond Dogs." I also kept "Station to Station" and "Low" on my turntable for weeks at a time in the 1970s during Bowie's "Berlin" period and listened to "David Live" obsessively, especially the mash-up of *Sweet Thing* and *Candidate* from "Diamond Dogs." For me, as for so many, David Bowie represented a glittering, odd, unearthly reminder that life is about change, risk, madness, and mayhem, and that while our domestic structures work hard to keep the madness at bay, we must be ready at all times to "turn and face the strange."

To understand Bowie, you partly have to understand what England was like in the 1970s and what it meant, in the middle of this gray, ruinous landscape of charred buildings, postwar debris, and financial collapse, to find out that there is a *Starman* "waiting in the skies." This was the message that British youth watching *Top of the Pops* in 1972 would have received loud and clear from a beautifully eccentric and sexy performance of *Starman* by Bowie and Mick Ronson. Dressed in shiny pant suits and wearing high boots and shaggy hairdos, Bowie and Ronson really did look like they had fallen to earth from some distant planet where people had fun, believed in something, and knew they could change worlds.

David Bowie's Ziggy Stardust told us to be receptive to the messages from Mars and other planets; he counseled youth to listen to the secret memos from the Starman, to pay attention to the coded communications from other worlds; he told us that the Starman would only speak to us if we sparkled ("if we sparkle, he may land tonight"), and he taught us that all that sparkles is indeed gold. And no sooner did he create a

persona with which to tell new stories about sex rock and riot than he killed the man and started again.

My first Bowie album was "Aladdin Sane." I studied the cover art for some clues as to who this ambiguously gendered person might be and I thrilled to the persona of the mad lad singing of mortality, protest, drag queens, and race riots in Detroit. I knew no queer people at that time and knew of few escapes from the suffocating normativity of British school life in the 1970s. But I felt that Bowie represented something special, something just out of reach, something or someone that I did not know yet but set off to encounter. With his otherworldly voice that ranged from low growls to ethereal falsettos, and with his calls to rebellion—both social and gendered—Bowie captured the emergent political imagination of a generation. His persona informed and led into the subcultural expressions that followed in punk rock and queer culture. Bowie disobeyed all laws of genre and he merged English glam rock with US soul music, rhythm and blues with jazz, and funk with electronica without seeming opportunistic, appropriative, or dilettantish.

As befits anyone as alien as Bowie, his sexuality was always up for grabs. It was not a question of deciding or confirming whether he was gay (*John, I'm Only Dancing*) or straight (*Be My Wife*), many of his public relationships have, after all, been with women; but Bowie always laid claim to a kind of excess, a set of identities that exceeded norms and expectations and that were some combination of male femininity (Ziggy), masculine exotic (Aladdin Sane), extraterrestrial sexiness (*The Man Who Fell to Earth*), ethereal beauty, originality, and innovation. The word most often used about Bowie, and one I have made recourse to here, is "otherworldly." His reputation as profoundly alien was enhanced by movies like Nicolas Roeg's 1976 space oddity: *The Man Who Fell to Earth*. This movie, like no other (apart from maybe his "walk off" cameo in *Zoolander*! And his voice acting appearance as the king in the *Spongebob Squarepants* movie) confirmed Bowie's status as unearthly. He needed no make-up to be convincing as a man from another world—in the film he is called a "visitor," a "freak," an "alien" and he manages to convey a sense of bodily oddness that is unique in film and that grounds the wild range of his musical styles.

Is there life on Mars? If you believe in David Bowie, the answer is yes. While Earth for Bowie is a place where time is on perpetual repeat (*Always Crashing in the Same Car*), in the exotic and exciting moonage daydreams that Bowie conjures, apocalypse appears alongside utopia, futures are exciting and curtailed ("we can be heroes . . . just for one day"), and the body is a place to play out colorful fantasies of love and rebellion. As we consider the legacy of a truly queer icon, a performer who invited us to "press your space face close to mine, love," we also bid farewell to someone who has reinvented fame, spectacle, eccentricity, and stardom.

The death of Bowie in January 2016, an event mourned widely and noted around the world, was followed in quick succession a few months later by the death of Prince. Prince, who had, only a week before his own death, performed *Heroes* live as a tribute to David Bowie (in Toronto on April 14, 2016), shares with Bowie not simply the year of his death but also a tangential and eccentric relation to masculine stardom. Like Bowie, Prince was not a star but a "starman waiting in the skies." Both he and Bowie

maintained a distance from their audiences because they thought they would "blow our minds" if they came any closer. The otherworldliness of both Prince and Bowie makes them not simply gender ambiguous but somehow in transit, trans* figures with the emphasis on the * or star. While Prince chose another symbol to represent himself after trying to wriggle free of an exploitative record contract associated with the proper name of Prince, the symbol * might have done just as well. Like Bowie, Prince absorbed stardom and launched himself into it as a persona or series of personae with no original self to frame the receding set of images that he set up and knocked down. Both stars wore makeup, dressed in heels and tights, refused to simply come out as queer and made outrageous music humming with sex, exploding with desire, brimming with loss, and threating mayhem at the very least. To be in relation to the music of Bowie or Prince was to stand in the storm hoping, praying that this highly original noise would be enough to shatter the shape of the ordinary once and for all.

My early encounters with Prince were less revelatory than the consciousness raising I had undergone through album after album with Bowie. I moved to Minneapolis to go to graduate school in the mid-1980s and *Purple Rain* was my introduction to the city, to life after punk, to the torture of oedipal repetition ("Maybe I'm just like my father, too bold / Maybe you're just like my mother / She's never satisfied"), to Lake Minnetonka, to sexual variation, to the matching of small men and tall women, to motorcycles. Indeed, one day when I could still barely ride my Honda Dream motorbike, a friend and I rode out to Chanhassen and loitered outside Paisley Park hoping to catch a glimpse of our hero. I never did see Prince in his glory days and only saw him in concert many years later when he had perfected a stage show dependent upon doing the splits many times (a move that certainly led to his hip problems and use of pain killers) and performing encore after encore, often outlasting the audience in energy and stamina. The show was flawless and very rehearsed—a far cry from his unscheduled appearances on stage in Minneapolis.

The Prince song that hooked me early on, apart from the obvious anthems like *Sign of the Times* (1987) and *Erotic City* (1984), was an odd, wistful ballad which was hard to find in its original 1985 form on any album, but that was passed around on cassette tape among people in Minneapolis in the late 1980s. The song, *Old Friends for Sale*, never surfaced officially. The version that appeared on the much maligned album "The Vault" was weaker and lacked the anguish of the original. The original version of the song is bluesy and melancholic. It tells of friends lost to drugs, the sting of betrayal, the petty hurts of ambition, the "through the looking glass" world of celebrity ("sun set in the west this morning"), the roller coaster ride of popularity ("people are talking / they say your kingdom is falling"). Unlike the caricatured acting in *Purple Rain* and the lingerie-clad masculine seduction of *Dirty Mind*, *Old Friends for Sale* offered a peek behind the curtain of fame, a chance for those who cared to see a different Prince, not someone getting off on the world's attention, but someone being quietly ripped off by "someone who said they would die for me." "Some things," Prince moans, "are better left unsaid / And some people are better left untrusted." The minefield of fame ("fame, puts you there where things are hollow" sang Bowie) sucked Prince down a rabbit hole of mistrust and in this song, from very early in his career, he proposed that he would

not live to see the arc of friends' betrayal, how it might play out, what it would mean for his legend—"maybe, maybe, maybe it'll all make sense when I'm dead."

That song haunts me still. It is a beautiful, flickering elegy to a life lost, a persona swallowed up by the industry and spat out on the other side of an exploitative contract. Like Bowie, Prince was well aware that the struggle was not with fans or even with false friends, it was with the monstrous music industry for which stars were just sources of revenue. Bowie's solution was to kill his alter egos and break up the band before the industry had a chance to batten on their live bodies or to declare them dead. Prince's method was to try to disappear behind a new name, a new symbol and re-emerge under his own sign. For both Bowie and Prince, the stage was a place to confront past and present, musical histories, and political futures, it was a place to transform, shapeshift, die, and be reborn. It was a platform for constant motion. It was a launching pad not for a career but for a ride into the stratosphere of human talent and experience. Bowie and Prince are both starmen, waiting in the sky, they'd like to come and meet us, but they know they'd blow our minds.

Rebel Rebel

> You've got your mother in a whirl
> She's not sure if you're a boy or a girl
> Hey babe, your hair's alright
> Hey babe, let's go out tonight.
>
> (Bowie 1974d)

Prince and Bowie for me, as for so many people, represented the possibility of stretching beyond social norms and hackneyed cultural forms of expression and generic expectations. Both embodied deeply seductive and intelligent versions of popular culture that wed subversion to accessibility, rebellion to credibility, and transformation to performance. Over the course of long and varied careers in music and performance, David Bowie and Prince were able to sustain, with considerable vigor, meaningful and lasting relations to musical experimentation—and in different ways, both musicians were able to articulate those experiments through bodily gestures and a series of ambiguously gendered personae.

While Bowie looked up to the sky and sang of spacemen, heroes, apocalypse, changes, riots (*Panic in Detroit*), madness ("Aladdin Sane"), and glamorous night worlds, Prince fell to earth and penned raunchy anthems about sex and bodily experiments. Bowie, who came up in the original Space Age of the moon landing and various Apollo missions, crafted idioms of extraterrestrial life and unearthly consciousness. His work is not exactly science fiction, but there is more than a touch of utopia in his music and lots of references to off-worlds, fantastic voyages and odysseys into the unknown. For Prince, the Apollo space missions landed in the Midwest and became a different kind of erotic exploration—in *Purple Rain*, his love interest was an actress, Patricia Kotero, for whom he suggested the stage name of Apollonia. Whether orbiting earth on an

Apollo mission then or plunging into the waters with an Apollonian lady, both Bowie and Prince were "floating in a most peculiar way."

On screen, on stage, and in real life, Prince often wore more lingerie than his girlfriends and gave form to a sexy but highly unconventional form of hetero-masculinity. Both Bowie and Prince found and exploited space within the, often constricting, confines of heteronormative conventions and tipped masculinity to the point of an eccentric and slightly shocking form of performative femininity. As mentioned earlier, Bowie played up his androgyny and sexual ambiguity and he never denied rumors about his bisexuality. That said, Bowie also, famously, regretted claiming to be bisexual and later described himself as a closet heterosexual.[1] "Closet heterosexual" is not a bad description for Prince either. Like Bowie, Prince pioneered a gender-bending style that both emphasized his virtuosity and uniqueness and brought out a queerness and a transness that exceeds simple divisions between gay and straight or trans and cis and that offers access to complex, polyrhythmic worlds of love, lust, apocalypse, and heartbreak. Prince, a favorite icon for drag kings in the nineties and a figure so unclassifiable that for a while he refused a name and instead was known by a symbol, combined an authoritative ability to improvise and innovate with a playful tendency to flirt and seduce. The sign that Prince used for a while to stand for his performance persona, a symbol commonly known as "the love symbol," combined the signs for man and woman. Prince used this symbol in an effort to part ways with his record label, Warner Bros., which, he felt, was exploiting him and his music in a way that, he said, could be called "slavery." By using an unpronounceable symbol, Prince felt that he could interrupt the label's plan for squeezing the maximum amount of profit out of his work. By calling attention to the unjust ownership of Black music by white-run labels and by recognizing that this ownership of Black culture extends through the gender stabilizing insistence on naming and classification, Prince refused to obey the laws of gender, genre, or generic marketing. His refusal of a name, his attempt to slip the net of classification altogether, and his decision to use a multiply gendered sign instead are part and parcel of a set of fugitive practices deployed by African Americans in the long afterlife of slavery. Hortense Spillers has shown how the production of gendered bodies within slavery in terms of the emasculation of Black male bodies and a scrambling of paternity, maternity, and kinship itself leaves a legacy within which "the historic outline of dominance, the respective subject positions of 'female' and 'male,' adhere to no symbolic integrity" (Spillers 2003: 204). This project of confronting the marketing strategies of a rapacious music industry was given full expression in Prince's music also where he sidestepped conventional gendered performances and inhabited a vocal range that veered abruptly from low growls to falsetto trills.

Bowie and Prince posed questions of sex, gender, and identity to their audiences in the form of "what ifs" or hypothetical questions about potential scenarios, desires, forms of being. Bowie's career was filled with shifting personae and he moved fluidly in and out of shapes, sounds, and visions. Similarly, Prince muddied the waters of his purple presence and was read variously as a closeted gay man, a transvestite, a secret

[1] David Bowie described himself as a "closet heterosexual" to the *Rolling Stone* in 1983 after claiming at earlier moments to be gay. For a survey of his sexual fluctuations see Clews 2013.

heterosexual, a Christian fetishist, and so on. The trans* element of each artist emerges out of their mobile relations to desire and identification. The trans* genres that they produced and inhabited include gender ambiguous or gender switching songs that sow willful confusion at the level of voice and address. Such songs are often sung in the second person singular as a form of intimate dialogue, and they involve the fantastical projection of a "what if," a harmonic hypothetical, a question, a speculation, a transposition. The genre ranges from rebellious gender-bending anthems (*Rebel Rebel*) to melancholic songs of disappointment and loss (*Sometimes It Snows in April* and *If I Were Your Girlfriend*) and the flexibility of gender forms a contrast to the inflexibility of other forms of social identification.

Prince often imagined himself into a queer and even trans* relation to heterosexuality. And he is not alone in this practice in Black pop performance. Beyoncé, just to give one other example, also fantasizes in one "hypothetical trans*" song about being a boy in order to access the privileges of hetero manhood. In his "what if" or "hypothetical trans*" narrative, Prince indulged in a hot fantasy of accessing his girlfriend's intimate realms by being or becoming her "girlfriend." In his 1987 song, *If I Were Your Girlfriend*, he poses as his lady's best friend and so occupies a trans* position in which he switches gender, sneaks into the henhouse of female beauty, and inserts himself into a different kind of intimacy with his woman—the song is dizzying in its queerness, bathed in a unique if hetero-pornographic lesbian eroticism and articulate about the desire to be and to have the female object of desire. Like a female friend, he sings in a falsetto to his lover, he would wash her hair, bathe her, watch her get ready and in turn he would dance for her, join her in crying at a movie and share her secrets, her fears, her desires. If he was her girlfriend, the singer proposes, he would have access to all that he lost when he became her man. Here the trans* aspiration is both expressed in that all too conventional visual idiom of hetero-pornographic fantasies of two women performing for the male gaze but it also expresses itself more interestingly as a kind of vocal transitivity. The song inhabits, in fact, a wide range of positions under the heading of Black heterosexuality and absorbs queer, patriarchal, and feminist discursive positions into one breathy ballad of desire.

But for all that, the song can also be read as plainly *lesbian* and as such it forces the listener to realize how few songs there are within which a male-bodied singer longs for a lesbian relation to his female partner. Like a dog whistle for queer artists, *If I were Your Girlfriend* attracted a host of queer artists who clearly heard the lesbian overtones of the song. For example, Prince's song became the foundation for a queer lesbian response song a decade later in 1997 when Queen Pen and Meshell Ndegeocello teamed up in a response to the hypothetical trans* song by Prince. "If I was your Girlfriend" he sang, "if she was your girlfriend, she wasn't last night" respond Queen Pen and Meshell Ndegeocello.

In this Prince song, in the lesbian response song, and in another trans* hypothetical song by Beyoncé (*If I Were a Boy*), the cross-gender wish emerges within the context of a queered landscape of Black heterosexuality. But it also names these cross-gender desires by way of a language of youth—the love object and the lover are "girls" in the Prince song and in Beyoncé's classic anthem *If I Were a Boy*, she deliberately uses the terminology of *boy* rather than *man*. These terms, which have worked as diminutives within an archive of anti-Black racism, operate here to stall the violence of adulthood

and to prolong the period of hopeful fantasy that can sometimes limn the experience of childhood. The fact that Prince and Beyoncé suture themselves to hypothetical trans* subjectivities implies that they find a latitude—breathing room if you like—in the categories of "girl" and "boy" that quickly seal over in the rush to adult heteronormativity. It also suggests that Black heterosexuality and white heteronormativity are not the same thing. These songs of wistful longing, empathic identification, and desire project both across gendered bodies and across time, reaching back to the seemingly more flexible embodiments of "boys" and "girls."

Beyoncé's queer anthem is not necessarily trans but may be trans*. *If I Were a Boy* (2008) does not feature the narrative voice of a person born into a female body but wishing for a male one as much as a heterosexual woman wondering what it must feel like to have male privilege. Even though the song registers as heteronormative in its orientation and articulates a heterosexual frustration that Lauren Berlant has named in various works as "the female complaint" (Berlant 2008), nonetheless, in its fleeting hypothetical fantasy ("If I were . . ."), it names a common trans-masculine fantasy of becoming not just a man but a better man than those male subjects who have no idea how it feels to be a girl in a hierarchized system of gender. The conditional tense of the song—*If I Were a Boy*—reminds us of the contingency of gender even as it gives voice to the yearning, the longing, the once impossible desire that trans people have felt about becoming the gender they feel themselves to be.

The song is about being and becoming, but it is also about the differences between men and women that heterosexuality both constructs and enforces and the lack of access that most men have to the experience of being woman and vice versa. When Beyoncé does not sing "If I were a man . . ." but instead offers "If I were a boy . . ." she makes a sly nod to the racialized terrain of manhood and reminds the audience that privilege and access are multiply layered through vectors of race, class, and appearance among other things. The hypothetical gendered wish that Beyoncé frames gets refracted through the limited privilege that Black manhood actually represents within a white supremacist world, and it offers a utopian gender aspiration girded by dystopian reality. The queer and trans* valences of the song and their extra-human aspirational qualities emerged in a surprising video for a British toy company (Smyths Toys Superstores) where the song was retooled as *If I Were A Toy* (2014, used for example in Smyths 2020) and a little boy fantasied about occupying a range of nonhuman positions in toyland including, at various points, a queen, a motorbike, and a rocket! The gender-bending set of desires was established within the song as unremarkable and appealing in a world where fantasy is everything. For Prince too, fantasy is everything. He sings in *Old Friends for Sale*: "But life is no fun, life ain't no fun without fantasy." By juxtaposing these hypothetical trans* songs, the fantasies of gender transformation entertained by Prince, Meshell, Queen Pen, and Beyoncé, we can see the long-lasting and yet not frequently noted influence that Prince has had on Black female performers. Beyoncé indeed is often mythologized as sui generis but in fact the comparison to Prince is a reminder of how much she must have learned from the purple one.

Bowie too favored the diminutive form of "boys," and he also modeled as the lesbian partner of his girlfriend! But for Bowie, the term "boy" was part of a critique of white

male heteronormative culture that he launched in *Boys Keep Swinging* (1979). While in that song, Bowie took aim at the laddish privileges afforded to white men in British culture—"Heaven loves ya / The clouds part for ya / Nothing stands in your way / When you're a boy"—in earlier stages of his life he often appeared to be channeling his inner lesbian. For example, in his early relationship with Angie Bowie, the two looked more like a butch-femme couple or andro twins than heterosexual husband and wife! But on account of his hit, *Boys Keep Swinging*, he, like Prince is often read as gay or as a figure who channels gay male energy. *Boys Keep Swinging*, for me, is not a very interesting song even though Bowie appears in three different forms of drag in the video that accompanies it. But Bowie has many other trans* songs in his archive (like *She's Got Medals*, about a female-bodied person who passes as a man and joins the army and then ditches everything when guns start firing) and the transitivity of Bowie's aura lies not in some clear articulation of gayness or homo desire, it can be found rather in his voice.

For example, in *Sweet Thing*, we can locate a trans* voice in the swooping vocals that paint a "portrait in flesh" while singing of a city thick with sin and peopled by hustlers and cruisers, lovers in doorways and pimps crooning "boys, boys it's a sweet thing." Similarly, in *Wild is the Wind* from "Station to Station," Bowie pays tribute to Nina Simone meeting her low-slung love song with a faster-paced and deeply felt hymn of passion—"you kiss me, with your kiss my life begins." Like Prince, and like other rangy male singers such as Jimmy Scott, Bowie's vocals were most obviously influenced by great female singers such as Roberta Flack, Joan Armatrading, Joni Mitchell, Nancy Wilson, and he sings well at both the high and low ranges of his vocals paying tribute to female divas in some songs and finding a funky bass zone in others.

Prince also used the falsetto range well and his best falsetto songs like *Nothing Compares to You* have indeed been covered by female singers suggesting that the gender flexibility that he routes through Black heterosexuality is more than just gender-bending. Prince's falsetto's is a tribute to Sylvester and Smokey Robinson among others, a refusal to define masculinity in terms of a repudiation of (Black) femininity, and a staging of virtuosity that exceeds the bodily boundaries imposed by normative gender. Both Bowie and Prince, in this respect, are and were heroes who rewrote the script of heroism, boyfriends who rewrote the script of heterosexuality, singers who eroticized the throat and opening as much as the guitar and thrusting, icons for whom fame was just an unfortunate by-product of pursuing their art. They were stars in the sky and not stars in the celebrity sense. They were starmen, sparkling figures in the Barthesian sense of the word to sparkle, they were real stars, bright stars, they were Black stars.

Coda—Blackstar

Bowie left us a final album to decode, "Blackstar" (2016), where he intones:

> "I can't answer why (I'm not a gangster)
> But I can tell you how (I'm not a flam star)
> We were born upside-down (I'm a star star)

Born the wrong way 'round (I'm not a white star)
(I'm a blackstar, I'm not a gangster
I'm a blackstar, I'm a blackstar
I'm not a pornstar, I'm not a wandering star
I'm a blackstar, I'm a blackstar."

(Bowie 2016)

Not a white star, not a gangster, not a wandering star, a black star—Bowie's final message, part physics/part undercommons, draws upon the metaphors of space that saturate his entire output. A black star in physics represents, Wikipedia tells us, "a transitional phase between a collapsing star and a singularity," it is a zone where event and infinity collide, where matter disintegrates into a vacuum. It is a space of death and dying. But black star could also be a way of rethinking racialized embodiment itself such that the thin white duke recognizes himself in the Black aesthetics that swirl through his music, the soul inflections that he channels and inhabits and the machinery of fame that works through a process of Black music/white stars, transferring fame to white bodies from music created through and around the experience of Blackness. "I'm a blackstar," Bowie sings, "I'm a blackstar." So, while we attribute some of Bowie's incandescent oddness to gender and sexual ambiguity, race is also a huge part of what rendered Bowie a star—not a white star, not a pornstar, not a wandering star, but a black star.

As Bowie and Prince now pass into immortality, as they assume legendary proportions, as they come to represent the expansiveness of wild reinvention, musical experimentation, bodily flexibility, political imagination, and queer uncertainty, we should look up to the sky and sparkle in the hopes of receiving messages from pop culture's most beloved astronaut, the starmen waiting in the sky. And, just as scientists and ecologists recently moved the Doomsday Clock thirty seconds closer to the end of mankind's final hour, so the combined efforts of Bowie and Prince and our continued engagement with them nudge the clock forward allowing us to "steal time, just for one day."

References

Berlant, Lauren (2008), *The Female Complaint: The Unfinished Business of Sentimentality in American Culture*, Durham: Duke University Press.
Bowie, David (1967), *She's Got Medals*, track 5 (side two) on *David Bowie*, Deram Records.
Bowie, David (1971), *Changes*, track 1 on *Hunky Dory*, RCA Records.
Bowie, David (1972a), *John, I'm Only Dancing*, track 2 on *John, I'm Only Dancing*, RCA Records.
Bowie, David (1972b), *Starman*, track 4 on *The Rise And Fall Of Ziggy Stardust And The Spiders From Mars*, RCA Records.
Bowie, David (1973), *Panic in Detroit*, track 4 on *Aladdin Sane*, RCA Records.
Bowie, David (1974a), *Candidate*, track 4 on *Diamond Dogs*, RCA Records.

Bowie, David (1974b), *David Live* [album], RCA Records.
Bowie, David (1974c), *Sweet Thing*, track 3 on *Diamond Dogs*, RCA Records.
Bowie, David (1974d), *Rebel Rebel*, track 6 on *Diamond Dogs*, RCA Records.
Bowie, David (1975), *Young Americans* [album], RCA Records.
Bowie, David (1976), *Wild is the Wind*, track 3 (side two) on *Station to Station*, RCA Records.
Bowie, David (1977a), *Always Crashing in the Same Car*, track 5 on *Low*, RCA Records.
Bowie, David (1977b), *Be My Wife*, track 6 on *Low*, RCA Records.
Bowie, David (2016), *Blackstar*, track 1 on *Blackstar*, ISO, Columbia and Sony.
Bowie, David and Brian Eno (1977), *Heroes*, track 3 on *Heroes*, RCA Records.
Bowie, David and Brian Eno (1979), *Boys Keep Swinging*, track 3 (side two) on Lodger, RCA Records.
Clews, Colin (2013), "1983. David Bowie Changes his Mind about Being Gay," *GAY in the 80s*, April 29. Available online: https://www.gayinthe80s.com/2013/04/1983-david-bowie-changes-his-mind-about-being-gay/ (accessed May 14, 2022).
Knowles-Carter, Beyoncé G. (2008), *If I Were a Boy*, track 1 on *I am Sasha Fierce*, Columbia.
Oscar Smyths (2020), *Oscar Smyths—If I Were a Toy (Official Video from the Smyths TV Ad)*. October 14, 2020. Video, 2:21. Available online: https://www.youtube.com/watch?v=qAlorzLNvH4 (accessed May 14, 2022).
Prince (1980), *Dirty Mind*, track 1 on *Dirty Mind*, Warner Bros.
Prince (1984a), *Erotic City*, track 3 on *Let's go Crazy*, Warner Bros.
Prince (1984b), *Purple Rain*, track 4 (side two) on *Purple Rain*, Warner Bros.
Prince (1986), *Sometimes It Snows in April*, track 12 (side two) on *Parade*, Paisley Park and Warner Bros.
Prince (1987a), *If I Were Your Girlfriend*, track 2 (side three) on *Sign o' the Times*, Paisley Park and Warner Bros.
Prince (1987b), *Sign o' the Times*, track 1 (side one) on *Sign o' the Times*, Paisley Park and Warner Bros.
Prince (1999), *Old Friends 4 Sale*, track 8 on *The Vault: Old Friends 4 Sale*, Warner Bros.
Purple Rain (1984), [Film] Dir. Albert Magnoli, USA: Warner Bros. Pictures and Purple Films.
Queen Pen and Me'Shell Ndegeocello (1997), *Girlfriend*, track 11 on *My Melody*, Lil'Man and Interscope.
Spillers, Hortense J. (2003), "Mama's Baby, Papa's Maybe: An American Grammar Book," in Hortense J. Spiller (ed.), *Black, White and In Color: Essays on American Literature and Culture*, 177–203, Chicago, IL: University of Chicago Press.
The Family (1985), *Nothing Compares to You*, track 6 (side two) on *The Family*, Paisley Park and Warner Bros.
The Man Who Fell to Earth (1976), [Film] Dir. Nicolas Roeg, United Kingdom: British Lion Films.

Black Queen and King

Iconographies of Self-empowerment, Canon, and Pop in the Current Music Video

Kathrin Dreckmann

Recent music video productions make striking use of a motif from European art history that has been known from antiquity up to the present. It oscillates between glorification, self-empowerment, and enthronement. The use of this motif is above all pioneered in productions of young Black artists who critically question the European concept of the canon. This concept has grown historically, established itself academically and institutionally, and formed the reference point of a history of art itself. It becomes phenomenologically visible when the commodity value of artworks is discussed in feuilletons or while auctioning off artworks worth millions. Works of art whose value is quantified in dizzying sums are, for example, works by Leonardo da Vinci, Pablo Picasso, Amadeo Modigliani, Francis Bacon, and Edvard Munch. However, the aura of the work of art does not only include its often monetary value, which is sometimes hard to imagine, but rather also the place where the work of art is sacrally staged. According to Walter Benjamin, this place is so significant because it shows the works of art as originals and not "merely" technically reproduced copies.

In the digital age, images and also images of images are technically reproduced. In the age of social media, images "which we regard under given contextual conditions as analogically notated realisations of a possible order of the visible" (Majetschak 2003: 43)[1] are used differently. It would go too far to go into detail about different practices, modes of design, theories, aesthetics, and politics of images in this contribution. Central to this study is the realization that "images do not usually appear in isolation, but in conjunction with other media forms, such as sound or writing, with which they interact in complex ways" (Schröter 2022: 95).[2]

[1] Own translation.
[2] Own translation.

In the age of mass media processing and distribution, images are no longer bound to a single place, as Benjamin claimed. Instead, there are special institutions and architectures that claim for themselves both monetary and cultural-historical trade with originals. In addition, there is the political dimension of art and images which is linked both to the value of money, fame, and the power to bring the past into the present. If we may assume that we are surrounded by images that do not implicitly or explicitly convey a political message and that the political language of images recurs to a past, the symbols and intentions of political images of the past always correspond to those of the present and thus refer to an "order of the visible." The spectrum of subjects ranges from audiences to assassinations, from popes and princes to partisans and parliaments (Fleckner, Warnke and Ziegler 2011). The Louvre may certainly be considered one of the most important places of image and art production in Europe and, at the same time, the place of visual orders of the past. It is the pictorial memory of Europe that is staged and housed there in magnificent architecture and in the form of paintings. The most expensive paintings in the world are housed there, and the history of the works exhibited there is itself linked to the building. Kings and emperors have cared for the artistic memory since the musée du Louvre was built, and in so doing have also nurtured the legacy of their own glory.

Kings in the Louvre

Louis XIV's use of artistic representations was a good example of the successful staging strategies of "organized glorification." His media representation is reminiscent of "modern advertising" (Burke 1993: 12).[3] Even his Baroque ruler portrait by the painter Hyacinthe Rigaud, which can be seen in the Louvre, shows the well-known absolutist ruler who sought above all to influence public opinion and justify his rule through his manipulative image policy (Burke 1993: 10–12). It is precisely the "relationship between art and power and especially for the consideration of the theme of the 'production of great men'" (Burke 1993: 10–12)[4] that lends itself to Louis XIV. According to Peter Burke, the interpretation of art is essentially always concerned with "communication, the production, circulation and reception of symbolic forms" (Burke 1993: 9),[5] especially when it comes to looking at the staging strategies of kings in art history and highlighting coronations and royal significance in the media.

In the history of art, such visual staging strategies have been developed in different ways and their connection to political visual programs is sometimes more articulated, sometimes less. The Sun king may be an extreme example, whose political and media staging strategies can be compared with those of Richard Nixon or Margaret Thatcher,

[3] Own translation.
[4] Own translation.
[5] Own translation.

but the history of art has always been characterized by political messages and directives. However, other examples can be found that can be understood as a justification of ruling in the art history of the musée du Louvre.

Now, if the point is that logics of visibility become strong political image programs that spread in the digital media, constellating and reflecting the past and present anew, then the music video *Apeshit* (2018) by The Carters, that is, the union of Beyoncé aka "Queen Bey" and her husband Jay-Z, is a remarkable production. European image programs between glorification, self-empowerment, and enthronement, as found in the original artworks of the Louvre, are linked with the artist's own transcultural image programs between a critique of Eurocentrism, an empowerment strategy, and the aesthetics of the gaze of an Afro-American diaspora.

These hybrid image programs open up hybrid and transcultural orders of visibility. The image in its central functions between religion, art, and science changes its texture here and marks hybrid links between function, aesthetics, and politics.

It is remarkable that the subject matter of queen and king in particular are aesthetically located in Afrofuturism and in the field of recent Black empowerment strategies.[6] Janelle Monáe's references to Sun Ra and Beyoncé's album "Lemonade," which primarily uses Afro-diasporic references and references to the queen theme, show the queen and king metaphor as a concept that deals with the value of Black life and rises up to aesthetically question Western historical canon formation. The king and queen metaphor is itself inherent in Afrofuturism and can be seen, for example, in the sci-fi novels of Octavia Butler[7] and in contemporary productions such as the film *Black Panther* or Beyoncé's *Black Is King*. The cyborg fantasies negotiated in the latter examples, which are linked to outer space utopias, are part of a paradigmatic aesthetic of media strategies between empowerment and agency. In *Apeshit*, the theme of queens and kings' self-empowerment is told from the perspective of Black people on white image power. Music video researcher Carol Vernallis puts it as follows: "The video helps broaden our sense of what counts as art and shifts our anchor points for what matters most" (Vernallis 2018: 12).

[6] The queen and king motif is an important subject matter in Afrofuturism in that as early as Sun Ra, alternative social orders are imagined on an alien planet. Sun Ra, who dressed his Arkestra in campy DIY science fiction robes with Egyptian decor, appears as an Egyptian sun god. The depiction of god-kings is thus already present in the first generation of Afrofuturism and points to the beginning of royal symbolism. This symbol of domination is incorporated in Beyoncé's album "Lemonade" and the film *Black Is King* as well and is clearly linked to "empowerment, resistance, communication, and imagination within popular culture" (Coleman and Smith 2022). Another example of this can be found in Janelle Monáe's work, for example, in the song *Django Jane*.

[7] In Butler's Parable series, for example, the protagonist fantasizes the human colonization of space. This is a metaphor of domination that is not explicitly identified by the naming of queens and kings. A reflection of domination, which is not to be identified as "conquest" of space as a destructive gesture—or more precisely, not as a *dis*covery, but rather a *re*covery, a drawing from one's own human potential, the past, the cultural heritage, the possibility of a (self-)healing.

Apeshit

Megastars Beyoncé and Jay-Z produced their music video *Apeshit* (2018) in the Louvre, a place that may be considered an emblematic building for the cultural hegemony of the traditional occidental order.

In terms of art history, this video is a sensation because, first, it makes works of art (especially from the Renaissance period) accessible to a pop culture audience; second, on a meta-level, it exposes the bourgeois concept of art as exclusively white, thus making the history of knowledge accessible to a mainstream audience as a history of European (image) discourses of power (Ullrich forthcoming).

The fact that European visual history is used as the central point of reference for the video, which is about Black identity and Black pride, is just as astonishing as the appropriation of white art history by Black visual aesthetics that reformulate the orders of visibility. For in the political use of images lies one of their most important areas of validity (Figure 11.1).

The art historian Horst Bredekamp writes in *Image Acts. A Systematic Approach to Visual Agency*: "[T]here is the use of images in politics . . . [O]ne of their roles has always been the representation of dominion" (Bredekamp 2017: 1). It is seemingly reversed here, for Black art does not appear in the canon of occidental art collections, but its representational logics become visible by developing a history that hybridizes white and Black gaze regimes. The choreography by Belgian dancer and choreographer Sidi Larbi Cherkaoui, who had previously worked with Beyoncé for the album "Lemonade," also takes this idea and turns primarily to the gods. He says he was inspired for his choreography by the "mythological goddesses" he expressed

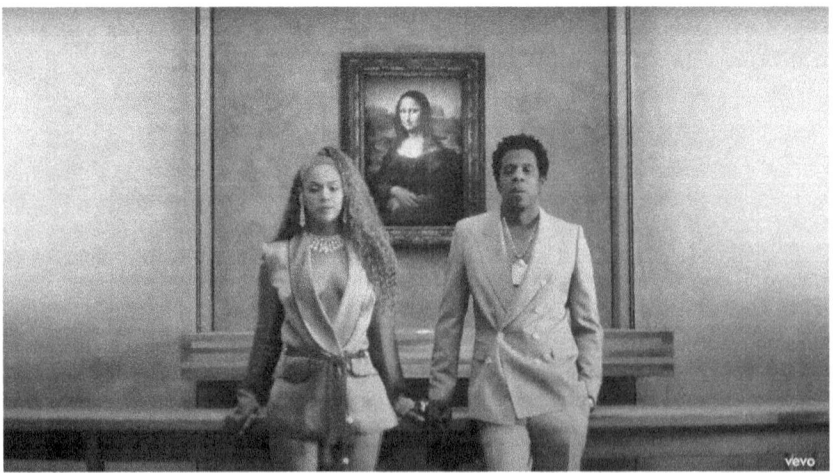

Figure 11.1 The Carters in front of the *Mona Lisa*. *Apeshit* by The Carters, 2018. Screenshot from YouTube.

with choreographies by Martha Graham. He thinks dance, mythology, and art history converge with the artworks exhibited in the Louvre and images used in the video: "There's a lot of narrative in this clip, a lot of story being developed, and it really makes you think about history and culture and what's actually represented in art" (Kim 2018).

Apollo

Beyoncé and Jay-Z have brought the Louvre to pop as a new set of images. Shared, posted, and posed with millions of times: a new flood of images has descended upon the Louvre. The two stars were, after all, the ones who made this new popularity possible ("Beyoncé and Jay-Z help Paris Louvre" 2019) and at the same time linked it to themselves via social media. This operation was so successful that their video was given its own place on the official homepage of the museum and thousands of their fans made the pilgrimage to Paris (Chrisafis 2019). They came, of course, not to see the centuries-old art collected and exhibited there, but to visit the location where the music video was shot (Figure 11.2).

So a reversal of Benjamin's account has taken place here: it is not the original, it is digital reproducibility that has sanctified the place. The Carters as queen and king and at the same time as new icons. From Christianity to pop: unlike Marilyn Monroe, who was staged as an icon by Warhol, "Queen Bey" creates herself out of the (white) canon

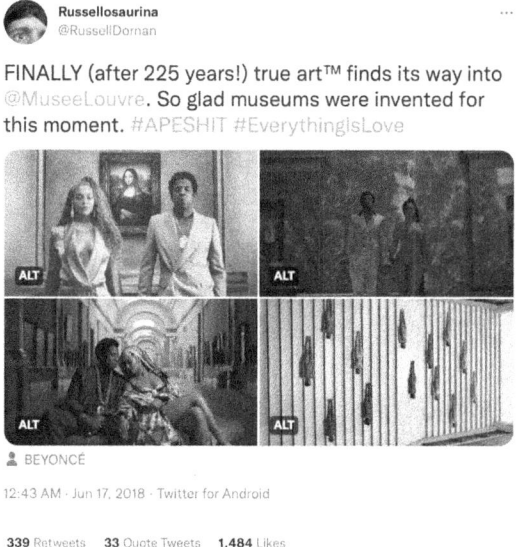

Figure 11.2 A reaction to the Music Video on Twitter. Screenshot from Twitter.

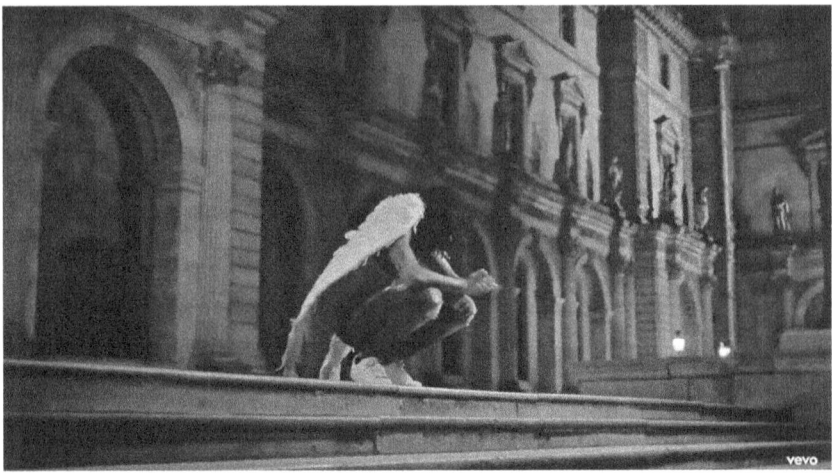

Figure 11.3 Black Icarus in front of the Louvre. *Apeshit* by The Carters, 2018. Screenshot from YouTube.

of art history, she herself as a figuration between Phoenix from the ashes and Icarus reference.

This theme is already evident at the beginning of the video: the Icarus theme is taken up and the rise of the "Queen Bey"—as she is called in pop history—is linked here with the themes of art history and architecture. Thus, in the opening scene of the video, a Black man with a grand piano can be seen in front of the Louvre's entrance (The Carters 2018: 00:05–00:15). It is night and Black Icarus is crouching in front of the museum (Figure 11.3).

Immediately afterward, before the first appearance of Beyoncé and Jay-Z, the Galerie d'Apollon can be seen—a royal gallery first built in the sixteenth century and rebuilt for King Louis XIV after a fire on February 6, 1661. The rise of the two Black artists through popular culture is thematically linked here directly to white art history as represented in the Louvre, and to the Sun king's prestigious project, the Galerie d'Apollon (The Carters 2018: 00:15).

In the video, especially at the beginning, there is a lot of work with cutouts and blatant camera positions in order to draw attention to hierarchies. The camera position from below is contrasted with a position from above. The ceiling fresco *Apollo Slays the Python* by Eugéne Delacroix, which is filmed immediately afterward in a long shot from below and can be seen at the beginning of the video, symbolizes the above, to which Icarus has no access because he is sitting in front of the Louvre— he is outside and closed off (The Carters 2018: 00:17–00:21). In the next scene you see him filmed from above, in the next scene from below the Apollo fresco. In Greek and Roman mythology, Apollo is the god of light, prophecy, temperance, the arts, music, and poetry. Apollo's first act in Lycia was to kill the serpent Python (Ovid 1916: v. 1, v. 434) (which in the Homeric Hymn is a female dragon, in Metamorphoses by

Ovid the python is made of rotting mud) with an arrow. It was through the death of Python that he gained his prophetic powers. The showing of this very painting by Delacroix in the *Apeshit* video transfers the connection of art, fame, and power to the married couple The Carters and is meant to suggest ascension, ability, and talent that exists and is used and at the same time is duly staged. The power connection in particular is shown through the pieces of the French crown jewels preserved in the gallery, but Apollo's role as protector of the arts and music also play an important role here.

La Vierge au coussin vert

In the next scene, the artwork *La Vierge au coussin vert* (*Madonna with the Green Cushion*) can be seen in extracts (The Carters 2018: 00:21–00:27). This is an oil painting by the Italian artist Andrea Solari, painted between 1507 and 1510, in which Madonna is nursing the baby Jesus. The Italian Renaissance painter Giovanni Bellini, a pupil and later successor of Leonardo da Vinci, brought Italian Renaissance painting to France (Badt 1914: 15). In order to understand what is referenced here, the viewer must realize that up until the Renaissance, a work of art was "predominantly not regarded as 'art' in the modern sense, but as 'cult' and representation" (Poeschel 2016: 14).[8] At the same time, "the significance of works of art as part of our cultural heritage" is always implicit (Poeschel 2016: 16).[9] In the representation of themes, the Italian Renaissance relied on contemporary historical ideas, but they were influenced by the pictorial tradition of Roman antiquity, which played a role above all in the treatment of themes of mythology (Poeschel 2016: 18).

The image motif of the nursing Mary is quoted in the video right at the beginning. It is referenced as a motif that also appears in ancient Egyptian high culture. For example, the goddess Isis breastfeeding her child Horus. Maternal fertility and royal theology are thought of together here. The motif of Maria Lactans is also continued in the Coptic reception and pictorial tradition, so it can be clearly read by the Renaissance audience and linked to the representation of antiquity. It is clear to the viewers that Mary's milk is divine and that it confers supernatural powers. In the ancient Egyptian tradition, too, divine milk was passed on to the child through both Isis and Hathor. Both pop stars are therefore given a gift, like prophecy; the image comes alive here and is transferred to the two stars in a new still image that becomes a moving image, the artwork becomes the image and changes in time and corresponds with the new images of which the Maria Lactans has now become a part. Prophetic abilities gained through the killing of the python and the divine milk of kings are here related to a new moving image iconography in which the queen and king become part of a dialogical "order of the visible."

[8] Own translation.
[9] Own translation.

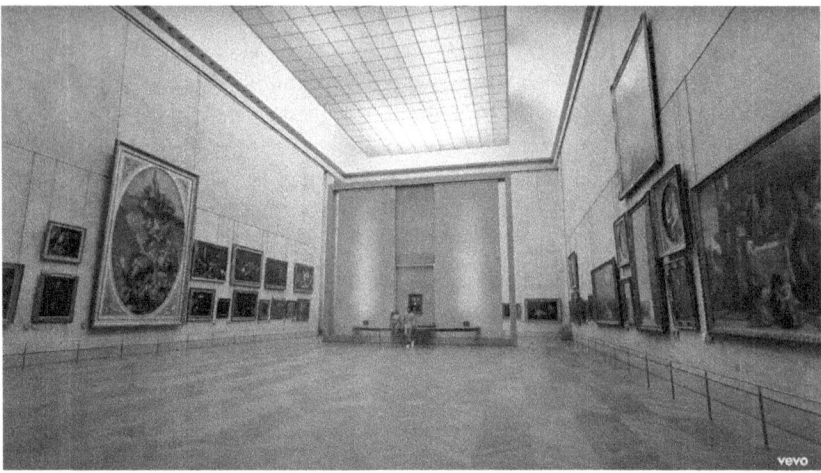

Figure 11.4 The Carters in the Salle des États. *Apeshit* by The Carters, 2018. Screenshot from YouTube.

The fact that this picture, of all things, is the first to appear in *Apeshit*, and is used as a visual quote, acts like the framing for The Carters that can be seen after the visual recourse to the ceiling fresco of the gallery in the great hall of the Louvre. They themselves are framed by the art, appearing iconic themselves. Visible behind them is one of the most famous oil paintings in the world, dating from the height of the Italian Renaissance in the early sixteenth century: Leonardo da Vinci's *Mona Lisa* (The Carters 2018: 00:38–00:57) (Figure 11.4).

The *Mona Lisa*

In the eighteenth century, the painting *La Gioconda* had been placed in the musée du Louvre in Paris; after the French Revolution, the *Mona Lisa* was hung by Napoleon in his bedroom and after his banishment, it returned to the Louvre until its spectacular theft on August 21, 1911. Later it was hidden from the Nazis to avoid being stolen, delegated to America by Charles de Gaulle, sent to Tokyo in the 1970s, then to Moscow, and finally back to the musée du Louvre. Without now referring to the painting's library-filling art historical significance, the work is undisputed apart from its aesthetic value as a symbolic central reference for the European art canon and is certainly one of the musée du Louvre's best-known paintings with political content. When Beyoncé and Jay-Z now position themselves in front of *La Gioconda* and sing about their own ascent, the motif of empowerment, ascent, special abilities, and possibilities, which is united in both megastars, can certainly also be used here against the backdrop of the themes of Icarus, the killing of Python by Apollo as well as the pictorial motif of Maria Lactans. The lyrics in the video state:

I can't believe we made it (this is what we made, made)
This is what we're thankful for (this is what we thank, thank)
I can't believe we made it (this a different angle)
Have you ever seen the crowd goin' apeshit? Rah!
Gimme my check, put some respect on my check
Or pay me in equity, pay me in equity
Or watch me reverse out the debt (skrrt)
He got a bad bitch, bad bitch
We livin' lavish, lavish
I got expensive fabrics
I got expensive habits
He wanna go with me (go with me)

(The Carters 2018: 01:14–01:41)

They sing to themselves as the ones who made it, grateful for their fame and success. They exhibit themselves at the musée du Louvre, incorporate themselves into a series of curated artworks: they have empowered themselves. But it's not just about their own fame in the music business; the video is also about positioning themselves as Black artists and demonstrating and symbolizing their own abilities. Their music video corresponds with the motifs of a European art context and places its symbolic content in the context of their own creative period. This message becomes clear at the latest when the *Portrait d'une femme noire* (*Portrait of a Black woman*), painted in 1800 by Marie Guillemine Benoist, is shown (The Carters 2018: 05:37) (Figure 11.5).

It is considered the portrait of a free Black woman after the temporary abolition of slavery in the French colonies in 1794. This period is also significant for the women's movement in the same period. Slavery was reintroduced by Napoleon Bonaparte

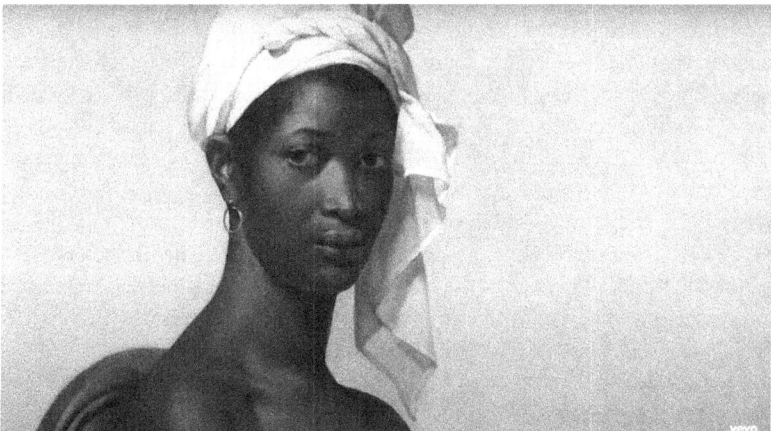

Figure 11.5 Part of the Painting *Portrait d'une femme noire*. *Apeshit* by The Carters, 2018. Screenshot from YouTube.

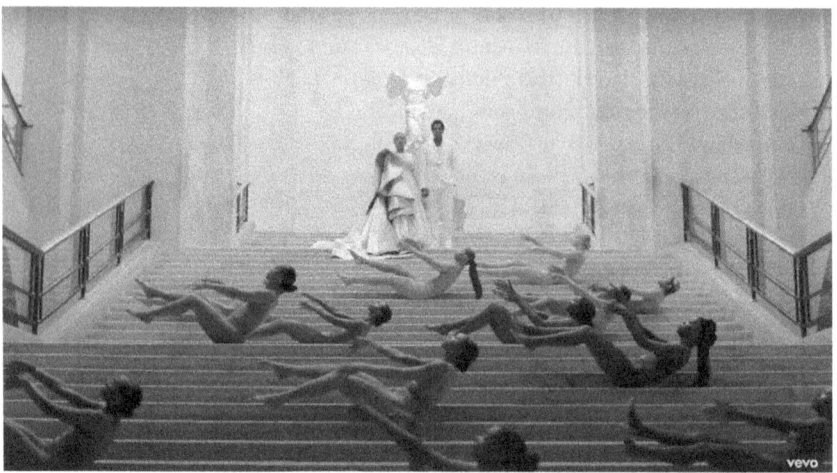

Figure 11.6 The Carters in front of the *Nike* with dancers. *Apeshit* by The Carters, 2018. Screenshot from YouTube.

around 1802 but abolished again in 1848. The French Classicist painter Benoist was a supporter of the women's movement. One of her most famous paintings is the quoted *Portrait d'une femme noire*. The fact that she now highlights this painting of all things positions the Black Woman dramaturgically in the video as a central reference point.

But the position of the two performers in front of the *Nike of Samothrace*, which is placed at the top of the Daru staircase in the Denon Wing, is also a reference (The Carters 2018: 00:58–01:03) (Figure 11.6).

Not only is it one of the most famous sculptures in the musée du Louvre, it also stands for victory and peace. The goddess is in the landing position and is centrally placed in the video. Black and white people lie on the stairs in front of them. The Nike is an important Hellenist figure, centrally positioned architecturally in the musée du Louvre. Therefore, it is not surprising that one of the most important visual references is developed from there in the video. Beyoncé herself stands in front of the sculpture and brings herself to the fore. This is reinforced by the Black dancers, who choreographically perform a heavy, sharply accentuated, and expressive movement sequence with identifying Graham technique and form the shadow of Nike, so to speak, by figuratively referencing her themselves and including her in the dramaturgy. Nike as a sculpture can be seen in the background, acting as a white projection surface and also standing for what is missing, while a group of dancers fills this hole (The Carters 2018: 01:00–01:06). Nike has such an important role in pop culture and in the art world, and she is also one of the central figures in the Louvre. The scene on the stairs for the dancers with the Nike symbolizes the ascent, empowerment, and hybrid aesthetics between image, dance, and sculpture. The Nike has long been an iconic image circulating in occidental culture and the choreography in front of it in the Louvre itself becomes iconic.

Imperial Coronation of Napoleon I in Notre-Dame de Paris

One of the most important pictorial references in the video is Jacques-Louis David's *Sacre de l'empereur Napoléon Ier et couronnement de l'impératrice Joséphine dans la cathédrale Notre-Dame de Paris* (*Coronation of Emperor Napoleon I and coronation of Empress Josephine in Notre-Dame Cathedral of Paris*, 1804) (The Carters 2018: 01:38–01:49) (Figure 11.7).

David, who had painted the *Heroes and Martyrs of the Revolution*, especially at the time of the French Revolution, became Napoleon's commissioned painter after the political times had changed, painting the imperial pomp and extensively staging the cult of military heroism (Lee 1999: 230–3).

The painting depicts the imperial coronation of Napoleon I in Notre-Dame de Paris, which was intended to symbolically and sacrally legitimize Napoleon's legal status as emperor of the French. Sacrally staged, with luxury and pomp, the pope present in gold, Napoleon in royal dress, the classicist monumental painting captures the complexity of the unusual imperial coronation. Napoleon, who wanted to forget his time as king, looked for strategies in Roman historiography for this goal and took Octavian, who proclaimed himself Caesar, as his inspiration and had himself proclaimed emperor. With his coronation, the revolution was finally over and the republic became a monarchy once again, along with its new nobility. This painting shows a man making himself emperor. Even in the contextualization of art history, this painting is unusual for the time:

> Monumental depictions of coronations in the medium of painting are rather the exception before David . . . David's Coronation has one feature in common with

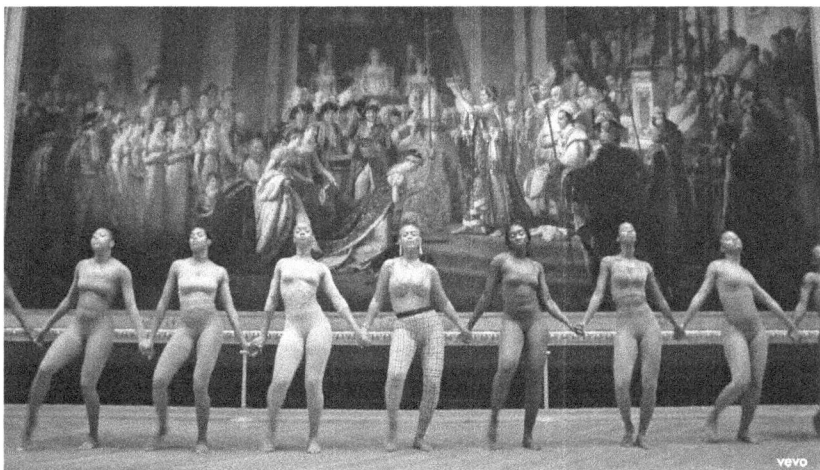

Figure 11.7 Beyoncé and Dancers in front of *Coronation of Emperor Napoleon I and coronation of Empress Josephine in Notre-Dame Cathedral of Paris. Apeshit* by The Carters, 2018. Screenshot from YouTube.

many other depictions of the subject: the painting was conceived as part of a coronation cycle, a four-part series of large-format paintings that would also show the enthronement of the ruling couple in Notre-Dame, their arrival in front of the Hôtel de Ville in Paris, and the army's pledge to the emperor taken on the Field of Mars. (Hattendorff 2011: 68–9)[10]

This painting thus stands for royal self-empowerment like no other in the history of painting. The fact that Jay-Z and Beyoncé now refer back to this painting again and again also places them in the image of a fantasy of self-empowerment using a corresponding amount of pomp and is formulated less from a gesture of oppression. Rather, The Carters appropriate David's coronation to present themselves as a king and queen befitting their status.

In the painting, which is also shown repeatedly in the video, "dynastic moments" play a "central role." There are "almost 200 people as protagonists and witnesses of the coronation of Napoleon and his wife Joséphine" (Hattendorff 2011: 66)[11] because the aim was "to prove that the ruling house had enough people in attendance" (Hattendorff 2011: 67).[12] It is also important for The Carters to be witnessed as a royal couple. The images of the painting, their mass media dissemination via social media has now associated both their image with the coronation of Napoleon. Initially for the half-life of the hashtag, making the very recipients their witnesses. Again and again, this image of the painting has been shared and spread. Suddenly Jay-Z and Queen Bey are part of the coronation.

It is noteworthy that David only decided late on to "put Joséphine's coronation by her husband in the picture" (Hattendorff 2011: 67) instead of Napoleon's coronation. This had the following background:

> But at quite a late stage in the development of the painting, certainly before May 1807, David was advised by his former student Gérard that his presentation lacked nobility and appeared faintly ridiculous. Such an arrangement would also have meant that both Josephine and the Pope were simply passive onlookers. David also planned to show the Pope watching the event with his hands on his knees, but Napoleon intervened.. . . Therefore, in the final work, Napoleon is shown raising the crown in both hands before placing it on Josephine's head.. . . The Pope gives a blessing with his mitre at his feet and with his magnificent papal tiara, a gift from Napoleon, placed on the altar behind him. Napoleon was almost certainly consulted about these changes, but he could not have kept track of the picture's progress because he was away from Paris for most of 1807 . . . David resorted to Renaissance working practices to plan and organize the *Coronation*. (Lee 1999: 248)

[10] Own translation.
[11] Own translation.
[12] Own translation.

In a way, there is an analogy here as well. "Queen Bey" is perceived as being much more present choreographically than Jay-Z. She is staged as a queen; he is perceived as a commentator. It is remarkable that this painting not only plays a central role for The Carters and their coronation and relegitimation as pop kings and queens, but the painting itself also served Napoleon to secure his power. For, as was common in the period, propaganda was "massed in all available media," in that the "invention of the nation and the associated actualisation of stories and national myths relied primarily on images" (Flacke 2011: 169).[13] The reasons for this kind of influential dissemination of images lay in the fact that modern nation-states lacked legitimacy for their formation and therefore invented a tradition: "For its justification, the nation needed a past as well as a present and a future. Therefore, it was necessary to actualize histories of distant and nearer times" (Flacke 2011: 169).[14] The representation in the video is thus itself bound to a history that was subject to certain media power constellations. This is also reflected in the video, which corresponds to the artwork. The music video researcher Vernallis even sees "Queen Bey" crowned before Josephine:

> Beyoncé and her dancers, in formation before David's The Coronation of Napoleon, valorize the couple. Beyoncé, with her hair in bun, has been crowned before Josephine. The songs thickens with Beyoncé´s voice, autotuned and multi-tracked against the full rhythm arrangement . . . To Beyoncé´s left there are the painting's folds of white fabric (a nod in a thread contributing to the headdress of the women in Portrait d'une Négresse). (Vernallis 2018: 31)

Vernallis highlights a gesture of female power. This dialectic after the end of the French Revolution and French Republic is linked to the enthronement of a woman whose coronation was neither as empress nor as a woman in tradition or protocol. The Black queen interacts in the video and in dance with her dancing entourage in the room with the painting. At the same time, according to Vernallis, she references the *Portrait d'une Négresse* (Vernallis 2018). In the first scene (The Carters 2018: 01:44), the clothing of the crowned empress in particular is transferred in its materiality to secular fashion figures: her exclusively Black dancers wear leggings and bras in the colors of their skin; she alone wears a pair of flared leggings in the Burberry look. So the fashion here is also a sign of dramaturgical development of the video and exhibition of a queen, of iconography transposed into the genre of the music video. Like icons of the Christians, they show secular representations here and in a way tie in with the icon images of Andy Warhol's pop art. Thus, in front of the Nike, she wore a dress by Stephane Rolland with a frilly cape by Alexis Mabille draped over one arm (The Carters 2018: 00:58) (Figure 11.8). The Nike in particular, as a symbol for the car manufacturing company Rolls Royce, represents a gain in distinction in the context of luxury branding and joins this visual demonstration of power with a different fashion labeling (Pietzcker 2018: 3–19). And so it goes on:

[13] Own translation.
[14] Own translation.

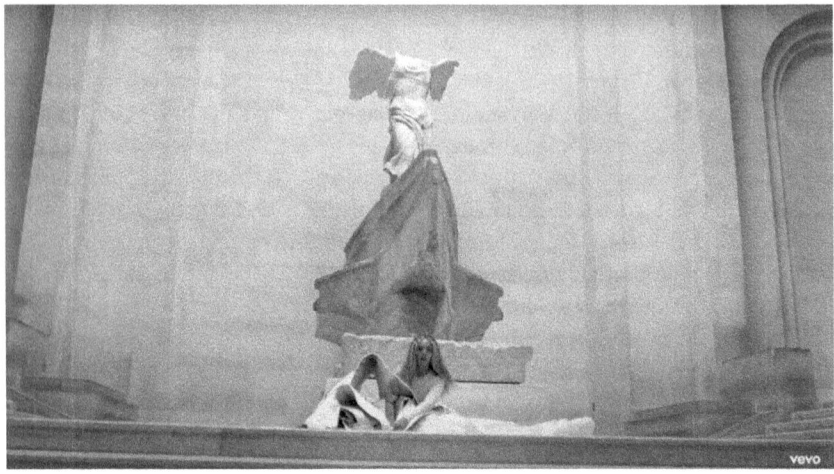

Figure 11.8 Beyoncé in front of the *Nike of Samothrace*. *Apeshit* by The Carters, 2018. Screenshot from YouTube.

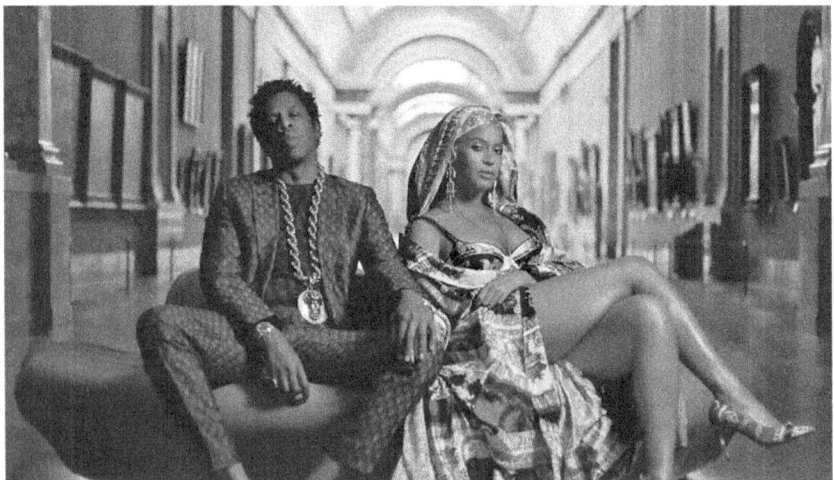

Figure 11.9 Jay-Z and Beyoncé posing in the Grand Gallery. *Apeshit* by The Carters, 2018. Screenshot from YouTube.

The dance alongside the Sphinx that follows a flashback of Nike to this scene (The Carters 2018: 01:52) shows her in an MCM logo bustier and a Misa Hylton–designed coat with swirling Y/Project boots wrapping each leg. Even relaxing in the Grand Gallery required layers of Versace clothing, while Beyoncé is dressed in a baroque print (The Carters 2018: 02:07). Expensive designer clothes are used as a stylistic device to pick up on the pomp of the museum (but also that of the staging of, for example, the coronation) and transfer it to the present day (Figure 11.9).

Money and pomp are thought of together here, and at the same time a knowledge of the pictorial contexts is assumed, linking the fantasy of money and the emancipation and advancement associated with it with a cultural habitus. This is not a story about possession; it is a story about the history of exclusion that is preserved institutionally in the memory of famous museums and it is that of a societal ascent through prestige, fame, and money, a story about the conditions enabling them to produce this video in the first place. Equally, it is also about exclusions between the nineteenth century and today and the transfer of the staging strategies into a theater of secular pop cultural iconographies of power.

The Sabine Women

This style of correspondence between artwork, dance, performance, and narrative image from established artworks of the European canon continues to be referenced throughout the video (Figure 11.10). After the coronation, however, the video takes a turn toward postcolonial critique by means of the images hung in the Louvre. This happens as follows:

Next to the Sphinx, another painting by Jacques-Louis David is shown in the next scene, a few seconds later: *The Intervention of Sabine Women* from 1799, which depicts the mythological robbery of the Sabine women shortly after the founding of the city of Rome (The Carters 2018: 01:57–02:00). The artist David adheres to the scene according to which Sabine women throw themselves between Romans and Sabines in order to stop the bloodshed. The scene is depicted with Romulus threatening to pierce a half-elusive Tatius with his spear, but hesitating, and in the middle between them

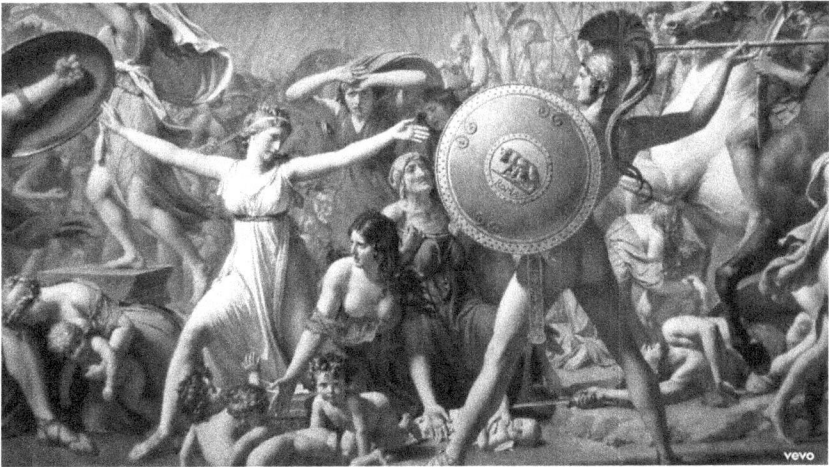

Figure 11.10 *The Intervention of Sabine Women. Apeshit* by The Carters, 2018. Screenshot from YouTube.

is a radiant woman who throws herself between the combatants with great pathos. The woman is staged here as a conciliating principle of peace, while at the same time alluding to the violence between Rome and the Sabines. By showing the entire painting without a frame, it takes on a scenic character in the video—it seems like an excerpt from a narrative of action—staged as a transition from still image to moving image.

After two seconds, a Sabine woman holding her child can be seen in close-up, grabbing the leg of a Soldier (The Carters 2018: 01:59). This is followed by an interlude showing the goddess of victory in front of a choreographic display of Black women, which brings this figure and its message into the foreground. Afterward, an image by David is shown again: The *Portrait of Madame Récarnier* (Figure 11.11).

The woman, dressed in a white cape and shown on a chaise longue, contrasts with two half-naked Black women (they are dressed in pantyhose and body-colored bras) (The Carters 2018: 02:15–02:18). The scene demonstrates a bond between two Black women with the veil of a single white woman. To the right and left of the painting are portraits of two men: the one on the left is Pope Pius VII and on the right is a self-portrait of David. David, and the pope look down on two women with white headscarves choreographed in the foreground, touching in the middle, thus distantly quoting a swan.

In the next scene, the Black women's gaze is directed straight ahead: they do not react to the portraits of the men hanging above them. The implication of the swan motif makes perfect sense, as it points mythologically to the siblings who were not separated. Apollo turned Zygnos into a swan out of pity because the death of his friend Phaeton affected him strongly. From this arose the swan song as a lament of Zygnos. The swans are mythologically associated with the Muses and Apollo (Ovid 1916, v.II, v. 539). The choreography reads like a parenthesis to the previous scenes and at the

Figure 11.11 Swan Motif in front of the *Portrait of Madame Récarnier*. *Apeshit* by The Carters, 2018. Screenshot from YouTube.

same time offers a dialectic of colonial art and a male gaze in that the women take up the colorfulness of the image, identify iconographic elements, and reinterpret them choreographically: they are seen and belittled by the personalized institutions of power in which they do not appear. They permeate aesthetics and meaning by absorbing and inverting them, revealing themselves as muses of art on the verge of death and their own politically pictorial program, opposed to poses and gestures. This is followed by a long shot of Rosso Fiorentino's *Pietá* (1537–40). It shows the martyrdom of the crucifixion of Jesus (The Carters 2018: 02:45).

An important painting by Théodore Géricault is shown: *The Charging Chasseur* (1812). In this one, an imperialist gesture is put into the picture, depicting a Napoleonic cavalry officer ready to charge (The Carters 2018: 03:23). The next scene in the video takes up this gesture and alienates it by having a Black man standing on a horse, thus alienating the colonial idea: he stands up and relates to the gesture nobilitated by its hanging in the Louvre (Figure 11.12).

At the same time, Jim Crow aesthetics are recalled, since the cowboy was shown primarily white and this regularity is reversed (The Carters 2018: 03:24). Similar postcolonial reflections start a few seconds later (The Carters 2018: 03:33): *Hermes Fastening his Sandal* by Lysippos is inserted and the motif is reinterpreted as a contemporary knee pose—as a gesture for Black people who were shot by the police for racist motives (The Carters 2018: 03:37). Jay-Z underlines this interpretation by rapping again in front of the *Medusa* (The Carters 2018: 03:46). The *Venus de Milo* appears afterward (The Carters 2018: 03:50–03:59). The *Venus de Milo* is a figure of the goddess Aphrodite and, along with the *Laocoon Group* and the *Nike of Samothrace*, is symbolic of Hellenistic art. The absence of her arms has been interpreted in contemporary media culture as a "metaphor of the male gaze," "the

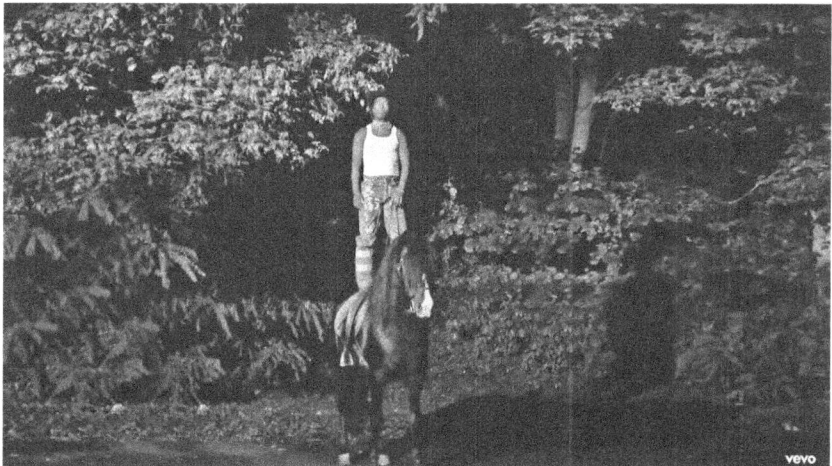

Figure 11.12 Black Man on a horse in contrast to *The Charging Chasseur*. *Apeshit* by The Carters, 2018. Screenshot from YouTube.

embodiment of beauty," and as a symbolic image of violence against women. Beyoncé used this symbolism once before in the video for *Get Me Bodied* (Knowles-Carter 2007). The Venus theme, which appears prominently in Botticelli's *Birth of Venus* and also in Beyoncé's album "Lemonade," has been shown to be symbolic of white art, for example, in the case of Sara Bartmann. There the Black woman replaces the white woman as part of an empowerment strategy. Here Beyoncé references the racist (colonial) exhibitions of humans in the past and the fetishization of Black women: "The beauty of Black women was always viewed under the colonial lens to both dehumanize and fetishize them, promoting them as images of hypersexual beings, unable to reach the 'classical beauty' that is the *Venus de Milo*" (Dhindsa 2018).

The empowerment gesture is made clear by her movement and is imitated by the artist, taken ad absurdum and transferred to Napoleon's coronation. This is followed by *The Wedding Feast at Cana* (1563) by Paolo Veronese (The Carters 2018: 04:28–04:31).

Fin

In the art historical examination of references in video, it has thus become apparent that the music video, first, is not only in correspondence with video and video art, but also enters into a very important relationship with the visual arts and creates new pictorial orders.

Second, precisely these relationships between art history and music video not only indicate classical hybridization processes between early media, film and video art but also develop an offensive political language in confrontation with other media beyond pop cultural strategies of the 1970s or 1980s, which can be discussed in the context of subculture or counterculture in pop culture studies. This self-developed language, which indicates exclusion without self-victimization but consciously appropriates it, is new. On the one hand, it thereby ennobles the music video itself; on the other hand, it creates a new visual language in that the painting itself becomes an image that corresponds with images. Admittedly, the Western art tradition of the Renaissance (and English Baroque painting since Mannerism) has always proceeded from images of images. But here the moving image then becomes an image itself again and circulates in the social media. The media image is separated from its place and also nobilitates the original, creating new memories of the original.

When such correspondences between history, art, and politics are invoked and brought into conversation again in the contemporary music video, the question arises as to what extent new transmedial and transcultural (moving) image concepts can be discussed in this medial correspondence between history, politics, and media. In addition, close reading—here as an iconographic individual case study, as an in-depth investigation—shows that this simultaneously has methodological consequences for a pop cultural image theory. The application of traditional image-specific terms and their operating principles in relation to pop cultural works holds

great appeal, as this allows us to determine an effect that extends far beyond the realm of the pop cultural.

References

Badt, Kurt (1914), *Andrea Solario - Sein Leben und seine Werke. Ein Betrag zur Kunstgeschichte der Lombardei*, Leipzig: Klinkhardt & Biermann.
"Beyoncé and Jay-Z help Paris Louvre to Record Number of Visitors" (2019), *Reuters*, January 3. Available online: https://www.reuters.com/article/us-france-tourism-louvre-idUSKCN1OX1B3 (accessed April 12, 2022).
Bredekamp, Horst (2017), *Image Acts: A Systematic Approach to Visual Agency*, Berlin and Boston: De Gruyter.
Burke, Peter (1993), *Ludwig XIV - Die Inszenierung des Sonnenkönigs*, Berlin: Wagenbach.
Chrisafis, Angelique (2019), "Beyoncé and Jay-Z help Louvre Museum Break Visitor Record in 2018," *The Guardian*, January 3. Available online: https://www.theguardian.com/world/2019/jan/03/beyonce-jay-z-help-louvre-museum-break-visitor-record (accessed April 12, 2022).
Dhindsa, Hardeep (2018), "'The Carters' Apeshit Gave me a Glimpse of the Postcolonial Museum," *Sportula Europe*, May 21. Available online: https://sportulaeurope.wordpress.com/2021/05/21/apeshit-postcolonial-museum/ (accessed April 25, 2022).
Flacke, Monika (2011), "Nation," in Uwe Fleckner, Warnke Martin and Hendrik Ziegler (eds.), *Handbuch der politischen Ikonographie. Band II Imperator bis Zwerg*, Munich: C. H. Beck.
Fleckner, Uwe, Martin Warnke and Hendrik Ziegler (eds.) (2011), *Handbuch der Politischen Ikonographie. Band I und II*, Munich: C. H. Beck.
Hattendorff, Claudia (2011), "Krönung," in Uwe Fleckner, Martin Warnke and Hendrik Ziegler (eds.), *Handbuch der politischen Ikonographie. Band II Imperator bis Zwerg*, Munich: C. H. Beck.
Kim, Michelle Hyun (2018), "The Choreographer for the Carters' "APESHIT" Video on Being Inspired by Mythology and Martha Graham," *Pitchfork*, June 21. Available online: https://pitchfork.com/thepitch/choreographer-beyonce-jayz-apeshit-video-interview-inspired-by-mythology-martha-graham/ (accessed April 12, 2022).
Knowles-Carter, Beyoncé (2007), *Beyoncé—Get Me Bodied (Timbaland Remix) ft. Voltio*. Directed by Beyoncé Knowles-Carter and Anthony Mandler. November 24, 2009. Music Video, 6:35. Available online: https://www.youtube.com/watch?v=WNCC7tIcChY (accessed May 1, 2022).
Lee, Simon (1999), *David*, London: Phaidon Press.
Majetschak, Stefan (2003), "Bild und Sichtbarkeit. Überlegungen zu einem transdisziplinären Bildbegriff," *Zeitschrift für Ästhetik und allgemeine Kunstwissenschaft*, 48 (1): 27–45.
Ovid (1916), *Metamorphoses, Volume I*, Cambridge, MA: Harvard University Press.
Ovid (1916), *Metamorphoses, Volume II*, Cambridge, MA: Harvard University Press.
Pietzcker, Dominik (2018), "Luxus jenseits ideologischer Kritik und affirmativer Haltungen," in Dominik Pietzcker and Christina Vaih-Baur (eds.), *Luxus als Distinktionsstrategie Kommunikation in der internationalen Luxus- und Fashionindustrie*. 3–19, Wiesbaden: Springer Gabler.

Poeschel, Sabine (2016), *Handbuch der Ikonographie: Sakrale und profane Themen der bildenden Kunst*, Darmstadt: Philipp von Zabern.

Schröter, Jens (2022), "Zum Eurozentrismus im Begriff des Bildes," *Zeitschrift für Medienwissenschaft*, 14 (1): 91–100. Available online: https://mediarep.org/bitstream/handle/doc/19114/ZfM_26_91-100_Schroeter_Eurozentrimus_.pdf?sequence=4&isAllowed=y (accessed May 19, 2022).

Smith, Christin and Loren Saxton Coleman (2022), "Ancestor is King: The Role of Afrofuturism in Beyoncé's Black is King," *Critical Studies in Media Communication*, Available online: https://doi.org/10.1080/15295036.2022.2038386 (accessed May 29, 2022).

The Carters (2018), *THE CARTERS - APESHIT (Official Video)*. Directed by Ricky Saiz. June 16, 2018. Music Video, 6:05. Available online: https://www.youtube.com/watch?v=kbMqWXnpXcA (accessed May 1, 2022).

Ullrich, Wolfgang (forthcoming), "Anpassung und Selbstbehauptung: Über eine Empowermet-Strategie in Musikvideo, Bildender Kunst und Mode," in Kathrin Dreckmann and Christopher Jost (eds.), *Musikvideos und Transkulturalität: Manifestationen sozialer Utopie?* Münster: Waxmann.

Vernallis, Carol (2018), "Introduction: APES**T (APESHIT) Beyonce and Jay-Z at the Louvre," *Journal of Popular Music Studies*, 30 (4): 11–70.

12

Audiovisual Art Is about Hybridization

Barbara London

Barbara London launched MoMA's collection of book works, collected single-channel videos, mixed-media installations, performances, music, and sound as art for the MoMA. In doing so, she established and curated the first collection of music videos in one of the largest museums in the world.

What parameters applied to you when you collected objects and works?
I began my curatorial career in the early 1970s, when I considered contemporary art in the context of history. Ideas and their articulation in a chosen medium went hand in hand. I focused on alternative practices, art that thrives on the periphery where there is the freedom to experiment and even fail.

Starting out, I regarded the inexpensive, offset, and readily circulatable artist book as a valid form, and launched MoMA's "bookworks" collection and organized an exhibition. At the same time, I followed artists' uses of consumer media tools and their seat-of-the-pants output. This took the form of single-channel video, mixed-media installation, performance, music, sound as art, and visionary crossovers between disciplines. My research has taken me to underground, alternative venues in my hometown, New York, and in London, Paris, Cologne, Tokyo, Beijing, Singapore, and Melbourne. I have always carried out research under my own umbrella, independent of someone or some institution's controlling influence and ulterior motive. I have followed leads through word of mouth, looked and listened to divergent points of view. I've made decisions based on my own knowledge and what I have learned from others. With this foundation, I have made choices about what to exhibit and what to collect.

I was fortunate to have worked at MoMA with access to experienced senior curators. I learned that MoMA's founding director, Alfred Barr, often said that acquisition decisions are made with the best scholarship and perspicacity, yet choices made with the greatest intentions may long afterwards be considered only ten percent right. Immersed in the present, one lacks the critical judgment of hindsight. I work hard and have tried my best to be as astute as possible.

Regarding selection, what are the parameters that determine which art should be included in the MoMA collection today, for example, and what were they in the past?
When considering an artwork for acquisition, I ask myself: where does the work stand in the context of the medium's history? Where is the originality? It has never mattered

whether something was crudely made or finely polished; how ideas are articulated is what counts, in addition to context. For example, a video work created in China in the late 1980s had parameters that differed from a work created in New York at the same time. I consider what distinguishes the artwork, and factor in the artist's access to tools, as well as their statement.

As a Westerner, I try to understand what my own blinders are. In the 1970s and 1980s as I studied media art in Japan, I read the *Tales of Genji*, watched the films of Kurosawa, ate sushi, and learned enough Japanese to communicate with artists, all to better understand their cultural context. When visiting artists in their studios, I often ask what might appear to be stupid questions, because I'm trying to learn. Sometimes I miss or misunderstand important cues, and later try to catch up.

How can we deal today with the fact that indigenous, Black perspectives may not be represented in such collections?
For years, contemporary art has had a Western-oriented perspective. Curators, art historians, and critics had to start the research process somewhere. From that starting point, practitioners have slowly come to understand their biases and have strived to comprehend other cultural voices and expand their vantage point. We read everything we can get our hands on; talk to as many people as possible; visit artists in their studio; venture out and sometimes collaborate.

While in my office at MoMA, I had an open door and met with artists, professors, writers, and others passing through town. In this way I gathered first-hand information, learned about other points of view, as new information sunk in. I believe in keeping good records, establishing networks of communication, and being receptive to information in different forms. I have tried to be open about how I have seen the evolving field of media art. The MoMA Library holds all of the reference materials I assembled during my four decades of studying video and sound as art. Hopefully this archive of reference material continues to be updated.

You have worked with the most diverse materialities and forms between materialization and impermanence, between ephemeral music and materialized sound. What role does sound play in the interplay with the moving image? How do these two dimensions hybridize in video art?
When I began my career, the field of media art was wide open, and I recognized that artists approached the new audiovisual consumer tools from different disciplines. Some artists recognized that sound was as important as the visual image. With the field's clean slate and lack of history, artists with backgrounds in painting, sculpture, and the performing arts had equal footing as they approached video and sound and created groundbreaking work. Artists tore down the walls that shielded traditional music from change. Nam June Paik played the piano as a child and went on to push boundaries and make brilliantly paced, contrarian video and performance work. In high school, Bill Viola played drums, and then after studying the components of the electronic signal—sound and image bundled together—he created videotapes and installations that resonated with his viewers' heartbeats. The painter James Nares

formed a punk band, and performed simple percussive actions he captured in video and film. He also created some of the sounds for several of Joan Jonas's early single-channel videos, a vertical one for which she recorded with the camera turned ninety degrees and countered video's standard horizontal format.

Video as art has a plethora of hybrid forms. As a wide-ranging field, it encompasses single-channel audiovisual work that may best be experienced with a good sound system, and viewed on a monitor, a smart phone, streamed online, or projected. Three-dimensional video-sound work falls into the category of installation, and might include multiple projections, multiple monitors or a combination, and generally has dimensional sound heard through particular kinds of amplifiers and speakers; a work might be site-specific in the way it addresses the particular location where it is presented. Proper viewing conditions for one work may not be suitable for another.

Audiovisual art is about hybridization and the radical breaking down of conventional forms. Definitions are verbal handles that curators, critics, and scholars draft and use on a temporary basis. Definitions offer some comfort level for comprehending the new; however, definitions require upgrades in the same way that technology-derived art does.

When it comes to the exhibitability of historical objects in particular: how can they be played? For example early cassettes, do they have to be digitized first? Do you think that something is lost from the original work of art, which may be linked to the specific materiality of the storage medium?
When I teach graduate art students, I explain that they are the curators of their own lives. They must take care of what they create, because no one else will. It is up to them to define the aesthetics of a particular work of theirs. What is inherent and what are the parameters of a work? For example, the artist must identify: the resolution of the image and its scale, whether it should be projection or presented on a monitor or flat screen; the technical specs of the original tape or file; the precise characteristics of the sound (to say *loud* isn't enough); they must determine the specifications of playback equipment needed to display a work. The artist must be prepared to handle eventual upgrades in order to maintain the aesthetics of their original vision. Video made in the late 1960s / early 1970s with analogue consumer tools generated black-and-white, grainy images, with edits that were either crude or impossible to do. A decade later, as digital equipment became available, it opened the way for smoothly edited color video and sound work. To move a video or sound artwork from analog to digital requires close attention to the artist's intention. Hopefully the artist is still with us and is able to sit with the editor as the transfer is made, and a new archival master is generated. This is when critical aesthetic decisions are made. (As a rule of thumb, never throw out an early archival master, because you never know what may occur in the future.)

When video art emerged, there was a clear distinction between consumer-grade and broadcast quality gear—the former was more affordable, the other inaccessible. In today's world, hardware and software are more obtainable and flexible. There will always be a distinction between an individual artist's aesthetic and that of a commercial entity, whoever the latter may be (television or cable station, record producer, etc.).

Of critical importance is for an artist to keep a careful record of what equipment was used to create a work. Documentation should include: indication of what camera and/or microphone was used to record; the name of the editing software; the original archival format of the work and where archival copies are kept and how they are stored; floorplans for an installation, coupled with a diagram of an installation's wiring. All of this, with other forms of documentation, determines the future life of a work. If some component is lost or forever unavailable, will the artwork cease to exist? And who will make this decision?

Video formats modernize faster than the seasons change. The responsibility of a curator or collector is to understand an artist's intentions. Once the artist communicates these particulars, the museum or private collector needs to have the information, in writing, as to what are the essentials that define the artist's aesthetics surrounding a particular artwork; furthermore, what needs to be considered when technology inevitably goes through upgrades. To gather this information, ideally the museum conservator and registrar, together with the curator, should conduct an artist interview. Together they would discuss how to handle upgrades in the future, when none of them is around. Furthermore, once a media artworks has been dismantled, the curator, registrar, art handler/installer, and conservator should sit down together to document what they have learned about the particular work, and store the new information in their collection files.

Although related, how a work of art is presented and how it is collected are important but distinct fields. Both revolve around the aesthetics of the artist who created a particular work. Lastly, the museum or the private collector—which have documented ownership and thus rights to exhibit a work on their premises—need to be prepared to respond when the loan of a work might be requested. There are many factors to consider: insurance, shipping, and what components are part of the loan.

How would you describe the new different reception situations? Video art, on the one hand, has its place in the museum. But some works can also be seen online. Earlier works had a close relationship to TV and its technical conditions, if you think for example of Paik's works for TV. Does TV presuppose a different attitude to reception than viewing the work in the museum? Music videos were shown on TV, today on the smartphone—how are the semantics also changed here by other receptions? Does this also change the meaning of the video in general?

Contemporary art evolves in tandem with changes in society and technology. In the late 1960s / early 1970s—a time of counterculture—artists responded to power structures by seeking alternatives to elite museums as well as to television's one-way street of disseminating programming which had no exchange with its viewers. The earliest audiovisual artwork was presented alternative spaces run by artists, on radio, and sometimes on public access cable television, once it became available. As museums gradually opened up and embraced video and sound as art forms, museum staff discovered that their young audience gravitated immediately toward audiovisual art installed in their galleries. The public is sophisticated and is interested in experiencing media art; it's the language of today. It took museums some time to figure out how and

in which spaces to best present audiovisual artwork. There will always be a learning curve for institutions adapting to anything new.

In the early 1980s, and for only a few months, the most creative music videos—by fiercely independent artists who broke all the rules—were seen and heard on MTV. Now thirty years later, as broadcast and cable television are on the wane, much of society turns to the expanding internet for entertainment, information, and social encounters. Creatives and their audience readily engage with the evolving forms, as definitions are being written and rewritten and new forms of distribution emerge. In today's world, artists are creating audiovisual artwork that pertains to the present moment. The most adventuresome are not wedded to one art form or one outlet.

Listening is also historicized by the different technical playback devices. Is it important in curatorial practice to make the sound intended by Paik, Viola, or Cage audible for us today? Is that possible at all?

An artist's intention must always be considered when presenting their historical artwork. Among the many issues curators, institutions, and private collectors need to contemplate include: what is the archival format? What playback equipment was originally used? How close to the original aesthetics is a work when presented with an updated file format and updated equipment? How comfortable is/was the artist to upgrade? A curator or collector must take into account any change that might have occurred to the artist's aesthetics in the transition from the original to the updated versions of a sound work intended by such artists as Paik, Viola, or Cage. This is critical. I've seen good and plenty of bad examples.

Your work is also linked to MTV's early music videos and has a special history, especially with regard to the early work of David Bowie, who, as you know, included references to art, theater, early film, and theory throughout his work. How do you assess Bowie's work in the transition from video art to music video and what makes his work so special?

In the mid-1980s, MTV stopped paying attention to originality and appeared to concentrate on financial gain. They didn't focus on how David Bowie brilliantly interacted with visual artists and technicians, the creatives who worked with him on his music videos. In 1985, I realized that record companies were being bought and sold as their archives languished or were lost; I saw how producers moved on and either had no rights to or paid little attention to their past work; archival materials often went missing. I jumped in and organized the exhibition *Music Video: The Industry and Its Fringes*, interested in how musicians and visual artists came together as equals to collaborate and create a work. I secured permission to exhibit thirty-six music videos, and at the same time obtained archival submasters of each, with the rights for MoMA to present the work in future only in its galleries. The collection of music videos grew to approximately ninety titles.

David Bowie was a genius, an artist who started his career in mime and followed an interdisciplinary trajectory that evolved naturally. He approached the production of every work seriously. He was the artist; he hired creative people to work with him.

He understood the importance of being able to control all aspects of his artwork, right from the moment an idea formed.

When we speak of experimental sound and video, we are usually talking about an avant-garde type of video. Can a mainstream type of video develop at all under market-economic conditions, if one thinks, for example, of Grace Jones in Keith Haring's video or Andy Warhol's *I Am Not Perfect*?
Avant-garde is a loose term. As artists experiment, they look over their shoulder at what the commercial world is doing; and for the commercial world, it is vice versa. Artists create their own artwork; they might be hired to develop a project for a commercial entity, perhaps in order to gain access to what otherwise might be inaccessible cutting-edge tools.

Ideas are borne within the audiovisual landscape and reflect the tenor of a moment. I'm interested in ideas and creativity, and landmark artworks that hit high notes, no matter what the medium or the work's position in the cultural landscape is. Andy Warhol was a prescient genius, so was Tony Basel, Keith Haring, David Bowie, and many others. Bottom line, creativity is what drives and feeds my soul and that of many others.

Some works in the field of video art have been created through exchange processes between several artists. How are such hybridization processes to be evaluated on the production level? From whom does art come and who is art? Is there still a subject or does everything flow together?
There's a difference between collaboration and "for hire" work. For example, David Bowie never collaborated. He was the artist and everything he created evolved from his choices and decisions—from his vision.

Collaborations among artists are effective but they tend to be short-lived for many reasons. Artists come together to produce a work, and through collaboration they learn from one another. They reach a new level of invention together. Eventually they separate and move on, having achieved something unique through working together.

How much subjective perspective is there in your video collection? Is it your personal relationship to art and artists or is it the period from the 1970s and 1980s until today that has influenced you and vice versa, so that works from this period are particularly strongly represented in your collections and curations?
When I began my career, the eminent curator Kynaston McShine warned that I'd best understand the artists of my generation, because we shared the same cultural codes. It proved to be true. For this reason, to stay up-to-date I've always taught graduate art students as a way to stay abreast of emergent ideas, as best as I'm able.

The earliest artworks that I managed to get into the MoMA collection have the stamp of my vision, my interests and understanding. My recent curatorship and writing reflects my mental growth and interaction with the youngest generation. I learn from artists and hopefully they learn from me. It is a rewarding, two-way experience.

Future Aesthetics on Hybrid Media

13

Music Video Distortion and Posthuman Technogenesis

Kristen Lillvis

In the video for *ATA* (2016), singer Olga Bell performs against a variety of landscapes: sand dunes dotted with grasses, thickets composed of twisting branches, a hallway decorated with graffiti, and city sidewalks populated by pedestrians and construction scaffolding. Rather than simply existing within these environments, Bell evolves with and through the surrounding world. In the video's opening moments, her image subtly stutters—a visual glitch—and she, like the branches that wave behind her, appears shifted by the breeze. In another scene, the camera captures Bell through a window, and digital effects contort both her body and the building, simultaneously bringing the viewer toward Bell and also transporting the singer's fractured form through the casement. Later, frozen in the action of walking down a city street, Bell's body begins to spread apart. A tree branch, pulsing to the beat of the song, moves across the screen, and multiple faces—all belonging to Bell—reveal themselves in the void between her shoulder blades. Bell, like her environment, exists as both one and many. Twisting and stretching, expanding and fragmenting, she transforms in concert with the world around her.

Bell's *ATA* continues a tradition of distortion in music videos that extends beyond the artist's body, with directors disrupting cinematic conventions of continuity as well as the human form. Mathias Bonde Korsgaard argues that the persistence of a musical track frees music videos from the classical Hollywood film expectation of "a temporally continuous narrative and a spatially coherent space" (Korsgaard 2017: 152). Music video images—and the cuts between them—instead communicate values such as "excess" (Korsgaard 2017), "acceleration" (Demopoulos 2000), "fluidity" (Vernallis 2013), and "spectacle" (Darley 2000).

However, strings of images in music videos also tell stories about the self. Like post-classical films, music videos use quick cuts and complicated plots to reflect "relativized or unhinged" space and time (Vernallis 2013: 15; Thanouli 2006: 188; Shaviro 2016). Yet in music videos as well as in what Carol Vernallis calls our current "post-post-classical moment" of film history, directors "smooth out" disjointedness to produce coherent narratives of the subject (Vernallis 2017). In post-post-classical films and music videos, "multiple, even contradictory subjectivities can be presented relatively

seamlessly," Vernallis states. "Individual moments can come forward and recede, counterbalancing larger sections, without any gaining primacy" (Vernallis 2017). Images in music videos do convey not only values, then, but also the subjectivities of the artists or actors featured in the texts.

Distorted images in music videos tell tales about subjectivity in terms of the individual's relationship with their surroundings. In music videos, face and body distortion—whether rendered through claymation and stop-motion animation, 3D modeling, or projection mapping—reflects the technology of the time and often provides insight into anxieties at that moment in history. For this chapter, I am particularly interested in how distortion in music videos reflects "technogenesis," or the "coordinated transformation" of technology and (post)human identity (Hayles 2012: 81). Drawing from N. Katherine Hayles's discussion of technogenesis, I argue that music videos such as Bell's *ATA* show the mutually constitutive relationship between artist and environment. Rather than reading distortion in the video as a critique of technology and its effects on bodily integrity, I maintain that *ATA* communicates the embodied subject's persistence in its coevolutionary relationship with the environment. Comparing *ATA* to other distortion-heavy music videos, including 1990s hip-hop videos directed by Harold "Hype" Williams and the 2018 music video for Holly Herndon and Jlin's *Godmother*, I assert that distortion in music videos tells the story of the self-transforming with—rather than in reaction to—the environment. Ultimately, by highlighting both technological changes and physical transformations, music videos use distortion to emphasize the importance of embodiment for the posthuman subject.

Distortion as Reaction in Music Videos

The action of music videos—whether the classics that aired on MTV in the 1980s or new texts posted directly to YouTube this week—often plays out via close-ups of a performer's face and body. Music video close-ups not only "highlight the star" and "showcase performances" (Vernallis 2017) but also make up for the limitations of the medium's delivery method. Unlike live events where audiences witness musical performances on the stage as well as on large screens, viewers typically watch music videos on smaller-scale displays such as televisions, computer monitors, and mobile devices (Korsgaard 2017: 110). Korsgaard notes that music videos have historically employed "generally closer framing" and "routine use of close-ups" to combat the "flat or shallow sense of space" and "low image resolution" of small screens (Korsgaard 2017: 150, 110). Accordingly, the message of a music video develops at least in part through the artist's or actor's facial expressions, whether naturalistic (see, for example, David Bowie's *Life on Mars* [1973] and Sinéad O'Connor's *Nothing Compares 2 U* [1990]) or emphasized through special effects (examples include Peter Gabriel's *Sledgehammer* [1986] and Soundgarden's *Black Hole Sun* [1994]). Even today, "when a performer knows that a flurry of post-production business may appear suddenly behind her

and might alter her expressions in post" (Vernallis 2013: 49), face and body close-ups continue to communicate the video's values and storylines.

Music videos that use distortion effects to transform the performer tell stories not only about the artist (as persona, character, or stand-in for the viewer) but also about their physical, virtual, and sociopolitical environments. In his 1990s hip-hop videos, for instance, "Hype" Williams uses distortion to convey the artist's eminence in their field and authority over others. Williams famously employs a fisheye lens in his videos, exaggerating artists' faces when they approach the camera and compressing images at the margins. In Busta Rhymes's
Gimme Some More (1998), Williams uses a wide-angle lens to accentuate Rhymes's face and the symbols of power he thrusts at the camera, including his boxing glove-covered fist, stacks of money, and comically large guns and cigars. The fisheye further bolsters Rhymes's image by magnifying items associated with heteronormative masculinity in rap videos (Williams 2014: 66), including a luxury car's grill and women's lips, breasts, and buttocks. Even when deployed for humor, such as the scene in which Rhymes poses in an exaggerated muscle suit in front of body builders, the fisheye lens emphasizes the artist's dominion over his environment, with Rhymes's muscle-suited physique further enlarged and the brawny men behind him compressed. Steven Shaviro argues in his examination of Missy Elliott's *The Rain (Supa Dupa Fly)* (1997) that Williams employs wide-angle shots of forward-facing artists to put the artist's "face and body right in your [the viewer's] face (or right in the camera)" (Shaviro 2005: 173). As Shaviro suggests, this focus on frontality reflects the artist's relationship with both their physical and virtual environments. By getting right in the viewer's face/camera's lens, Busta Rhymes reigns supreme over not only others on the screen but also those individuals watching from home.

In addition to giving the artist authority in physical and virtual spaces, Williams uses his wide-angle lens to position artists as dominant over their sociopolitical environments. Kay Dickinson asserts that in "deliberately antirealist" music videos such as those directed by Williams, Black artists propel "African American representation off into new, and hopefully less constricted spaces" (qtd. in Williams 2014: 64). While Dickinson's "constricted spaces" describe immaterial (or not exclusively material) domains of power, in Williams's music videos, the artist's expansiveness in small physical spaces corresponds with a rejection of hegemonic restrictions on representation. In both his breakout video, Rhymes's *Woo-Hah!! Got You All in Check* (1996), and Elliott's *The Rain*, Williams mixes open spaces with sets "walled on both sides, so that the space is narrow but deep" (Shaviro 2005: 173). In *Woo-Hah!!* Rhymes dances in a small, star-filled blue box and swings his arms around a fabric-draped purple enclosure. The sets, though suffocating, do not quite fill the camera's lens, and thus the viewer sees the exaggerated physical presence of Rhymes dominating not only the small space of the video's setting but also the soundstage beyond; in other words, Busta Rhymes rules over the production as a whole. In *The Rain*, Elliott similarly raps from a "claustrophobi[a]"-inducing dark room, this one complete with swinging gears (Shaviro 2005: 174; DeFrantz 2003). Though Shaviro views the scene as "industrial, and vaguely ominous" (Shaviro 2005: 173–4), Elliott preserves her authority. Outfitted

in a now-iconic inflated black vinyl jumpsuit and wearing sunglasses reaching to the crown of her head, Elliott's body—further exaggerated by the fisheye lens—fills the screen but remains safe from the swinging gears and from Black women rappers' hypersexualization. James Gordon Williams asserts that Rhymes's videos challenge "limiting narratives" of Black representation and experience (Williams 2014: 64), while Ghia Godfree argues that Elliott "calls into question traditional music videos' reliance on the objectified female performer" (Godfree 2005: 68). In each video, the artist exceeds the small spaces as well as the narrow roles offered to Black performers.

While "Hype" Williams often uses a wide-angle lens to position the artist as dominant over their physical, virtual, and sociopolitical environments, distortion in music videos also communicates anxieties about the environment's influence on the artist and, by proxy, the viewer. In *The Rain*, Williams's fisheye lens not only exaggerates Elliott and symbols of her power, including a Hummer's grill and the faces and bodies of famous friends such as Timbaland and Da Brat, but the lens also distorts elements of landscape, conveying what Thomas F. DeFrantz describes as "an Afrofuturist conception of distended time and space" (DeFrantz 2003), a "relativized" temporal and spatial structure that other videos have adopted (Shaviro 2016). Elliott retains her power in the claustrophobic interior spaces of *The Rain*, but Williams presents the outdoors as potentially threatening. On the beach and while driving her Hummer, Elliott reigns supreme, her body and vehicle (an extension of her) amplified by the fisheye lens. However, when perched on a hill in a neon-green tracksuit, she loses some of her authority over the space. DeFrantz notes that Elliott appears "uncomfortable and gigantic" sitting on the "patently fake, day-glo green" grass (DeFrantz 2003), and Shaviro points out the "*2001*-ish (Stanley Kubrick, 1968) monolith" looming in the background of the scene (Shaviro 2005: 174). The fisheye lens emphasizes Elliott's hands and torso as she sways from her seat on the hill, and Williams uses additional effects to further distort Elliott's face, momentarily expanding her eyes and mouth to superhuman proportions. However, Williams does not use the camera to capture only Elliott's presence; instead, he also employs the wide-angle shot to enlarge the hill. Several times during the video, Williams relegates Elliott and the monolith to the top of the screen, compressing them, while the hill takes up two-thirds of the view. Though, as Godfree argues, Elliott "confounds nature and technology by the distortion of her physical self" (Godfree 2005: 68), the outdoor environment in this scene overpowers her, and those instances when her eyes or mouth appear extra large take on new significance as potential side effects of her presence in this foreboding space.

Posthumanism, the Artist, and the Environment

Busta Rhymes and Missy Elliott's music videos may demonstrate their exceptionalism, but Williams's use of the fisheye lens to exaggerate not only Elliott's body but also the outdoor environment evidences the impossibility of escaping interdependence in a posthuman world. Posthumanism, a response to the fiction of the self-created, self-contained subject, explains the individual as inherently connected to—and, in

fact, constituted by—those entities that surround them (Lillvis 2017: 2–3). Extending Gilles Deleuze's and Félix Guattari's concept of "becoming," Jack Halberstam and Ira Livingston argue that the posthuman subject "vibrates across and among" the borderlines that distinguish the self from other people, powers, environments, and technologies (Halberstam and Livingston 1995: 14). Rather than simply transforming through this relationship with the other, the subject comes into being again and again via its place within "assemblages" of entities distinct from yet connected to the self (Deleuze and Guattari 1987). "The dependence or interdependence of bodies on the material and discursive networks through which they operate means that the umbilical cords that supply us (without which we would die) are always multiple," Halberstam and Livingston argue. "The partial re-configurablity of needs means that our navels are multiple as well" (Halberstam and Livingston 1995: 17). As Halberstam and Livingston suggest, posthuman subjects "never/always leave the womb" (Halberstam and Livingston 1995: 17), and the assemblages in which posthuman subjects locate themselves similarly come into being, shift, and deteriorate over time.

While Halberstam and Livingston situate umbilical cords as supply lines for the posthuman subject, the conduits that connect self and other must be understood as multidirectional. In her study of "technogenesis," or the coevolution of people and technologies, N. Katherine Hayles examines the epigenetic implications of posthuman networks, highlighting the "dynamic interplay between the kinds of environmental stimuli created in information-intensive environments and the adaptive potential of cognitive faculties in concert with them" (Hayles 2012: 97). Drawing upon the work of evolutionary biologists, Hayles asserts that feedback loops intertwine humans with their techno-rich surroundings, and epigenetic changes (heritable mutations spurred by the subject's surroundings) result in environmental modifications that "favor the spread of these changes" (Hayles 2012: 100). She explains that, for example, "[y]oung people in developed societies tend to reconfigure their environments" to support "a growing capacity for hyper attention" (Hayles 2014: 103). These environmental changes then increase the youths' "cognitive ability to take in different information streams" as well as "the pleasurable effects of doing so" (Hayles 2014: 103). Umbilical links to the surrounding world not only alter posthuman subjects fundamentally, chromosomally, but posthuman subjects also alter their environments—including their technologies—to support and reflect their new selves.

Technogenesis hinges both on environmental development and on neural plasticity, or on the capacity of neural networks to change throughout life, including into adulthood. Like Deleuze and Guattari, who insist that "becoming is not an evolution, at least not an evolution by descent and filiation" (Deleuze and Guattari 1987: 263), Hayles argues that while epigenetic changes are heritable, posthuman technogenetic feedback loops operate not linearly but rhizomatically, with mutations and adaptations for both individuals and their environments occurring over a lifetime. Moreover, she emphasizes that technogenesis results in a range of effects for posthuman subjects and their societies. "Contemporary technogenesis, like evolution in general, is not about progress," Hayles asserts. "That is, it offers no guarantees that the dynamic transformations taking place between humans and technics are moving in a positive

direction" (Hayles 2012: 81). The "coordinated transformations" between people, technologies, governments, corporations, and others may create "win-win situations," she argues, or the adaptations may advantage one entity over another (Hayles 2012: 81, 18).

Unexpectedly, then, videos such as Apashe's *Good News* (2019) and The Weeknd's *Save Your Tears* (2021) foreground contemporary anxieties about the coordinated transformation of technology and the individual's sense of self, including bodily identity. In *Good News*, young people dance and fight in response to visuals available only on the VR (virtual reality) or AR (augmented reality) headsets that obscure their eyes (a different type of facial "distortion" that pairs with Apashe's image digitally overlaid with code). Additionally, a woman becomes the leader of a revolution not due to a political platform but because her social media posts go viral. In *Save Your Tears*, The Weeknd similarly critiques social media's impact on perceptions of the self, using facial prosthetics to reflect his disdain for plastic surgery and celebrity culture (Aswad 2021). Both videos reflect what Shaviro describes as "post-continuity" film stylistics, including expressions of "technological changes (i.e., the rise of digital and Internet-based media) and of more general social, economic, and political conditions (i.e., globalized neoliberal capitalism, and the intensified financialization associated with it)" (Shaviro 2016). Like post-continuity films, these music videos distort classical narrative structures, and they also take the additional step of distorting the artist or actors to question the integrity of (post)human subjectivity and embodiment.

Despite the videos' messages of concern, identity persists because of the subject's involvement in feedback loops and assemblages. In her theory of neuronal plasticity, Catherine Malabou states that identity operates through "a process of autoconstitution" rather than as "a permanent essence":

> The plasticity of the self, which supposes that it simultaneously receives and gives itself its own form, implies a necessary split and the search for an equilibrium between the preservation of constancy (or, basically, the autobiographical self) and the exposure of this constancy to accidents, to the outside, to otherness in general (identity, in order to endure, ought paradoxically to alter itself or accidentalize itself). What results is a tension born of the resistance that constancy and creation mutually oppose to each other. It is thus that every form carries within itself its own contradiction. And precisely this resistance makes transformation possible. (Malabou 2008: 71)

The technogenetic relationship between subject and surroundings requires of the individual a suppleness through which identity persists and change becomes possible.

Malabou relies on neuroscientists Antonio Damasio's, Marc Jeannerod's, and Jean-Pierre Changeux's discussions of homeostasis and self generation to explain the necessity of the other—including the technological other—to the creation and maintenance of the self. While homeostasis, according to Damasio, "refers to the coordinated and largely automated physiological reactions required to maintain steady internal states in a living organism" (Damasio 1999: 39), conscious organisms enjoy the

"advantage" of being able to "establish a link between the world of automatic regulation (the world of basic homeostasis that is interwoven with the proto-self) and the world of imagination (the world in which images of different modalities can be combined to produce novel images of situations that have not yet happened)" (Damasio 1999: 303). The conscious being's ability to create "novel responses" to actual and anticipated or imagined environmental factors links homeostasis to "creation" and "transformation" (Damasio 1999: 304; Malabou 2008: 71; Changeux 1997: 127). Jeannerod explains, according to Malabou's English translation of his *La nature de l'esprit* (*The Nature of the Mind*), that "the biological function of intentional action ought ... to be investigated, not as maintaining a constancy, but rather as generating new properties ... Intentional movement thus becomes the means by which the organism and the environment reciprocally interact, and by means of which the subject constructs its own representation of the real" (qtd. in Malabou 2008: 75). Rather than serving as an obstacle to self identity, interdependence functions as the process by which subjects come into being, persist, and change.

Distortion as Coevolution in Music Videos

Technogenesis not only makes both the persistence of identity and the transformation of the self possible, but it also affords the individual some amount of agency in altering their environment. Hayles offers digital media—their creation, implementation, and analysis—as resources in the development of a politics of plasticity. She argues that digital media can serve as disruptors in the coevolution of humans and technology, even in those cases when the media work to "subvert or resist" technogenesis (Hayles 2012: 83). Hayles offers as an example Steve Tomasula's multimedia technotext *TOC: A New-Media Novel* (2009), which employs circular, linear, and fragmented narratives to convey the "inherent instability of temporal regimes" (Hayles 2012: 120). *TOC* tells tales of loss, frustration, and hope associated with the passage of time while also embodying temporal precarity in its composition, with collaborators "influencing the work in different directions at different times," in part due to the rapid pace of technological change and the absence of "big-time financing" (Tomasoula 2009; Hayles 2012: 120). As such, Hayles argues, *TOC* intervenes in the capitalistic structures of literary production and consumption, which transforms not only the artistic environment but also creators and audiences (Hayles 2012: 106, 120).

Moving from electronic literature to music videos, a politics of plasticity opens new readings of videos that engage with the theme of technological change. When studied as technotexts, music videos featuring face and body distortion show the co-constitutive relationship between artist and environment: how the umbilical links provide sustenance in multiple directions. Bell's *ATA*, like videos from Busta Rhymes, Missy Elliott, Apashe, The Weeknd, and others, brings together heterogeneous elements, including nature and culture as well as self and other, to emphasize the interconnection of the artist and their surroundings. Distortion in the videos reveals

that while heterogeneous pairings shape both artist and environment, posthuman subjectivity—including embodiment—persists.

Indeed, *ATA* tells the story of technogenesis through its images. In the video, Bell and her environment transform together. Standing before an ambulance, Bell's image—like the decals on the vehicle—stretches and twists, allowing the viewer to observe the artist and the ambulance simultaneously from the front and the back. The digital effects place Bell, her environment, and perhaps the viewer in relation to one another, together but distinct.

Additionally, through the production or creation of the video's distortion effects, *ATA* formally evidences technogenesis. In an essay describing the technical process of making *ATA*, director Baku Hashimoto relies on descriptions of his physical labor and body metaphors to explain how he brought the video into being. Discussing his use of 3D matte painting instead of 3D scanning, Hashimoto states, "I actually modeled all the objects by hand" (Hashimoto 2017). Though Hashimoto and Bell never met in person during the production of the video (Callahan 2016), Hashimoto's description of doing digital work "by hand" emphasizes the persistence of his body in the process.

The metaphors Hashimoto chooses to discuss his labor additionally point to the resilience of posthuman subjectivity and embodiment in technology-rich environments. When describing how he turned still photos of Bell into a dynamic music video, Hashimoto explains, "I simply projected the photos taken by Josh Wool to the whole scene and modeled an object so that its perspective bends weirdly against a rule of thumb" (Hashimoto 2017). Later, Hashimoto details his method for creating an abstract gradient using openFrameworks. He states that this method, which he calls "Feedback Displacement," "repeatedly warps an input image a little and then makes a pattern like hand-marbled silk" (Hashimoto 2017). This body-based language—"rule of thumb" and "hand-marbled silk"—again emphasizes the significance of the body to digital (and remote) work. Though technology has changed the process of making music videos, Hashimoto's body remains central to the creative act.

In his own study of film, Deleuze notes the relationship between film aesthetics, film production, and what Hayles calls technogenesis, arguing that director Kenji Mizoguchi's use of the rolling shot "unravels the successive fragments of space, to which are nevertheless attached vectors of a different direction" (Deleuze 1986: 194). As Adrian Martin asserts and Shaviro corroborates, the significance of Deleuze's analysis lies in its description of difference (Shaviro 2016); Deleuze states, "It is not the line which unites into a whole, but the one which connects or links up the heterogeneous elements, while keeping them heterogeneous" (Deleuze 1986: 194). While Deleuze describes the effect of Mizoguchi's shot—that is, what the viewer watches post-production—his discussion of "the line which unites" also relates to the act of filmmaking. Deleuze discusses rolling shots as well as high-angle, contiguous, and sequence shots, noting how they each affect the viewer's experience (Deleuze 1986: 193). Like the umbilical cords that link the posthuman subject to the surrounding world, Deleuze's lines unite production and product, director and viewer, into a relationship where each is shaped by the other yet each embodied and, thus, distinct.

Distortion as Disruption

Given that distortion in music videos tells the story of the coevolution of posthuman subjects and their technologies, then distortion may also provide insights into what's next. Technology has made it possible for artists and directors like Bell and Hashimoto to collaborate across continents. While the body remains prominent in their project, what happens when the collaborator is not posthuman but nonhuman? Holly Herndon and Jlin's *Godmother* (2018) features vocals from Spawn, an "artificial intelligence baby" and "singing neural network" who learned to perform through exposure to vocal training sets featuring Herndon and her collaborator Mat Dryhurst (Friedlander 2019; Herndon and Beta 2019; Herndon 2021). To create *Godmother*, Spawn listened to instrumental tracks by Jlin, an electronic musician, and performed her interpretation of Jlin's music using Herndon's voice model (Gotrich 2018). Though years of training and the expertise of developer and artist Jules LaPlace went into the collaboration, NPR Music producer Lars Gotrich notes that Spawn's nascency shines through. He states, "There's a raw, newborn quality to the track as it hums and sputters like a swarm of glitching bees, just trying to find its mother" (Gotrich 2018).

The idea of the glitch features heavily not only in the sound of *Godmother* but also the video. Reminiscent of Godley and Creme's *Cry* (1985) and Michael Jackson's *Black or White* (1991), *Godmother* perhaps offers a glimpse of Spawn as images of Herndon's and Jlin's faces alternate on the screen, shifting back and forth but also overlapping or glitching into something—or someone—new. The distorted faces in *Godmother* again evidence the transformative effects of technology on the subject, yet Herndon insists that her identity is not threatened. When discussing issues of consent and the question of royalties associated with AI music, Herndon asserts her agency: "If it's a voice model made from my voice—even if it's my publicly accessible, recorded voice—that voice model is my voice" (McDermott 2020). Though listeners hear Spawn in *Godmother*, Herndon and Jlin retain author credits, with Spawn "featured" as a performer. Similarly, in the video, the amalgam of Herndon and Jlin's faces might provide a view of Spawn, but each artist retains her distinct identity, a point *Godmother* emphasizes at the end of the video as the camera captures Jlin and Herndon sitting across from one another, laughing as they discuss the process of the album's creation.

More than simply stating her existence as separate from Spawn, however, Herndon acknowledges that the AI has changed her. Herndon celebrates that technogenesis has transformed her in concert with her creation, allowing both to exist together as distinct entities. "The point is to be constantly developing and updating yourself as a human," she states. "You can use AI as a collaborator or tool, but not as a replacement. Why would I want to replace myself? This is also a problem with algorithmic recommendation systems. If my sixteen-year-old self's tastes had been catered to fully by an algorithm on Spotify, I would be listening to the shittiest music. I needed interventions, that's how you grow and get exposed to different things" (McDermott 2020). Herndon describes the identity transformations she has experienced throughout her life as aided—but not replaced—by algorithms and AI. This neuronal plasticity,

the creation and maintenance of the self through exposure to the other, allows the posthuman subject to persist.

In music videos, bodily manipulations point to contemporary anxieties about technology, particularly worries about the extent to which technology impacts the body/self. However, even in videos where face and body distortions figure heavily, the embodied self persists. Distortion in music videos depicts the subject transforming with their environment in displays of technogenesis. As Hashimoto evidences in his discussion of making *ATA*, the process of music video creation also tells a story of transformation, with new techniques changing how videos are produced and viewed. Yet even in the face of these changes, the body remains present. By examining distortion in music videos, we are able to see more clearly the embodied subject's persistence in its coevolutionary relationship with the environment.

References

Apashe (2019), *Good News*. Directed by Arian Villagomez. September 18, 2019. Music video, 4:11. Available online: https://www.youtube.com/watch?v=Slv9aYoC4FM (accessed December 13, 2021).

Aswad, Jem (2021), "The Weeknd Reveals the Significance of His Full-Face Bandages, Ahead of Super Bowl," *Variety*, February 3. Available online: https://variety.com/2021/music/news/the-weeknd-bandages-super-bowl-plastic-surgery-1234898743/ (accessed December 13, 2021).

Bell, Olga (2016), *ATA*. Directed by Baku Hashimoto. May 23, 2016. Music video, 3:42. Available online: https://www.youtube.com/watch?v=DEzuZlUB3zM (accessed December 13, 2021).

Bowie, David (1973), *Life on Mars*. Directed by Mick Rock. July 9, 2015. Music video, 4:09. Available online: https://www.youtube.com/watch?v=AZKcl4-tcuo (accessed December 13, 2021).

Callahan, Sophia (2016), "Digital Distortion Slices Up Olga Bell's Newest Music Video," *Vice*, May 13. Available online: https://www.vice.com/en/article/kbn993/olga-bell-glitch-distortion-music-video (accessed February 6, 2022).

Changeux, Jean-Pierre (1997), *Neuronal Man: The Biology of Mind*, translated by Laurence Garey, Princeton Science Library edition, Princeton: Princeton University Press.

Damasio, Antonio R. (1999), *The Feeling of What Happens: Body and Emotion in the Making of Consciousness*, Boston: Houghton Mifflin.

Darley, Andrew (2000), *Visual Digital Culture: Surface Play and Spectacle in New Media Genres*, Milton Park: Routledge.

DeFrantz, Thomas F. (2003), "Believe the Hype: Hype Williams and Afrofuturist Filmmaking," *Refractory: A Journal of Entertainment Media*, 4. Available online: https://refractory-journal.com/believe-the-hype-hype-williams-and-afrofuturist-filmmaking-thomas-f-defrantz/ (accessed February 4, 2022).

Deleuze, Gilles (1986), *Cinema: The Movement-Image*, Minneapolis: University of Minnesota Press.

Deleuze, Gilles and Félix Guattari (1987), *A Thousand Plateaus: Capitalism and Schizophrenia*, translated by Brian Massumi, Minneapolis: University of Minnesota Press.
Demopoulos, Maria (2000), "Blink of an Eye: Filmmaking in the Age of Bullet Time," *Film Comment*, 36 (3): 34–9.
Elliott, Missy (1997), *The Rain (Supa Dupa Fly)*. Directed by Harold "Hype" Williams. October 26, 2009. Music video, 4:13. Available online: https://www.youtube.com/watch?v=hHcyJPTTn9w (accessed December 13, 2021).
Friedlander, Emilie (2019), "How Holly Herndon and Her AI Baby Spawned a New Kind of Folk Music," *The Fader*, May 21. Available online: https://www.thefader.com/2019/05/21/holly-herndon-proto-ai-spawn-interview (accessed December 13, 2021).
Gabriel, Peter (1986), *Sledgehammer*. Directed by Stephen R. Johnson. September 24, 2012. Music video, 5:45. Available online: https://www.youtube.com/watch?v=OJWJE0x7T4Q (accessed December 13, 2021).
Godfree, Ghia (2005), "Breaking Down Binaries: Redefining Gender and Sexuality through the Music Videos of Björk and Missy Elliott," *Spectator*, 25 (2): 61–70.
Godley & Creme (1985), *Cry*. May 12, 2020. Music video, 4:01. Available online: https://www.youtube.com/watch?v=ypMnBuvP5kA (accessed December 13, 2021).
Gotrich, Lars (2018), "Holly Herndon's AI Baby Sings to Her 'Godmother,'" *NPR Music*, December 4. Available online: https://www.npr.org/sections/allsongs/2018/12/04/672758884/holly-herndons-ai-baby-sings-to-her-godmother (accessed December 13, 2021).
Halberstam, Judith and Ira Livingston (eds.) (1995), "Posthuman Bodies," in Judith Halberstam and Ira Livingston (eds.), *Posthuman Bodies*, 1–19, Bloomington: Indiana University Press.
Hashimoto, Baku (2017), "Making-of: Olga Bell – ATA," last updated September 13. Available online: https://baku89.com/making-of/ata?lang=en (accessed December 13, 2021).
Hayles, N. Katherine (2012), *How We Think: Digital Media and Contemporary Technogenesis*, Chicago: University of Chicago Press.
Hayles, N. Katherine (2014), "Posthumanism, Technogenesis, and Digital Technologies: A Conversation with N. Katherine Hayles," interview with Holger Pötzsch, *The Fibreculture Journal*, 23: 95–107.
Herndon, Holly (2021), "Holly+," *Holly Herndon*, July 13. Available online: https://holly.mirror.xyz/54ds2IiOnvthjGFkokFCoaI4EabytH9xjAYy1irHy94 (accessed December 13, 2021).
Herndon, Holly and Andy Beta (2019), "Inside the World's First Mainstream Album Made with AI," *Vulture*, November 13. Available online: https://www.vulture.com/2019/11/holly-herndon-on-proto-an-album-made-with-ai.html (accessed December 13, 2021).
Herndon, Holly and Jlin (featuring Spawn) (2018), *Godmother*. Directed by Daniel Costa Neves. December 4, 2018. Music video, 2:49. Available online: https://www.youtube.com/watch?v=sc9OjL6Mjqo (accessed December 13, 2021).
Jackson, Michael (1991), *Black or White*. November 14, 2016. Music video, 11:01. Available online: https://www.youtube.com/watch?v=pTFE8cirkdQ (accessed December 13, 2021).
Jeannerod, Marc (2008), "Foreword," in Catherine Malabou (ed.), *What should we do with our brain?*, xi–xiv, New York: Fordham University Press.

Korsgaard, Mathias Bonde (2017), *Music Video After MTV: Audiovisual Studies, New Media, and Popular Music*, New York: Routledge.

Lillvis, Kristen (2017), *Posthuman Blackness and the Black Female Imagination*, Athens: University of Georgia Press.

Malabou, Catherine (2008), *What Should We Do with Our Brain?* New York: Fordham University Press.

McDermott, Emily (2020), "Holly Herndon on Her AI Baby, Reanimating Tupac, and Extracting Voices," *Art in America*, January 7. Available online: https://www.artnews.com/art-in-america/interviews/holly-herndon-emily-mcdermott-spawn-ai-1202674301/ (accessed December 13, 2021).

O'Connor, Sinéad (1990), *Nothing Compares 2U*. July 10, 2017. Music video, 5:08. Available online: https://www.youtube.com/watch?v=0-EF60neguk (accessed December 13, 2021).

Rhymes, Busta (1996), *Woo-Hah!! Got You All in Check*. Directed by Harold "Hype" Williams. May 8, 2020. Music video, 4:59. Available online: https://www.youtube.com/watch?v=EQzvQO2LcA4 (accessed December 13, 2021).

Rhymes, Busta (1998), *Gimme Some More*. Directed by Harold "Hype" Williams. September 10, 2011. Music video, 2:53. Available online: https://www.youtube.com/watch?v=un3NkWnHl9Q (accessed December 13, 2021).

Shaviro, Steven (2005), "Supa Dupa Fly: Black Women as Cyborgs in Hiphop Videos," *Quarterly Review of Film and Video*, 22: 169–79. Available online: https://doi.org/10.1080/10509200590921962 (accessed December 13, 2021).

Shaviro, Steven (2016), "Post-Continuity: An Introduction," in Shane Denson and Julia Leyda (eds.), *Post-Cinema: Theorizing 21st-Century Film*, 51–64, Falmer: Reframe Books.

Soundgarden (1994), *Black Hole Sun*. June 22, 2010. Music video, 5:20. Available online: https://www.youtube.com/watch?v=3mbBbFH9fAg (accessed December 13, 2021).

Thanouli, Eleftheria (2006), "Post-Classical Narration," *New Review of Film and Television Studies*, 4 (3): 183–96. Available online: http://dx.doi.org/10.1080/17400300600981900 (accessed December 13, 2021).

The Weeknd (2021), *Save Your Tears*. Directed by Cliqua. January 5, 2021. Music video, 4:08. Available online: https://www.youtube.com/watch?v=XXYlFuWEuKI (accessed 13 December 2021).

Tomasula, Steve (2009), *TOC: A New-Media Novel*, 3rd ed. Available online: https://www.tocthenovel.net/ (accessed December 13, 2021).

Vernallis, Carol (2013), *Unruly Media: YouTube, Music Video, and the New Digital Cinema*, Cary: Oxford University Press.

Vernallis, Carol (2017), "Beyoncé's Overwhelming Opus; or, the Past and Future of Music Video," *Film Criticism*: 41 (1). Available online: https://doi.org/10.3998/fc.13761232.0041.105 (accessed December 13, 2021).

Williams, James Gordon (2014), "Crossing Cinematic and Sonic Bar Lines: T-Pain's 'Can't Believe It,'" *Ethnomusicology Review*, 19 (Fall): 49–76.

14

Untimely Futures and the Art of Revolutionary Life

Jami Weinstein

[INTRO]

> I do not know what meaning [history] could have for our time if it were not *untimely*—that is to say, acting counter to our time and thereby acting on our time and, let us hope, for the benefit of a time to come. (Nietzsche 1997: 60, italics mine)

In a literal sense, it is almost absurd to claim that the past is untimely, since modern temporal logics insist that history is irrefutably located inside time in the mode of time passed. But as many theorists have argued (e.g., Ahmed 2010; Berlant 2011; Dinshaw et al. 2007; Edelman 2004; Eshun 2003; Halberstam 2005; Hartman 2002; Mbembé 2019; Muñoz 2009; Nyong'o 2019), when taken as dogma and enforced as *the* chronologic, the modernist progress narrative serves as a *defuturing* force. Underlying the enforcement of this narrative and its view of the future is the hidden premise that life is only rendered intelligible and futurable by virtue of adhering to the norms and forms of life already enrolled in its view of the future. Thus, any form of life that challenges this is placed outside of life and without a future. Taken to its extreme, these are life's negation, *not* life—or at best, they are future adjacent, where they are only bestowed partial futures to the extent that they conform to the norms and forms of life those futures require. Achille Mbembé names this "necropolitics," which he argues is the organizing principle of white capitalist logics of time and creates the conditions of futurity of some via the violent erasure of others such that "the human could be talked about only in the future tense and always coupled with the object [Black life], henceforth the human's double, or even its sarcophagus. The Negro is this future's prefiguration, as the history of the Negro refers to the idea of a quasi-infinite potential of transformation and plasticity who become the 'precondition'" (Mbembé 2019: 164). Thus, the normative promise of progress goes unfulfilled for all but a select few, whose futures are summarily foreclosed and, thus, their lives are *defutured*.

By introducing the notion of untimeliness to the past, Nietzsche disrupts this chronological closed circuit to reveal the past's more profound future orientation; it

is the mechanism by which the past in its multiplicity of potential operates against and on the present to generate futures. Pasts are contemporaneously entangled with futures, which themselves are untimely in a new way—since they, too, are enmeshed with both past and present. This shift toward time as multiple and, effectively, simultaneously present rather than linear not only dispels long-held beliefs concerning the rapport among past, present, and future and their respective linguistic tenses but also transfigures the concept of time at its ontological foundations—where its tripartite temporal structure is collapsed and time itself can be thought as *untimely* or outside of time. By tethering the untimely to time, time to life, and then life to the untimely and, thus, moving life to the fore, Nietzsche opens a portal to futures previously unimaginable and otherwise foreclosed by time in its sequential progress genre. On this view, a commitment to the past is worthy only to the degree that it cultivates life, since an exaggerated fidelity is "*harmful and ultimately fatal to the living thing whether this living thing be a man or a people or a culture*" (Nietzsche 1997: 62). The future as recursive, chronostatic, and cemented to the past is, as Nietzsche would quip, life's gravedigger. For, what is life's future in a logic that robotically replicates and enforces the past other than regress, stasis, and death? Life as untimely is, thus, liberated from time's *necrochronologics* that embed futures with toxic nostalgia, making futures thinkable and life, in its genre of change and novelty, living.

In diagnosing life as out of synch with time and time itself as asynchronous, Nietzsche endeavors to envision futures outside time as we know it, making the untimely a radical refusal and a call to stop *doing time* altogether. For, only when time no longer possesses an inextricable relationship to what he calls "monumental history" and its normative horizons, can life give way to its second nature, novelty, and aesthetic self-creation, and to stories of futures that time otherwise cannot tell. The antidote, Nietzsche argues, is to strike a delicate balance between forgetting and remembering—or, feeling unhistorically and historically—and harnessing what he calls a "plastic power," which determines "the capacity to develop out of oneself in one's own way, to transform and incorporate into oneself what is past and foreign, to heal wounds, to replace what has been lost, to recreate broken moulds" ([*sic*]; Nietzsche 1997: 62). While the past cannot be exhausted by the present, it might contain the conditions of possibility for any imaginable future.[1] To this end, he ventures:

> The best we can do is to confront our inherited and hereditary nature with our knowledge ... combat our inborn heritage and implant in ourselves a new habit, a new instinct, a second nature, so that our first nature withers away. It is an attempt to give oneself, as it were *a posteriori*, a past in which one would like to originate in opposition to that in which one did originate. (Nietzsche 1997: 76)

[1] For readers of Henri Bergson and Gilles Deleuze, these Nietzschean arguments will be familiar. Though fleshing out of details lies outside the scope of this chapter, it suffices to mention that their combined insights would add greater depth and support to the arguments herein, especially Bergson's concept "la durée" and its relation to life as creativity, novelty, and difference, and Deleuze's claim that "True philosophy, as a philosophy of the future ... must be untimely, always untimely" (Deleuze 2002: 1).

What Nietzsche describes abstractly as refusal of time, or locating life as the expression of the present, is an important first step forward in thinking about the relationship of history, life, and futures. However, only through more recent reevaluations of history and futurity by Afrofuturist, queer, feminist, and decolonial theorists in ostensibly egalitarian contexts does his methodological insight take on the force of political and existential urgency. For, it is through the vital work of these theorists and artists that we come to realize that modern temporality has been so radicalized as to deny life and futurity—despite its self-perpetuating, circular claims to the contrary. Thus, *a posteriori* historical reformulation has been indispensable for BIPOC, queer, trans*, and feminist liberation projects in the twenty-first century, as the defuturing life forces of their inherited pasts demand an architectural gesture that designs a future upon demolishing the past's anti-life foundations.

This move can be witnessed in Rev. Jessie Jackson's 1969 proclamation: "We are not African, we are not European, *we are a new people*, a beautiful people . . . I am Black! I am beautiful! I am proud!" (*Summer of Soul* 2021, italics mine). Jackson's underlying claim is that being an architect of one's own future, one's own living, requires a rejection of history's oracular role—breaking the chain between an inherited set of historical assumptions and the futures prescribed by them. Stated otherwise, this strategy undefines the future by unlearning the inherited past and seeks to "defamiliarize unquestioned, sedimented or 'common sense' discourses of the future" (Godhe and Goode 2017: 112). This can be nuanced by reference to Black Lives Matter, since in the face of the long history of unconscionable enslavement, segregation, police violence, and structural racism, not only is it essential that Black lives come to matter but also that Black lives are recovered from a stolen past. Mattering Black lives entails a simultaneous futuring but only by shedding the vestiges of life lived on borrowed, or imposed, notions time—time that scrambles white supremacist history into dominant imaginaries of "The Future," which erases the history of, and defutures, Black lives in one fell swoop. The combined force of erasure and defuturing can also be felt through the phrase "living while Black," which is derived from the innumerable instances where merely being Black or brown in what are perceived to be "white spaces" while engaged in ordinary activities, or indeed not doing anything at all, prompts a suspicious white person to call the police—often resulting in serious, if not fatal, consequences. This suspicion calls attention to the myriad ways in which the legitimacy and intelligibility of Black lives are routinely and often violently called into question and to the underlying infrastructure that perpetuates Black life's constitutive outside. As Sara Ahmed argues, "If to be human is to be white, then to be not white is to inhabit the negative: it is to be 'not'" (Ahmed 2007: 161). As such, living while Black can be reinterpreted as a confrontation with the logics of time, which, moreover, points to the ways that Black life as the precondition for life is always already untimely.

In light of this, it can be noted that slogans like "the future is female," "feminism is the radical notion that women are people," "we're here, we're queer, get used to it," and "decolonize the future" seem to capture a similar spirit: the need to insist on lives not inscribed into the current temporal genre, and to think into existence, or future, a people that is not yet here. While at this basic level there are resonances among them,

I resist the temptation to collapse their specificities and claim that any rejection of normative temporal logics is in itself to queer, fem, or decolonize time. For it is key to cache the potentiality of their individual temporal critiques and take heed of the vitally different relations they have to dominant temporal logics. Further, using these tropes as stand-ins to signify the non-normative dilutes their theoretical purchase. Thus, while not intending to equate race, gender, and sexuality as cut from the same mold in relation to time, it is important for what follows to intersect them in the service of understanding how the art of life and *refuturing* reveal life's immanent creative and revolutionary tendency.

Against this albeit abbreviated analysis of time and life, this chapter will consider Afrofuturism with a queer, feminist twist, through the work of a range of female, queer, trans*/nonbinary, and Black music-video artists. What will be argued in what follows is that their work makes an invaluable contribution to the project of envisioning novel and untimely possibilities for life and its futures. And, moreover, it transforms the practice of futuring into what I am calling an "art of revolutionary life"—an art that does not imitate, but creates, life.

Afrofuturism and the Untimely

As is well rehearsed in the literature, the term "Afrofuturism" was coined by Mark Dery in an opening passage of his "Black to the Future" interviews to denote "African-American signification that appropriates images of technology and a prosthetically enhanced future" (Dery 1994: 180). The neologism serves as an organizing framework for the collective efforts to imagine possible futures for a "community whose past has been deliberately rubbed out, and whose energies have subsequently been consumed by the search for legible traces of its history" (Dery 1994: 180). In the ensuing discussion about the use of speculative fiction by Black and, to some extent, queer authors, Greg Tate noted that it is curious that Black writers are underrepresented in the genre since "the condition of being alien and alienated, speaks, in a sense, to the way in which being black in America is a science fiction experience" (Dery 1994: 208). Indeed, it is hard to imagine a more profound sense of alienation than that born of the legacy of centuries of violent abduction, unfathomable dehumanization, and systematic severing of Black people from their languages, cultures, histories, families, and communities by European slave traders and owners.

Yet, it might just be the fact that these lives were rendered impossible by design that makes Afrofuturism such an effective form of critique—since the utter cleavage of life from futures and, therefore, living, places life in relation to the limits of livability of the very structures flaunted as life sustaining and promoting. With life cast outside a fabricated world that fails to sustain it, it becomes obvious that worlds are neither immune to questioning nor incapable of transformation. Critical futurisms must, thus, engage in practices both of unworlding and worlding in order to disorder and reorder the signification of the established world order. Unworlding in an Afrofuturist sense is not akin to the cautionary apocalyptic tales of technology or viruses bringing about the

extinction of life in the world, since for Black people and, to a different degree, queers, trans* people, and women, such an apocalypse has already occurred and is still acting on the present. The destruction affected through Afrofuturist unworlding is rather a critical, anti-humanist genealogy of the future that disentangles it from the forms and norms of life validated only by reference to a crystallized, static past, such that "the worlds they project in their art are characterised by multilayered temporalities where the simultaneity of past, present, future provides the speculative space for the artistic negotiation of emancipated liminal existence" (Aghoro 2018: 331). Unworlding, thus, constitutes a necessary part of a reconstitutive, architectural, futural strategy that involves razing the unlivable dwelling and designing livable worlds in its stead. Unmaking worlds is always at once a gaze to the past and a futural remaking, though when enacted tactically toward enabling future life, it is essential that this be done with a critical, not utopian, gesture. Critical reworlding insists that life and futures must be figured as open and generative of novelty, difference, and change—lest through utopian blueprints they get rescripted into just another narration of a world with its implicit, life-threatening progress chronologics. This approach toward reworlding can be understood as innovative in three dimensions, in that it addresses: "concepts, or new ways of thinking; percepts, or new ways of seeing and hearing; and affects, or new ways of feeling," which Gilles Deleuze argues are all necessary "to get things moving" (Deleuze 1995: 164–5). And it is precisely this three-dimensional strategy one must employ in "the ongoing work of storytelling in the making and mediation of worlds" (Berlant 2011: 8).

Afrofuturisms in their written, sonic, and visual aesthetic forms strive to carve out new futures for lives that have been relegated to the constituent outside of a modern world defined by its structural exclusion of all life that fails to conform to its predetermined norms. Accordingly, Paul Gilroy recognizes that the time has passed for "corrective or compensatory inclusion in modernity," arguing instead for a self-conscious, future-oriented strategy. Inspired by Fanon, and with Nietzschean echoes, he acknowledges that such a strategy involves knowing but unlearning history in order to wrest free of its life-stultifying grip (Gilroy 2001: 335–6). After all, "if you're going to imagine yourself in the future, you have to imagine where you've come from; ancestor worship in black culture is a way of countering a historical erasure" (Tricia Rose in Dery 1994: 215).

The otherworldly jazz musician Sun Ra, who drew on ancient Egyptian influences and cosmic space imagery in his music and performances, is generally considered to be one of the earliest proponents of Afrofuturism. He and the other Afrofuturists transport the past into the future in ways that use "temporal complications and anachronistic episodes that disturb the linear time of progress" and "adjust the temporal logics that condemned black subjects to prehistory" (Eshun 2003: 297). The desire to reclaim stolen histories and reimagine identities that go beyond the limitations imposed by a forced and alien diasporic existence speaks to the need for art and ways of living that instantiate otherworldliness, untimeliness, and, as we will see, a keen ability to shapeshift. In *Next Lifetime*, for example, Erykah Badu tells a multi-temporal, cyclical love story that takes place in periods she names "Motherland, 1637 A.D.," "The

Movement, 1968," and "Motherland, 3037" (Badu 1997). In each temporal cut, she is in a relationship with one man but desires another, musing "I guess I'll see you next lifetime," only to eventually circle back in the future to the initial man (life) she desired but could not have in 1637. Badu uses the guise of a love story to transport herself through time in a linear direction from the pre-transatlantic slave past, through the U.S. Civil Rights Movement "present," only to cycle back to an expansive Black future of the 3037 Motherland that resembles the past—though resurrected in a new, brightly neon-colored light. By employing key symbols to spark movement between temporalities—the ankh, or key of life, and the butterfly, encoded as metamorphosis—she propels herself through time to a future world achieved through life, change, and novelty. She also extends the core love story metaphorically to a future of love, joy, and community of Black life. Here, Badu performs what Achille Mbembé calls "producing life" by offering "work that also includes the production of symbols, languages, and meanings" (Mbembé 2019: 168) and has the effect of a "withering away of life . . . [that] is an unfolding onto an extreme outside" he names "*the zero world*," where, "neither matter nor life ends as such. They do not return to nothingness. They merely pursue a movement of exiting toward something else" (Mbembé 2019: 168–9). Badu's zero world 3037 Motherland is a future not constrained by the trappings of time's humanist, self-fulfilling, and exclusionary temporal logic that would relegate her and her future *transcestors* to the role of its ancestral precondition, but instead moves beyond to provide a vision of the potential futures immanent to life.

Untimely Genres

Returning to the notion of Afrofuturism and its position in relation to the genre of science fiction—more recently relabeled speculative fiction, it is important to note that: within modernist, capitalist, humanist worldviews, representations of technoscientific futures are often used in the self-reflexive service of reifying both progress narratives and the norms and forms of life and futures aliased by them. After all, advancements in science and technology connote progress on a modern read. Given the earlier discussion concerning the link between the temporal foundation of progress logics and the unfulfillable promises they make in relation to life futures, it might seem paradoxical to ground a vital liberation strategy in technoscientific terms. Afrofuturism is not, however, "pure" science fiction; as mentioned, it also uses the historical genre insofar as it also works to recover and represent a past it resignifies through reference to ancient symbols, as in Badu's *Next Lifetime* video, and arguably could be considered a form of nonlinear Bildungsroman of Black life reimagining origins and their future trajectories through a renegotiation of present circumstances in a sort of "coming of life" story. Further, genres have a sneaky way of pushing beyond themselves—even while remaining contained within their own pre-drawn boundaries—because they are formulated through and by affect. As Berlant describes, "genres provide an affective expectation of the experience of watching something unfold, whether that thing is in life or in art" (Berlant 2011: 6). Thus, bending and blending genres interrupts

expectations, providing a rupture that allows the generation of new thought and affective experience and the charting of paths toward novel ways of living.

Elsewhere I have argued for a move to *transgenre* in place of gender because of how it suggests type, kind, sort, category, and style-evokes the scientific term "genus" or family, captures a productive sense of generic as set apart from restrictive classification praxes, and exposes an essential affective dimension. This shift was meant to divest discussions of gender, and by extension sex and bodies, from their conventional oedipal organizing principles and to capture what Jacques Derrida described as genre's impurity, contamination, and participation without membership (Derrida 1980: 74). Genre also, importantly, reveals a lost ontological excess in corporeal figurations considered according to gendered tropes: locked into categories and so oedipalized, gender fails to account for the extent to which bodies are fluid, uncontainable assemblages, and sites of constant negotiation (Weinstein 2011 and 2012). A decade later, I would still insist on genre's myriad potentials in the domain of gender, though with the coda that we must expand its sphere to encompass considerations of life. In other words, I reckon that thinking life in terms of genres or perhaps better, *transgenres*, might be fruitful for reworlding and futuring projects in that it incorporates the affectivity, potentiality, creativity, and innovation that makes life always already excessive and beyond itself, and other than life as it is articulated through its norm-and temporally bound singularity. As Tricia Rose noted, this tips the scales "in favor of multiple meanings ... which can't be fixed and floated across time and space" (Dery 1994: 214), which returns us to the earlier suggestion that futurist projects must engage in a great deal of shapeshifting.

Negotiating existence and identity—or enacting transgenres—in the attempt to create potential futures in a context structurally designed to relegate certain lives to its constitutive outside requires a delicate choreography, of "more or less continuous metamorphoses, of multiple inversions, of plasticity, including anatomical, and of corporeality, if required machinic" (Mbembé 2019: 164). For, as Samuel L. Delany claims, one must avoid "constructing something so rigid as an identity, an identity in which there has to be a fixed and immobile core, a core that is structured to hold inviolate such a complete biological fantasy as race whether white or black" (Dery 1994: 190). In the case of many Afrofuturists, genre-bending or shapeshifting has become an art form in which identities become endlessly mobile by affectively *incorporating* difference: names and alter egos are fluidly adopted then switched; styles and fashions are blended and shifted to trouble expectations of gender and sexuality; and music genres are mixed, created, upended, and recreated. One could say that genre distortion is a core mechanism of the un- and reworlding engine. It is worth considering several artists who, while perhaps not all Afrofuturists in the sense of using tropes from speculative fiction, have negotiated the ever-shifting identity terrain in this way and have, thus, set the stage for others to envision alternate futures and worlds and ways of existing within them. Erykah Badu, for instance, adopted her artistic identity as a way of distancing herself from her given name, which she refers to as her "slave name," where the "kah" in Erykah is an ancient Egyptian word meaning vital energy, and "Badu" is both her favorite jazz scat and means "manifest truth and light" in Arabic. In other works, she dubs herself, among others, Badulla Oblongata (pointing to the

medulla oblongata which controls the autonomic functions of breathing, heart rate, and blood pressure, as well as the sleep wake cycle—the basic functions of life) and Amerykah, plainly locating herself in relation to the so-called "American Dream."

Meshell Ndegeocello, too, refashioned herself by adopting a name drawn from African roots, where "Ndegeocello" means "freedom" in Swahili. But she takes genre mobility several steps further through her masculinity, bisexuality, multi-instrumentalism, and alternating vocal tones—resisting easy classification when measured against cis-heteronormative expectations. In tandem with her limit-pushing identity play, Ndegeocello's music is a bricolage of genres spanning funk, soul, jazz, hip-hop, reggae, spoken word poetry, and rock, though she is often credited for sparking the neo-soul movement with her debut "Plantation Lullabies" (1993). Ndegeocello reflects that: "music is the only time I feel genderless, raceless" (Ndegeocello 2014). When pressed to respond to continual demands to define her gender and sexuality, Ndegeocello has a seasoned retort: "Homo sapien . . . That's what I am. I am a female homo sapien. If you want to discuss my sexuality then the blatant thing to say is I'm sexually functional with both sexes" (in Phoenix 1994: 34). While an amusing shield for Ndegeocello's frustration with the relentless demand to explain her seemingly "incoherent" sexuality, evoking the term "homo sapiens" (Latin: "wise man") speaks to the deeper illegibility of Black life, Black thought, and Black female sexuality as figured against the "Human" within the white, cis-heteropatriarchal temporal matrix. Goldin-Perschbacher argues that this "is in keeping with queer of colour critique, a political mode of being, thinking and making art that exposes identity politics' inherent reinvestment in intertwining heteropatriarchal, racist and classist formations" (Goldin-Perschbacher 2013: 473). I would argue further that her genre-bending, bisexual masculinity, music, and performances disrupt and exceed gender's ability to predict sexuality in ways that support the use of *transgenre*. Ndegeocello explains, "I'm far from butch, believe it or not. And not feminine, I guess. A femme in a butch body," comparing herself to "an X-man, a musical hybrid" (in Phoenix 1994: 33). Describing her own work as "Afrocentric," Ndegeocello's lyrics are infused with fierce social critique, as in the track *Shoot'n Up and Gett'n High* (1993), where she confronts racism head-on, in a taunting but eerily paradoxical sexy, masculine vocal style:

> Revolution against this racist institution
> The white man shall forever sleep with one eye open
> Dehumanize me
> Set aside and criticize
> I'm livin' in the midst of genocide. (Ndegeocello 1993)

One could also point to her entire sophomore album "Peace Beyond Passion" (1996) with its scathing but nuanced critique of the impacts of Christianity and white heteronormativity on the lives of Black women and queer people—often played out in the accompanying videos in ways that further complicate Ndegeocello's fluid identity and political views. For example, in the video for *Leviticus: Faggot*, the protagonist is a young man who is kicked out of his home by a religious and abusive father because

he is gay. Overlaid with Ndegeocello's smooth, soulful, almost joyful singing "Save me from, Save me from, Save me from this life . . . Beautiful angels dance around my soul . . . as I rise," the final scene shows the protagonist collapsed on the bathroom floor after having committed suicide only to be transformed into an almost indistinguishable Ndegeocello, who rises and exits the room—effectively liberated from a life of erasure under the violent structures of homophobia and resurrected as the character's *transgenred*, queer future (Ndegeocello 2007).

Other artists, such as FKA Twigs and Zebra Katz, have remarked on the ways that racial and sexual identity can trouble interpretations of musical genre. FKA Twigs attributes the difficulty of critics to identify her musical style, which "shares certain sonic threads with classical music" and hymns, to the fact that she is mixed race. She observes:

> When I first released music and no one knew what I looked like, I would read comments like: "I've never heard anything like this before, it's not in a genre." And then my picture came out six months later, now she's an R&B singer. . . . If I was white and blonde and said I went to church all the time, you'd be talking about the "choral aspect." (Beaumont-Thomas 2014)

Zebra Katz, branded a "queer rapper," is hesitant to identify with either descriptor. In discussing the odd focus on sexuality in relation to his music, he offers:

> I don't know, you tell me what it is! I don't even really make rap music. People just say that because I'm brown . . . there's so much more to what an artist embodies than a label or genre . . . we are going to break any boundaries that are put before us and defy any genres that we're labeled with.. . . . What other genre of music has "queer" as a headline? (Kelley and Katz 2022)

Indeed, it is not surprising that so many Afrocentric or Afrofuturist artists are resistant to labels or genres if what Judith Butler taught us is true—that there is no truth to gender, and by extension neither sex nor sexuality. For what is it to proclaim such a truth other than to do so against the backdrop of predetermined white, colonialist, cis-heteropatriarchal scripts that insist upon fixed norm-deviance dualisms only to measure, discipline, and control life in relation to them? Map this onto my argument above about how these same scripts buttress the very concepts of time that preempt life and summarily defuture, and it is clear to see why shapeshifting and the inchoate might be essential parts of a liberatory, world-building egress. This is not to argue that there are no valid strategic reasons to declare one's identity. But bracketing those, I wish to underscore that transgenre flexibility—a strategic refusal to be categorized or answer "intelligibly" and the disavowal of the chronologics that demand an answer to a question that should not be posed in the first place (the question itself is illegible outside the confines of those logics, just as being outside those logics makes one illegible)—pinpoints the excess and disruption that queer- and Afro- futurisms affect and how they function as critical unworlding mechanisms. It is for this reason that

perceived incoherence seems so intolerable, as it simultaneously reveals the cracks in the established order by renegotiating its life-limiting structures and provides the possibility of reworlding through forms of living that were excluded by design.

The Art of Revolutionary Life

They started calling us computers. People began vanishing, and the cleaning began. You were dirty if you looked different. You were dirty if you refused to live the way they dictated. You were dirty if you showed any form of opposition at all. And if you were dirty, *it was only a matter of time.* (Monáe 2018, italics mine)

While it would be impossible in the scope of this chapter to discuss the full breadth of prolific singer, songwriter, rapper, actor, and science fiction author Janelle Monáe's contribution to queer-, feminist-, and Afro- futures, it is worth taking a quick detour to consider her trio of earlier works, including the 2007 "Metropolis: Suite 1 (The Chase)" and "The ArchAndroid" from 2010, which gave birth to her alter ego Cindi Mayweather, a female android who represents the ultimate Other to the Human and serves as a flexible stand-in for a wide range of oppressed identities. This rich duo of expressionistic futurist works drawing from a diverse range of influences—from Fritz Lang to Alfred Hitchcock, Philip K. Dick, and Debussy—are, thus, highly charged cultural critiques that examine contemporary structures of oppression and endeavor to imagine futures for a multiplicity of Other lives. In Monáe's first single from "The Electric Lady" (2013), featuring fellow Afrofuturist Erykah Badu in the guise of Badulla Oblongata and Monáe as her alter ego Cindi Mayweather, she addresses oppression in its multiple formations through its titular acronym Q.U.E.E.N., denoting Queer, Untouchables, Emigrants, Excommunicated, and Negroid (Benjamin 2013). With lyrics like "Even if it makes others uncomfortable / I will love who I am" and "Categorize me / I defy every label" it should come as no surprise that Monáe herself has since identified as bisexual, pansexual, polyamorous, queer and, recently, nonbinary (using either she/her or they/them pronouns), saying, "I am everything. But I will always, always stand with women. I will always stand with Black women. But I just see everything that I am, beyond the binary" (Mier 2022). Other lyrics from the track testify to Monáe's commitment to Afrofuturism and evoke strategies that, like Gilroy, forgo efforts to seek corrective inclusion into modernist temporal worldviews ("been 'droids far too long," "Add us to equations but they'll never make us equal") and, instead, reclaim pasts ("Are we a lost generation of our people?") to create and imagine ("this melody will show you another way") fem-centric alternative futures ("She who writes the movie owns the script and the sequel").

This is highlighted in the video's introductory voiceover where a woman from the "Ministry of Droids," who appears normatively white, is projected into the scene through a monitor, situated front and center in a stark, minimalist, black-and-white,

dystopic world. While a backdrop of classical string music plays, as if attending high tea in a castle, the woman announces:

> It's hard to stop rebels that time travel but we at the Time Council pride ourselves on doing just that. Welcome to the Living Museum where legendary rebels from throughout history have been frozen in suspended animation. Here in this particular exhibition, you'll find members of WondaLand and their notorious leader Janelle Monáe along with her dangerous accomplice Badulla Oblongata. Together they launched Project Q.U.E.E.N., a musical weapons program in the 21st Century. (Monáe 2018)

There can be no doubt what this "Time Council" is meant to represent and who is locked in "suspended animation" as the camera first pans to two Black men, smeared in ashy white paint, wearing only colorful, handmade cloth undergarments, posed as if mid-dance or on the verge of attack, before zooming in on Monáe sipping tea at a table in a black, militaristic-style uniform jacket with a red braided-rope sash, and Badu (seen from the back), with a blonde afro, donning a white robe and gold forearm armor, leaning on a table in a pose that could be described as somewhere between commanding and sexually submissive, protected by a gray poodle facing the camera, and flanked by two men to whom she is seemingly imparting her revolutionary strategies. When the music begins and the frozen come to life, Monáe sings the line "they call us dirty coz we break all their rules," which forms a transition to the conceptual underpinning of her 2018 "emotion picture" *Dirty Computer*.

Dirty Computer musically and visually skillfully imagines, re-encodes, and creates an untimely future universe, that through its multi-level, genre-flexibility shapes potentials for queer-, feminist-, Black future life. As the epilogue of this section demonstrates, the film ushers in a dystopian near-future world where people (called "computers") are captured and sent to a laboratory to be "cleansed" of the perceived bugs and viruses in their systems—read variously as Blackness or queerness—by a memory erasure drug called "nevermind." The last line's reference to this process being "a matter of time" is striking and circles back to the "Time Council" of "The Electric Lady" and arguments made earlier about the ways that the chronologics of progress work through historical amnesia and situating Black lives as life's precondition. The film follows a temporal trajectory that starts in a critical, archaeological, unworlding mode showing the stark realities of life as it is trapped in the limitations of time's deadening grip, through to a joyous, celebratory ontological mode that, through a combination of musical styles, visuals, and a much discussed scene of intimacy between Monáe and another woman, affectively and conceptually creates potentialities in the present that allow for the speculative, architectural, reworlding of its final scene, where Monáe's character and her fellow dirty computers escape the laboratory and are enveloped by, and evaporate into, a blinding light. While the viewer does not see the future nor its blueprint, by dissolving into it, Monáe's character is finally free of the chains of time that rendered her and the other dirty computers lifeless and trapped in their predetermined corporeal formations. Following Deleuze, I would argue that this final scene produces

futures in which life is not formed by constructing new subjectivity constellations but rather is formed as a work of art (Deleuze 1995: 95) which has the ultimate aim "to set free ... [the] invention of a people, that is, a possibility of life" (Deleuze 1997: 4).

[Outro] The Future Is Dirty

Afrocentric artists and Afrofuturists have set a high bar for self-creation by shaking our modern chronic habits and creating themselves and, thus, a new world of futurable lives through aesthetic production. Through shapeshifting multiplicity, unlearning and reimagining pasts, and projecting alternative histories of and for the future, theirs is always already a revolutionary and untimely project. As queer rapper Lil Nas X sings in his infamous track *Montero (Call Me by Your Name)*, "it's a sign of the times every time that I speak" (Lil Nas X 2021). This and the work of the artists mentioned earlier echo Tavia Nyong'o's claim that "it is eminently possible for a work of art to focus into a single duration a whole virtual history of oppression and resistance, while remaining caught up in a relation to the future" (Nyong'o 2019: 118). In what I have argued above, it is clear that I am not particularly interested in the "transgressive" potential of aesthetic work, since that ricochets to the question of *what* is being transgressed and thereby back to the circular logic of time and its relationship to history. What I have argued instead is that our focus ought to be on the contaminated, transgendered, transformative, innovative, untimely essence of life and, from that basis, draw from the excess potential contained in the past to enact futures for living that are otherwise unimaginable in time.

References

Aghoro, Nathalie (2018), "Agency in the Afrofuturist Ontologies of Erykah Badu and Janelle Monáe," *Open Cultural Studies*, 2: 330–40.

Ahmed, Sara (2007), "A Phenomenology of Whiteness," *Feminist Theory*, 8 (2): 149–68.

Ahmed, Sara (2010), *The Promise of Happiness*, Durham: Duke University Press.

Badu, Erykah (1997), *Erykah Badu - Next Lifetime*. Directed by Erykah Badu. February 18, 2022. Music Video, 4:05. Available online: https://www.youtube.com/watch?v=07uSAIcXFmg (accessed May 24, 2022).

Beaumont-Thomas, Ben (2014), "FKA Twigs: 'Weird Things Can be Sexy,'" *The Guardian*, August 9. Available online: https://www.theguardian.com/music/2014/aug/09/fka-twigs-two-weeks-lp1 (accessed May 24, 2022).

Benjamin, Jeff (2013), "Janelle Monae Says 'Q.U.E.E.N.' Is for the 'Ostracized & Marginalized,'" *Fuse.tv*. Available online: https://www.fuse.tv/videos/2013/09/janelle-monae-queen-interview (accessed May 24, 2022).

Berlant, Lauren (2011), *Cruel Optimism*, Durham: Duke University Press.

Deleuze, Gilles (1995), *Negotiations, 1972–1990*, translated by Martin Joughin, New York: Columbia University Press.

Deleuze, Gilles (1997), *Essays Critical and Clinical*, translated by Daniel W. Smith and Michael A. Greco, Minneapolis: University of Minnesota Press.
Deleuze, Gilles (2002), *Pure Immanence: Essays on a Life*, New York: Zone Books.
Derrida, Jacques (1980), "The Law of Genre," translated by Avital Ronell, *Critical Inquiry*, 7 (1), special issue on Narrative: 55–82.
Dery, Mark (1994), "Black to the Future: Interviews with Samuel R. Delany, Greg Tate, and Tricia Rose," in Marc Dery (ed.), *The Flame Wars: Discourse of Cyberculture*, 179–222, Durham: Duke University.
Dinshaw, Carolyn, Lee Edelman, Roderick A. Ferguson, Carla Freccero, Elizabeth Freeman, Judith Halberstam, Annamarie Jagose, Christopher S Nealon, and Tan Hoang Nguyen (2007), "Queer Temporalities: A Roundtable Discussion," *GLQ*, 13: 177–95.
Edelman, Lee (2004), *No Future: Queer Theory and the Death Drive*, Durham: Duke University Press.
Eshun, Kodwo (2003), "Further Considerations on Afrofuturism," *CR: The New Centennial Review*, 3 (2): 287–302.
Gilroy, Paul (2001), *Against Race: Imagining Political Culture Beyond the Color Line*, Cambridge, MA: Harvard University Press.
Goldin-Perschbacher, Shana (2013), "'The World Has Made Me the Man of My Dreams': Meshell Ndegeocello and the 'Problem' of Black Female Masculinity," *Popular Music*, 32 (3): 471–96.
Goode, Luke and Michael Godhe (2017), "Beyond Capitalist Realism – Why We Need Critical Future Studies," *Culture Unbound*, 9: 108–29.
Halberstam, Judith (2005), *In a Queer Time and Place: Transgender Bodies, Subcultural Lives*, New York: New York University Press.
Hartman, Saidiya (2002), "The Time of Slavery," *South Atlantic Quarterly*, 101 (4): 757–77.
Kelley, Eva and Zebra Katz (2022), "Zebra Katz Doesn't Give a Fuck About Your Hot Takes: The Hip-Hop Artist on the Art and Politics of Performance," *Ssense*. Available online: https://www.ssense.com/en-us/editorial/music/zebra-katz-doesnt-give-a-fuck-about-your-hot-takes (accessed May 24, 2022).
Lil Nas X (2021), *MONTERO (Call Me By Your Name)*. Directed by Tanu Muino and Lil Nas X. March 26, 2021. Music Video, 3:09. Available online: https://www.youtube.com/watch?v=6swmTBVI83k (accessed May 24, 2022).
Mbembé, Achille (2019), *Necropolitics*, Durham: Duke University Press.
Mier, Thomas (2022), "Janelle Monáe Shares Non-Binary Identification: 'So Much Bigger Than He or She,'" *Rolling Stone*, April 21. Available online: https://www.rollingstone.com/music/music-news/janelle-monae-shares-non-binary-1341131/ (accessed May 24, 2022).
Monáe, Janelle (2013), *Q.U.E.E.N. Feat. Erykah Badu*. Directed by Alan Ferguson. May 2, 2013. Music Video, 6:04. Available online: https://www.youtube.com/watch?v=tEddixS-UoU (accessed May 24, 2022).
Monáe, Janelle (2018), *Dirty Computer [Emotion Picture]*. Directed by Andrew Donoho and Chuck Lightning. April 27, 2018. Video, 48:37. Available online: https://www.youtube.com/watch?v=jdH2Sy-BlNE&t=140s (accessed May 24, 2022).
Muñoz, José (2009), *Cruising Utopia: The Then and There of Queer Futurity*, New York: New York University Press.
Ndegeocello, Meshell (1993), Shoot'n Up and Gett'n High, track 4 on Plantation Lullabies, Maverick.

Ndegeocello, Meshell (2007), *Leviticus: Faggot*. Directed by Kevin Bray. December 7, 2007. Music Video, 4:09. Available online: https://www.youtube.com/watch?v=U0N83NvSfk4 (accessed May 24, 2022).

Ndegeocello, Meshell (2014), *Comet, Come to Me: A Journey into Meshell's Work (Mini-documentary)*. Directed by Karen B. Song. October 29, 2014. Video, 12:40. Available online: https://www.youtube.com/watch?v=s9-BVXjEMBA (accessed May 24, 2022).

Nietzsche, Friedrich (1997), *Untimely Meditations*, edited by Daniel Breazeale, translated by R.J. Hollingdale, Cambridge: Cambridge University Press.

Nyong'o, Tavia (2019), *Afrofabulations the Queer Drama of Black Life*, New York: New York University Press.

Phoenix, Val C. (1994), "Me'Shell: Uncensored, Unfettered," *Deneuve Magazine*, 4 (2), April. Available online: https://www.curvemag.com/articles/from-the-soul-meshell-ndegeocello/ (accessed May 24, 2022).

Summer of Soul (...Or, When the Revolution Could Not Be Televised) (2021), [Film] Dir. Thompson, Ahmir Khalib "Questlove," USA: Searchlight Pictures and Hulu.

Tillet, Salamishah (2021), "With 'Summer of Soul', Questlove Wants to Fill a Cultural Void," *New York Times*, June 30, updated July 10, 2021. Available online: https://www.nytimes.com/2021/06/30/movies/questlove-summer-of-soul-harlem-cultural-festival.html (accessed May 24, 2022).

Weinstein, Jami (2011), "Transgenres and the Plane of Language, Species, and Evolution," *Lambda Nordica*, 4 (16): 85–111.

Weinstein, Jami (2012), "Transgenres and the Plane of Gender Imperceptibility," in Henriette Gunkel, Chrysanthi Nigianni and Fanny Söderbäck (eds.), *Undutiful Daughters: New Directions in Feminist Thought and Practice*, 155–68, New York: Palgrave Macmillan.

15

Feeling Closer to the Track—The Representation of Blackness in Music Video

Modu Sesay

Modu Sesay is a London-based photographer and director of short films and award-winning music videos. The interview provides an insight into his workflow and vision for his art as well as his collaboration with Black artists like Sampa the Great and Danny Brown. In conversation with the editors Sesay reveals his sources of inspiration and reflects on the importance of collaboration and heritage and how they can be utilized to create a unique aesthetic of (Female) Black Empowerment.

You worked with Sampa the Great in the past, for example the cooperation for the video *Energy (feat. Nadeem Din-Gabisi). Birds and The Bee9* won the Australian Music Award. The video is about Female Black Empowerment and equality in general. How was its particular aesthetic created? Especially when it comes to the representation of Black bodies, nature, the choice of colors, clothing, and jewelry.
This was created through weeks of conversation with Sampa the Great, her manager Carl Pires and the creative producer Clara Stewart. Sampa wanted to create a film around a dream she had where she went to purgatory. In this place she experienced life and death at the same time, it was the birth of the "energy" visual. We wanted to show the nuances of when you toe the line between life and death.

We aimed to fully represent Black bodies by showing the full spectrum of Black people from light skin to dark skin in one place. Black heritage is extremely vast and can be seen across the world. Jewelry was a massive part of the styling, Africa is rich in precious metals and stones, so we called on Lucky Little Blighters to provide phenomenal pieces that helped us go back to our roots, where as kings and queens we would wear these beautiful pieces daily, we wanted to represent the regal side of Africa. For clothing, the styling differed depending on the scene. The first main scene was the studio shot with Sampa and all our cast together. We went with a skin tone vibe here, to show vulnerability and strength—we wanted everyone to look the same and to represent the army of our ancestors and our future. For the beach scene, we went for an all-white look to show our angelic glory when we are out in nature, our natural resting place surrounded by the elements. Styling outside of the nude scene was all about layers, representing the rich history and layers that Black people have and show on a regular

basis. We've been through so much. Not only do we have so many layers due to our rich history, we also have many layers to hide and be chameleon-like in the diaspora, this is important for us to be able to survive in all situations throughout history.

Beyoncé and Monáe work with many pop cultural and multimedia references in their work, bringing them together to create their own aesthetic of Black Female Empowerment. The videos that you directed develop a dynamic and reference structure that is constituted by certainty. What is the concept behind this?
The dynamic nature of my videos is meant to be a representation of human emotions. We are all multi-faceted and go through a variety of emotions. We very rarely move in a linear fashion to our goals (or so we believe). The journey from beginning to end has its ups and downs but certainty in the final goal and solution is the only thing that will allow us to get there, embracing the dynamic challenges life throws at us. Belief, i.e., certainty, is the edge that gets you through.

The references usually come from striking imagery that tells a story within a single frame. There is a certainty in which I want the final images to be. A lot of my imagery comes from social media and my direct peers, it is very important to me as it helps me build a visual world in which my characters have a purpose and move with faith toward their goals

Do references to avant-garde artists of the 1970s and 1980s play a role in your creative process? Is the fusion of art, video, and performance play inspired by the Afrofuturism movement a possibility to create a Black video aesthetic? How important are artists like Sun Ra for you and your work?
I'm more inspired by the musicians of the 1990s. This spanned from America to London and Africa, being raised in London in a proud African household. This was a heavy influence on my creative process as I was regularly exposed to 1990s music and culture from a young age, through parties and variety of media.

There has always been a Black video aesthetic even from the beginning—it is natural for us to lean toward one way of telling our story. I feel moving forward there is definitely an excitement for the future of Black videos inspired by the Afrofuturism movement. We have more of *a say* and we have more *to say*, there is less of a stigma attached to Blackness, I think this is what may feel like there's a new wave of Black aesthetic.

I feel more inspired by artists such as Michael Jackson, Marvin Gaye, and Otis Redding rather than Sun Ra from that golden era. For me their influence spanned from the 1990s into my early years of filmmaking. They were all extremely enigmatic, creating their own subculture and living in their own lane.

In your video *Energy* one can see processes of hybridization between video, performance, and poetry. Where do you see the use of Krio, the language of Sierra Leone, located in this fusion? What does it mean for you to use it in your work?
Fusing together different mediums is really important to me and is something that I try to incorporate in all my work, it helps to keep the visuals dynamic so I am able to tell the same story from different perspectives.

It was in the middle of the video and we utilized it as a transition point, it was the movement into Sampa's final form, where all the uncertainty of life started to make sense, we started to let go and look into the future. This was very fitting as Krio is the language of freed slaves, for me this is the definition of coming together, refocusing and moving forward. Using Krio was powerful for me because, as my mother tongue, it helped me tell a story from the motherland; I was able to relate and tie in my own African heritage into the final film, making it very personal. I am extremely family driven; my upbringing plays a very important role in my creative process so it's such a pleasure for me to be able to touch upon this in such a personal way in one of my best pieces of work.

By designing a Black aesthetic that is spiritual, that points to something (e.g., scene on the beach, energy at all, traditional clothing, rite by the sea)—is this also about overcoming something? How can you depict something like that? Where do your ideas come from? Does liminality play a role here?
The scenes on the beach before the rite by the sea is about overcoming, stigmata, your mind, your negative thoughts—expel your demons and move forward. This all culminates in the scene at the water where you must finally take the leap of faith. The rite by the sea was informed by the ancient Brazilian tradition of Candomblé, where hundreds of thousands of people congregate on the beach, load up offerings, and cast them overboard. We drew upon this reference to tell the story of Sampa moving forward. With the ritual informing our styling, art direction, and movement. Where we had all-white styling, flowers in abundance, nestled in a basket that represents the traditional boat.

My ideas traditionally come from the people around me, conversations I am having with them and visual moments I feel I directly relate to. I try to draw on real-life experiences that I have seen and experienced. I'm inspired by human emotion and what is real, looking deep into people's characteristics, both good and bad. However, this scene was greatly influenced by Candomblé, a suggestion that came from Clara during our conversations with Sampa. It felt like a natural choice, as Sampa wanted to explicitly show the transition into her final form.

In Monáe's work, we repeatedly find a queer gaze that aims at overcoming the human (e.g., in *Dirty Computer*). Do you think that the hegemony of whiteness is something that is also to be overcome in this special form of projective thinking into the future? For example, the white male subject that has been the basis for virtually everything that was considered classical philosophical thinking for centuries.
I think it is very important that we show the most honest representation of Blackness possible. We are a phenomenal example of the human race, and shining a light on the best version of ourselves will naturally dispel the myth of white hegemony. We are the soul and foundation of life with all human life coming from Africa, and to this day natural resources and Black people are vital in running the world. As we grow in confidence telling our story on the global stage, I feel we will naturally overcome the

stigmata put on Black people and our strength and knowledge will sit rightfully at the pinnacle of intellectual and philosophical thinking.

You also work with other Black artists, such as Danny Brown. In your videos and short films, you create your own aesthetic, a new world. How does this world differ from other music video worlds? Can a common utopia be found in your work that is connected to others?

I like to believe the aesthetic I am trying to create is reality but remixed. I firmly believe the underground subculture is always right in front of your face, you just need to shift your perspective and you can experience it in all its glory.

My style is different as I try to portray my vision of the artist I am documenting. I take what is standard to them and the genre they are showcasing, then put my own abstract spin on it. For example, in Danny Brown's video I led with his loud crazy on-stage persona but juxtaposed it with his thoughtful and impactful words on life and his mantra of being at peace with oneself. From what I had seen previously, these two sides of Danny were represented separately up until this video. So, I wanted to show that his calmer side informs the high-energy side of his on-stage persona and performances. The calmness is where he becomes at one with himself to the point where he can get on stage and fully let go. Stoicism is something I try to draw upon, with shots that tell a story without much having to be done by the artist. I like to put them in a beautiful scenario then capture them being at one with the space they are in. My main aim is to show reality but in an unconventional manner where possible.

How do you think art and music together? How do you develop conceptual artistic perspective on music? Is hybridity an important concept for you?

To me, art is music and music is art, they go hand in hand. I believe great art and great music should have the same effect on humans. It should move you, make you feel. If you create really strong work, it will evoke a strong emotion or perspective from the masses. Also, I believe one can be elevated by the other. I really enjoy going to an exhibition and there's music that helps tell the story of the artist or the art I am experiencing, it helps tell the story and vice versa. A good music video for me is one that makes you feel closer to the track and understand the space the artist was in when they made it. I mostly go with the feeling that a track gives me, then draw on my own life experiences, fashion magazines, and images I see on social media to generate a visual space for that feeling to live in.

My own artistic perspective has been developed over the years through experimenting with different styles and ways to tell a story. I have come to the conclusion that I like to tell the story of reality—but with a twist, so this is what I propose to artists. Hybridity is an essential part of my creative process. I believe you can't tell a story from one perspective and get the full picture. I feel the most dynamic of videos are ones that tell the same story but in a variety of viewpoints.

Your portrayal of Black London rappers and Black musicians plays with the concept of Black masculinities. Has something changed in the past few years when you think about the contrast of rappers in your videos, e.g., who like to show off their money, their "bitches," and so on, as opposed to other artists like Salute who show their vulnerability?

All Black musicians have their own way of "flexing." Everyone has been through something in their life that they've had to push past one way or another; some are more abrasive than others; however, they are all making powerful moves in order to progress. I will always try to document all sides of the Black experience; that could be from people that come from a poorer background and their battles can be more direct and physical at times, or artists from a richer background that can focus more on creating art but still have to go through the battle of acceptance in a predominantly white society.

VI

Media Art Hybrids

16

Hold Up

Mapping the Boundaries between Music Video and Video Art

Kirsty Fairclough

The synesthetic combination of music and moving images has a considerably long and more diverse history than that of music television, and certainly of MTV, a diversity that is beginning to be increasingly recognized in the field of contemporary audiovisual studies. However, its position in global culture has been firmly cemented since the arrival of MTV, and it is currently experienced in many ways through various technologies. As its popularity and proliferation thanks to digital technologies have grown, a surprisingly small and distinct focus on its formal analysis by media and culture scholars has developed, as confirmed by such volumes as Vernallis's *Experiencing Music Video* (2004) and Railton and Watson's *Music Video and The Politics of Representation* (2011), *The Oxford Handbook of New Audiovisual Aesthetics* (Richardson, Gorban and Vernallis 2015), and *Digital Music Videos* (Shaviro 2017).

Yet music video has long been a problematic and controversial form. It has been characterized as residing somewhere between commerciality and art and between creative expression and promotion. The music video in its early incarnation as a promotional tool was always both tangible and ephemeral, and this aesthetic tension certainly persists in the digital era. It may be that its boundaries are perhaps vaguer and fuzzier than ever before. The music video continues through both itself and something other as an expression of audiovisual creativity and commerce, even if it has become less clear exactly what this commerce is trading beyond the music video itself as a kind of vital currency.

What is yet to be fully addressed is how the form of music video can be mapped onto a range of other audiovisual aesthetic practices. As Vernallis puts it in her key text, *Unruly Media* (2013), "At one time we knew what a music video was but no longer . . . We used to define music videos as products of record companies, in which images were put to recorded pop songs to sell songs. But no longer" (Vernallis 2013: 10–11). As I have written elsewhere (Arnold et al. 2017), there is an evolution from Vernallis's unashamed celebration of music video aesthetics as a distinct format in *Experiencing Music Video* (Vernallis 2004) to her later work *Unruly Media*'s discussion of the music

video in the context of a "mixing board aesthetic" (Vernallis 2013: 4) of YouTube clips and new digital cinema which for her have become inseparable from music video itself.

Yet despite the music video becoming increasingly intrinsic to contemporary digital culture, scholarly work in this area has not grown much further and has not fully considered how it maps onto other audiovisual forms. This chapter then will explore how the music video net may be cast wider, not only in terms of connections with broader histories of audiovisual studies but also in terms of practices from video art to global popular culture. It will address how music video can be situated in terms of an "audiovision" or "audiovisuology" that can destabilize what we thought we knew about the music video, even in its "classic" MTV period. It will then examine how specific forms of music video and video art are shaped by this very culture themselves and vice versa.

One way to approach the art of the music video would be to focus on the use of digital video techniques as can be explored in the work of Vernallis (2004) and Shaviro (2017) where they examined such techniques as compositing, motion control, morphing software, and other digital special effects as well as their remediation of media forms such as experimental cinema or video art. Yet this approach is limited, and this chapter will attempt to explore the aesthetic dynamics that stem from the hybridity of music videos and video art and how these aesthetically hybrid forms could be described as discursive devices that shape contemporary culture.

Re-popularizing the Music Video

As Feisthauer states:

> After a period of stagnation and disinterest in the early 2000s, music videos nowadays are much more than just an advertisement for a specific song and even more than just a visual product to accompany the music. The music video has become an independent art form with a vast and interactive audience, making it a, if not the, most democratic one. (Feisthauer 2022: 3)

While the notion of democracy in music video production remains somewhat debatable, the music video's popularity and vast hybridization have propelled it into a complex form (with much more porous boundaries) which is constantly influenced by other forms.

Music videos are currently a hugely efficient method of consuming music. According to YouTube's Global Head of Music, Lyor Cohen, more than two billion logged-in YouTube users are now playing music videos on the platform each month (Ingham 2020). Given such statistics which show no sign of slowing, it is reasonable to suggest that they remain a primary means through which music is consumed worldwide.

In terms of the aesthetics of the music video, they continue to push boundaries. As Blessing Borode states in *New Wave Magazine*:

Music videos continue to innovate new ways for people to tell their stories. It has become more than just a part of our consumption of music, art, and entertainment but a tool that's used to add another dimension to projects. With different elements of animation, design, and effects we can spend a few moments in a world the artist has created, where the story told becomes more than something we listen to but a moving concept. Every detail put into creating these visuals - from the location and design of the set, the styling of the artists and extras, the way each shot transitions into the next, down to the colour grading - all play a part in our overall experience. (Borode n.d.)

Borode is, of course, discussing the music video, but one would be forgiven for thinking that these words are describing other forms of audiovisuology. The idea of the music video as an ever-shifting concept is now so closely linked to video art that the boundaries of each form appear to collapse into each other. It is only the means of exhibition that may differentiate the two, and even this is not clear-cut in contemporary culture.

The Rise of Video Art

As has been widely documented and discussed, the accessibility of cameras for self-documentation took place around the time of the emergence of Sony's Portapak cameras in 1967. This democratized the moving image, as the camera was no longer confined to the film studio, and it quickly became subsumed into everyday life. This handheld camera led to the rise of video art. The form is said to have begun when Nam June Paik used his new Sony Portapak to shoot footage of Pope Paul VI's procession through New York City in the autumn of 1965. Later that same day in a café in Greenwich Village, Paik played the tapes and video art was said to have been created.

Because cameras were relatively low in cost, this allowed mass consumption and usage of the technology to become widespread, giving individuals the ability to shoot and experiment with creating their own filmic experiences. Artists quickly embraced this new technology and used it to comment upon societal issues of the day. Many artists of the late 1960s and 1970s post-Paik used video to create artwork that parodied television and advertising, highlighting what they saw as television's insidious power. As stated in *Art Miami Magazine*,

> For its time, video art was radically new, which is why some artists felt it was an ideal format for pushing limits in contemporary society with art. For example, during the Feminist art movement, many women artists who were trying to distinguish and distance themselves from male artist forebearers chose video for the opportunities that hadn't been widely established or tapped. Also, many artists with a social or political cause who wanted to spread the unexposed and important

information, video came across as a medium conducive to both affordability and broad distribution capabilities. (Art Miami Magazine n.d.)

Alongside this, the distinctions between art and popular culture were beginning to blur, just as the boundaries between low- and high-brow art were growing more porous from the 1950s onward. Similarly, movements in performance art and installations found a new outlet through the video camera as artists sought to find new ways of presenting the themes and issues that they desired to explore. For many artists, there was much less of an emphasis on storytelling via linear narratives as is often seen in the music video, and much more of an increased focus on the creation of imagery and sound which interrogated sociopolitical issues.

Video art became known for creating often disjointed and enigmatic fragments of imagery that offer innovative ways of processing and reflecting on societal issues. In a contemporary context, video art is now an established means of artistic creation taking numerous forms—from recordings of performance art to stand-alone installations that incorporate vast and numerous screens to works created for digital distribution only.

Where Music Video Meets Video Art

The establishment and increasing popularity of both music video and video art as a means of creative expression for artists are now firmly cemented in popular culture and contemporary art contexts. Video art is now considered a highly influential medium in the art world. What is clear is that the connections between video art and music video are even more present than at the height of the MTV era.

Holly Rogers, in her book *Sounding the Gallery* (2013), suggests: "While musicians and artists have long sought conceptual interaction, the materials available have restricted practical realisation and few examples of such communication exist. Previous audiovisual practices, such as lantern shows, music theatre, opera, synaesthetic experimentation, early direct film, and so on, were intermedial primarily at the level of reception" (Rogers 2013). Today, however, this interaction seems closer than ever at the level of creation, where musical artists borrow from and use the form and function of video art to express new audiovisual concepts.

To explore the aesthetic dynamics that emerge from the hybridization of music videos and video art, we must consider some examples before we can explore the close alignment of both forms.

The work of artist FKA Twigs provides a key example of where the music video form moves ever closer to video art. Her visual work continually pushes the limits of what music video can be, particularly in terms of the interrogation of feminist ideas. In the video for her first single, *Water Me* in 2013 on YouTube, the skills of visual artist Jesse Kanda were employed, making an immediate statement about FKA Twigs's ambitions as an artist. It was clear that mainstream popularity may be an ambition, but her aesthetic and messaging lay somewhere within a video art tradition.

In the self-directed music video for *Pendulum* (2014) we see a close-up of FKA Twigs's mouth, and a slow zoom-out reveals her suspended in bondage ropes made of her hair. She is hanging from the ceiling, staring directly into the lens of the camera; she moves to immerse her face in liquid mercury, tries to vocally express herself but is unable to do so. She then moves to emerge from the liquid, unshackled and dances defiantly as a pendulum swings. This set of imagery reveals a vulnerability and self-expression that appear rarely in a context where complex emotions and nuanced manifestations of female identities, particularly related to sexuality, are not often portrayed in mainstream music video. Her work may offer a fresh perspective on how female artists are allowed to visually represent their own identities in audiovisual cultures. Indeed, how FKA Twigs presents herself throughout her work points toward an attachment to the tenets of contemporary feminism that appears much more complex and nuanced than that of many other high-profile female performers who have thus far publicly declared their attachments to feminism.

FKA Twigs has consistently created imagery that challenges idealized womanhood as is routinely portrayed in the music video, particularly in a mainstream context. Her work may provide a more open space through which issues surrounding feminism may be played out, given that the edges of her work map onto a video art sensibility in that linear narrative is often absent, fragmented imagery is present, and a critique of mainstream ideas is often at the forefront. Her work presents a deeply introspective and personal vision that lacks any sense of aspirationalism—unlike many of her celebrity feminist contemporaries, such as Beyoncé.

The audiovisual aesthetic FKA Twigs displays appears somewhat problematic to the mainstream media in that she possesses an image that is difficult to comprehend. She is not easy to pigeonhole and effectively presents a conundrum in that she appears complex because she presents a sense of a deeply introspective identity, yet she is also an accessible celebrity. The popular media appears to find this difficult to decipher given the complexity of her audiovisual presentation, which acts as a disruption to the postfeminist regulatory framework that is frequently presented in popular culture. This is due to her exploration of her own relationship and response to reductive representations projected onto women through her visual imagery and performance style. FKA Twigs's video work is concerned with obliquely critiquing the representations and misrepresentations in popular culture as well as reflecting a deeply personal perspective. Her videos interrogate issues of rape, pregnancy, female fantasy, and desire in a way that moves toward intelligent explorations of liberation and empowerment through female creativity and self-expression.

As FKA Twigs's work illustrates, the music video is an important discursive register of the transmission and reiteration of feminist ideas and appears to challenge the discourses surrounding famous women and how their bodies are scrutinized, celebrated, and denigrated. Her body is still aestheticized, but what appears different is that its visual representation seems to be deeply personal and self-controlled. *M3LL155X* (a variant of Melissa, a transcendent spirit she refers to as her "personal feminine energy") is FKA Twigs's third EP and consists of a sixteen-minute accompanying video comprising four self-directed music videos. In this work,

FKA Twigs presents often sexually charged performances and utilizes dance and performance in a way that is acutely expressive and appears to document her own feminist identity. Her performance style allows her to transform both the media-constructed horrors and fantasies that young women must negotiate in mainstream culture and remixes them in such a way that may point toward a form of resistance that may signal a feminist identity.

Music critics almost unanimously praised *M3LL155X*. Anupta Mistry of Pitchfork stated: "As a creative package the EP is unimpeachable; a high-concept, intellectually curious project that's evocative, accessible, and transgressive enough to satisfy the competing demands of a newly broadened fan-base and her existing audience of Tumblr-educated aesthetes. *M3LL155X* builds on her previous work, exploring ideas of dominance and submission and drilling down almost completely into the self" (Mistry 2015: 22). The *NME* prefaced their review by stating: "In an age where a poor-taste Rihanna video promo can launch multi-thousand-word think pieces, Twigs has conceived (and directed) a daring and provocative piece of capital-A Art" (Nicolson 2015).

M3LL155X presents a sense of the documentation of a deeply personal perspective on representations of women in popular culture while offering a distinct message that being a famous woman does not preclude her from exploring her subjectivity in a specific way. It appears to espouse a message that suggests she is creating work that is deeply personal and is not directly catering to a mass audience (which, of course, it is as a product of the commercial music industry) or indeed to any fan base. She often appears unconcerned with creating work that would appeal to anyone except herself, a sensibility which aligns her closely with a tradition of female video artists. It is through her imagery that this is most apparent. Her work moves well beyond the idea of female pop stars "owning" their sexuality and subverting conventional expectations. While her music videos are often sexually charged, FKA Twigs embodies her celebrity feminist identity on her terms. Her music videos often ask the audience to routinely engage with imagery that comments upon conventional representations of women in more complex ways than are often presented in the mainstream music video. In this way, her work moves much closer to video art in its aesthetic and thematic presentation.

The video for the song *I'm Your Doll*, a key section of *M3LL155X*, is a blunt statement on rape culture. Dressed like a pigtailed schoolgirl, FKA Twigs dances in front of an older white man which leads to a situation in which she has no power; FKA Twigs's head is then attached to a blow-up sex doll which the man penetrates. The scene is constructed as a ritual rape and one that FKA Twigs has knowingly entered into. It can be read as a commentary on the patriarchy of the music industry, where female artists must literally become detached from a manufactured body that is not theirs to own. At the end of the sequence, her body is deflated and she is left on the bed, trapped in the same position.

Some elements of *I'm Your Doll* and FKA Twigs's work more widely recall the work of Björk—another artist whose audiovisual work is closer to video art than music video—in that they present a deeply personal, erotic, and sensual sense of self that appears uncontrived and unmanufactured. The visual representations FKA Twigs uses seem to emanate from a resistance to rebrand or change for the sake of attaining mass success

and widespread celebrity status. Her work is nuanced and presents a more complex critique of the representations of women and their sexuality in the music industry. Its complexity lies in the fact that it is contextualized by mental rather than physical desire. Whereas for many female artists, artistic freedom and feminist expression must still be signed off by figures of patriarchy with endless power, it would appear that FKA Twigs has been afforded a certain amount of artistic freedom by her record label, Young Turks, allowing and encouraging her to challenge prohibitive boundaries and idealized representations. This may well be related to the fact that like Björk, FKA Twigs's work emanates from a more independent electronic musical context rather than a mainstream pop music arena—from a place where notions of freedom and independence appear rather more possible for female artists.

Media coverage has tended to downplay FKA Twigs's role as a music video director and producer of her own video work, predictably preferring to focus on her physicality, image, and relationship status. Yet she resists commenting and instead uses her work to express her views on the existing reductive structures that women in music must still negotiate.

The last section of the video *Glass and Patron* is concerned with self-empowerment. It most readily resembles a music video of any of the four segments. In one interview, FKA Twigs suggests that it is a comment upon the need to step outside of digital culture to connect with one's sense of an authentic self. Here FKA Twigs is located in a forest with her dancers, the forest representing a reconnection with nature and the body, far away from technology. A white van is visible disrupting the tranquility of the scene. Often, FKA Twigs's videos begin with extreme close-ups. Here she is revealed upside down, singing "hit me with your hands, double-knot my throat, mother." The camera moves out revealing her heavily pregnant form, pulling colored scarves from her vagina. The music changes pace and the scarves begin to fall away to reveal her dancers, elegantly swimming through them. The camera cuts to a catwalk in the forest, FKA Twigs sitting on a silver throne with her dancers voguing in front of her, awaiting her approval. The video is a celebratory 2015 version of a 1990s dance festival in which FKA Twigs's dancers are gloriously celebrating their art and their community. The voguing represents a kind of re-establishing of their connections to their bodies as a marker of their self-expression. Here, FKA Twigs is the leader of the group and echoes Madonna's use of voguing in the 1980s where a heterosexual woman appropriates a marginalized culture in order to enrich her own cultural cachet—but in a much less obvious manner. This, of course, is part of audiovisual culture and FKA Twigs presents the fine line between appropriation and appreciation as a knowingly blurred one. *Glass and Patron* is ultimately celebratory and respectful of the subculture which she is utilizing. *M3LL155X*, and FKA Twigs's work more generally, is attempting to marry several disparate cultures from performance art to hip-hop and voguing. This melding of styles is presented as a way of documenting her own explorations into more ephemeral and complex representations of female identity and moves away from universal, definitive, and rational understandings.

Much of what makes FKA Twigs unique is the varied and complex presentations of herself put forth through her music videos. Her commitment to exploring how

technology can be manipulated and used to manipulate the female form presents work that can be perceived as feminist without overtly labeling it as such. She presents a contrary quality that addresses a culture where human interactions are so heavily mediated that a search for real connection is futile and redundant. Her work challenges this notion and speaks to the complexity of contemporary celebrity and digital cultures where her femininity and feminism are difficult and contradictory. Yet, this is precisely where her authenticity is written across her works so explicitly.

FKA Twigs provides a sound example of a musical artist who is producing music videos that sit so closely to video art that it seems redundant to attempt to make a distinction between her and other female video artists. Aside from the machinery of the music industry that buttresses the production of her work, the differences are moot. The showing of her work at Manchester International Festival in 2015 attests to the fact that music video can be exhibited in a contemporary art festival and has found a place in the cultural landscape alongside video art.

We can trace the connections between the music video and video art quite easily if we then look closely at the work of a well-known video artist such as Pipilotti Rist, best known for creating video installations and immersive video-based environments, often characterized, and influenced by music video and popular culture as well as the early historic video work of feminist artists like Carolee Schneemann and Joan Jonas. Rist presents work that critiques popular culture, comments on the objectification of the female body, and presents a rich visual language that is often as accessible as it is strange.

1997's *Ever Is Over All* is one of Rist's first large-scale pieces of video art which consists of the use of large screens offering an immersive spatial dimension to her rich visual language. In this piece, Rist presents imagery interrogating female sexuality via hyper-saturated images of the everyday. The work is filmed in a single take using widely available camera technology and emphasizes the painterly qualities of standard-definition video, which can be considered a fundamental part of the imagery. Accompanied by a musical soundtrack that is closely related to the dreamy electronic soundscape of FKA Twigs, the piece consists of two large overlapping projections. On one huge screen a woman (Rist) confidently walks down a city street, smiling to herself. She carries with her a tall flower of a species that is seen on the other large screen, seen blowing in the breeze in a field. Both videos are presented in slow motion. Then in a maniacal burst of violence, the woman swings the flower at the window of parked cars. The windows smash immediately upon impact and the flower is now a weapon strong enough to break glass. A police officer is also walking down the street, and we expect the woman to be apprehended; however, the officer smiles in approval and continues walking past. This destructive behavior then becomes a cathartic feminist statement.

The piece is so close to being a music video that it is easy to forget that its place is in the gallery. It uses the tropes so effortlessly that its edges blur into what we understand as the music video form. As Ted Snell states:

> Rist has been extremely successful in merging high and low culture and the art world. Her lush videos and multimedia installations mesh together notions

of female sexuality and music video pop culture, with an imagined optimism presented in contrast to our everyday reality. This feminist intervention provides a powerful and ebullient critique, which is in turn having a powerful effect in re-shaping popular culture. (Snell 2017)

As is now well documented, musical artist Beyoncé paid direct homage to Rist in the video for *Hold Up* as part of the visual album "Lemonade" in 2016, where a new generation was able to experience video art for the first time. The homage to Rist's visuals for Beyoncé chimes with her own call to action, not only concerning betrayal within a relationship but also for feminist values to be embedded firmly into American society.

Rist's work sits within the liminal space between music video and video art alongside FKA Twigs's. Rist is particularly notable in the canon of female video artists. Her work has been shown in public spaces such as Times Square in New York City, where sixty-two video screens displayed a loop of her face smashed up against a window critiquing the spectator's gaze on femininity. The piece gained worldwide attention for its placement within one of the most well-known symbols of capitalism.

Conclusion

As has been illustrated here, it is difficult to disentangle the form and function as well as the relationship between commercial video and video art. Of course, there has been debate between the two forms and the lines distinguishing both have since become blurred in the digital age, giving reason to consider the music video as an art form rather than solely as a tool of commerciality. As Jody Berland stated in her essay "Sound Image and Social Space: Music Video and Media Reconstruction" (1993), the video "present[s] a particular mode of cultural cannibalisation, in which the soundtrack has been digested lifetimes ago, in fact consumed by the image, which appears to be singing" (Berland 1993: 3). While this statement is decades old, it deserves to be reconsidered in this context.

Today it seems that both forms have collapsed into each other rather than held their own as this chapter set out to explain. What we are left with is a very close relationship between the two forms, with video art being influenced by the tropes of music video and with music videos featuring ambiguous imagery that operates in ways strikingly similar to video art. It is evident from the examples discussed here that the aesthetic dynamics stemming from the hybridity of music videos and video art are collapsing into each other in interesting ways that demand further analysis. Music videos and video art are shaped by the same ideas, and there is much less to separate them than in the past.

As Cassie da Costa states:

Increasingly, the music video format offers a platform to video artists whose work is usually played on loops in sparsely populated gallery spaces. Beyond those

white walls is a YouTube-driven visual culture where songs serve as housing for far-fetched world-building. Recently, the artist and cinematographer Arthur Jafa collaborated with Kanye West for his song *Wash Us in the Blood*, a commentary on police murders of black people. The video splices together found and filmed footage and animation to create a visual collage, adapting the methodology used in Jafa's well-known film *Love is the Message, The Message is Death* from 2016 (which he set to Kanye's gospel-inspired track *Ultralight Beam*, creating in effect an unofficial music video). And last year, for musician Solange's visual album When I Get Home, multimedia artist Jacolby Satterwhite used 3D animation—partly inspired by drawings his mother made during schizophrenic episodes—to create a black Southern take on the Panathenaic Stadium, hovering over Houston's Third Ward. Solange herself directed and choreographed plenty of the visual sequences in the 41-minute film, and has, over the last several years, developed her own visual art practice around and within her music. (Da Costa 2020)

These two examples from well-known artists speak further to the blurring of the boundaries between video art and music video. In order to understand how artists use music video today, we need to look to the gallery—not only in terms of connections with broader histories of audiovisual studies but also in terms of practices from video art to global popular culture. The music video should be situated in terms of an "audiovisuology" in that it does have the capacity to destabilize what we thought we knew about the form. It is clear that in a culture where borrowing from other forms to create new work is standard, we must examine how music video and video art are themselves shaped by this very culture.

References

Arnold, Gina, Daniel Cookney, Kirsty Fairclough and Michael Goddard (eds.) (2017), *Music/Video: Histories, Aesthetics, Media*, New York and London: Bloomsbury Academic.

Art Miami Magazine (n.d.), "Nam June Paik and History Of Video Art," *Art Miami Magazine*. Available online: https://artmiamimagazine.com/nam-june-paik-and-history-of-video-art/ (accessed March 20, 2022).

Berland, Jody (1993), "Sound, Image and Social Space: Music Video and Media Reconstruction," in Simon Firth, Andrew Goodwin and Lawrence Grossberg (eds.), *Sound and Vision: The Music Reader*, 1–17, London: Routledge.

Borode, Blessing (n.d.), "The Art Of Music Videos," *New Wave Mag*. Available online: https://www.newwavemagazine.com/single-post/the-art-of-music-videos (accessed March 20, 2022).

Da Costa, Cassie (2020), "When Video art Meets the Music Video," *Apollo*, July 24. Available online: https://www.apollo-magazine.com/where-video-art-meets-the-music-video (accessed April 29, 2022).

Feisthauer, Leo (2022), *Theorizing Music Videos of the Late 2010s: A Prosumer's Study of a Medium*, Stuttgart: J.B. Metzler.

FKA Twigs (2013), *FKA Twigs - Water Me*. Directed by Jesse Kanda. March 8, 2013. Music video, 3:23. Available online: https://www.youtube.com/watch?v=kFtMl-uipA8 (accessed May 31, 2022).

FKA Twigs (2014), *FKA Twigs - Pendulum*. Directed by FKA Twigs. January 15, 2015. Music video, 5:00. Available online: https://www.youtube.com/watch?v=O8yix8PZKlw&t=0s (accessed May 31, 2022).

FKA Twigs (2015), *FKA Twigs - M3LL155X*. Directed by FKA Twigs. August 13, 2015. Music video, 16:33. Available online: https://www.youtube.com/watch?v=bYU3j-22360 (accessed May 31, 2022).

Ingham, Tim (2020), "Over 2BN Youtube Users Are Now Playing Music Videos Every Month," *Music Business Worldwide*, November 17. Available online: https://www.musicbusinessworldwide.com/over-2bn-youtube-users-are-now-watching-music-videos-every-month/ (accessed March 20, 2022).

Knowles-Carter, Beyoncé (2016), *Beyoncé - Hold Up* (Video). Directed by Beyoncé Knowles-Carter. September 4, 2016. Music video, 5:16. Available online: https://www.youtube.com/watch?v=PeonBmeFR8o (accessed May 31, 2022).

Mistry, Anupa (2015), "FKA Twigs – M3LL155X Review," *Pitchfork*, August 19. Available online: http://pitchfork.com/reviews/albums/20985-m3ll155x/ (accessed April 11, 2022).

Nicolson, Barry (2015), "FKA Twigs – 'M3LL155X' Review," *NME*, August 17. Available online: http://www.nme.com/reviews/fka-twigs/16215 (accessed April 11, 2022).

Railton, Diane and Paul Watson (2011), *Music Video and the Politics of Representation*, Edinburgh: Edinburgh University Press.

Richardson, John, Claudia Gorban and Carol Vernallis (2015), *The Oxford Handbook of New Audiovisual Aesthetics*, Oxford: Oxford University Press.

Rist, Pipilotti and Thomas Rhyner (1997), *Ever Is Over All*. Directed by Pipilotti Rist. Video, 4:07.

Rogers, Holly (2013), *Sounding the Gallery: Video and the Rise of Art-Music*, New York: Oxford University Press.

Shaviro, Steven (2017), *Digital Music Videos*, New Brunswick: Rutgers University Press.

Snell, Ted (2017), "Here's Looking at: Pipilotti Rist, Ever Is Over All," *The Conversation*, November 14. Available online: https://theconversation.com/heres-looking-at-pipilotti-rist-ever-is-over-all-87077 (accessed December 21, 2022).

Vernallis, Carol (2013), *Unruly Media: YouTube, Music Video, and the New Digital Cinema*, Oxford: Oxford University Press.

Vernallis, Carol (2004), *Experiencing Music Video: Aesthetics and Cultural Context*, New York: Columbia University Press.

17

But Still . . . Is It Art?

Contemporary Music Video, Art (Discourse), and Authority—Revisited

Maren Butte

Recently, there has been a remarkable increase of video artists who use the music video format as their medium for expression instead of displaying their audiovisual compositions in loop or multiscreen arrangements in museum and gallery spaces. In her article "Where Video Art meets Music Video," Cassie da Costa—writer for *Another Gaze*, *The New Yorker*, and *Vanity Fair*—describes this phenomenon as a shift from white cube to a "YouTube-driven visual culture where songs serve as housing for far-fetched world-building" (Da Costa 2020). She refers to the music video pieces by Solange and Jacolby Satterwhite, by musician and artist Klein and Allah, as well as to Kanye West's collaboration with Arthur Jafa for songs like *Wash Us in the Blood*. This music video from 2020 with political content, for example, shows a fragmentary split-screen collage of found (mobile) footage images and animations depicting police violence toward Black people, also showing clips of Breonna Taylor and Ahmaud Arbery, who both died resulting from racially motivated violence; as well as Covid-19 patients hyperventilating into oxygen masks, suggesting unequal medical care for POC during the pandemic. The montage with repetitive electronic sound including vocal fragments between rap and gospel singing unfolds an ambivalent emotional state of anger, grief, persistence, and hope, moving the spectator toward a liminal state of empathy and a "felt crisis," or: shock effect in the sense of Walter Benjamin (Benjamin ([1935] 1969: 250–1). Most certainly, concerning the aesthetic decisions and creative processes, West's and Jafa's music video is artful—because of its arrangement of content of form, its aesthetic practices, and its affective force. Also its media (self-)reflexivity and visual mode of critique make it indistinguishable from art—as it is commonly defined in the Global North.[1] And yet, it was not perceived as art.

Art Review's online magazine recommended watching the piece, but only Jafa's related film *Love is the Message* was reviewed by art critic Oliver Basciano (ArtReview 2020).[2] Jafa's

[1] I will refer to the varied definitions of art in the course of this chapter.
[2] This short website text on the production conditions of the video also tells that "museums around the world co-streamed Jafa's *Love is the Message*. The film—an ode to a century of Black American

music video and film shared the aesthetics and image material but appeared on different topographies: museum and video formats of the global internet. Regarded as expressions of "culture industry" (Adorno) and as commercial form, music video still seems to be at the margins of art discourse—despite the vital exchange of aesthetic ideas between arts and music business spheres and thousands of collaborations crossing disciplines. But today, social, technological, and discursive shifts have brought about a re-evaluation of the relationship between art and commerce. Current music videos reorganize forms of artistic value and commodity, as well as the relation between representation and authority, museum, and media (an-)archive. Referring to Vernallis's idea of an *audiovisuality* as (art) form, this chapter is dedicated to this transformed relationship between contemporary music video and art (discourse). It traces art discourses (from Greenberg to Walter Benjamin, Arthur Danto, and Rosalind Krauss) which appear as fractal remnants in the hybrid music video culture, foremost the relations between "pure form" and representation, uniqueness, and (media) reproduction.

This chapter explores the fractal hybridity of music video *as* art: its transgressive aesthetic modes and authorial discursive framings. By doing so, the chapter seeks to contribute to critical research on music video as a genre and cultural form of (audiovisual) expression from a media cultural perspective. Referring to and modifying Sung Bok Kim's idea I propose the assertion that music video is quite simply art because the concepts of music video and art have transformed to contain both of them (Kim 1998: 51–71). Kim argues that the concept of art has expanded so radically since the avant-garde that it has become impossible to draw any line between art and non-art. This, of course, makes irrelevant the twentieth-century-related question: "Is it art?" And yet, it needs to be asked in a deconstructive manner: contemporary music video challenges the idea of art in a specific way and enables one to conceive both differently. It helps to rethink and shift meaning processes, patterns of authority, and judgment and of (capitalist) governance and freedom. The ways in which art values are defined reflect ways we, anthropologically speaking, perceive the world and ourselves: as globally connected and technologized (post-)modern subjectivities of late capitalism and singular human beings at the same time.

Music Video in the Light of (Modern) Art Discourse on the Singularity of the Art Work

Music video has diverse roots in artistic audiovisual practices of modern art: for example, early experimental films by Hans Richter and Walter Ruttmann, theatrical forms such as revues and panoramas, artistic concepts such as Surrealism, Dadaism,

triumphs, and violence meted out by the police—is soundtracked by West's gospel-inflected *Ultralight Beam* (2016). Discussing Jafa's *Love Is The Message* last week, and the film's powerful but conflicted sense of pathos, *ArtReview*'s Oliver Basciano wrote: "there is no hierarchy to the empathy with which the artist treats the individual images: celebrity, historical, family or poor, the same structural racism abounds."

Cubism, Bauhaus, Constructivism, and experiments with animated image and sound by Oskar Fischinger, as well as in performance and body art practices, pop art, Scratch and intermedia art, and of course, video art. And yet, it has been either excluded from art discourse of the late twentieth century or was associated with culture industry. The term was coined by Adorno and Horkheimer in *The Dialectics of Enlightenment* as well as in Adorno's *Aesthetics*, where they criticize the degeneration of art into products of modern mass culture. They define postwar capitalism as an ideology, and consumership as a subtle mode of governance. Adorno characterizes the "sensually pleasant" in art products, and especially its audiovisual dimension, as a "deception … of direct fulfilment in the here and now" and as "substitute gratification" (Adorno [1958/59] 2018: 571). This conception of (non-)art clearly echoes Kant's normative notion that art should be purposeless—something which he formulated in the *Critique of Judgement* (Kant [1790] 2000).[3] Here he distinguishes between free and dependent beauty. Kant requires an object for a purely aesthetic judgment by an independent subject.

But first and foremost, art critic Clement Greenberg's writings on modernist painting formulated a similar and very influential normative notion of art to be autonomous and therefore "freed" from worldly content or entertaining pleasure or purpose (Greenberg 1989). His idea of art was also not referring to classical conceptions of Plato or, for example, German classicist Joachim Johann Winckelmann, where *mimesis* or *beauty* denoted the artwork. In the essays collected in *Art and Culture* (1961), Greenberg unfolds a radical modern view on the fine arts, foremost painting. His essays clearly differentiate art from kitsch by categorizing the latter as "commercial art" with "mechanical formulas" and as "fake sensations" (Greenberg 1989: 10). Further essays then denote the (material) medium as the decisive element of art, the "significant form" (Greenberg 1989: 240)[4] or aesthetic "unity" (Greenberg 1989: 226) that comes with the elimination of representative or gestural content. The 1950s abstract paintings by Jackson Pollock, Barnett Newman, and Mark Rothko, which were striving for acceptance as art in the United States at that time themselves, served as a starting point for Greenberg's idea of the artwork as autonomous and a form of pure aesthetic experience (compare Kuspit n.d.). Art critic Donald Kuspit explains:

> For Greenberg, a consummately formal, purely material, nonsymbolic work—for example, a painting finessing its flatness in the act of acknowledging it—was an exemplification of positivism, which he saw as the reigning ideology of the modern world. What counted in a Morris Louis painting, for example, was the way the colours stained the canvas, confirming its flatness while seeming to levitate

[3] Here Kant famously explains that aesthetic judgments were "judgments of taste" resting on subjective feelings and yet holding a universal validity (Kant [1790] 2000: 5: 203–204). Judgments of taste rely on "disinterestedness" (interesseloses Wohlgefallen) and purposelessness in the sense that the artwork does not want to give pleasure (Kant [1790] 2000: 5: 221).

[4] He is referring to Mallarmé's idea of "pure poetry" here.

above it. The painting had presumably no other meaning than the sheer matter-of-factness of its colours and their movement on the canvas. (Kuspit n.d.)

Kuspit's quote illustrates to two dimensions of the art experience imagined by Greenberg that partly still resonates in definitions of art today. It explains a mode of literalness and self-reflexivity (here: of "flatness" [Greenberg 1989: 100]) that is combined with a kind of ritualistic moment of transcendence: modern rationalism and the liminality of the *aura* (here: levitation). I will return to the notion of aura later when revisiting Benjamin's essay "The Work of Art in the Age of Mechanical Reproduction".

In a way, Greenberg's idea of singularity and material purity affirms the invention of art in eighteenth-century Europe, namely Romanticism where—as French philosopher Jean-Luc Nancy, among others, has pointed out—arts and crafts were divided (Nancy 1996: 16) and the modern type of artist as genius emerged; as well as the concept of the creative and sensitive spectator. Interestingly enough, Romanticism was fascinated with fragments, ruins, hieroglyphs; forms that were ideal in their timeless temporality and imaginative beauty. By its fullness and the synthesis of the arts (language, music, image), music video appears as the opposite of the fragmentary which was the ideal conception of art during that time. At the same time, it appears as the exact model for a *Gesamtkunstwerk* (total work of art).

To return to the dominant discourse on art in the middle of the twentieth century: Greenberg received pop art and Neo-Dadaist art as a decline because art had lost its singularity, purity, sublimity, and organic unity (an idea not far away from Winckelmann's *harmony*) to combinatory strategies and modes of distraction—to their worldliness. According to Greenberg, the ordinary of everyday life, which was the main interest of the new arts, did not belong to the sphere of art. In most music videos the relation to the world is essential—it relates to the experiences and identities of makers and consumers. Greenberg's ethos of modernism and medium purity was continued in the art discourse, for example, by Michael Fried and others, and it can also be traced to contemporary abstract art.[5] Since then, art discourse has diversified into varied contrapositions to Greenberg's formalism insisting on the relevance of considering the *zeitgeist* and historical condition of an artwork or artist, for example, Leo Steinberg, Harold Rosenberg, and Lawrence Alloway, who insisted on the necessity to weigh in the relation between art and life in discourse (Kuspit n.d.). Finally, with the emergence of postmodern art (Fluxus, Happenings, performance and video art), a variety of theoretical approaches emerged—from visual culture theories (John Berger, Jonathan Crary) and post-structural concepts by Barthes and Derrida (Rosalind Krauss) to psychoanalysis and feminist theories (Lucy Lippard, Linda Nochlin, Griselda Pollock) as well as Neo-Marxist, postmodernist, and post-internet theories (Benjamin Buchloh, T.J. Clark, Featherstoke, Wallace). Today, as Kuspit writes, art criticism and discourse has diversified and runs parallel, focusing

[5] See as an example the recent publication *Abstract Video. The Moving Image in Contemporary Art* by Gabrielle Jennings (Jennings 2015).

on different particles from the art historic repertoire of "formal, psychological, moral, social, and spiritual" dimensions (Kuspit n.d.).

Art after the End of Art . . . the Crisis of Art Discourse in Postmodernism

As mentioned ahead, with the rise of transdisciplinary and "dematerialized" art of the 1960s (Lippard 1997), art discourse has come into crisis itself (Osborne 1989: 32). For example, philosopher Peter Osborne describes the postmodern conception of art as a hybrid constellation of tradition and its overcoming: a backward orientation toward the art discourses of modernity and at the same time an opening toward questions of representation and the social function of art (Osborne 1989: 32). And also Victor Burgin argues against Greenberg's for a "politics of representation" and suggests the art object to be just "one medium among others"—not holding a singular status anymore (Burgin quoted in Osborne 1989: 33). Art practice is being reconceptualized by the younger generation of artists at this time as "a set of operations performed in a field of signifying practices," including mixed media, as well as the

> direct reinstatement of social and political representational content into the work, and the reintroduction of traditional, art historical iconographic material (usually in a deliberately hybrid, ironic, or parodic fashion), to straightforward repetitions of the 'historical' avant-garde's internal attack upon the art institution itself, through the simple designation of everyday, mass-produced commodities as aesthetic objects in their own right. (Osborne 1989: 33)

US-American critic Arthur Danto interprets the situation differently. In his seminal work *What Art Is?* he describes—with reference to Hegel—how art had come to an end because it had—with the age of art manifestos of the 1950s and then the dematerialization of the artwork in the 1960s—become philosophical. Danto's tipping point of argument is a passage about Andy Warhol's *Brillo Boxes* (1964): the display of the exact same boxes that would have been bought in stores (equivalent to Duchamps's *objets trouvées* in the 1910s). Before those, Danto had argued that art was "embodied meaning" to be interpreted by the viewer (Danto 2015: 38). The identical Brillo Boxes installed as art work turn the question of art from essentialism to contextualism and philosophical thought (Danto 2015: 38). Donald Kuspit's book *The End of Art* (2005) argues accordingly that "art has been replaced by postart, a term invented by Alan Kaprow, as a new visual category that elevates the banal over the enigmatic, the scatological over the sacred, cleverness over creativity" (Kuspit 2005: cover text). The central argument is the loss of even the "aesthetic experience" in postmodern art (Kuspit 2005: cover text). While modern art modeled a "universal human unconscious," postmodern art had "degenerated into an expression of narrow ideological interests" and—with Frank Stella—an "assimilation of art into everyday life" (Kuspit 2005: cover text, 9). Referring to works of Marcel Duchamp and Barnett Newman, Kuspit

re-interprets forms of aesthetic experience from a contemporary point of view. He re-introduces terms of ritualistic practice like "alchemy," "magic," "transubstantiation," "osmosis." And he defines the creator, spectator, and art work as "mediumistic" agents. Furthermore he emphasizes the "consecrated posterity"—the moment of a "suspended judgment" instead of a pleasing object (Kuspit 2005: 14–20).

According to this hybridization of art theory by the end of the twentieth century, how does music video interweave with this understanding of art in between tradition and resolution of ideas? It clearly shares ideas of art in between philosophy, individual aesthetic experience, and ideological representation. But it brings one important aspect into consideration: technical mediality.

Appropriation and Design: Transgressive Music Video Art Practices

Having laid out a sketch of art discourse from the 1950s to the present, this section of the chapter takes a closer look at the concrete modes of medial exchange between both fields and their discursive contexts—from appropriation and design to reproduction. There are countless interminglings of music video and art that are grounded in referential relations like citation or appropriation—but also in aesthetic practices and structures. These relationships become conspicuous by iconic styles or clear citations of elements or practices from art history; or, by the authority of famous film directors or artists; or, by their memorable synthetic quality and semantic multi-layeredness; or, by a clear form of a political comment by aesthetic means (shock effect); or, just by an audiovisual flamboyance of pleasure. To name some examples: R.E.M.'s *Losing My Religion* recreating Caravaggio's chiaroscuro technique; Damien Hirst's *Country House for Blur*; Mark Pellington for Pearl Jam's *Jeremy* (1993); Michel Gondry's complex montage of layering a repetitive plan sequence for Kylie Minogue's *Come Into My World* (2001) or his surreal clip of Foo Fighter's *Everlong* (1997); Allison Schulnik's animated sculptural work for Grizzly Bear's *Ready, Able* (2009); Nicki Minaj's *Cassie The Boys* with its visual reference to Yayoi Kusama's famous *Dots Obsession* (2012); Rihanna's *Rude Boy* inspired by the iconic work of Keith Haring (2009); Solange's *Almeda* playing with serial spatial arrangements of minimalist art (2019); Sigur Rós' *Varúð* (2012, directed by Ryan McGinley) reminiscent of feminist video art; Pipilotti Rist's appropriation of a Chris Isaac song transforming it into a montage with scream performance (*I'm a Victim of This Song*, 1995); Powell's *Freezer* (2017, directed by Wolfgang Tillmans) showing elements of kinetic sculpture with water in movement, strangely complementing the rhythm of the sounds—as well as poetic images of landscapes and plants, then detailed photographs of cops and soldiers; Anton Corbijn's *Heart-Shaped Box* or Samuel Bayer's *Smells Like Teen Spirit*, both for Nirvana; Stephen R. Johnson's stop-motion animation for Peter Gabriel's *Sledgehammer*; Spike Jonze's cop drama parody for *Sabotage*; Chris Cunningham's *Frozen* for Madonna (1998); Franz Ferdinand's *Take Me Out* using pictorial techniques of Dada, Soviet propaganda,

Monty Python's animation and the cinematography of Busby Berkeley (Jonas Odell, 2004); Fat Boy Slim's *Praise You* by Spike Jonze presenting a whimsical flash mob dance performance (1998); Mykki Blanco's *Loner* (2016), Azealia Banks's post-internet aesthetics in *Atlantis* (2018); and almost every music video with and by Björk.

The examples mentioned could, of course, be supplemented, and they show themselves artistically inspired in different ways; partly the references are cinematic. But some videos clearly appropriate an art historical style, an artistic process, or they incorporate another art form. Often those references to art have been (mis-)interpreted as appropriation—of intellectual, cultural, and artistic property; as a form of copying or stealing. A reading which (re-)constructs a hierarchy between art and music video, suggesting one-way directions of influence. But appropriation itself is also a conceptual form within art history itself. Art discourse denotes these strategies as pastiche, mimicry, or travesty; they often imply critical feminist or Marxist dimensions of critique.[6] In this regard, John Walker, who examines the interrelationship between the two in his study on pop art "crossovers," writes ironically that this looting from the world of art is defensible at least insofar as modern art itself is guilty of cultural appropriation, referring to primitivism, among other things (Walker 1987: 8). Walker's study traces a tradition of music video since the 1960s in London: he describes a climate of exchange between music and art and shows how this had an effect on the visual dimensions of pop, as well as on the fine arts. It was in this period the first "all over designs" for pop music emerged consisting of fashion, habitus, and self styles, stage sets, photography, record covers, and so on which were often based on artistic models such as Dada, futurism and Bauhaus; and of course also on the responses of the audience, their "emotional and cultural needs" (Walker 1987: 5–6). Of course, these concepts of "all over designs" and "styles" have a longer history, art critic Alex Coles, Vilem Flusser, Dan Graham, Ina Blom, and Hal Foster have observed in the studies on the relation between art and design (Coles 2007; Blom 2007). For example, Foster refers to design as an incorporation of art by capitalism in postmodernism–as a routinized transgression. He calls for a critical reading of the respective situatedness between autonomy and transgression. Such a dialectical reading of music video design undertakes a search for the hybrid: It asks about the fluid "situatedness" of the artistic within a late capitalist media sphere. How does a music video serve, thwart, shift the ideological structure; what (micro-)forms of autonomy does it achieve?

From Reproduction to Post-medium and Video Culture

In addition to the forms of appropriation and design described earlier, there is, of course, a deep structural aesthetic relationship between music video and video art. Just like music video, video art was itself also determined as an "all-embracing form" (Rush 2007: 8)

[6] See for example Dyer 2006 and Evans 2009, especially Douglas Crimp, "Appropriating Appropriation" (Evans 2009: 189–93).

and a hybrid nature reorganizing the relation between aesthetics and politics. Both share their emergence along with technological innovations and generate their expressive material out of media technological possibilities. But while video art acted from the margins in the field of art, music video developed in a sphere of commercial TV from the start—apart from early DIY experiments, of course, that reappear in the "influx of homemade videos" of digital platforms like TikTok today (Arnold et al. 2017: 9). Video art emerged in a period of dynamic social, economic, and cultural change and was in its radical aesthetic forms and contents influenced by Fluxism, performance art, body art, Arte Povera, pop art, minimalist sculpture, conceptual art, avant-garde music, experimental film, contemporary dance, and other forms of cultural expression. As video art scholar Chris Meigh-Andrews writes, the increasing accessibility to affordable technical equipment has transformed video "from an expensive specialist tool exclusively in the hands of broadcasters, large corporations and institutions into a ubiquitous and commonplace consumer product. In this period video art has emerged from a marginal activity to become arguably the most influential medium in contemporary art" (Meigh-Andrews 2014: 1, 3). "Cameras brought art and images to the masses, writes music video scholar Gina Arnold, allowed casual views for a wider experience of the world" (Arnold et al. 2017: 4). Michael Rush even likens camera with "Sony Corporation's Portapak" (Rush 2007: 7).

It is known that in the beginning, video art was a form of artistic counterculture transforming the aesthetics and the art discourse gradually. Michael Rush, for example, has shown how it was initially characterized by an appropriative departure from the cinematic repertoire of forms by differently centered, non-linear, and anti-representative camera movement, looking grainy, black and white, and showed a rough editing and experimental methods of exploring bodies, spaces, and continuous movement as well as autobiography (Meigh-Andrews 2014: 3). As representative examples, Rush mentions Vito Acconci, Bruce Nauman Joan Jonas, Richard Serra, Peter Campus, later Gary Hill, and Sam Taylor-Wood, among others. He differentiates three phases of video art: from the early experimental phase and, second, explorations of narrative modes and autobiographical formats and activist content, to, third, forms of hybridization of technologies as well as the dissolution of boundaries in installations, digital video, and so on. And with the works of Nam Jun Paik and Vostell, he indicates the unconditional proximity of video art to electronic and experimental music (Cage, Ligeti, Stockhausen) (Hegarty 2015: 5), as well as its inherent search movement for art terms and recognition within the visual arts. Here, too, the debate unfolds along the question of medium specificity, to what extent an aesthetic experience is possible in an immaterial and time-based ephemeral medium. In her book *A Voyage on the North Sea: Art in the Age of the Post-Medium Condition*, Rosalind Krauss transforms Clement Greenberg's idea of the "pure" art form and names the contemporary situation a "post-medium" condition. In her view, purity still is a part of art but no longer bound to the simple form of painting or sculpture. It could be achieved within the indistinctive interweaving of different media; each artwork should thrive for the "essence of Art itself," as "different specificity" (Krauss 2000: 10, 56). Of course,

Krauss also refers to Walter Benjamin's seminal essay "The Work of Art in the Age of Mechanical Reproduction" (1935) where he argues that the essence of art and the perceptive apparatus had been radically transformed by the technical possibilities of reproduction of photography and film. According to Benjamin, the aura as traditional and ritualistic value of the unique work of art is threatened by reproducibility (Benjamin [1935] 1969: 219–20). But this loss is also productive as it reorganizes the aesthetic and the political. While he sees the aura in relation to fascist aesthetics, the modes of photography and film transform the spectator into a critical mass media culture society. Reproduction thus diminishes the authority of the museum (cult value), and the shift of reception to the mobile public space strengthens the exhibition value. Music video would have to be located against this background of a shift in discourse in the post-medium condition. In her edition on *Music/Video*, Gina Arnold sees it precisely here when she discusses music video as a distributed art form. She describes it, with Sean Cubitt, in relations and finds its position in between electronic technology, analogue cinema, television, and digital fluid pastiches on YouTube and other streaming platforms. Figurations of art seem to run right through these different media spheres.

Music video takes place distributedly and also as consumer practice (e.g., in the DIY reviving of TikTok) (Arnold et al. 2017: 9); a making-do of cultures and tastes (De Certeau 2011).[7] Contemporary music video artworks and practices thus navigate through capitalist spheres—a process that is no longer adequately defined by Adorno's formula of culture industry.

New Hybrids: Two Music Video Art Examples

The examples of contemporary hybrid constellations of music video art unfold interesting and self-reflexive modes of audiovisuality and aesthetic experience, a fractal uniqueness within reproduction, and a suspension of judgment within the flow of audiovisual compositions. The mode of aesthetic experience of music videos has been explored in detail by Vernallis and others. I propose the following extension: to understand the aesthetic perception of a music video as art, it needs to be understood as site-specific to its own topography of a media sphere. The term "site-specific" refers to a work of art that is designed specifically for a particular location and that has an interrelationship with the location.[8] The location here is clearly not a container space but a transitory materialization of media expression.

[7] "Practice" refers to Michel de Certeau's idea of a set of performative actions (De Certeau 2011).
[8] "As a site-specific work of art is designed for a specific location, if removed from that location it loses all or a substantial part of its meaning. The term site-specific is often used in relation to installation art, as in site-specific installation; and land art is site-specific almost by definition." See: Tate Art Term "Site-Specific," https://www.tate.org.uk/art/art-terms/s/site-specific (accessed March 23, 2022).

The site and medium specificity of the music video lies in its "audiovisuality," which can be entertaining and self-reflexive at the same time. This means the recipient is affected and at the same time contemplating about what he or she sees. Audiovisuality might appear as an "osmosis" (Duchamp) and mutual transformation of music and moving images, floating in perception. This floating, however, does not appear homogeneous at all, but perforated, shifted, syncopated in the process— yet synchronized and structured again and again (like figure and ground, only not two-dimensional, but permeable). Herein would lie the possibility of seeing something like a deconstructive medium specificity or purity within reproduction.

The music video *Lost Day* by US-American folk-rock band Other Lives may serve as an example here (Other Lives 2019). The video is set in a cabin in the mountains of Oregon and shows a single interior space where the band (pose-)performs in alternating positions (Figures 17.1–17.3). The montage of shots is an unusual one: the camera has recorded the action repeatedly moving from top to bottom of the image. And this movement always ends at the bottom frame and begins again, a metaphoric image for the endless repetition or reproduction (interestingly enough, the video was produced during the pandemic and its quarantines). This creates a strange continuity in the filmic image, like the movement of the image in an app's scrolling process, but into the other direction (downward). The music is a gentle folk song with a clear chorus structure and light vocal tracks that hold the tone. There's a coup at the end of the video: singer Jesse Tabish, who had been either standing or sitting and singing into a mic in all the frames of the video, ends up floating in space while the camera does its downward sweeping motion (Figure 17.4). It's only a brief moment, but it's a powerful one. On the level of representation it seems banal; a spiritualistic camera trick that underlines the mystical aspect of

Figure 17.1 *Lost Day* by Other Lives, 2019. Directed and edited by James Taylor Gray. Music video, 2:58. Screenshot from YouTube.

Figure 17.2 *Lost Day* by Other Lives, 2019. Directed and edited by James Taylor Gray. Music video, 2:58. Screenshot from YouTube.

Figure 17.3 *Lost Day* by Other Lives, 2019. Directed and edited by James Taylor Gray. Music video, 2:58. Screenshot from YouTube.

the music. However, it can also be seen differently: as an aesthetic experience of a medial specificity. In the repetition, the eye (and thus also the kinesthetic sense) experiences a downward inclination that the body unconsciously tries to resist and wants to pull upward. The floating figure at the end thus appears as a felt levitation, a moment of aura generated mechanically and formally and carried along by the music, which exhibits a clear form of levitation in the choral singing.

Figure 17.4 *Lost Day* by Other Lives, 2019. Directed and edited by James Taylor Gray. Music video, 2:58. Screenshot from YouTube.

Another specific form of resonance as aesthetic experience is also unfolded by musician and artist Klein's collaborative music video with Chantal Adams, *Cry Theme* (Klein 2017). Klein's videos often play "with emotional drama and digital communication" (LaBelle 2015: xiii); working with overall atmospheres and moods. In *Cry Theme*, a song about mourning where a group of Black people assembles at a beach shore to perform a ritual of saying goodbye to an undefined dead person. Klein appears dressed in a flowing orange dress, and a man in a suit stands in the dark, sometimes breaking the fourth wall, looking into the camera directly into the eyes of the spectator. The video plays with an estrangement of everyday actions and experiences and highlights the details: a slanted view, an exaggerated angle, symbolic colors, and many moments which suspend judgment and meaning. Klein often works with colors, for example, in her pieces with artist Allah, who is interested in the construction of colors and the effect of blue light on skin. In *Cry Theme* the color orange dominates the scene and opens a wide range of interpretations: from autumn light and affective intensity (from excitement to danger) to religious meanings in Christianity, Hinduism, and Buddhism, as well as different meanings in varied African and Afrodiasporic contexts. The dye (carotene) is also derived from processes of photosynthesis and a mark transformation of energy. The music is strongly reduced to piano chords accompanied by strangely distorted voices singing "I never cry," culminating into a multilayered loop of electronic sounds that create a dense spatial "sound chunk" apparently "hanging" in space (Figure 17.5).

According to Costa, this video belongs to a music video subgenre in which artists comment on Blackness and diaspora. *Cry Theme*, among others, is not working with "obviously impressive or ostentatious black expressions, but to the subtle, small, and everyday, building a connective tissue between tiny gestures and chance encounters"

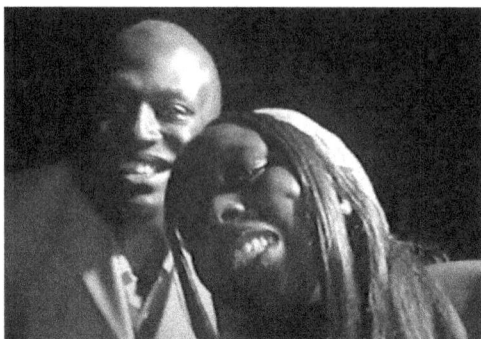

Figure 17.5 *Cry Theme* by Klein, 2017. Directed by Chantal Adams and Klein, edited by Chantal Adams. Music video, 3:44. Screenshot from Vimeo.

(Da Costa 2020). Costa suggests that those artists deliberately choose the music video format and its "short and sound-shaped forms" to explore their position "in the mass market space which black artists have historically determined and directed: the music industry," while at the same time—although not being interested in the museum at all—negotiating the representation of Black artists in hegemonic archives. The argument clearly echoes twentieth-century art discourse, yet turning it into something else. A complex resonance of uniqueness, postmodern mass media aesthetics, and identity politics, reviving and burying old ideals (of white supremacy within art discourse).

Conclusion

This chapter is dedicated to the relationship between music video and art discourse. Based on the observation that both share their aesthetic practices and that there are numerous collaborative and transdisciplinary exchanges, as well as based on the thesis that music video is simply art because their fields have become unbounded, some discourses of art theory were revisited and put in relation to the history, theory, and aesthetics of music video. It became apparent which discourses are still effective and how they can appear as fractal remnants in the hybrid music video culture. In particular, the dualisms of singularity and pure form on the one hand, and representation and reproduction on the other, are reconfigured in music video in ever new ways. The social, cultural, and technological changes have also led to a shift in discourse from the object to post-medium and media spheres, which reorganize forms of representation and authority, forms of museum, (an-)archive and institution. Finally, the aesthetic experience became important; the two sample analyses indicated complex entanglements of discourse traditions: hybrids between the singularity of art and a plurality of political identities—in their interweaving with the media-technical dispositif. They were unique, "site-specific," and political art works within the media sphere at once.

References

Adorno, Theodor W. ([1958/9] 2018), *Aesthetics*, Cambridge and Medford: Polity.
Arnold, Gina, Daniel Cockney, Kirsty Fairclough and Michael Goddard (eds.) (2017), *Music/Video – Histories, Aesthetics, Media*, London: Bloomsbury Academic.
ArtReview (2020), "Watch: Arthur Jafa Directs Kanye West in 'Wash Us in the Blood,'" *ArtReview*, July 1, 2020. Available online: https://artreview.com/watch-arthur-jafa-directs-kanye-west-in-wash-us-in-the-blood/ (accessed March 23, 2022).
Benjamin, Walter ([1935] 1969), "The Work of Art in the Age of Mechanical Reproduction," in Hannah Arendt (ed.), *Illuminations*, translated by Harry Zohn, 217–52, New York: Schocken Books.
Blom, Ina (2007), *On the Style Site. Art, Sociality, and Media Culture*, Berlin: Sternberg Press.
Coles, Alex (ed.) (2007), *Design and Art*, London and Cambridge, MA: MIT.
Da Costa, Cassie (2020), "Where Video Art Meets the Music Video," *Apollo Magazine*, July 24. Available online: https://www.apollo-magazine.com/where-video-art-meets-the-music-video/ (accessed March 23, 2022).
Danto, Arthur (2015), *After the End of Art. Contemporary Art and the Pale of History*, Princeton: Princeton University Press.
De Certeau, Michel (2011), *Practice of Everyday Life*, Berkeley: University of California Press.
Dyer, Richard (2006), *Pastiche*, London and New York: Routledge.
Evans, David (ed.) (2009), *Appropriation*, Cambridge, MA: MIT.
Greenberg, Clement (1989), *Art and Culture. Critical Essays*, Boston: Beacon.
Hegarty, Paul (2015), *Rumour and Radiation. Sound in Video Art*, New York and London: Bloomsbury.
Jennings, Gabrielle (2015), *Abstract Video. The Moving Image in Contemporary Art*, Oakland: California University Press.
Kant, Immanuel ([1790] 2000), *Critique of the Power of Judgment*, edited and translated by Paul Guyer and Eric Mathews, Cambridge and New York: Cambridge University Press.
Kim, Sung Bok (1998), "Is Fashion Art?" *Fashion Theory*, 2 (1): 51–71.
Klein (2017), *Cry Theme*. Directed by Chantal Adams. October 19, 2017. Music video, 3:44. Available online: https://www.youtube.com/watch?v=FlMUxTFclvI (accessed April 4, 2022).
Krauss, Rosalind (2000), *A Voyage on the North Sea: Art in the Age of the Post-Medium Condition*, London: Thames & Hudson.
Kuspit, Donald Burton (2005), *The End of Art*, Cambridge: Cambridge University Press.
Kuspit, Donald Burton (n.d.), "Art Criticism. Other Criteria. Rosenberg and Alloway," *Britannica*. Available online: https://www.britannica.com/art/art-criticism/Other-Criteria-Rosenberg-and-Alloway (accessed March 31, 2022).
Lippard, Lucy (1997), *Six Years: The Dematerialization of the Art Object from 1966 to 1972*, Berkeley: University of California Press.
Meigh-Andrews, Chris (2014), *A History of Video Art*, New York and London: Bloomsbury.
Nancy, Jean-Luc (1996), *The Muses*, translated by Peggy Kamuf, Stanford: Stanford University Press.

Osborne, Peter (1989), "Aesthetic Autonomy and the Crisis of Theory: Greenberg, Adorno, and the Problem of Postmodernism in the Visual Arts," *New Formations*, 9: 31–49.
Other Lives (2019), *Lost Day*. Directed by James Taylor Gray. December 14, 2019. Music video, 2:58. Available online: https://vimeo.com/379401361 (accessed April 4, 2022).
Rush, Michael (2007), *Video Art*, London: Thames & Hudson.
Vernallis, Carol (2004), *Experiencing Music Video*, New York: Columbia University Press.
Walker, John A. (1987), *Cross-Overs. Art into Pop / Pop into Art*, London and New York: Methuen.

Time-Based Media Art in Music Video—One Does Something the Other Cannot

Julia Stoschek

Julia Stoschek repeatedly emphasizes in interviews that she was strongly attracted to music video culture in the 1980s. Her fascination with the clip genre had a strong influence on her and also influenced her passion for collecting video art. Today, she is one of Europe's most important collectors of time-based media art.

In your private collection, you have placed the history of video in the larger context of time-based media art. Different multimedia approaches that form a canon of time-based video art are brought together in your collection. What parameters guided you when you collected objects and works?
At present, over 900 artworks by 291 artists across genres and generations offer an overview of time-based art from the 1960s to today with a strong focus on works made after 2000. A collection forms the understanding of our past, an "archive of temporalities," as Daniel Birnbaum has nicely put it. This, in turn, determines the possibilities for future building. Art, literature, and film, they all build worlds. As Beuys beautifully put it: "The future we want must be invented. Otherwise we will get one that we do not want." By collecting, you shape the future. That is what I firmly believe in.

Are there often qualities in works by newly discovered and surprising artists that remind you of older time-based media artworks? Are there aesthetic and structural analogies between the artists in the collection?
Video art is a medium still in its infancy. I don't say this as a bad thing, because what follows is that there is still a lot of formal and technological experimentation happening amongst younger video artists that tests or expands the limits of the discipline—take the work of Meriem Bennani and P. Staff, for instance. If painting was the most effective way of communicating the movement of power and zeitgeist of the Renaissance, then time-based media seems best positioned to reflect the thrust of our modernity. I think the artists in the collection are united by this ethos more than any other kind of aesthetic or structural imbrication.

Do you see references from time-based media art in music video, or vice versa, do you think music video is cited, imitated, or hybridized in time-based media art?
There are definitely citations—take Pipilotti Rist's video work *Ever Is Over All* from 1997 and its re-appropriation by Beyoncé in her music video for *Hold Up* in 2016. I'm sure it works the other way, too, that video art references music videos (like Arthur Jafa's *Love Is The Message, The Message Is Death* [2016]). But I think these two genres of moving image production set out to fundamentally do different things. I would not place the two within the frameworks of imitation or hybridization given that an implicit hierarchy is being suggested here. The purpose and narrative scope of both are different—it would be unfair to make them face off against each other. One does something the other cannot.

Is the genre of the music video becoming formally and aesthetically more present in media art? Or is the music video always present anyway, as both clip aesthetics and formats mutually influence each other?
Mass media products like the music video are often pastiched in various ways in media art. This is no secret. I'm thinking, again, about Jafa's *Love Is The Message, The Message Is Death*, where the popular affect of the music video lends itself to amplify a range of scenes pertaining to histories of Black suffering and systemic racism in the United States. A genius work. In other words, I think the more interesting question here is less about how one form influences the other than it is to ask how they can exist in dialogue or synthesis with one another. For one form to enrich the other.

When we talk about a canon of video art, we are also talking about selection. What parameters of collecting distinguish your selection for example from those of MoMA's, which primarily pursues a public collection strategy?
My approach to collecting was never completeness, although it is obviously much easier with time-based art. You can't start a collection focused on painting and acquire key pieces from all eras. With time-based art you can. I am not interested in having 100 works by 100 artists in the collection, but rather the key works and groups of works by the relevant artists of their time. Although the collection is already quite diverse, it is important for me to continue to amplify different or marginal voices and perspectives. My team and I do a lot of research and discuss potential acquisitions in light of a long-term strategy. Technical questions and concerns are part of the consideration as well. I do have a clear attitude, but all in all I am less restricted than public institutions like MoMA, which I consider a strength: the collection reflects my taste and some of the greatest acquisitions were led by instinct.

When it comes to the exhibitability of historical objects in particular: how can they be played, for example early cassettes, do they have to be digitized first? Do you think that something is lost from the original work of art, which may be linked to the specific materiality of the storage medium?
Our ten-year anniversary exhibition, curated by artist Ed Atkins, was titled *Generation Loss*. The term generally refers to the process of a qualitative loss in successively copied

data. Everything that reduces the representative quality as copies of data are made can be regarded as a form of "generation loss."

There certainly is a difference in reception whether you experience a 16 mm film work on the original medium or digitized and reproduced through a video projector. Sometimes the sound of the 16 mm projector is even transferred onto the digital file, as these traces of the original materiality are considered important for the viewer.

When making exhibitions, we try to reproduce the works on the media they were produced for—where it is possible. But digitizing is a form of conservation for the future. Once a work is acquired, we have clear institutional practices for dealing with digital art that are in line with MoMA's and Guggenheim's archival media standards. New acquisitions must be thoroughly evaluated and documented to determine the exact type of digital format. The files are then transferred to a digital repository. To meet all of the different requirements, a multistage strategy for long-term archiving was developed for the JULIA STOSCHEK COLLECTION, based on the "three-pillar approach." The goal is to consolidate the heterogeneous collection on a digital level in just a few established and homogeneous target formats. This noticeably reduces the conservation effort since only a manageable number of formats need to be regularly checked and monitored to safeguard against formats that are becoming obsolete. This is flanked by individual solutions for artworks that do not support a standardized procedure.

How would you describe the new and different modes of reception? Video art on the one hand has its place in the museum, galleries, and private collections, but some works can also be seen online. Earlier video works have a close relationship to TV and its technical conditions, if you think for example of Paik's work for TV. Does TV presuppose a different attitude to reception than looking at media art in the museum? Music videos were shown on TV, today it is the smartphone—is the perception of the video content influenced by the circumstances under which it is shown? For example, on the smartphone, online, or in the collection?
In their beginnings, film and video art were profoundly democratic and accessible media, with few limits or restrictions for artists and viewers. In the early 1960s, artists such as Gerry Schum and his *Fernsehgalerie* (*TV Gallery* on German TV) promoted the idea that video art should be accessible to everyone because it is reproducible.

If art wants anything at all, it wants to be seen. The scarcity of video art was imposed by the art market. That is why it is so important to me to return to the original idea of this art form. I want the video art in my collection to be able to be seen by anyone, anywhere in the world, at any time. In 2020 we started streaming the collection online, in close collaboration with the artists. Through our website jsc.art, over 220 film-, video-, and sound-based works by sixty-two artists from the collection can be watched in their entirety without restrictions.

The online platform will never replace a visit to a museum, where walking through an exhibition along works provides a special space for reflection. But why do we need to limit access to an art form for which, to begin with, all we need are the devices we all already own?

Is it imaginable for you to have screenings of video art on smartphone screens?
Yes. But for informative or educational reasons rather than for the experiential component.

Do you think that there is a big subjective perspective present in your video collection? For example, is your personal relationship to art and artists or to the period from the 1970s and 1980s until today (that has influenced you and vice versa) a reason that works from this period are particularly strongly represented in your collections and curations?
No, I wouldn't say so. We are trying to represent different generations and an overview of time-based art from the 1960s to today. A focus lies on new productions and contemporary art, which I want to be part of as a collector and when making exhibitions. Almost all of my recent acquisitions are works from the last ten years.

When you look at the most recent work in the field of time-based media, are there topics that are more the subject of debate today than they were ten years ago?
With the speed of today's media landscape, ten years is a much longer period of time than it was, for example, in the 1990s. The most fundamental shift I can see is that the West finally seems to realize that it is not alone in the world. I see this clearly in the art world, where there is a growing influence of decolonially framed confrontations with systemic racism, visible in artistic production and cultural policy (restitution) for example. There is finally a serious look at freeing oneself from a white, male, Western canon. History is also being questioned retrospectively: does it represent reality or were certain voices structurally suppressed?

Talking about technology, I think the next ten years will be crucial. Virtual reality and AI will make a leap forward and change our reception of time-based media art completely.

Biographies

AnAkA applies ancestral root work techniques to practices of herbalism, filmmaking, tattooing, photography, music, and movement. They utilize visual and sonic preservation as a tool to reclaim severed wisdoms due to the echoing generational disturbances global colonization has caused. Since 2014 AnAkA has been cultivating the AKTIV8 Archive, a preservation of Afro-Indigenous culture bearers and current global movements. AnAkA curates AKTIV8 Portals to share the AKTIV8 Archive with the public virtually and in person, bringing the knowledge to their community while preserving the sacredness of the wisdom. Ethnography is a colonial concept. There is wisdom that the Afro-Indigenous world desires to spearhead properly archiving ourselves. The AnAkA / AKTIV8 movement catapults the urgent systematic change in order to exchange sacred wisdom, how we experience art and culture outside of colonial institutions, and create an avenue for archivists of color to know they have a lane in research and media.

Maren Butte is an assistant professor for theater and performance studies at the Institute for Media and Cultural Studies at Heinrich Heine University Düsseldorf. Before that, she was a research assistant at the Research Institute for Music Theater at the University of Bayreuth (2015), a postdoc research fellow at the Collaborative Research Center 626 conducting the research project *Aesthetic Experience in the Sign of the Dissolution of Artistic Limits* at the Freie University of Berlin (2011–14, funded by the German Research Foundation DFG), and she was a postdoc researcher at the Swiss National Science Foundation research project *Iconic Criticism / eikones* at the University of Basel (2006–9) in Switzerland. She did her doctorate on the audiovisual aesthetics of melodrama (2014) and is currently researching performative practices between the arts and between art and everyday (media) life, body techniques, and digital technologies.

Kathrin Dreckmann is an assistant professor at the Institute for Media and Cultural Studies, Heinrich Heine University in Düsseldorf, Germany. She has published extensively on music videos, popular culture, and media art in several journals with publishers such as DeGruyter, Hatje Cantz, and Bloomsbury. She is the publisher of *Musikvideo reloaded* (2021), *Music Video and Transculturality* (2022), *Queer Pop* (2023), and *Fringe of the Fringe* (2023). All books deal with the central topics of (music-)video aesthetics, pop cultural production processes, and video art.

Kirsty Fairclough is Reader in Screen Studies at the School of Digital Arts (SODA) at Manchester Metropolitan University, UK. Kirsty is the co-editor of *Prince and Popular Culture* (Bloomsbury), *The Music Documentary: Acid Rock to Electropop* (Routledge),

The Arena Concert: Music, Media and Mass Entertainment (Bloomsbury), *The Legacy of Mad Men: Cultural History, Intermediality and American Television* (Palgrave), *Music/Video: Forms, Aesthetics, Media* (Bloomsbury) and author of the forthcoming *Beyoncé: Celebrity Feminism and Popular Culture* (Bloomsbury) and *Pop Stars on Film* (Bloomsbury). She is the co-curator of *Sound and Vision: Pop Stars on Film* and curator of *In Her View: Women Documentary Filmmakers* film seasons at HOME, Manchester, and is also chair of the Manchester Jazz Festival.

Jack Halberstam is a professor of gender studies and English at Columbia University in New York. He conducts research in the fields of queer theory and gender studies, focusing on the presentation and representation of gender and sexuality. Books: *Skin Shows: Gothic Horror and the Technology of Monsters* (1995), *Female Masculinity* (1998), *In a Queer Time and Place* (2005), *The Queer Art of Failure* (2011), *Gaga Feminism: Sex, Gender, and the End of Normal* (2012), *Trans*: A Quick and Quirky Account of Gender Variance* (2018), *Wild Things: The Disorder of Desire* (2020).

Wulf Herzogenrath sees himself as a mediator between artworks, the artist, and the public. The art historian completed his doctorate in 1970 with his thesis on Oskar Schlemmer's murals. After working at the Folkwang Museum, he went on to work at the Neue Nationalgalerie and the Hamburger Bahnhof in Berlin. He directed the Kölnischer Kunstverein until 1989 and curated, among other things, the first solo exhibition with Nam June Paik in Europe in 1976. He was director of the Kunsthalle Bremen from 1994 to 2011. In 2012, Herzogenrath was elected director of the art department of the Akademie der Künste in Berlin.

Henry Keazor is a professor of early modern and contemporary art history at Heidelberg University. In accordance with this assignment, one of his research fields focuses on the art of the Early Modern period, particularly the Italian and French Late Renaissance and Baroque periods. Moreover, he conducts research on and teaches contemporary art and architecture and the phenomenon of art forgery. Another important branch of his publications covers the reception of art in media such as film and music video. His most recent publication on this topic is *Raphael's "Schule von Athen": Von der Philosophenschule zur Hall of Fame* (*Raphael's "School of Athens": From the Philosophers' Academy to the Hall of Fame*, 2021).

Mathias Bonde Korsgaard is an associate professor of film and media studies at the School of Communication and Culture, Aarhus University, Denmark. He has published extensively on music videos and audiovisual studies in leading journals and with publishers like Oxford, Routledge, and Bloomsbury. He is the author of *Music Video After MTV: Audiovisual Studies, New Media, and Popular Music* (2017), which covers some core issues in the study of music video—including the history, analysis, and audiovisual aesthetics of music video—while also specifically engaging with the digital afterlife of music video online. Furthermore, Korsgaard is the editor-in-chief of the Danish online film journal *16:9*, which publishes articles in both Danish and

English on film and audiovisual media, also including the publication of scholarly video essays. His upcoming research includes two edited anthologies: *Traveling Music Video* (with Tomáš Jirsa) and *Nordic Music Videos* (with Anna-Elena Pääkkölä and John Richardson).

Laura Leuzzi is an art historian and curator. Dr. Leuzzi was a research fellow and co-investigator on the AHRC-funded project *Richard Demarco: The Italian Connection* (2018–21; DJCAD, University of Dundee). She was a postdoctoral researcher on the AHRC-funded projects *EWVA - European Women's Video Art in the 70s and 80s* (2015–18) and *REWINDItalia Artists' Video in Italy in 70s and 80s* (2011–14), both at DJCAD. She is the author of articles and essays in books and exhibition catalogs, with her research focused on early video art, European video art histories, art and feminism, and new media. She has presented internationally and given lectures at several universities. She is the co-editor of *REWINDItalia. Early Video Art in Italy* (John Libbey, 2015) and *EWVA European Women's Video Art in the 70s and 80s* (John Libbey 2019). She is currently an honorary visiting research fellow at RGU and the University of Abertay as well as a researcher at Sapienza University of Rome.

Kristen Lillvis is the Mary Alice Muellerleile Endowed Chair in English at St. Catherine University. She is the author of *Posthuman Blackness and the Black Female Imagination* (2017) and co-editor of *Community Boundaries and Border Crossings: Critical Essays on Ethnic Women Writers* (2016). She is also the project director and co-editor of *Movable: Narratives of Recovery and Place*, which collects, maps, and archives stories of recovery from substance and alcohol use disorders.

Barbara London is a New York–based curator and writer who founded the video-media exhibition and collection programs at the Museum of Modern Art, where she worked between 1973 and 2013. Her recent projects include the podcast series *Barbara London Calling*, the book *Video Art/The First Fifty Years* (2020), and the exhibition *Seeing Sound* (Independent Curators International), 2021–6. London was the first to integrate the internet as part of curatorial practice, with *Stir-fry* (1994), *Internyet* (1998), and *dot.jp* (1999). She organized one-person shows with such media mavericks as Laurie Anderson, Peter Campus, Teiji Furuhashi, Gary Hill, Joan Jonas, Shigeko Kubota, Nam June Paik, Song Dong, Steina Vasulka, Bill Viola, and Zhang Peili. Her thematic exhibitions at MoMA included *Soundings: A Contemporary Score* (2013), *Looking at Music* (2009), *Video Spaces* (1995), *Music Video: The Industry and Its Fringes* (1985), and *Video from Tokyo to Fukui and Kyoto* (1979). London's writing has appeared in many catalogs and publications, including *ArtForum, Flash Art, Yishu, Leonardo, Art Asia Pacific, Art in America, Millennium, Modern Painter*, and *The Guardian*.

Chris Meigh-Andrews, Emeritus Professor of Electronic and Digital Art at the University of Central Lancashire, has been making and exhibiting his video installations and electronic imaging work internationally since 1978 and has held artist's residencies both in the UK and abroad. He has also written and lectured extensively on the history and

practice of artists' video, both within the UK and internationally. His book *A History of Video Art: the Development of Form and Function*, originally published by Berg (Oxford and New York, 2006) and in Japanese by Sangensha (Tokyo, 2012), was published by Bloomsbury in an enlarged and updated edition in 2013 and in Mandarin by the Chinese Pictorial Publishing Co. Ltd. (Shanghai, 2018). He is currently the UK consultant for *The Emergence of Video Art in Europe (1960-1980)* and Editor-in-Chief (UK and Europe) of the forthcoming three-volume *Encyclopaedia of New Media Art* (Bloomsbury, 2023).

Ulrike Rosenbach studied sculpture at the Düsseldorf Academy of Fine Arts with Karl Bobeck, Norbert Kricke, and Joseph Beuys. From 1989 to 2007 she was a professor of Media Art at the Hochschule der Bildenden Künste Saar and taught at renowned European and international art institutes, including the famous California Institute of Arts (CAL Arts) in Los Angeles. Since 1972, her preferred technical medium has been video. Her early performance works in closed-circuit style gained international recognition and secured her a place among the most influential international avant-garde artists. Ulrike Rosenbach has always considered herself a political artist; she was particularly committed to the equal rights of female artists in the international art scene. Rosenbach has been a member of the Akademie der Künste Berlin since 2016.

Linnea Semmerling is the director of the Düsseldorf Inter Media Art Institute (IMAI). She holds a BA in Cultural Studies from Maastricht University and an MA in Art Studies from the University of Amsterdam. Her PhD dissertation in Technology Studies, entitled *Listening on Display: Exhibiting Sounding Artworks 1960s—Now*, was awarded the 2019 Media Art Histories Emerging Researcher Award. In her curating, research, and writing, Semmerling investigates socially engaged artistic practices and the relationships between technologies, institutions, and the senses.

Modu Sesay was born in Lagos to Sierra Leonean parents. Filmmaker Modu Sesay pursued a career in accounting before realizing his creative potential. Swapping the calculator for the camera, Modu quickly made a name for himself through shooting music videos and short films for hip-hop artists such as Sampa The Great and Jay-Z. Since then he has collaborated with and created content for a range of clients, including Adidas, Mini Cooper, and Domino Records. Modu's dreamy, artful, and surreal aesthetic is encapsulated through his ability to first build a world and then welcome us into it through the eyes of his characters. Modu is also heavily involved in East London-based PrettyBird UK and Northwest London–based Solo City Films, both being multidiscipline studios creating contemporary films, installations, and performance art, with work featured in spaces such as Ace Hotel London and Protein Studios.

Julia Stoschek is an art collector and shareholder of "Brose GmbH." She founded her collection of time-based art in 2003 after seeing Douglas Gordon's video *Play Dead: Real Time* (2003) at Gagosian Gallery in New York. Since then she has assembled one of the most comprehensive collections of time-based art from the 1960s to today. In

2007, Stoschek opened the JULIA STOSCHEK COLLECTION in Düsseldorf. In 2016, a second exhibition space opened in Berlin, making it the first collection in Germany to be presented in two locations. In addition to her work as a collector, Julia Stoschek supports institutions, artists, and scientists in the realization of projects in the field of time-based art and is involved in committees of international institutions. Stoschek is Vice-Chairwoman of the KW Institute for Contemporary Art, Berlin. She is also a member of various committees and councils, including the Performance Committee at the Whitney Museum of American Art, New York, Nationalgalerie, Berlin, and Kunstsammlung NRW, Düsseldorf.

Elfi Vomberg is an assistant professor at the Institute for Media and Cultural Studies, Heinrich Heine University in Düsseldorf, Germany. Her research focuses on culture, aesthetics, and history of acoustic media as well as on the field of Archive and Memory Studies. She has published extensively on cancel culture and cultural boycotts in media cultures in several journals with publishers such as Springer, edition text+kritik, DeGruyter, Hatje Cantz, and Bloomsbury. She completed her dissertation in 2018 at the Research Institute for Music Theatre at the University of Bayreuth with the thesis *Wagner Societies and Wagnerians Today*. The international study was funded by the JSPS (Japan Society for the Promotion of Science), the Bavarian America Academy, and the Max Planck Society. Vomberg is also producer and dramature at the WDR (West German Broadcasting) and invented the international music video series *Machiavelli Sessions* with the artists Jorja Smith, OG Keemo, Felix Kummer, and Ebow. This project earned her a nomination for the Prix Europa.

Jami Weinstein is an associate professor and senior lecturer in Gender Studies and English at Linköping University and a researcher at the Centre for Gender Research at Uppsala University. She is a critical social and political theorist, publishing in: contemporary continental philosophy; queer, trans*, and feminist theory; science and technology, humanimal, and environmental theory; and critical life studies. She is currently completing a monograph, *Vital Ontologies: The Facts of Life Reconsidered*, from research completed during her project "Vital Signs: Life, Theory, and Ethics in the Age of Global Crisis" funded by the Swedish Research Council, as well as co-writing a book on epigenesis. Weinstein has co-edited three special issues: "Anthropocene Feminisms" (*philosSOPHIA: A Journal of Continental Feminism*), "Deleuze and Gender" (Deleuze Studies/Edinburgh University Press), and "Tranimalities" (*Transgender Studies Quarterly*); she has also co-edited the volume *Posthumous Life: Theorizing Beyond the Posthuman*, on the "Critical Life Studies" series she co-edits on Columbia University Press.

Index

3D animation 154, 196
14 Video Paintings [DVD] 36
16 mm film 97, 98, 215
40 Jahre videokunst.de [exhibition] 75
235 Cologne 59–60, 63–70, 72
2001: A Space Odyssee [film] 156

Absence of Satan [video] 39
Abwärts [band] 64
Acconci, Vito 95, 205
Act III [video] 34
Adams, Chantal 209–10
Adorno, Theodor W. 199–200, 206
Afrofuturism 108, 127, 168–70, 173–4, 180
Ahmed, Sara 165, 167
AKTIV8 Archive 111
Aladdin Sane [album] 115–16, 118
Albarracín, Pilar 94 n.1, 98–100, 102
Allah [artist] 198, 209
All Day [music video] 86
All is Full of Love [music video] 14 n.6
Alloway, Lawrence 201
Almeda [music video] 203
Always Crashing in the Same Car [song] 116, 124
ambient music 36
ambient video 64–5
Amerykah [artist] 172
A-Movie [video] 39
Anderson, Laurie 30, 38, 73–4
Anderson, Wes 18–20
animation 73, 154, 175, 189, 196, 198, 203, 204
Another Gaze [magazine] 198
Antin, David 60 n.3
Apashe [artist] 158–9
Apeshit [music video] 86, 127–8, 130–5, 138–41
Apollo [ancient Greek deity] 129–32, 140
Apollo mission 118–19

Apollo Slays the Python [fresco] 130
app 207
Arbery, Ahmaud 198
The ArchAndroid [album] 174
Armatrading, Joan 122
Armes, Roy 12
ARoS 47 n.1, 48, 52
art discourse 199–205, 210
Arte Povera 205
artificial intelligence 161
Art Miami Magazine 189–90
art music video 48, 50
the art of pop video [exhibition] 14 n.5
Art Review [magazine] 198–9
art theory 203, 210
Ashley, Robert 29, 34–6
ATA [music video] 153–4, 159–60, 162
Atkins, Ed 214
Atlantis [music video] 204
Augmented Reality (AR) 158
aura 69, 73–5, 122, 125, 201, 206, 208
Auslander, Philip 87
Australian Music Award 179
authenticity 80, 89–90, 194
avant-garde 18, 29, 34, 39, 40, 53, 74, 108, 150, 180, 199, 202, 205
Aviici 89

Bachelorette [music video] 14
Bacon, Francis 125
Badu, Eryhak 169–71, 174–5
 Amerykah 172
 Badulla Oblongata 171, 174–5
Ballen, Roger 54
Banks, Azealia 204
Banksy 20
Barber, George 39, 68
Barr, Alfred 145
Barthes, Roland 201
Bartmann, Sara 142
Basel, Tony 150

Bauhaus 200, 204
BBC 24 n.1
Beat it [music video] 49–50
The Beatles [band] 49, 96
Bell, Olga 153–4, 159–61
Bellini, Giovanni 131
Be My Wife [song] 116
Benjamin, Walter 11, 125–6, 129, 198–9, 201, 206
Bennani, Meriem 213
Benoist, Marie Guillemine 133–4
Benson, George 16–17
Berger, John 94, 201
Bergson, Henri 166 n.1
Berkeley, Busby 53, 204
Berlan, Jody 195
Berlant, Lauren 121, 170
Berlin Atonal [band] 64
Betamax [video format] 62, 65–6
Beuys, Joseph 74, 213
The Beverly Hillbillies [TV-series] 20
Beyoncé 86, 120–1, 127–30, 132, 134–8, 142, 180, 191, 195, 214
Bieber, Justin 89
BIPOC (Black, Idigenous, People of Color) 167
Birds and the Bee9 [music video] 179
Birnbaum, Daniel 213
Birnbaum, Dara 39
Birth of Venus [painting] 42, 142
bisexual 119, 172, 174
Björk [artist] 14, 192–3, 204
Black Hole Sun [music video] 154
Black is King [film] 127
Black Lives Matter 81, 167
Black or White [music video] 161
Black Panther [film] 127
Blackstar [album] 122–3
Black to the Future [interview series] 168
Blake, Jeremy 54
Blanco, Mykki 204
Blom, Ina 204
Blue Monday [video] 39
blues [music genre] 116–17
Blur [band] 203
Bódy, Veruschka 11–12, 14, 17
Body Art 95, 200, 205

Bonaparte, Napoleon 132–3, 135–7, 141–2
Born Free [music video] 86
Born This Way [music video] 54
Borode, Blessing 188–9
Botticelli, Sandro 42–3, 142
boycott 79, 83–4, 87
Boys Keep Swinging [song] 122
Brillo Boxes [artwork] 202
Broadcast TV 39, 66, 95, 98, 104
Buddhism 209
Burgin, Victor 202
Burke, Peter 126
Busta Rhymes [artist] 155–6, 159
butch-femme 122
 butch 172
Butler, Judith 83, 173
Butler, Octavia 127
Buyse, Achiel 70 n.20
Byrne, David 30, 73

Cage, John 29, 35, 64, 73, 149, 205
cancel culture 79–84, 87–8, 90–1
Candomblé 181
candy storm 82, 90
canon 34, 53–4, 60 n.3, 75, 88, 94, 96, 98–9, 101, 103–4, 125, 127–9, 132, 139, 195, 213–14, 216
capitalism 158, 195, 199–200, 204
Caravaggio, Michelangelo Merisi 203
Cardew, Cornelius 29
The care [installation] 103
The Cars [band] 50
The Carters [band] 86, 127–42
Cassie The Boys [music video] 203
The Cave [video installation] 32–4
cell phone 23
Centers [video] 95
Centre Georges Pompidou 51
Chabot, Kevin 69
Changeux, Jean-Pierre 158
Chanhassen 117
The Charging Chasseur [painting] 141
Cherkaoui, Sidi Larbi 128
Childish Gambino [artist] 86
Christo 64
chronostatic 166
Circling [video] 38

cliptomathy 12
Clipworld 12
Closed-circuit video 43
Closer [music video] 52
Cohen, Lyor 188
Coles, Alex 204
colonization 107, 127 n.7
Come Into My World [music video] 203
Come Out [musical composition] 32
Coppola, Francis Ford 53
copyright 63, 65
Corbijn, Anton 52–3, 203
Corona/Covid-19 23, 198
counterculture 64, 142, 148, 205
Country House [music video] 203
Courbet, Gustav 19
Covers [exhibition] 47
Cox, Laverne 82
Crary, Jonathan 201
Cremona, Cinzia 94, 97
Crimp, Douglas 204 n.6
Crow, Jim 141
Cry [music video] 161
Cry Theme [music video] 209, 210
Cubism 200
culture industry 199–200, 206
Cunningham, Chris 14 n.6, 52–4, 203

Dachau 1974 [video installation] 31–2
Dadaism 199
DAF [band] 64 n.12
Damasio, Antonio 158
David, Jacques-Louis 135–7, 139–40
David Bowie 49, 115–19, 121–3, 149–50, 154
David Live [album] 115
da Vinci, Leonardo 125, 131–2
Dawn Creation [video] 38
Death Valley Days: Secret Love [video] 39
de Balzac, Honoré 19–20
Debussy, Claude 174
decolonization 106
DeFrantz, Thomas F. 156
de Gaulle, Charles 132
DeGeneres, Ellen 82
Delacroix, Eugène 130–1
Delany, Samuel L. 171

Deleuze, Gilles 157, 160, 166 n.1, 169, 175
del Toro, Benicio 18
De Rosa, Miriam 22
Der Plan [band] 59
Derrida, Jacques 171, 201
Dery, Mark 168
Desorgher, Simon 37–8
Diamond Dogs [album] 115
Die Maifrau [video performance] 43
Die Medienkunstagentur 235 Media in den 1980er und 1990er Jahren [research project] 70 n.20
Die Tödliche Doris [band] 59, 64
Different Trains [video installation] 32, 34
digital 11, 34, 54, 69–70, 74, 79–84, 87–9, 102, 106–7, 125, 127, 129, 147, 153, 158–60, 187–8, 190, 193–5, 205–6, 209, 215
Din-Gabisi, Nadeem 179
Directors Label [DVD publication] 53–4
Dirty Computer [film] 175, 181
Dirty Mind [song] 117
di Sopra, Elisabetta 94 n.1, 101–4
dispositif 22, 210
distribution catalogs 61, 63
Django Jane [song] 127 n.6
Documentary [video] 64 n.12
do it yourself (DIY) 63, 127 n.6, 205–6
Dokumenta 6 [exhibition] 73
Do Not Abandon Me Again [installation] 96
Doomsday Clock 123
Doppelgänger [video] 102
Dots Obsession [installation] 203
Dovey, Jon 39
Dryhurst, Mat 161
Duchamp, Marcel 47, 202, 207
Dundee Contemporary Arts 98
Dunham, Katherine 106
Dust Grains [video] 101
The Duvet Brothers 39
Dylan, Bob 43

Earth Wind and Fire [band] 108
Eilish, Billie 89
Einstürzende Neubauten [band] 59
The Electric Lady [album] 174–5
electronica [music genre] 116

Energy (feat. Nadeem Din-Gabisi) [music video] 179
Eno, Brian 30, 36–7, 59, 65
Equality Act 79, 81
Erotic City [song] 117
Etre blonde c'est la perfection [video] 102
Ever is Over All [video] 194, 214
Everlong [music video] 203
Eviva España/Y Viva [song] 100
exhibitability 147, 214
exhibition 14, 47–56, 61–2, 74–6, 89, 96, 137, 142, 145, 149, 175, 182, 189, 206, 214–16
experimental art 17–18
experimental film 50, 199, 205

Facebook 81
Famous [song] 79 n.1
Fanon, Frantz 169
fascism 62
Fat Boy Slim [artist] 204
Feisthauer, Leo 188
Female Black Empowerment 109, 179–80
female gaze 95, 97
feminism 42, 44, 100, 167, 191, 194–95
feminist movement 93, 101
 Feminist art movement 189
femme 109, 122, 172
Fernsehgalerie [TV program] 215
Festival International de la Bande Dessinée d'Angoulême 20 n.13
Fiorentino, Rosso 141
Fischinger, Oskar 73, 200
Fiske, John 21
Five Foot Two [film] 89
FKA Twigs 109, 173, 190–5
Flack, Roberta 122
Flitcroft, Kim 39
Flusser, Vilem 204
Fluxus 40, 201
Foo Fighter [band] 203
Formation [music video] 86
Franz Ferdinand [band] 203
Freezer [music video] 203
The French Dispatch [film] 18–20
French Revolution 132, 135, 137
Fried, Michael 201

Friedrich, Caspar David 53
Frozen [music video] 203
funk [music genre] 116, 122, 172
Furor Latino [video] 98 n.3, 99

Gabriel, Peter 154, 203
Galerie d'Apollon 130
Gaye, Marvin 180
Generation Loss [exhibition] 214
Géricault, Théodore 141
Gesamtkunstwerk 201
Get Me Bodied [music video] 142
Gilroy, Paul 169, 174
Gimme Some More [music video] 155
Gioni, Massimiliano 96
Give Me the Night [music video] 16–17
glam rock 116
Glass, Philip 30, 34–5
Glass and Patron [music video] 193
Glauben Sie nicht, dass ich eine Amazone bin [video] 42
Global Groove [video] 34, 73
Godard, Jean-Luc 21
goddess 42–3, 128, 131, 134, 140–1
Godfree, Ghia 156
Godley and Creme 161
Godmother [music video] 154, 161
Goebbels, Heiner 64
Goldsmith, Leo 39
Gondry, Michel 52–4, 203
Good Morning Mr. Orwell [video] 34
Good News [music video] 158
Goodwin, Andrew 49, 51
Gorilla Tapes 39, 68
Gotrich, Lars 161
Graham, Dan 204
Graham, Martha 129, 134
The Greatest Hits of Scratch Video [VHS] 39
Greenaway, Peter 30, 37
Greenberg, Clement 199–202, 205
Grizzly Bear [band] 203
Guattari, Félix 157

Hamburger Bahnhof Berlin 44
Hamlet [play] 75
Happening 36, 201
Happiness is a Warm Gun [song] 96

Hardcastle, Ephraim 22. *See also* Pyne, William Henry
hardware 147
Haring, Keith 150, 203
Hashimoto, Baku 160–2
Hathor [ancient Egyptian deity] 131
Hauben für eine verheiratete Frau [installation] 43
Hayles, N. Katherine 154, 157, 159–60
Heart-Shaped Box [music video] 203
Hegel, Georg Wilhelm Friedrich 202
Hello Again [music video] 50
Hergé 20 n.13
Hermes Fastening his Sandal [statue] 141
Herndon, Holly 154, 161
Heroes [song] 116
Heroes and Martyrs of the Revolution [painting] 135
Hervol, Anke 74
hetero-masculinity 119
heteronormativity 121, 172
heterosexual 119–22, 193
Heyme, Hansgünther 75
Hill, Gary 205
Hinduism 209
Hirst, Damien 52, 203
Hitchcock, Alfred 174
Hold Up [music video] 195, 214
homeostasis 158–9
Homo Sapiens Sapiens [video] 96
Hoover, Nan 62 n.7, 97
Horkheimer, Max 200
Horn, Rebecca 73
Hurston, Zora Neale 106
Hybrid 9, 11–17, 21–2, 24, 26, 43–5, 77, 80, 84–5, 110, 113, 127, 134, 147, 151, 172, 185, 188, 199, 202, 204–6, 210
hybridity 17, 21–2, 24–6, 44, 83–4, 90, 182, 188, 195, 199

I am not the girl who misses much [video] 96–7
Icarus 130, 132
If I Were a Boy [song] 120–1
If I Were A Toy [music video] 121
If I Were Your Girlfriend [song] 120
Il Corpo delle donne-The Body of Women-[film] 102
Il Limite [video installation] 103–4
Imageb(u)ilder: Vergangenheit, Gegenwart und Zukunft des Videoclips [exhibition] 14 n.5
I'm a Victim of This Song [performance] 203
I'm Your Doll [music video] 192
Indigenous American 106–7
industrial [music genre] 63–4
Infermental [video magazine] 63
Ingres, Jean-Auguste-Dominique 19
installation 30–2, 36–7, 40, 53–5, 62, 96, 98, 103–4, 145–8, 190, 194, 205, 206 n.8–20
intermedia art 200
Inter Media Art Institute (IMAI) Düsseldorf 70
intertextuality 13
The Intervention of Sabine Women [painting] 139
iPhone 22
Isaac, Chris 203
Isis [ancient Egyptian deity] 131
It's Gonna Rain [musical composition] 32
I you me we us [video] 98

Jackson, Jessie 167
Jackson, Michael 14, 16, 49, 161, 180
Jafa, Arthur 196, 198, 214
Japsen [video] 97
Jay-Z [artist] 127–30, 132, 136–8, 141
jazz 116, 169, 171–2
Jeremy [music video] 203
Jesus 131, 141
Jirsa, Tomáš 13, 21–2
Jlin [artist] 154, 161
John I'm Only Dancing [song] 116
Jonas, Joan 147, 194, 205
Jones, Grace 150
Jonze, Spike 52–4, 203–4
JULIA STOSCHEK COLLECTION 215

Kanda, Jesse 190
Kant, Immanuel 200
Kaprow, Alan 202

Kardashian, Kim 79 n.1
Kijkhuis The Hague 60–3, 65–6, 69, 70 n.20
Kim, Sung Bok 199
Kinder, Marsha 50
The Kitchen [venue] 30–1, 34
Klein [artist] 198, 209–10
Klimt, Gustav 53
Korot, Beryl 29–34
Kotero, Patricia "Apollonia" 118
Kubrick, Stanley 53, 156
Kumamoto, Ryohei 22–3
Kunstakademie Düsseldorf 43
Kurosawa, Akira 146
Kuspit, Donald 200–3

Lady Gaga [artist] 54, 89
Landis, John 14 n.7
Landscape [video] 97
Lang, Fritz 174
Laocoon Group [statue] 141
LaPlace, Jules 161
Laraaji [artist] 108
La Source [painting] 19
La Vierge au coussin vert [painting] 131
Le Désespéré [painting] 19
Le Duende Volé [video performance] 99
Lemonade [album] 127–8, 142, 195
Le Mystère Picasso [film] 18 n.11
Les Immatériaux [exhibition] 51
Les Reines Prochaines 97
Leviticus: Faggot [music video] 172
LGBTQIA+ 85–6
Life on Mars [music video] 154
Ligeti, György 29, 205
Lil Nas X [artist] 176
LIMA Amsterdam 70
Little Mix [band] 24 n.22
Live in GB [video] 64 n.12
Loner [music video] 204
look at me. 25 Jahre Videoästhetik [exhibition] 14 n.5
Losing My Religion [music video] 203
Lost Day [music video] 207–9
Louis XIV 126, 130
Love is the Message, The Message is Death [film] 196, 198, 214
Low [album] 115

Lucky Little Blighters 179
Lyrical School [band] 22–4
Lysippos 141

McShine, Kynaston 150
Madonna/Maria Lactans 102, 131–2
Madonna [artist] 193, 203
Madonna [Christian saint] 102–3, 131
mainstream 40, 50, 59, 104, 128, 150, 190–3
Malaria [band] 64 n.12
male gaze 95, 97, 99, 104, 120, 141
Mallarmé, Stéphane 200 n.4
Mamma [video] 102
Manchester International Festival 194
The Man Who Fell to Earth [film] 116
Mary [Christian saint] 131
masculinity 119, 122, 155, 172
Mayweather, Cindi 174
Mbembé, Achille 165, 170
Media Dokumenta 6: 1977 [exhibition] 76
Medina, Cuauhtémoc 100
Medusa [statue] 141
Meier, Dieter 73
Mekas, John 30
metalepsis 17
Metoo 81
Metropolis: Suite 1 (The Chase) [album] 174
Metropolitan Museum New York 18
Meyerbeer, Giacomo 15
M.I.A. [artist] 86
Minaj, Nicki 203
minimalist art 203
Minogue, Kylie 203
Miss Americana [film] 86–7, 89–91
Missy Elliot [artist] 155–6, 159
Mistaken Memories of Mediaeval Manhattan [installation] 36
Mistry, Anupa 192
Mitchell, Joni 122
Mizoguchi, Kenji 160
M3LL155X [music video] 191–3
Modigliani, Amadeo 125
Monáe, Janelle 127, 174–5, 180–1
Mona Lisa/La Gioconda [painting] 128, 132

Monk, Meredith 30, 64
Mon Oncle [film] 20
Monroe, Marilyn 129
Montero (Call Me by Your Name) [music video] 176
MonteVideo 60–3, 65, 68 n.19, 69, 70 n.20
Monty Python 204
Mortensen, Lise (formerly Pennington) 48 n.3, 52–3, 56
Moving [video] 38
MTV 21, 34, 47, 50, 59, 149, 154, 187–8, 190
Mufaro's Garden [music video] 110
Muldrow, Georgia Anne 109
Müller, Heiner 64
Mulvey, Laura 95, 97
Munch, Edvard 125
Murray, Erin 23, 25
Musée d'Art Moderne de la Ville de Paris 51
Musée d'Orsay 19
Musée du Louvre 74, 126–34, 139, 141
Museo Nazionale Archeologico 103–4
Muses 140–1
Museum für Angewandte Kunst Köln (MAKK) 14
Museum of Modern Art (MoMA) 49–51, 93, 145–6, 149–50, 214–15
Musical Dancing Spanish Doll [video performance] 98 n.3, 99
Music for Airports [music album] 36
Music to See [exhibition] 48, 50, 52, 54–5
Music Video: The Industry and its Fringes [exhibition] 49, 149
My Music [exhibition] 48, 52, 54–5
My Name is (Video) [video] 34

Nancy, Jean-Luc 201
Nares, James 146
Nauman, Bruce 59, 65, 205
Ndegeocello, Meshell 120, 172–3
Netflix 85–6
Newman, Barnett 200, 202
new wave 63, 180
New Wave Magazine 188
The New Yorker [magazine] 18, 198

Next Chapter [film] 89
Next Lifetime [music video] 169
Nguyen, Thao 24
Nietzsche, Friedrich 165–7, 169
Night of a Thousand Eyes [video] 39
Nike of Samothrace [sculpture] 134, 137–8, 141
Nine Inch Nails [band] 52
NME [magazine] 192
Nothing Compares 2 U [music video] 154
Nothing Compares to You [song] 122
NOTHINGTOSEENESS Weiß Stille Nichts [exhibition] 74
NPR Music 161
Nyman, Michael 30, 37
Nyong'o, Tavia 176

O'Connor, Sinéad 154
Øberg, Morten 55
Oblongata, Badulla 171–2, 174–5
Odell, Jonas 204
Old Friends for Sale [song] 117, 121
On Land [music album] 36
One World: Together At Home [TV-program] 24 n.22
Ono, Yoko 96
opera 11–13, 15, 32, 36, 75, 190
Oregon 110, 207
Original Demo Video 64 n.12
OSHUN [artist] 109
O Superman (For Massenet) [music video] 38, 73
Other Lives [band] 207–9
Ovid 130–1, 140

Paganini, Niccolò 15
Paik, Nam June 29–30, 34–5, 49, 64, 73, 146, 148–9, 189, 205, 215–16
Paisley Park 117
Palm Pictures 53
Panathenaic Stadium 196
Panic in Detroit [song] 118
Paysage du clip [exhibition] 51
Peace Beyond Passion [album] 172
Pearl Jam [band] 203
Pendulum [music video] 191
Péquignot, Julien 50–1, 55

Perfect Lives [video] 36
Perry, Katy 82
Phaeton 140
Phenom [music video] 24–5
Picasso, Pablo 18 n.11, 125
Pickelporno [video] 97
Piene, Otto 18–19 n.11
Pietá [painting] 141
Pires, Carl 179
Pitchfork [magazine] 192
Plantation Lullabies [song] 172
Plato 200
Playback [exhibition] 51, 55
Polka Dots and Moonbeams [video] 39
Polke, Sigmar 73
Pollock, Griselda 201
Pollock, Jackson 18, 200
Pope Paul VI 189
Pope Pius VII 140
Porter, Billy 85
Portrait d'une femme noire [painting] 133-4. *See also* Portrait d'une Négresse
Portrait d'une Négresse [painting] 137. *See also* Portrait d'une femme noire
Portrait of Madame Récarnier [painting] 140
Pose [TV show] 85
Posthumanism 156
Postmodern Art 201–2
Postpunk 39, 63
Powell [artist] 203
Praise You [music video] 204
Pride Month 79
Prince [artist] 115–23
prosumer 88
protest 79–84, 86, 90–1, 94, 116
P. Staff [artist] 213
Punk 63–4, 116–17, 147
Punto de Fuga [video] 98–9
Purple Rain [song] 117–18
Pyne, William Henry 22 n.18
 Ephraim Hardcastle 22 n.18
Python [mythological creature] 130–2

Q.U.E.E.N. (Queer, Untouchables, Emigrants, Excommunicated, and Negroid) 174–5

Queen Pen [artist] 120–1
Queer Eye [TV show] 82, 85
Queerness 119–20, 175

The Rain (Supa Dupa Fly) [music video] 155–6
Ray, Man 53
Ray, Ola 16
Ready, Able [music video] 203
Rebel Rebel [song] 118, 120
Reflexionen über die Geburt der Venus [video] 42–4
Reich, Steve 29–34
R.E.M. [band] 203
Reynolds, Ryan 82
Richter, Hans 199
Rigaud, Hyacinthe 126
Rihanna [artist] 192, 203
Riley, David 96
Rist, Pipilotti 73, 96-7, 101, 194–5, 203, 214
Robinson, Smokey 122
Robinson, Sylvester 122
rock'n'pop Museum Gronau 14
Rolland, Stephane 137
Rolling Stone [magazine] 119 n.1
Romanek, Mark 52–3
Ronson, Mick 115
Rós, Sigur 203
Rose, Tricia 169, 171
Rose Hobart [video] 39
Rosenberg, Harold 201
Rosler, Martha 101
Rothko, Mark 200
Rude Boy [music video] 203
Rugaard, Dorthe Juul 48 n.3, 54–6
rumba flamenca [song] 99
Run and Run [music video] 22
RuPaul 82
Rush, Michael 95, 205
Ruttmann, Walter 199

Sabine Women 139–40
Sabotage [music video] 203
Sacre de l'empereur Napoléon Ier et couronnement de l'impératrice Joséphine dans la cathédrale Notre-Dame de Paris [painting] 135

Sad-Eyed Lady of the Low Lands
 [song] 43
Salieri, Antonio 15
Salyu 22, 24
Sampa the Great [artist] 179, 181
sampling 17–18, 32, 34, 39
San Francisco Museum of Modern
 Art 93
Save Your Tears [music video] 158
Schaeffer, Pierre 29
Schaulin-Rioux, Jeremy 23, 25
Schneemann, Carolee 194
Schum, Gerry 215
Scopitones 26
Scratch Video 38–40, 68, 200
Searching [film] 23
Semiotics of the Kitchen [video] 101
Serra, Richard 205
Sesay, Modu 179
Shaviro, Steven 11, 13–14, 17–18, 20–1,
 155–6, 158, 160, 188
She's Got Medals [song] 122
shitstorm 82, 84, 86–7
Shoot'n Up and Gett'n High [song] 172
Sign of the Times [song] 117
Simone, Nina 122
single-channel video 145, 147
Situationism 40
Sledgehammer [music video] 154, 203
smartphone 22–4, 26, 148, 215–16
Smyths Toys Superstores 121
social media 23, 80–1, 83, 86–9, 125,
 129, 136, 142, 158, 180, 182
software 147–8, 188
Solange [artist] 196, 198, 203
Solomon R. Guggenheim Museum 215
Sometimes It Snows in April [song] 120
Sonne statt Reagan [music video] 74
Sony Portapak 189, 205
Soundgarden [band] 154
Soundies 25–6
Spawn [artist] 161
speculative fiction 168, 170–1
Sphinx 138–9
Spongebob Squarepants [film] 116
stage persona 182
star 16, 26, 79–81, 85, 87–90, 116–18,
 122–3, 128–9, 131–2, 154, 192

Starman [song] 115
Star Wars [film] 53
Station to Station [album] 115, 122
Stockhausen, Karlheinz 29, 205
Sun Ra [artist] 108, 127 n.6, 169, 180
Super 8, 102
Surrealism 40, 199
Sweet Thing [song] 115, 122
Swift, Taylor 79–91
Swinton, Tilda 18

Tabish, Jesse 207
tablet 23 n.21, 26
Take Me Out [music video] 203
Talking Heads [band] 49
Tambling, Jeremy 12–14
Tati, Jacques 20
Taylor, Breonna 17
TBWA\Hakuhodo 22
technogenesis 153–4, 157, 159–62
Technology/Transformation: Wonder
 Woman [video] 39
Teeming [video] 38
Temporary [video] 102
Text and Commentary [video
 installation] 32–3
Thao & The Get Down Stay Down
 [band] 24–5
There is a Myth [video] 103
This is America [music video] 86
Three Tales [video installation] 33–4
Thriller [music video] 14, 16
Throbbing Gristle [band] 59, 64
Thursday Afternoon [installation] 36
TikTok 89, 205–6
Tillmans, Wolfgang 203
Time Based Arts Amsterdam 60–1, 69,
 70 n.20
time-based media art 213–14, 216
TOC: A New-Media Novel [multimedia
 project] 159
Tomasula, Steve 159
Top of the Pops [TV show] 115
Tortilla a la española [video] 101–2
Touch [song] 24 n.22
Transness 119
True Stories [film] 89
Trump, Donald 90

Twitter 23 n.20, 79, 81, 84–5, 129
Two [film] 97

UbuWeb 59
U-matic cassette/tape [video format] 61–3, 65–6, 68, 70
Understand Yourself [music video] 110
Untitled [video] 102
U.S. Civil Rights Movement 170

van Beethoven, Ludwig 14
Vanitas [video] 102
Vanity Fair [magazine] 198
van Vliet, Tom 61
Variazioni Minime [video] 102
Varúð [music video] 203
Vasulka, Steina 30, 49
Vasulka, Woody 30, 49
VCR (video casette recorders) 60, 65–6
Venice Biennale 14, 96, 100
Venus 42–3, 142
Venus de Milo [statue] 141–2
Vereniging van Videokunstenaars 61
Veronese, Paolo 142
VHS casette/tape [video format] 39, 60, 62–3, 65–70
Vicet, Marie 51, 55–6
Video 2000 66
Videocongress [magazine] 63
Videokalos Image Processor 38
Videomusic [vide magazine] 63
videotheek 61
Videothek [exhibition] 75
The Village Voice [newspaper] 50
Viola, Bill 146, 149
Violent Incident [video] 65
Violin Power [performance] 30
Virtual Reality (VR) 158, 216
Viva España [video performance] 98 n.3, 100
voguing 193
Völklinger Hütte 14

vom Bruch, Klaus 43
Vostell, Wolf 75, 205

Warhol, Andy 50, 52, 129, 137, 150, 202
Wash Us in the Blood [song] 196, 198
Water Me [music video] 190
Watson, Paul 48
The Wedding Feast at Cana [painting] 142
The Weeknd [artist] 158–9
Wellingtons Sieg oder die Schlacht bei Vittoria [musical composition] 15
West, Kanye 79 n.1, 86, 196, 198–9
When I Get Home [album] 196
Why [video] 102
Wijers, Gaby 70 n.20
Wild is the Wind [song] 122
Williams, Harold "Hype" 154–5
Williams, James Gordon 156
Williams, William Carlos 32
Wilson, Robert 74
Wirths, Axel 63
Woo-Hah!! Got You All In Check [music video] 155
The World of Music Video [exhibition] 14 n.5
The World's a Little Blurry [film] 89

Yes Frank No Smoke [video] 39
You need to calm down [music video] 79, 80, 82–3, 85, 86, 88, 90–2
Young Americans [album] 115, 124
YouTube 11, 15, 17, 23, 25–8, 54, 58–9, 70, 82–3, 92, 105, 124, 128, 130, 132–5, 138–41, 143–4, 154, 162–4, 176–8, 188, 190, 196–8, 206–9, 211

Zebra Katz [artist] 173, 177
Ziggy Stardust 115, 116, 123
Zoolander! [film] 116
Zoom [program] 24, 27

www.ingramcontent.com/pod-product-compliance
Lightning Source LLC
Chambersburg PA
CBHW062215300426
44115CB00012BA/2068